D0761240

The Work of Art in the Age of
Its Technological Reproducibility,
and Other Writings
on Media

The Work of Art in the Age of
Its Technological Reproducibility,
and Other Writings
on Media

WALTER BENJAMIN

EDITED BY
Michael W. Jennings, Brigid Doherty, and Thomas Y. Levin

TRANSLATED BY
Edmund Jephcott, Rodney Livingstone, Howard Eiland, and Others

THE BELKNAP PRESS OF
HARVARD UNIVERSITY PRESS
Cambridge, Massachusetts London, England 2008

Additional copyright notices appear on pages 425–426, which
constitute an extension of the copyright page.

Benjamin, Walter, 1892–1940.
[Kunstwerk im Zeitalter seiner technischen Reproduzierbarkeit. English]
The work of art in the age of its technological reproducibility,
and other writings on media / Walter Benjamin;
edited by Michael W. Jennings, Brigid Doherty, and Thomas Y. Levin;
translated by Edmund Jephcott . . . [et al.].—1st ed.
p. cm.
Includes index.
ISBN-13: 978-0-674-02445-8 (pbk. : alk. paper)
1. Art and society. 2. Photography of art. 3. Mass media—Philosophy.
4. Arts, Modern—20th century—Philosophy. 5. Benjamin, Walter, 1892–1940—
knowledge—Mass media. 6. Benjamin, Walter, 1892–1940—Translations into English.
I. Jennings, Michael William. II. Doherty, Brigid. III. Levin, Thomas Y.
IV. Jephcott, Edmund. V. Title.
N72.S6B413 2008
302.23—dc22 2008004494

CONTENTS

ILLUSTRATIONS

A NOTE ON THE TEXTS

The following editions of works by Walter Benjamin are referred to throughout this volume:

> *Gesammelte Schriften,* 7 vols., with supplements, ed. Rolf Tiedemann, Hermann Schweppenhäuser, et al. (Frankfurt: Suhrkamp, 1972–1989).
> *Selected Writings,* 4 vols., ed. Michael W. Jennings et al. (Cambridge, Mass.: Harvard University Press, 1996–2003).
> *The Arcades Project,* trans. Howard Eiland and Kevin McLaughlin (Cambridge, Mass.: Harvard University Press, 1999).

The texts included in this volume are for the most part drawn from the four volumes of Benjamin's *Selected Writings;* we have modified a few of the translations published there in the course of our work on the section introductions.

The editors of the present volume are grateful not just to Benjamin's accomplished translators, but in particular to Howard Eiland for the editing work that went into the *Selected Writings.* Our research assistants Annie Bourneuf and Ingrid Christian have made invaluable contributions to the textual apparatus, and Charles Butcosk and Lisa Lee provided expert help with the acquisition of materials for the illustrations.

The Work of Art in the Age of

Its Technological Reproducibility,

and Other Writings

on Media

EDITORS' INTRODUCTION

Although Walter Benjamin had written short texts on painting and the graphic arts during his student years, it was not until the 1920s that he became intensely engaged with a broad range of modern media. These included new technologies that produced changes in, and served as virtual or actual prostheses for, human perception; instruments of mass communication such as the newspaper and the radio; new techniques of display related to urban commodity capitalism; and artistic media such as painting, photography, and film.

Born in Berlin in 1892, Benjamin had grown up in a city deeply marked by the rampant growth of German industry in the last quarter of the nineteenth century. Modern technologies were pervasive in the German capital—arguably more so there than in any other European metropolis of the era. Germany had been united as a nation only in 1871, and the period that immediately followed (known in German as the *Gründerjahre*, or foundational years) was characterized by a remarkable economic boom that reshaped the face of Berlin. The early years of Benjamin's career as a writer, which began while he was still in high school, were given over not to an exploration of the experience of the modern city, but to a reevaluation of the philosophy and literature of German Romanticism and to the development of a theory of criticism rooted in that very Romanticism. In studies of Friedrich Schlegel's criticism, Johann Wolfgang von Goethe's prose, and Baroque mourning plays, Benjamin developed a highly original theory of literature based on concepts and practices derived from the works themselves.

The rhythms of Benjamin's practice and theory of criticism in the years 1912–1924 interweave two movements. On the one hand, his criticism calls for the demolition or demystification of the unified, autonomous work of art. In a typically striking formulation, Benjamin calls this process of demolition or demystification the "mortification of the work";[1] scholars today, using a term from a seminal 1918 speech by the German sociologist Max Weber, might speak of its "disenchantment."[2]

1

Benjaminian criticism attempts to reduce the seemingly coherent, integrally meaningful work to the status of "ruin," "torso," or "mask," to name but a few key figures of his criticism. On the other hand, his theory also strives for a productive moment: the isolation and redemption of shards of an "immanent state of perfection" that had been shattered and denatured—made meaningless—in the course of history.[3] In an important essay on Goethe's novel *Elective Affinities*, Benjamin defines the object of criticism as the discovery of the "truth content" of the work of art. The dense intertwining of brilliant immanent criticism and broad-gauged cultural theory in these works has ensured them a special status in the history of literary theory.

In the course of the 1920s, Benjamin turned his gaze from the German literary and philosophical tradition to a series of problems in contemporary culture. A key stage in this process was his involvement with artists of the European and Soviet avant-gardes who had gathered in Berlin in the early part of the decade. Crucially, this involvement with avant-garde artists, architects, and filmmakers overlapped with Benjamin's brief affiliation with the university in Frankfurt as he unsuccessfully attempted to have his study of the Baroque mourning play accepted as a *Habilitationsschrift* that would qualify him for a teaching position in a German university. Also during this period, in 1923 he was forming friendships with the architect, cultural critic, and film theorist Siegfried Kracauer (1889–1966), the philosopher Theodor Adorno (1903–1969), and the chemist Gretel Karplus (1902–1993, later Gretel Adorno); and in 1924 he began a long relationship with the Latvian journalist and theater director Asja Lacis (1891–1979), who encouraged Benjamin to undertake a serious study of Marxism and to whom his epochal 1928 book *One-Way Street* was dedicated. In late 1922 and early 1923 a new group of international avant-garde artists came together in Berlin and launched the publication of a journal called *G*, an abbreviation of the German word *Gestaltung*, meaning "formation" or "construction." The artists of the "*G*-group" included a number of figures who would go on to shape important aspects of twentieth-century culture: the architect Ludwig Mies van der Rohe (1886–1969), the painter and photographer László Moholy-Nagy (1895–1946), the international constructivist El Lissitzky (1890–1941), and the former Dadaists Raoul Hausmann (1886–1971) and Hans Richter (1888–1976), the latter the group's dominant personality and the driving force behind the journal. Benjamin, along with his wife, the journalist Dora Sophie Pollak (1890–1964), and his friend Ernst Schoen (1894–1960), a composer and music theorist

who would go on to direct one of Germany's national radio stations, all began to move at the fringes of this community. The group as a whole focused on the possibilities that new technologies and industrial practices were opening up for cultural production, and Benjamin took part in the debates that were regularly held in artists' ateliers across Berlin. For Benjamin, Moholy-Nagy's theorization of the variously reciprocal relationships among technological change, the production of new media forms, and the development of the human sensorium was particularly important. Many of the writings included in this volume, foremost among them Benjamin's magisterial essay "The Work of Art in the Age of Its Technological Reproducibility," constitute often radical explorations and theoretical extensions of the reconsiderations of relationships among technology, media, and the human sensory apparatus—explorations that emerged as central to the contributions of the G-group and indeed to German culture at large, especially in the context of the economic stabilization that brought an end to the period of inflation and hyperinflation of the earlier 1920s.

By now, it should be clear that we are using the terms "media" and "medium" in a broadly inclusive manner. A central aspect of Benjamin's work is the attempt to rethink the complex processes through which our sensory and cognitive apparatuses engage the world around us. In his writings on Romanticism, Benjamin had already offered a highly original reconceptualization of relationships among persons, works of art, and the larger world. Benjamin's early theoretical emphasis, developed largely in relation to the history of German literature and philosophy, broadened and intensified as he turned to the consideration of works of art produced by means of new technologies, and indeed to the devices and appurtenances of those technologies themselves. Virtually every essay in this volume examines some aspect of the manner in which individual works, genres, media, or technological apparatuses *mediate* the complex processes by which we perceive, act upon, and function within that world. This volume, then, goes beyond considerations of modern media such as the newspaper and radio, artistic media such as painting, photography, and film, and the techniques of display and advertisement that have had such a profound effect on human consciousness and the nature of human embodiment under the conditions of modernity. The texts assembled here also explore individual devices and entities such as the still camera and movie camera, the various forms of the panorama, engineering diagrams, the telephone, and such architectural forms as the train station, underground sewer systems, and, crucially, the arcade.

Benjamin's work in this field in the 1920s is astonishing for its range and depth. We should remember that there was no general theory of media on which Benjamin could build—only theoretical meditations on older individual forms such as painting and photography, or local reflections on new forms such as radio, film, and the illustrated press. Partly as a professional strategy (he sought in this period to establish himself as a journalist and indeed as a leading critic of culture), partly as a practical matter (he saw in radio a potentially lucrative outlet for his writings), but mainly driven by new aesthetic and political commitments, Benjamin aimed to establish himself as a principal commentator on new literary directions and new media forms then emerging in Germany, France, and the Soviet Union.

In the course of the 1920s, then, Benjamin increasingly combined criticism of specific media forms with an effort to construct a more comprehensive theory of media—much as he had done in the case of literature and philosophy up until 1924. Yet if 1924 represents a watershed year in Benjamin's intellectual life, the year 1933 marks a traumatic rupture in his personal life. Although the signs of Hitler's accession to power in Germany had been impossible to ignore since 1932, the burning of the Reichstag on February 27, 1933, made it clear to even the most stubbornly hopeful German intellectuals on the political left that their native land would no longer tolerate them or their ideas. Benjamin, as a German Jew, was under no illusions regarding the implications not just for his work, but for his very life. A number of his closest friends and colleagues, including Bertolt Brecht (1898–1956), Ernst Bloch (1885–1977), and Siegfried Kracauer opted immediately to go into self-imposed exile; Benjamin himself left Berlin for Paris in mid-March. He would spend the remainder of the decade, and indeed the rest of his life, moving between Paris and a series of temporary refuges that included Brecht's house in Skovsbostrand, Denmark, his former wife's *pensione* in San Remo, Italy, and, a favored place, the Spanish island of Ibiza. The impact of exile on Benjamin's thought in general—and on his writings on media in particular—was pervasive and fundamental. The famous remarks on the relationship between aesthetics and politics with which "The Work of Art in the Age of Its Technological Reproducibility" concludes make plain the political urgency of Benjamin's attempt to develop something like a "media theory" in the 1930s. If fascism could aestheticize politics and even war, communism, Benjamin asserted, was bound to respond by politicizing art.

Tellingly, however, the politicized theory of media Benjamin devel-

oped in the course of the 1930s did not develop exclusively out of an engagement with contemporary media forms. With increasing intensity Benjamin's thoughts turned instead to history: to the period of the emergence of urban, and specifically metropolitan, commodity capitalism. For Benjamin, the construction of a massive sociocultural history of Paris in the years after 1850 was nothing less than a study of the emergence of modernity as such. This project bore the working title "Arcades Project" and, had Benjamin been able to complete it, might finally have been called "Paris, Capital of the Nineteenth Century." The project took its working title from the proliferation of mercantile galleries, or arcades (in German, *Passagen*) in mid-nineteenth-century Paris. "These arcades, a new invention of industrial luxury, are glass-roofed, marble-paneled corridors extending through whole blocks of buildings, whose owners have joined together for such enterprises. Lining both sides of these corridors, which get their light from above, are the most elegant shops, so that the *passage* is a city, a world in miniature."[4] Benjamin focuses on these structures as the organizing metaphor for his study for a number of reasons: they are a historically specific artifact of the period in question, a particularly concentrated figure for the public presence and particular visual character of nineteenth-century commodity capitalism; and the arcades were themselves a preeminent site of, and apparatus for, the organization of vast realms of perception for the denizens of the modern metropolis. The organization and reconfiguration of human perception would indeed have emerged as a central theme of the great work that Benjamin never finished. The materials from the Arcades Project that did find their way into finished works, most prominently a series of essays on the French poet Charles Baudelaire (1821–1867), included innovative reconsiderations of key modernist problems: the role of the urban crowd as an optical device for the strolling *flâneur;* the significance of *actual* optical devices such as panoramas, peep shows, and magic lanterns in the habituation of city dwellers to the new conditions of metropolitan experience; and especially the modern practices of display and advertising that emerged in Paris and would come to shape the perception of the world in such a pervasive manner.

Benjamin's interest in this era, then, is anything but antiquarian. He was convinced of a profound *synchronicity* between the dramatic changes that took place in Europe around 1850 and the convulsive political upheavals marking the Europe in and about which he was writing during the 1930s. At the center of the theory of history Benjamin developed as part of the Arcades Project stands the notion that certain historical mo-

ments and forms become legible only at a later moment—one that corresponds to them and only to them. Certain forms analyzed in the Arcades Project (for example, the panoramas, and the "panoramic" literature that arose in their wake) are moments in the prehistory of a later form such as film. "I have found," Benjamin wrote to Gretel Karplus in 1935, "that aspect of the art of the nineteenth century which only 'now' becomes recognizable—it had not been so before and it will never be so again."[5] It seems, then, that Benjamin hoped that readers of his essay on the work of art would become aware not only of the political and epistemological potentialities of forms of art made possible by means of new technologies of production and reproduction, but also of their correspondence to the artifacts and modes of perception inhabiting other historical moments, and thus of the particular—and particularly endangered—character of our own embeddedness in history. The essays included in this volume are thus not merely indispensable contributions to the theory of various forms of media that emerged in Benjamin's lifetime; they are also invested with Benjamin's sense that those forms bore within them a recognition of the "fate of art in the nineteenth century because it is contained in the ticking of a clockwork whose hourly chiming has first penetrated into *our* ears."[6]

In what follows, we have eschewed the chronological organization of Benjamin's *Selected Writings* as well as the generic ordering of the German edition of his collected works, opting instead to group the essays under what we hope are suggestive conceptual rubrics. The first section, "The Production, Reproduction, and Reception of the Work of Art," includes some of Benjamin's best-known essays on the nature and status of the work of art. These texts pose provocative questions regarding the place of art in modern society, the perceptual and more broadly cognitive conditions under which art is produced, and the implications of the reception of art for human agency, indeed for the experiences of the human subject as such. The section that follows, "Script, Image, Script-Image," explores relationships between the graphic element of all writing and modern technologies of representation as they interact with human sensory and cognitive capacities. These essays are united in their documentation of Benjamin's conviction that meaning takes shape and resides in the world of urban commodity capitalism not only in discursive, systematic form, but perhaps even more significantly in flashes that leap out from the graphic forms of writing's "new eccentric figurativeness"[7] as that writing was bodied forth in props on a stage, an engineering diagram, or an advertisement. These first two sections are intended to serve as the introduction to broad issues that cut across media, genres, and individual

works. The sections that follow—on painting and graphics, photography, film, and the publishing industry and radio—offer concentrated introductions to Benjamin's most important essays on these forms.

A word is certainly in order regarding the principle of inclusion that informed this selection of Benjamin's essays on modern media. In an important sense, Benjamin's work does not lend itself to anthologization, segmentation, or conceptual ordering. In a marvelous 1925 essay on Naples that he coauthored with Asja Lacis, Benjamin emphasized the porosity of the city's architecture as a figure for a more general porosity in the conduct of life: "Building and action interpenetrate in the courtyards, arcades, and stairways. In everything is preserved the potential space of play [Spielraum] that would make it possible to become a site [Schauplatz] of new, unforeseen constellations. The definitive, the characteristic are avoided. No situation appears just as it is, intended as such forever; no form asserts its own 'just so, and not otherwise.'"[8] The generic and conceptual "walls" between the various aspects of Benjamin's production are, if anything, even more porous than those of the Naples courtyard. The meditations on perception included in this volume threaten to bleed into a number of essays on the concept of experience written in the early 1930s, essays such as "Experience and Poverty";[9] reflections on graphicness and display are imbricated in the great series of essays on the theory of language; the theorization of a politics of media suggests relays to many essays on politics and culture; and, as we have suggested above, nearly everything Benjamin wrote after 1934 is generated by or related to the great torso of the Arcades Project. Had we pursued each of these filiations and constellations, we would soon have had a multivolume edition rather than a single volume intended for the general reader and classroom use.

The most vexing questions surrounding any principle of selection spring from the status of the Arcades Project. Debates on the textual status of this body of material, which remained unfinished and unpublished during Benjamin's lifetime, continue to rage. To what extent is the volume that was published as Das Passagen-Werk in Germany and The Arcades Project in the United States a finished text? According to some of Benjamin's editors, this material is simply a compilation of research notes, citations, and more or less polished reflections on those notes and citations: a vast, endlessly fascinating quarry. According to others, extensive sections of the volume are conceptually ordered, rhetorically finished arguments on specific aspects of nineteenth-century Parisian life and the modernity it epitomized. With a very few exceptions, we have selected only finished essays for this volume, and have reluctantly

refrained from including any of the fascinating series of fragments that make up the Arcades Project. We urge the reader, though, to follow the various complexes of ideas sketched here into the labyrinth of the arcades, and to pursue Benjamin's thoughts on film, photography, radio, newspapers, the graphic arts, painting, and architecture in that less ordered but perhaps even more suggestive text.

Notes

1. See Walter Benjamin, "The Ruin," Chapter 15 in this volume.
2. Max Weber, "Science as a Vocation," in *From Max Weber: Essays in Sociology,* ed. H. H. Gerth and C. Wright Mills (New York: Oxford University Press, 1946), p. 155.
3. Walter Benjamin, "The Life of Students," in *Selected Writings, Volume 1: 1913–1926* (Cambridge, Mass.: Harvard University Press, 1996), p. 37. Benjamin's understanding of these scattered shards may be derived from the Jewish mystical concept of "Tikkun," or the shattering of the vessels. On Benjamin's relationship to Jewish messianism, see especially Anson Rabinbach, "Between Enlightenment and Apocalypse: Benjamin, Bloch and Modern German Jewish Messianism," *New German Critique,* 34 (Winter 1985); and Irving Wohlfarth, "On the Messianic Structure of Walter Benjamin's Last Reflections," *Glyph,* 3 (1978). On the conception of Tikkun itself, see Gershom Scholem, *Major Trends in Jewish Mysticism* (New York: Schocken, 1954), pp. 245–248. Much of what Benjamin knew of Jewish messianism was derived from conversations with his close friend Scholem, who rediscovered the Kabbalah for modern scholarship.
4. Walter Benjamin, *The Arcades Project,* trans. Howard Eiland and Kevin McLaughlin (Cambridge, Mass.: Harvard University Press, 1999), p. 31. Benjamin quotes here, in the first fragment of *The Arcades Project,* from the *Guide illustré de Paris* (1852) and uses the French term *passage.* The quotation also appears on the first page of the 1935 exposé of the project, "Paris, the Capital of the Nineteenth Century" (*Arcades Project,* p. 3).
5. Walter Benjamin, *Gesammelte Briefe,* vol. 5 (Frankfurt: Suhrkamp Verlag, 1999), p. 171.
6. *The Correspondence of Walter Benjamin,* trans. Manfred R. Jacobson and Evelyn M. Jacobson (Chicago: University of Chicago Press, 1994), p. 509 (translation modified).
7. Walter Benjamin, "One-Way Street," in *Selected Writings,* vol. 1, p. 456.
8. Walter Benjamin and Asja Lacis, "Naples," in *Selected Writings,* vol. 1, p. 416 (translation modified).
9. See Walter Benjamin, *Selected Writings, Volume 2: 1927–1934* (Cambridge, Mass.: Harvard University Press, 1999), pp. 731–736.

I

THE PRODUCTION, REPRODUCTION, AND
RECEPTION OF THE WORK OF ART

"Just as the entire mode of existence of human collectives changes over long historical periods, so too does their mode of perception." In this line from section IV of the famous essay "The Work of Art in the Age of Its Technological Reproducibility," written in exile in Paris in the mid-1930s, Benjamin defines programmatically the field in which his work on modern media moves.[1] Within that field—of historical change in the human sensorium—Benjamin concentrates on two questions: the capacity of the artwork to encode information about its historical period (and, in so doing, potentially to reveal to readers and viewers otherwise inapprehensible aspects of the nature of their own era),[2] and the way in which modern media—as genres and as individual works—affect the changing human sensory apparatus. We can best approach these questions through a brief introduction to two writers, Alois Riegl and László Moholy-Nagy, whose work was in constant dialogue with Benjamin's.

Alois Riegl was perhaps the most important theoretician of art history in Europe in the period around 1900; his work exerted a decisive influence on subsequent generations of art historians, notably Wilhelm Worringer, Erwin Panofsky, the scholars associated with the Warburg Institute, and the "second Viennese school" which Benjamin discusses in his essay "The Rigorous Study of Art" (Chapter 5 in this volume). Although Riegl's rethinking of the *historiography* of art provided important impetuses to Benjamin,[3] his theory of the *production and reception* of art under changing historical conditions was equally important—and it is

this aspect of Riegl's work that has the most important implications for a theory of media.

Riegl strove, over the course of his career, to develop a model of historical causality that could help explain changes in style. At the heart of a complex answer to this question is his theory of the *Kunstwollen*—the manner in which a specific culture seeks to give form, color, and line to its art. With the concept of "artistic volition," Riegl sought to show how art tracked major shifts in the structure and attitudes of collectives: societies, races, ethnic groups, and so on. *Kunstwollen* is the artistic projection of a collective intention. "All human volition," Riegl wrote in his most influential work, *Late Roman Art Industry*, "is directed toward the satisfactory shaping of [man's] relationship to the world. . . . The formative *Kunstwollen* regulates the relation of man to things as they appear to the senses: the manner in which man wishes to see each thing shaped or colored thereby comes to expression. . . . Man is, however, not solely a being who takes in impressions through the senses—he is not only passive—but also a desiring—that is, an active—being, who will interpret the world as it reveals itself to his desire (which changes according to race, place, and time)."[4] Works of art—or rather *details* within the work of art—are thus the clearest source of a very particular kind of historical information. They encode not just the character of the artistic production of the age, but the character of parallel features of the society: its religion, philosophy, ethical structure, and institutions. When, in an essay such as "The Author as Producer," Benjamin addresses the question of the political uses of art, he does so not so much from a foundation in Marxist theory as from his reading of Riegl. He can thus claim that the "political tendency" of a work of art depends not so much on its political tendentiousness as upon its *literary quality*—that is, upon its form. Because only its literary quality can reveal its position *in* "the relations of production of its time." In many of the essays included in this volume, we see Benjamin developing historical and political interpretation on the basis of aesthetic commentary. We witness how Benjamin teases out the structure and significance of a historical era on the basis of the relationship established between the stylistic detail and the *Kunstwollen*. It is just this capacity to extrapolate from the individual, concrete detail to the culture at large that is the mark of the researcher able "to trace the curve of the heartbeat [of a historical era] as the line of its forms. The only such master has been Riegl, . . . in whom the deep insight into the material will [*Wollen*] of an era expresses itself conceptually as the analysis of its formal canon."[5] Focused less on the direct political efficacy of a work, and

not at all on its agitational potential, Benjamin's interest in all works of art remains rooted in what they can reveal to us about the relationship between the historical era under study and our own historical position.

Just as works of art express collective positions (often in highly mediated form), they also, for Benjamin, play an important role in shaping the human sensory capacity. Underlying all of Benjamin's thought is the conviction that the seemingly most obvious things—who we are, the character of the physical environment in which we move, and the character of the historical moment in which we live—are in fact denied to us. The world in which we live in fact has, for us, the character of an optical media device: his most frequent description of our world is in terms of "phantasmagoria." Originally an eighteenth-century illusionistic optical apparatus, involving shadows of moving figures projected past an audience and onto a wall or screen, phantasmagoria as redefined by Benjamin becomes a figural image of the world of urban commodity capitalism: an environment so suggestively "real" that we move through it as if it were given and natural, when in fact it is a socioeconomic construct. For Benjamin, the term "phantasmagoria" captures both the powerful and the deeply illusory quality of this environment, a characteristic that has a debilitating effect upon the human ability to come to rational decisions—and in fact to perceive and understand its own world.

In 1922, in the essay "Production-Reproduction," Moholy-Nagy had proposed a necessary relationship between technology, media, and the development of the human sensorium. He assigned the leading role in this process to art produced by means of new technologies, which is "instrumental in this development . . . for art attempts to create new relationships between familiar and as yet unfamiliar data, optical, acoustic, or whatever, and forces us to take it all in through our sensory equipment."[6] This essay's principle contribution to our understanding of the role of new media lies in its distinction between what Moholy calls "reproduction" and "production." Reproduction is the mimetic replication of an extant external reality: this "reiteration of relationships that already exist" can have little effect on the development of new perceptual capacities, since such practice merely reproduces relationships already accessible to the senses. "Production," however, names those types of art practices that employ technology to actively create new relationships. For Moholy, the automatism of the camera lens is a crucial prosthesis, an extension of the range and power of the human visual apparatus that alone can reveal to human cognition new relationships between elements of the perceptual world. Benjamin would later call these elements new "image-

worlds." What Moholy is interested in here is not so much the representation of things as they are, not the "true nature" of the modern world, but instead a harnessing of new media's potential for cognitive and perceptual transformation. Moholy's theories on photography as a technological prosthesis are inseparable from his anthropology; they remain rooted in a call for a continuous recasting of the human cognitive apparatus and the values and behaviors that are based upon it.

Many of the essays in this volume thus examine modern technological apparatuses in terms of their effects—both real and potential—upon the human sensory capacities. The earliest such analysis, in the section "To the Planetarium" from *One-Way Street*, makes the planetarium a virtual theatrum mundi: in the modern planetarium, with its "optical connection to the universe," ancient forms of communion with the cosmos (dominated, in Benjamin's view, by Rausch or the ecstatic trance) give way to new forms of human relation to the universe. "In technology a physis is being organized through which mankind's contact with the cosmos takes a new and different form." From the planetarium, then—that consummate figure of the technological organization of perception—two possible paths lead forward. One is the path of violence that leads, for the collective, to "the nights of annihilation" of World War I. And the violence wreaked by technology is not merely martial and collective; it inheres in every individual encounter as well. Benjamin never lets the reader forget the overwhelming, indeed annihilating effect of new apparatuses upon the human body and its senses. As he puts it in "The Telephone" section of *Berlin Childhood around 1900*, "I tore off the two receivers . . . thrust my head between them, and was inexorably delivered over to the voice that now sounded. There was nothing to allay the violence that now pierced me. Powerless, I suffered, seeing that it obliterated my consciousness of time, my firm resolve, my sense of duty."[7]

Yet it is precisely from such violence that Benjamin imagines the emergence of a new modern subject and a new modern collective. The second path leads, then, to a new collective body, which Benjamin understands as the proletariat that took shape in the revolts following the abdication of the kaiser in November 1918. Indeed, it is only the paroxysm produced by the new, technologized "conditions of life" that can allow "mankind to bring the new body under its control." While in Moholy-Nagy's work the potential of political agency is implied but never named, Benjamin's understanding of the new forms of perception that arise in interaction with modern technology never loses sight of Marx's maxim that our task is not to understand the world but to change it.

Benjamin has in fact often been accused of a technological utopian-ism: the broad conviction that certain properties of technological media as such hold within them the potential for social change. It is clear enough today that while the impact of a medium such as film has been massive, it has not been entirely of the sort that Benjamin envisioned. Yet that charge is too simple. First of all, Benjamin very clearly recognized that the qualities he detected in the new media are necessary but in no way sufficient conditions, always requiring an actualization through spe-cific works (the focus of some of the other essays on cinema in this vol-ume) and always threatened by appropriation through the interests of big capital. Second, any generalized valorization of the forms of modern media such as photography, film, the newspaper, and radio, to say noth-ing of painting and writing, must be understood as a heuristic horizon against which the social uses of art can be measured. The social poten-tials of art certainly seemed one of the few positive aspects of a Europe on the verge of war and threatened by a seemingly triumphant fascism.

This intensive reciprocity between technology and the human sen-sory capacities provides the artwork essay with its conceptual spine. New technologies provide "polytechnic training" in the "organizing and regulating" of responses to the lived environment.[8] Benjamin's emphasis on "training" here is anything but an isolated instance. As detailed in the introduction to Part III of this volume, many of Benjamin's texts from the 1920s made reference to an approach to pedagogy called *Anschauungsunterricht,* which might be rather awkwardly translated as "instruction in perception and intuition." In an August 1929 radio broadcast entitled "Children's Literature," Benjamin emphasizes the con-temporary relevance of *Anschauungsunterricht* as pedagogy rooted in the use of concrete things and visual media with important consequences for a new perceptual literacy. "Children's Literature" announces:

> The extraordinary relevance to the current situation that all experiments in *Anschauungsunterricht* possess stems from the fact that a new, stan-dardized, and wordless sign-system seems to be emerging in the most var-ied fields of present-day life—in transportation, art, statistics. At precisely this point, a pedagogical problem touches on a comprehensive cultural one that can be summed up in the slogan: "Up with the sign and down with the word!" Perhaps we shall soon see picture books that introduce children to the new sign language of transport or even statistics.[9]

And the important essay "Little History of Photography" emphasizes the role of photography as a "training manual" for modern life.

Film, on this reading, trains its viewers through the use of a technological apparatus (camera, editing, projection) to deal with the "vast apparatus" in which we live, the apparatus of phantasmagoria. Some part of this capacity is inherent in the particular manner in which forms of modern media engage with the world. Yet Benjamin's central concern in the artwork essay is less with the specific qualities of modern media than with a particular "ability" common to all art under modern conditions: its reproducibility. The simple fact that any work of art from whatever period is today susceptible to technological reproducibility has enormous consequences not just for its mass reception but for its inmost qualities as well. Perhaps the most famous pages of the essay concern Benjamin's attack on those very qualities that have defined the privileged status of the individual work of art in the Western tradition: its uniqueness, authenticity, and authority.

Benjamin's idea is of course a scandal and a provocation: he offers a frontal attack on the very notion of the iconic work of culture, the product of a great genius that by its very nature shifts our understanding of human nature and human history. Yet this attack is the precondition for any liberation of art from the cultural tradition—and its rootedness in cult and ritual. For Benjamin, the "present crisis and renewal of humanity"—and one must recall that this text was written under the very real threat of fascism—can come to be only on the ground produced by a "shattering of tradition."[10]

The key move in Benjamin's essay, the move that alone names this shattering of tradition, is the distinction between auratic and nonauratic art forms. The term "aura," which first appears in the 1929 essay "Little History of Photography," is then fully developed in the artwork essay: "What, then, is the aura? A strange tissue of space and time: the unique apparition of a distance, however near it may be. To follow with the eye—while resting on a summer afternoon—a mountain range on the horizon or a branch that casts is shadow on the beholder is to breathe the aura of those mountains, of that branch."[11] A work of art may be said to have an aura if it claims a unique status based less on quality, use value, or worth per se than on its figurative distance from the beholder. Figurative, since, as the definition intimates, this distance is not primarily a space between painting and spectator or between text and reader but the creation of a psychological inapproachability—an authority—claimed for the work on the basis of its position within a tradition. The distance that intrudes between work and viewer is most often, then, a temporal distance: auratic texts are sanctioned by their inclusion in a

time-tested canon. For Benjamin, integration into the Western tradition is coterminous with an integration into cultic practices: "Originally, the embeddedness of an artwork in the context of tradition found expression in a cult. As we know, the earliest artworks originated in the service of rituals. . . . In other words: *the unique value of the 'authentic' work of art always has its basis in ritual.*"[12]

This is in effect a description of the inevitable fetishization of the work of art, less through the process of its creation than through the process of its transmission. If the work of art remains a fetish, a distanced and distancing object that exerts an irrational and incontrovertible power, it attains a cultural position that lends it a sacrosanct inviolability. It also remains in the hands of a privileged few. The auratic work exerts claims to power that parallel and reinforce the larger claims to political power of the class for whom such objects are most meaningful: the ruling class. The theoretical defense of auratic art was and is central to the maintenance of their power. It is not just that auratic art, with its ritually certified representational strategies, poses no threat to the dominant class, but that the sense of authenticity, authority, and permanence projected by the auratic work of art represents an important cultural substantiation of the claims to power of the dominant class.

Reproducibility is thus finally a *political* capacity of the work of art; its very reproducibility shatters its aura and enables a reception of a very different kind in a very different spectatorial space: it is precisely the shattering of the aura that enables the construction, in the cinema, of a political body through "simultaneous collective reception" of its object.

As we have noted in the general introduction to this volume, Benjamin was convinced of a profound *synchronicity* between the period of the emergence of urban industrial capitalism around the middle of the nineteenth century and the Europe of the 1930s so marked by convulsive political upheavals, and thus of a synchronicity between the technological and artistic forms that they produced. Benjamin expressly hoped that readers of the artwork essay would become aware not just of the political and epistemological potentialities of new media forms, but also of the way that these potentialities are derived from their particular historical situation—that relationship that Benjamin was convinced obtained between every present day and a period or periods that preceded it. For Benjamin, the kind of knowledge of history that could produce social change became available *only* in the recognition of aspects of this synchronicity. As the remarkable fragments contained in Convolute N of *The Arcades Project* suggest, the images produced in particular historical

moments are related to images of prior epochs through a "historical index." "For the historical index of the images not only says that they belong to a particular time; it says, above all, that they attain to legibility only at a particular time. . . . Every present day is determined by the images that are synchronic with it; each 'now' is the now of a particular recognizability."[13] The great study of the Parisian arcades and indeed the entirety of the reflection on media that grew out of it are thus driven by a historical interest that is anything other than antiquarian: it seeks to produce a "dangerous critical moment" that alone can reveal the conditions obtaining all around us.[14]

The essay "Paris, Capital of the Nineteenth Century" is a concise, if highly elliptical catalog of the motifs and problems Benjamin hoped to address in his study of the arcades. The essay (actually a full exposé of the Arcades Project as Benjamin conceived it in 1935) offers a series of remarkably suggestive insights not merely into a series of artistic, technological, and architectural forms—into the arcades themselves and into the new possibilities of iron construction, into the panoramas and world exhibitions, into lyric poetry and photography, and into the bourgeois interior and the proletarian barricade—but also into the transformative and generative relations that obtained *among* these forms themselves *and* between them and the characteristic forms of Benjamin's own era. Although, in "Paris, the Capital of the Nineteenth Century," these relations are more often suggested than articulated, many fragments from *The Arcades Project* draw explicit connections:

> The fact that film today articulates all problems of modern form-giving—understood as questions of its own technical existence—and does so in the most stringent, most concrete, most critical fashion, is important for the following comparison of panoramas with this medium. "The vogue of panoramas, among which the panorama of Boulogne was especially remarkable, corresponds to the vogue for cinematographs today. The covered arcades, of the type of the Passage des Panoramas, were also beginning their Parisian fortunes then." Marcel Poëte, *Une vie de cité Paris* (Paris, 1925), p. 326.[15]

Benjamin's verb here, quoted from Poëte, is crucial: the cinematograph *corresponds to* the Parisian panorama—meaning that it does not *develop* from it. Benjamin in fact described his project as the attempt to "root out every trace of 'development' from the image of history."[16] The resolutely historical nature of Benjamin's project is driven thus not by any antiquarian interest in the cultural forms of past epochs, but by the conviction

that any meaningful apprehension of the present day is radically contingent upon our ability to read the constellations that arise from elements of a past that is synchronous with our own time and its representative cultural forms.

MICHAEL W. JENNINGS

Notes

1. We have reproduced here the second version of Benjamin's essay, the version that Benjamin himself considered the "master version," or *Urtext*. For a full discussion of the status of this version in relation to the others, and for a brilliant presentation of the problem of cinema in the artwork essay, see Miriam Bratu Hansen, "Room for Play: Benjamin's Gamble with Cinema," *October*, 109 (Summer 2004): 3–45.
2. "What is at stake is not to portray literary works in the context of their age, but to represent the age that perceives them—our age—in the age during which they arose. It is this that makes literature into an organon of history." Benjamin, "Literary History and the Study of Literature" in *Selected Writings, Volume 2: 1927–1934* (Cambridge, Mass.: Harvard University Press, 1999), p. 464.
3. On Riegl's historiography, see Michael Jennings, *Dialectical Images: Walter Benjamin's Theory of Literary Criticism* (Ithaca: Cornell University Press, 1987), pp. 151–163.
4. Alois Riegl, *Late Roman Art Industry*, trans. Rolf Winkes (Rome: Giorgio Bretschneider, 1985), p. 215.
5. Benjamin, Review of Oskar Walzel, *Das Wortkunstwerk*, in *Gesammelte Schriften*, vol. 3 (Frankfurt: Suhrkamp Verlag, 1972), p. 50.
6. László Moholy-Nagy, "Production-Reproduction," in Christopher Phillips, ed., *Photography in the Modern Era: European Documents and Critical Writings, 1913–1940* (New York: Metropolitan Museum of Art, 1989), pp. 79–82.
7. For a more general discussion of technology and the senses in Benjamin's autobiographical writings, see Gerhard Richter, *Walter Benjamin and the Corpus of Autobiography* (Detroit: Wayne State University Press, 2000), especially chs. 3 and 4.
8. See Chapter 1, sections XIII and XV, in this volume.
9. Benjamin, "Children's Literature," in *Selected Writings*, vol. 2, p. 251 (translation slightly modified).
10. See Chapter 1, section III.
11. See Chapter 28 in this volume for Benjamin's early use of the term "aura." For the later definition, see Chapter 1, section IV.
12. See Chapter 1, section V.

13. Benjamin, *The Arcades Project,* trans. Howard Eiland and Kevin McLaughlin (Cambridge, Mass.: Harvard University Press, 1999), pp. 462–463, Convolute N3,1.
14. Ibid., p. 463.
15. Ibid., p. 530, Convolute Q1a,8.
16. Ibid., p. 845, Convolute H°,16.

> The true is what he can; the false is what he wants.
> —Madame de Duras[1]

1

The Work of Art in the Age of Its Technological Reproducibility

SECOND VERSION

I

When Marx undertook his analysis of the capitalist mode of production, that mode was in its infancy.[2] Marx adopted an approach which gave his investigations prognostic value. Going back to the basic conditions of capitalist production, he presented them in a way which showed what could be expected of capitalism in the future. What could be expected, it emerged, was not only an increasingly harsh exploitation of the proletariat but, ultimately, the creation of conditions which would make it possible for capitalism to abolish itself.

Since the transformation of the superstructure proceeds far more slowly than that of the base, it has taken more than half a century for the change in the conditions of production to be manifested in all areas of culture. How this process has affected culture can only now be assessed, and these assessments must meet certain prognostic requirements. They do not, however, call for theses on the art of the proletariat after its seizure of power, and still less for any on the art of the classless society. They call for theses defining the tendencies of the development of art under the present conditions of production. The dialectic of these conditions of production is evident in the superstructure, no less than in the economy. Theses defining the developmental tendencies of art can therefore contribute to the political struggle in ways that it would be a mistake to un-

19

derestimate. They neutralize a number of traditional concepts—such as creativity and genius, eternal value and mystery—which, used in an uncontrolled way (and controlling them is difficult today), allow factual material to be manipulated in the interests of fascism. *In what follows, the concepts which are introduced into the theory of art differ from those now current in that they are completely useless for the purposes of fascism. On the other hand, they are useful for the formulation of revolutionary demands in the politics of art* [*Kunstpolitik*].

<div style="text-align:center">II</div>

In principle, the work of art has always been reproducible. Objects made by humans could always be copied by humans. Replicas were made by pupils in practicing for their craft, by masters in disseminating their works, and, finally, by third parties in pursuit of profit. But the technological reproduction of artworks is something new. Having appeared intermittently in history, at widely spaced intervals, it is now being adopted with ever-increasing intensity. Graphic art was first made technologically reproducible by the woodcut, long before written language became reproducible by movable type. The enormous changes brought about in literature by movable type, the technological reproduction of writing, are well known. But they are only a special case, though an important one, of the phenomenon considered here from the perspective of world history. In the course of the Middle Ages the woodcut was supplemented by engraving and etching, and at the beginning of the nineteenth century by lithography.

Lithography marked a fundamentally new stage in the technology of reproduction. This much more direct process—distinguished by the fact that the drawing is traced on a stone, rather than incised on a block of wood or etched on a copper plate—first made it possible for graphic art to market its products not only in large numbers, as previously, but in daily changing variations. Lithography enabled graphic art to provide an illustrated accompaniment to everyday life. It began to keep pace with movable-type printing. But only a few decades after the invention of lithography, graphic art was surpassed by photography. For the first time, photography freed the hand from the most important artistic tasks in the process of pictorial reproduction—tasks that now devolved upon the eye alone. And since the eye perceives more swiftly than the hand can draw, the process of pictorial reproduction was enormously accelerated, so that

it could now keep pace with speech. Just as the illustrated newspaper virtually lay hidden within lithography, so the sound film was latent in photography. The technological reproduction of sound was tackled at the end of the last century. *Around 1900, technological reproduction not only had reached a standard that permitted it to reproduce all known works of art, profoundly modifying their effect, but it also had captured a place of its own among the artistic processes. In gauging this standard, we would do well to study the impact which its two different manifestations—the reproduction of artworks and the art of film—are having on art in its traditional form.*

III

In even the most perfect reproduction, *one* thing is lacking: the here and now of the work of art—its unique existence in a particular place. It is this unique existence—and nothing else—that bears the mark of the history to which the work has been subject. This history includes changes to the physical structure of the work over time, together with any changes in ownership. Traces of the former can be detected only by chemical or physical analyses (which cannot be performed on a reproduction), while changes of ownership are part of a tradition which can be traced only from the standpoint of the original in its present location.

The here and now of the original underlies the concept of its authenticity, and on the latter in turn is founded the idea of a tradition which has passed the object down as the same, identical thing to the present day. *The whole sphere of authenticity eludes technological—and of course not only technological—reproduction.* But whereas the authentic work retains its full authority in the face of a reproduction made by hand, which it generally brands a forgery, this is not the case with technological reproduction. The reason is twofold. First, technological reproduction is more independent of the original than is manual reproduction. For example, in photography it can bring out aspects of the original that are accessible only to the lens (which is adjustable and can easily change viewpoint) but not to the human eye; or it can use certain processes, such as enlargement or slow motion, to record images which escape natural optics altogether. This is the first reason. Second, technological reproduction can place the copy of the original in situations which the original itself cannot attain. Above all, it enables the original to meet the recipient halfway, whether in the form of a photograph or in that of a gramophone

record. The cathedral leaves its site to be received in the studio of an art lover; the choral work performed in an auditorium or in the open air is enjoyed in a private room.

These changed circumstances may leave the artwork's other properties untouched, but they certainly devalue the here and now of the artwork. And although this can apply not only to art but (say) to a landscape moving past the spectator in a film, in the work of art this process touches on a highly sensitive core, more vulnerable than that of any natural object. That core is its authenticity. The authenticity of a thing is the quintessence of all that is transmissible in it from its origin on, ranging from its physical duration to the historical testimony relating to it. Since the historical testimony is founded on the physical duration, the former, too, is jeopardized by reproduction, in which the physical duration plays no part. And what is really jeopardized when the historical testimony is affected is the authority of the object, the weight it derives from tradition.

One might focus these aspects of the artwork in the concept of the aura, and go on to say: what withers in the age of the technological reproducibility of the work of art is the latter's aura. This process is symptomatic; its significance extends far beyond the realm of art. *It might be stated as a general formula that the technology of reproduction detaches the reproduced object from the sphere of tradition. By replicating the work many times over, it substitutes a mass existence for a unique existence. And in permitting the reproduction to reach the recipient in his or her own situation, it actualizes that which is reproduced.* These two processes lead to a massive upheaval in the domain of objects handed down from the past—a shattering of tradition which is the reverse side of the present crisis and renewal of humanity. Both processes are intimately related to the mass movements of our day. Their most powerful agent is film. The social significance of film, even—and especially—in its most positive form, is inconceivable without its destructive, cathartic side: the liquidation of the value of tradition in the cultural heritage. This phenomenon is most apparent in the great historical films. It is assimilating ever more advanced positions in its spread. When Abel Gance fervently proclaimed in 1927, "Shakespeare, Rembrandt, Beethoven will make films. . . . All legends, all mythologies, and all myths, all the founders of religions, indeed, all religions, . . . await their celluloid resurrection, and the heroes are pressing at the gates," he was inviting the reader, no doubt unawares, to witness a comprehensive liquidation.[3]

IV

Just as the entire mode of existence of human collectives changes over long historical periods, so too does their mode of perception. The way in which human perception is organized—the medium in which it occurs— is conditioned not only by nature but by history. The era of the migration of peoples, an era which saw the rise of the late-Roman art industry and the Vienna Genesis, developed not only an art different from that of antiquity but also a different perception. The scholars of the Viennese school Riegl and Wickhoff, resisting the weight of the classical tradition beneath which this art had been buried, were the first to think of using such art to draw conclusions about the organization of perception at the time the art was produced.[4] However far-reaching their insight, it was limited by the fact that these scholars were content to highlight the formal signature which characterized perception in late-Roman times. They did not attempt to show the social upheavals manifested in these changes in perception—and perhaps could not have hoped to do so at that time. Today, the conditions for an analogous insight are more favorable. And if changes in the medium of present-day perception can be understood as a decay of the aura, it is possible to demonstrate the social determinants of that decay.

What, then, is the aura? A strange tissue of space and time: the unique apparition of a distance, however near it may be.[5] To follow with the eye—while resting on a summer afternoon—a mountain range on the horizon or a branch that casts its shadow on the beholder is to breathe the aura of those mountains, of that branch. In the light of this description, we can readily grasp the social basis of the aura's present decay. It rests on two circumstances, both linked to the increasing emergence of the masses and the growing intensity of their movements. Namely: *the desire of the present-day masses to "get closer" to things, and their equally passionate concern for overcoming each thing's uniqueness [Überwindung des Einmaligen jeder Gegebenheit] by assimilating it as a reproduction.* Every day the urge grows stronger to get hold of an object at close range in an image [*Bild*], or, better, in a facsimile [*Abbild*], a reproduction. And the reproduction [*Reproduktion*], as offered by illustrated magazines and newsreels, differs unmistakably from the image. Uniqueness and permanence are as closely entwined in the latter as are transitoriness and repeatability in the former. The stripping of the veil from the object, the destruction of the aura, is the signature of a perception whose "sense for all

that is the same in the world"[6] has so increased that, by means of reproduction, it extracts sameness even from what is unique. Thus is manifested in the field of perception what in the theoretical sphere is noticeable in the increasing significance of statistics. The alignment of reality with the masses and of the masses with reality is a process of immeasurable importance for both thinking and perception.

<div align="center">V</div>

The uniqueness of the work of art is identical to its embeddedness in the context of tradition. Of course, this tradition itself is thoroughly alive and extremely changeable. An ancient statue of Venus, for instance, existed in a traditional context for the Greeks (who made it an object of worship) that was different from the context in which it existed for medieval clerics (who viewed it as a sinister idol). But what was equally evident to both was its uniqueness—that is, its aura. Originally, the embeddedness of an artwork in the context of tradition found expression in a cult. As we know, the earliest artworks originated in the service of rituals—first magical, then religious. And it is highly significant that the artwork's auratic mode of existence is never entirely severed from its ritual function. In other words: *the unique value of the "authentic" work of art always has its basis in ritual.* This ritualistic basis, however mediated it may be, is still recognizable as secularized ritual in even the most profane forms of the cult of beauty. The secular worship of beauty, which developed during the Renaissance and prevailed for three centuries, clearly displayed that ritualistic basis in its subsequent decline and in the first severe crisis which befell it. For when, with the advent of the first truly revolutionary means of reproduction (namely photography, which emerged at the same time as socialism), art felt the approach of that crisis which a century later has become unmistakable, it reacted with the doctrine of *l'art pour l'art*—that is, with a theology of art.[7] This in turn gave rise to a negative theology, in the form of an idea of "pure" art, which rejects not only any social function but any definition in terms of a representational content. (In poetry, Mallarmé was the first to adopt this standpoint.)[8]

No investigation of the work of art in the age of its technological reproducibility can overlook these connections. They lead to a crucial insight: for the first time in world history, technological reproducibility emancipates the work of art from its parasitic subservience to ritual. To an ever-increasing degree, the work reproduced becomes the reproduction of a work designed for reproducibility.[9] From a photographic plate,

for example, one can make any number of prints; to ask for the "authentic" print makes no sense. *But as soon as the criterion of authenticity ceases to be applied to artistic production, the whole social function of art is revolutionized. Instead of being founded on ritual, it is based on a different practice: politics.*

VI

Art history might be seen as the working out of a tension between two polarities within the artwork itself, its course being determined by shifts in the balance between the two. These two poles are the artwork's cult value and its exhibition value.[10] Artistic production begins with figures in the service of magic. What is important for these figures is that they are present, not that they are seen. The elk depicted by Stone Age man on the walls of his cave is an instrument of magic, and is exhibited to others only coincidentally; what matters is that the spirits see it. Cult value as such even tends to keep the artwork out of sight: certain statues of gods are accessible only to the priest in the cella; certain images of the Madonna remain covered nearly all year round; certain sculptures on medieval cathedrals are not visible to the viewer at ground level. *With the emancipation of specific artistic practices from the service of ritual, the opportunities for exhibiting their products increase.* It is easier to exhibit a portrait bust that can be sent here and there than to exhibit the statue of a divinity that has a fixed place in the interior of a temple. A panel painting can be exhibited more easily than the mosaic or fresco which preceded it. And although a mass may have been no less suited to public presentation than a symphony, the symphony came into being at a time when the possibility of such presentation promised to be greater.

The scope for exhibiting the work of art has increased so enormously with the various methods of technologically reproducing it that, as happened in prehistoric times, a quantitative shift between the two poles of the artwork has led to a qualitative transformation in its nature. Just as the work of art in prehistoric times, through the exclusive emphasis placed on its cult value, became first and foremost an instrument of magic which only later came to be recognized as a work of art, so today, through the exclusive emphasis placed on its exhibition value, the work of art becomes a construct [*Gebilde*] with quite new functions. Among these, the one we are conscious of—the artistic function—may subsequently be seen as incidental. This much is certain: today, film is the most serviceable vehicle of this new understanding. Certain, as well, is the fact

that the historical moment of this change in the function of art—a change which is most fully evident in the case of film—allows a direct comparison with the primeval era of art not only from a methodological but also from a material point of view.

Prehistoric art made use of certain fixed notations in the service of magical practice. In some cases, these notations probably comprised the actual performing of magical acts (the carving of an ancestral figure is itself such an act); in others, they gave instructions for such procedures (the ancestral figure demonstrates a ritual posture); and in still others, they provided objects for magical contemplation (contemplation of an ancestral figure strengthens the occult powers of the beholder). The subjects for these notations were humans and their environment, which were depicted according to the requirements of a society whose technology existed only in fusion with ritual. Compared to that of the machine age, of course, this technology was undeveloped. But from a dialectical standpoint, the disparity is unimportant. What matters is the way the orientation and aims of that technology differ from those of ours. Whereas the former made the maximum possible use of human beings, the latter reduces their use to the minimum. The achievements of the first technology might be said to culminate in human sacrifice; those of the second, in the remote-controlled aircraft which needs no human crew. The results of the first technology are valid once and for all (it deals with irreparable lapse or sacrificial death, which holds good for eternity). The results of the second are wholly provisional (it operates by means of experiments and endlessly varied test procedures). The origin of the second technology lies at the point where, by an unconscious ruse, human beings first began to distance themselves from nature. It lies, in other words, in play.

Seriousness and play, rigor and license, are mingled in every work of art, though in very different proportions. This implies that art is linked to both the second and the first technologies. It should be noted, however, that to describe the goal of the second technology as "mastery over nature" is highly questionable, since this implies viewing the second technology from the standpoint of the first. The first technology really sought to master nature, whereas the second aims rather at an interplay between nature and humanity. The primary social function of art today is to rehearse that interplay. This applies especially to film. *The function of film is to train human beings in the apperceptions and reactions needed to deal with a vast apparatus whose role in their lives is expanding almost daily.* Dealing with this apparatus also teaches them that technology will release them from their enslavement to the powers of the apparatus only

when humanity's whole constitution has adapted itself to the new pro-
ductive forces which the second technology has set free.[11]

VII

*In photography, exhibition value begins to drive back cult value on all
fronts.* But cult value does not give way without resistance. It falls back
to a last entrenchment: the human countenance. It is no accident that the
portrait is central to early photography. In the cult of remembrance of
dead or absent loved ones, the cult value of the image finds its last refuge.
In the fleeting expression of a human face, the aura beckons from early
photographs for the last time. This is what gives them their melancholy
and incomparable beauty. But as the human being withdraws from the
photographic image, exhibition value for the first time shows its superi-
ority to cult value. To have given this development its local habitation
constitutes the unique significance of Atget, who, around 1900, took
photographs of deserted Paris streets.[12] It has justly been said that he
photographed them like scenes of crimes. A crime scene, too, is deserted;
it is photographed for the purpose of establishing evidence. With Atget,
photographic records begin to be evidence in the historical trial [*Prozess*].
This constitutes their hidden political significance. They demand a spe-
cific kind of reception. Free-floating contemplation is no longer appropri-
ate to them. They unsettle the viewer; he feels challenged to find a partic-
ular way to approach them. At the same time, illustrated magazines begin
to put up signposts for him—whether these are right or wrong is irrele-
vant. For the first time, captions become obligatory. And it is clear that
they have a character altogether different from the titles of paintings. The
directives given by captions to those looking at images in illustrated mag-
azines soon become even more precise and commanding in films, where
the way each single image is understood seems prescribed by the se-
quence of all the preceding images.

VIII

The Greeks had only two ways of technologically reproducing works of
art: casting and stamping. Bronzes, terra cottas, and coins were the only
artworks they could produce in large numbers. All others were unique
and could not be technologically reproduced. That is why they had to be
made for all eternity. *The state of their technology compelled the Greeks
to produce eternal values in their art.* To this they owe their preeminent

position in art history—the standard for subsequent generations. Undoubtedly, our position lies at the opposite pole from that of the Greeks. Never before have artworks been technologically reproducible to such a degree and in such quantities as today. Film is the first art form whose artistic character is entirely determined by its reproducibility. It would be idle to compare this form in detail with Greek art. But on one precise point such a comparison would be revealing. For film has given crucial importance to a quality of the artwork which would have been the last to find approval among the Greeks, or which they would have dismissed as marginal. This quality is its capacity for improvement. The finished film is the exact antithesis of a work created at a single stroke. It is assembled from a very large number of images and image sequences that offer an array of choices to the editor; these images, moreover, can be improved in any desired way in the process leading from the initial take to the final cut. To produce *A Woman of Paris,* which is 3,000 meters long, Chaplin shot 125,000 meters of film.[13] *The film is therefore the artwork most capable of improvement. And this capability is linked to its radical renunciation of eternal value.* This is corroborated by the fact that for the Greeks, whose art depended on the production of eternal values, the pinnacle of all the arts was the form least capable of improvement—namely sculpture, whose products are literally all of a piece. In the age of the assembled [*montierbar*] artwork, the decline of sculpture is inevitable.

IX

The nineteenth-century dispute over the relative artistic merits of painting and photography seems misguided and confused today.[14] But this does not diminish its importance, and may even underscore it. The dispute was in fact an expression of a world-historical upheaval whose true nature was concealed from both parties. Insofar as the age of technological reproducibility separated art from its basis in cult, all semblance of art's autonomy disappeared forever. But the resulting change in the function of art lay beyond the horizon of the nineteenth century. And even the twentieth, which saw the development of film, was slow to perceive it.

Though commentators had earlier expended much fruitless ingenuity on the question of whether photography was an art—without asking the more fundamental question of whether the invention of photography had not transformed the entire character of art—film theorists quickly adopted the same ill-considered standpoint. But the difficulties which photography caused for traditional aesthetics were child's play compared

to those presented by film. Hence the obtuse and hyperbolic character of early film theory. Abel Gance, for instance, compares film to hieroglyphs: "By a remarkable regression, we are transported back to the expressive level of the Egyptians. . . . Pictorial language has not matured, because our eyes are not yet adapted to it. There is not yet enough respect, not enough *cult,* for what it expresses."[15] Or, in the words of Séverin-Mars: "What other art has been granted a dream . . . at once more poetic and more real? Seen in this light, film might represent an incomparable means of expression, and only the noblest minds should move within its atmosphere, in the most perfect and mysterious moments of their lives."[16] It is instructive to see how the desire to annex film to "art" impels these theoreticians to attribute elements of cult to film—with a striking lack of discretion. Yet when these speculations were published, works like *A Woman of Paris* and *The Gold Rush* had already appeared. This did not deter Abel Gance from making the comparison with hieroglyphs, while Séverin-Mars speaks of film as one might speak of paintings by Fra Angelico.[17] It is revealing that even today especially reactionary authors look in the same direction for the significance of film—finding, if not actually a sacred significance, then at least a supernatural one. In connection with Max Reinhardt's film version of *A Midsummer Night's Dream,* Werfel comments that it was undoubtedly the sterile copying of the external world—with its streets, interiors, railway stations, restaurants, automobiles, and beaches—that had prevented film up to now from ascending to the realm of art. "Film has not yet realized its true purpose, its real possibilities. . . . These consist in its unique ability to use natural means to give incomparably convincing expression to the fairylike, the marvelous, the supernatural."[18]

X

To photograph a painting is one kind of reproduction, but to photograph an action performed in a film studio is another. In the first case, what is reproduced is a work of art, while the act of producing it is not. The cameraman's performance with the lens no more creates an artwork than a conductor's with the baton; at most, it creates an artistic performance. This is unlike the process in a film studio. Here, what is reproduced is not an artwork, and the act of reproducing it is no more such a work than in the first case. The work of art is produced only by means of montage. And each individual component of this montage is a reproduction of a process which neither is an artwork in itself nor gives rise to one through

photography. What, then, are these processes reproduced in film, since they are certainly not works of art?

To answer this, we must start from the peculiar nature of the artistic performance of the film actor. He is distinguished from the stage actor in that his performance in its original form, from which the reproduction is made, is not carried out in front of a randomly composed audience but before a group of specialists—executive producer, director, cinematographer, sound recordist, lighting designer, and so on—who are in a position to intervene in his performance at any time. This aspect of filmmaking is highly significant in social terms. For the intervention in a performance by a body of experts is also characteristic of sporting performances and, in a wider sense, of all test performances. The entire process of film production is determined, in fact, by such intervention. As we know, many shots are filmed in a number of takes. A single cry for help, for example, can be recorded in several different versions. The editor then makes a selection from these; in a sense, he establishes one of them as the record. An action performed in the film studio therefore differs from the corresponding real action the way the competitive throwing of a discus in a sports arena would differ from the throwing of the same discus from the same spot in the same direction in order to kill someone. The first is a test performance, while the second is not.

The test performance of the film actor is, however, entirely unique in kind. In what does this performance consist? It consists in crossing a certain barrier which confines the social value of test performances within narrow limits. I am referring now not to a performance in the world of sports, but to a performance produced in a mechanized test. In a sense, the athlete is confronted only by natural tests. He measures himself against tasks set by nature, not by equipment—apart from exceptional cases like Nurmi, who was said to run against the clock.[19] Meanwhile the work process, especially since it has been standardized by the assembly line, daily generates countless mechanized tests. These tests are performed unawares, and those who fail are excluded from the work process. But they are also conducted openly, in agencies for testing professional aptitude. In both cases, the test subject faces the barrier mentioned above.

These tests, unlike those in the world of sports, are incapable of being publicly exhibited to the degree one would desire. And this is precisely where film comes into play. *Film makes test performances capable of being exhibited, by turning that ability itself into a test.* The film actor performs not in front of an audience but in front of an apparatus. The film

director occupies exactly the same position as the examiner in an apti-
tude test. To perform in the glare of arc lamps while simultaneously
meeting the demands of the microphone is a test performance of the high-
est order. To accomplish it is to preserve one's humanity in the face of the
apparatus. Interest in this performance is widespread. For the majority of
city dwellers, throughout the workday in offices and factories, have to re-
linquish their humanity in the face of an apparatus. In the evening these
same masses fill the cinemas, to witness the film actor taking revenge on
their behalf not only by asserting *his* humanity (or what appears to them
as such) against the apparatus, but by placing that apparatus in the ser-
vice of his triumph.

XI

In the case of film, the fact that the actor represents someone else before
the audience matters much less than the fact that he represents himself
before the apparatus. One of the first to sense this transformation of the
actor by the test performance was Pirandello.[20] That his remarks on the
subject in his novel *Sigira* [Shoot!] are confined to the negative aspects of
this change, and to silent film only, does little to diminish their rele-
vance. For in this respect, the sound film changed nothing essential. What
matters is that the actor is performing for a piece of equipment—or, in
the case of sound film, for two pieces of equipment. "The film actor,"
Pirandello writes, "feels as if exiled. Exiled not only from the stage but
from his own person. With a vague unease, he senses an inexplicable
void, stemming from the fact that his body has lost its substance, that he
has been volatilized, stripped of his reality, his life, his voice, the noises he
makes when moving about, and has been turned into a mute image that
flickers for a moment on the screen, then vanishes into silence. . . . The
little apparatus will play with his shadow before the audience, and he
himself must be content to play before the apparatus."[21] The situation
can also be characterized as follows: for the first time—and this is the ef-
fect of film—the human being is placed in a position where he must oper-
ate with his whole living person, while forgoing its aura. For the aura is
bound to his presence in the here and now. There is no facsimile of the
aura. The aura surrounding Macbeth on the stage cannot be divorced
from the aura which, for the living spectators, surrounds the actor who
plays him. What distinguishes the shot in the film studio, however, is that
the camera is substituted for the audience. As a result, the aura surround-
ing the actor is dispelled—and, with it, the aura of the figure he portrays.

It is not surprising that it should be a dramatist such as Pirandello who, in reflecting on the special character of film acting, inadvertently touches on the crisis now affecting the theater. Indeed, nothing contrasts more starkly with a work of art completely subject to (or, like film, founded in) technological reproduction than a stage play. Any thorough consideration will confirm this. Expert observers have long recognized that, in film, "the best effects are almost always achieved by 'acting' as little as possible. . . . The development," according to Rudolf Arnheim, writing in 1932, has been toward "using the actor as one of the 'props,' chosen for his typicalness and . . . introduced in the proper context."[22] Closely bound up with this development is something else. *The stage actor identifies himself with a role. The film actor very often is denied this opportunity.* His performance is by no means a unified whole, but is assembled from many individual performances. Apart from incidental concerns about studio rental, availability of other actors, scenery, and so on, there are elementary necessities of the machinery that split the actor's performance into a series of episodes capable of being assembled. In particular, lighting and its installation require the representation of an action—which on the screen appears as a swift, unified sequence—to be filmed in a series of separate takes, which may be spread over hours in the studio. Not to mention the more obvious effects of montage. A leap from a window, for example, can be shot in the studio as a leap from a scaffold, while the ensuing fall may be filmed weeks later at an outdoor location. And far more paradoxical cases can easily be imagined. Let us assume that an actor is supposed to be startled by a knock at the door. If his reaction is not satisfactory, the director can resort to an expedient: he could have a shot fired without warning behind the actor's back on some other occasion when he happens to be in the studio. The actor's frightened reaction at that moment could be recorded and then edited into the film. Nothing shows more graphically that art has escaped the realm of "beautiful semblance," which for so long was regarded as the only sphere in which it could thrive.[23]

XII

The representation of human beings by means of an apparatus has made possible a highly productive use of the human being's self-alienation. The nature of this use can be grasped through the fact that the film actor's estrangement in the face of the apparatus, as Pirandello describes this experience, is basically of the same kind as the estrangement felt before one's

appearance [*Erscheinung*] in a mirror—a favorite theme of the Romantics. But now the mirror image [*Bild*] has become detachable from the person mirrored, and is transportable. And where is it transported? To a site in front of the masses.[24] Naturally, the screen actor never for a moment ceases to be aware of this. While he stands before the apparatus, he knows that in the end he is confronting the masses. It is they who will control him. Those who are not visible, not present while he executes his performance, are precisely the ones who will control it. This invisibility heightens the authority of their control. It should not be forgotten, of course, that there can be no political advantage derived from this control until film has liberated itself from the fetters of capitalist exploitation. Film capital uses the revolutionary opportunities implied by this control for counterrevolutionary purposes. Not only does the cult of the movie star which it fosters preserve that magic of the personality which has long been no more than the putrid magic of its own commodity character, but its counterpart, the cult of the audience, reinforces the corruption by which fascism is seeking to supplant the class consciousness of the masses.[25]

XIII

It is inherent in the technology of film, as of sports, that everyone who witnesses these performances does so as a quasi-expert. Anyone who has listened to a group of newspaper boys leaning on their bicycles and discussing the outcome of a bicycle race will have an inkling of this. In the case of film, the newsreel demonstrates unequivocally that any individual can be in a position to be filmed. But that possibility is not enough. *Any person today can lay claim to being filmed.* This claim can best be clarified by considering the historical situation of literature today.

For centuries it was in the nature of literature that a small number of writers confronted many thousands of readers. This began to change toward the end of the past century. With the growth and extension of the press, which constantly made new political, religious, scientific, professional, and local journals available to readers, an increasing number of readers—in isolated cases, at first—turned into writers. It began with the space set aside for "letters to the editor" in the daily press, and has now reached a point where there is hardly a European engaged in the work process who could not, in principle, find an opportunity to publish somewhere or other an account of a work experience, a complaint, a report, or something of the kind. Thus, the distinction between author and pub-

lic is about to lose its axiomatic character. The difference becomes functional; it may vary from case to case. At any moment, the reader is ready to become a writer. As an expert—which he has had to become in any case in a highly specialized work process, even if only in some minor capacity—the reader gains access to authorship. Work itself is given a voice. And the ability to describe a job in words now forms part of the expertise needed to carry it out. Literary competence is no longer founded on specialized higher education but on polytechnic training, and thus is common property.

All this can readily be applied to film, where shifts that in literature took place over centuries have occurred in a decade. In cinematic practice—above all, in Russia—this shift has already been partly realized. Some of the actors taking part in Russian films are not actors in our sense but people who portray *themselves*—and primarily in their own work process. In western Europe today, the capitalist exploitation of film obstructs the human being's legitimate claim to being reproduced. The claim is also obstructed, incidentally, by unemployment, which excludes large masses from production—the process in which their primary entitlement to be reproduced would lie. Under these circumstances, the film industry has an overriding interest in stimulating the involvement of the masses through illusionary displays and ambiguous speculations. To this end it has set in motion an immense publicity machine, in the service of which it has placed the careers and love lives of the stars; it has organized polls; it has held beauty contests. All this in order to distort and corrupt the original and justified interest of the masses in film— an interest in understanding themselves and therefore their class. Thus, the same is true of film capital in particular as of fascism in general: a compelling urge toward new social opportunities is being clandestinely exploited in the interests of a property-owning minority. For this reason alone, the expropriation of film capital is an urgent demand for the proletariat.

<div align="center">XIV</div>

The shooting of a film, especially a sound film, offers a hitherto unimaginable spectacle. It presents a process in which it is impossible to assign to the spectator a single viewpoint which would exclude from his or her field of vision the equipment not directly involved in the action being filmed—the camera, the lighting units, the technical crew, and so forth (unless the alignment of the spectator's pupil coincided with that of

the camera). This circumstance, more than any other, makes any resemblance between a scene in a film studio and one onstage superficial and irrelevant. In principle, the theater includes a position from which the action on the stage cannot easily be detected as an illusion. There is no such position where a film is being shot. The illusory nature of film is of the second degree; it is the result of editing. That is to say: *In the film studio the apparatus has penetrated so deeply into reality that a pure view of that reality, free of the foreign body of equipment, is the result of a special procedure—namely, the shooting by the specially adjusted photographic device and the assembly of that shot with others of the same kind.* The equipment-free aspect of reality has here become the height of artifice, and the vision of immediate reality the Blue Flower in the land of technology.[26]

This state of affairs, which contrasts so sharply with that which obtains in the theater, can be compared even more instructively to the situation in painting. Here we have to pose the question: How does the camera operator compare with the painter? In answer to this, it will be helpful to consider the concept of the operator as it is familiar to us from surgery. The surgeon represents the polar opposite of the magician. The attitude of the magician, who heals a sick person by a laying-on of hands, differs from that of the surgeon, who makes an intervention in the patient. The magician maintains the natural distance between himself and the person treated; more precisely, he reduces it slightly by laying on his hands, but increases it greatly by his authority. The surgeon does exactly the reverse: he greatly diminishes the distance from the patient by penetrating the patient's body, and increases it only slightly by the caution with which his hand moves among the organs. In short: unlike the magician (traces of whom are still found in the medical practitioner), the surgeon abstains at the decisive moment from confronting his patient person to person; instead, he penetrates the patient by operating.—Magician is to surgeon as painter is to cinematographer. The painter maintains in his work a natural distance from reality, whereas the cinematographer penetrates deeply into its tissue. The images obtained by each differ enormously. The painter's is a total image, whereas that of the cinematographer is piecemeal, its manifold parts being assembled according to a new law. *Hence, the presentation of reality in film is incomparably the more significant for people of today, since it provides the equipment-free aspect of reality they are entitled to demand from a work of art, and does so precisely on the basis of the most intensive interpenetration of reality with equipment.*

XV

The technological reproducibility of the artwork changes the relation of the masses to art. The extremely backward attitude toward a Picasso painting changes into a highly progressive reaction to a Chaplin film. The progressive attitude is characterized by an immediate, intimate fusion of pleasure—pleasure in seeing and experiencing—with an attitude of expert appraisal. Such a fusion is an important social index. As is clearly seen in the case of painting, the more reduced the social impact of an art form, the more widely criticism and enjoyment of it diverge in the public. The conventional is uncritically enjoyed, while the truly new is criticized with aversion. Not so in the cinema. The decisive reason for this is that nowhere more than in the cinema are the reactions of individuals, which together make up the massive reaction of the audience, determined by the imminent concentration of reactions into a mass. No sooner are these reactions manifest than they regulate one another. Again, the comparison with painting is fruitful. A painting has always exerted a claim to be viewed primarily by a single person or by a few. The simultaneous viewing of paintings by a large audience, as happens in the nineteenth century, is an early symptom of the crisis in painting, a crisis triggered not only by photography but, in a relatively independent way, by the artwork's claim to the attention of the masses.

Painting, by its nature, cannot provide an object of simultaneous collective reception, as architecture has always been able to do, as the epic poem could do at one time, and as film is able to do today. And although direct conclusions about the social role of painting cannot be drawn from this fact alone, it does have a strongly adverse effect whenever painting is led by special circumstances, as if against its nature, to confront the masses directly. In the churches and monasteries of the Middle Ages, and at the princely courts up to about the end of the eighteenth century, the collective reception of paintings took place not simultaneously but in a manifoldly graduated and hierarchically mediated way. If that has changed, the change testifies to the special conflict in which painting has become enmeshed by the technological reproducibility of the image. And while efforts have been made to present paintings to the masses in galleries and salons, this mode of reception gives the masses no means of organizing and regulating their response. Thus, the same public which reacts progressively to a slapstick comedy inevitably displays a backward attitude toward Surrealism.

XVI

The most important social function of film is to establish equilibrium be-
tween human beings and the apparatus. Film achieves this goal not only
in terms of man's presentation of himself to the camera but also in terms
of his representation of his environment by means of this apparatus. On
the one hand, film furthers insight into the necessities governing our lives
by its use of close-ups, by its accentuation of hidden details in familiar
objects, and by its exploration of commonplace milieux through the inge-
nious guidance of the camera; on the other hand, it manages to assure us
of a vast and unsuspected field of action [*Spielraum*].

Our bars and city streets, our offices and furnished rooms, our rail-
road stations and our factories seemed to close relentlessly around us.
Then came film and exploded this prison-world with the dynamite of the
split second, so that now we can set off calmly on journeys of adven-
ture among its far-flung debris. With the close-up, space expands; with
slow motion, movement is extended. And just as enlargement not merely
clarifies what we see indistinctly "in any case," but brings to light entirely
new structures of matter, slow motion not only reveals familiar aspects of
movements, but discloses quite unknown aspects within them—aspects
"which do not appear as the retarding of natural movements but have a
curious gliding, floating character of their own."[27] Clearly, it is another
nature which speaks to the camera as compared to the eye. "Other"
above all in the sense that a space informed by human consciousness
gives way to a space informed by the unconscious. Whereas it is a com-
monplace that, for example, we have some idea what is involved in the
act of walking (if only in general terms), we have no idea at all what hap-
pens during the split second when a person actually takes a step. We are
familiar with the movement of picking up a cigarette lighter or a spoon,
but know almost nothing of what really goes on between hand and
metal, and still less how this varies with different moods. This is where
the camera comes into play, with all its resources for swooping and
rising, disrupting and isolating, stretching or compressing a sequence,
enlarging or reducing an object. It is through the camera that we first dis-
cover the optical unconscious, just as we discover the instinctual uncon-
scious through psychoanalysis.

Moreover, these two types of unconscious are intimately linked. For in
most cases the diverse aspects of reality captured by the film camera lie
outside only the *normal* spectrum of sense impressions. Many of the de-

formations and stereotypes, transformations and catastrophes which can assail the optical world in films afflict the actual world in psychoses, hallucinations, and dreams. Thanks to the camera, therefore, the individual perceptions of the psychotic or the dreamer can be appropriated by collective perception. The ancient truth expressed by Heraclitus, that those who are awake have a world in common while each sleeper has a world of his own, has been invalidated by film—and less by depicting the dream world itself than by creating figures of collective dream, such as the globe-encircling Mickey Mouse.[28]

If one considers the dangerous tensions which technology and its consequences have engendered in the masses at large—tendencies which at critical stages take on a psychotic character—one also has to recognize that this same technologization [Technisierung] has created the possibility of psychic immunization against such mass psychoses. It does so by means of certain films in which the forced development of sadistic fantasies or masochistic delusions can prevent their natural and dangerous maturation in the masses. Collective laughter is one such preemptive and healing outbreak of mass psychosis. The countless grotesque events consumed in films are a graphic indication of the dangers threatening mankind from the repressions implicit in civilization. American slapstick comedies and Disney films trigger a therapeutic release of unconscious energies.[29] Their forerunner was the figure of the eccentric. He was the first to inhabit the new fields of action opened up by film—the first occupant of the newly built house. This is the context in which Chaplin takes on historical significance.

XVII

It has always been one of the primary tasks of art to create a demand whose hour of full satisfaction has not yet come.[30] The history of every art form has critical periods in which the particular form strains after effects which can be easily achieved only with a changed technical standard—that is to say, in a new art form. The excesses and crudities of art which thus result, particularly in periods of so-called decadence, actually emerge from the core of its richest historical energies. In recent years, Dadaism has amused itself with such barbarisms. Only now is its impulse recognizable: *Dadaism attempted to produce with the means of painting (or literature) the effects which the public today seeks in film.*

Every fundamentally new, pioneering creation of demand will overshoot its target. Dadaism did so to the extent that it sacrificed the market

values so characteristic of film in favor of more significant aspirations—
of which, to be sure, it was unaware in the form described here. The Da-
daists attached much less importance to the commercial usefulness of
their artworks than to the uselessness of those works as objects of con-
templative immersion. They sought to achieve this uselessness not least
by thorough degradation of their material. Their poems are "word-
salad" containing obscene expressions and every imaginable kind of lin-
guistic refuse. The same is true of their paintings, on which they mounted
buttons or train tickets. What they achieved by such means was a ruth-
less annihilation of the aura in every object they produced, which they
branded as a reproduction through the very means of its production. Be-
fore a painting by Arp or a poem by August Stramm, it is impossible to
take time for concentration and evaluation, as one can before a painting
by Derain or a poem by Rilke.[31] Contemplative immersion—which, as
the bourgeoisie degenerated, became a breeding ground for asocial be-
havior—is here opposed by distraction [*Ablenkung*] as a variant of social
behavior. Dadaist manifestations actually guaranteed a quite vehement
distraction by making artworks the center of scandal. One requirement
was paramount: to outrage the public.

From an alluring visual composition or an enchanting fabric of sound,
the Dadaists turned the artwork into a missile. It jolted the viewer, taking
on a tactile [*taktisch*] quality. It thereby fostered the demand for film,
since the distracting element in film is also primarily tactile, being based
on successive changes of scene and focus which have a percussive effect
on the spectator.[32] *Film has freed the physical shock effect—which Dada-
ism had kept wrapped, as it were, inside the moral shock effect—from
this wrapping.*

XVIII

The masses are a matrix from which all customary behavior toward
works of art is today emerging newborn. Quantity has been transformed
into quality: *the greatly increased mass of participants has produced a
different kind of participation.* The fact that this new mode of participa-
tion first appeared in a disreputable form should not mislead the ob-
server. The masses are criticized for seeking distraction [*Zerstreuung*] in
the work of art, whereas the art lover supposedly approaches it with con-
centration. In the case of the masses, the artwork is seen as a means of en-
tertainment; in the case of the art lover, it is considered an object of devo-
tion.—This calls for closer examination.[33] Distraction and concentration

form an antithesis, which may be formulated as follows. A person who concentrates before a work of art is absorbed by it; he enters into the work, just as, according to legend, a Chinese painter entered his completed painting while beholding it.[34] By contrast, the distracted masses absorb the work of art into themselves. Their waves lap around it; they encompass it with their tide. This is most obvious with regard to buildings. Architecture has always offered the prototype of an artwork that is received in a state of distraction and through the collective. The laws of architecture's reception are highly instructive.

Buildings have accompanied human existence since primeval times. Many art forms have come into being and passed away. Tragedy begins with the Greeks, is extinguished along with them, and is revived centuries later. The epic, which originates in the early days of peoples, dies out in Europe at the end of the Renaissance. Panel painting is a creation of the Middle Ages, and nothing guarantees its uninterrupted existence. But the human need for shelter is permanent. Architecture has never had fallow periods. Its history is longer than that of any other art, and its effect ought to be recognized in any attempt to account for the relationship of the masses to the work of art. Buildings are received in a twofold manner: by use and by perception. Or, better: tactilely and optically. Such reception cannot be understood in terms of the concentrated attention of a traveler before a famous building. On the tactile side, there is no counterpart to what contemplation is on the optical side. Tactile reception comes about not so much by way of attention as by way of habit. The latter largely determines even the optical reception of architecture, which spontaneously takes the form of casual noticing, rather than attentive observation. Under certain circumstances, this form of reception shaped by architecture acquires canonical value. *For the tasks which face the human apparatus of perception at historical turning points cannot be performed solely by optical means—that is, by way of contemplation. They are mastered gradually—taking their cue from tactile reception— through habit.*

Even the distracted person can form habits. What is more, the ability to master certain tasks in a state of distraction first proves that their performance has become habitual. The sort of distraction that is provided by art represents a covert measure of the extent to which it has become possible to perform new tasks of apperception. Since, moreover, individuals are tempted to evade such tasks, art will tackle the most difficult and most important tasks wherever it is able to mobilize the masses. It does so currently in film. *Reception in distraction—the sort of reception which*

is increasingly noticeable in all areas of art and is a symptom of profound changes in apperception—finds in film its true training ground. Film, by virtue of its shock effects, is predisposed to this form of reception. In this respect, too, it proves to be the most important subject matter, at present, for the theory of perception which the Greeks called aesthetics.[35]

XIX

The increasing proletarianization of modern man and the increasing formation of masses are two sides of the same process. Fascism attempts to organize the newly proletarianized masses while leaving intact the property relations which they strive to abolish. It sees its salvation in granting expression to the masses—but on no account granting them rights.[36] The masses have a *right* to changed property relations; fascism seeks to give them *expression* in keeping these relations unchanged. *The logical outcome of fascism is an aestheticizing of political life.* With D'Annunzio, decadence made its entry into political life; with Marinetti, Futurism; and with Hitler, the Bohemian tradition of Schwabing.[37]

All efforts to aestheticize politics culminate in one point. That one point is war. War, and only war, makes it possible to set a goal for mass movements on the grandest scale while preserving traditional property relations. That is how the situation presents itself in political terms. In technological terms it can be formulated as follows: only war makes it possible to mobilize all of today's technological resources while maintaining property relations. It goes without saying that the fascist glorification of war does not make use of *these* arguments. Nevertheless, a glance at such glorification is instructive. In Marinetti's manifesto for the colonial war in Ethiopia, we read:

> For twenty-seven years, we Futurists have rebelled against the idea that war is anti-aesthetic. . . . We therefore state: . . . War is beautiful because— thanks to its gas masks, its terrifying megaphones, its flame throwers, and light tanks—it establishes man's dominion over the subjugated machine. War is beautiful because it inaugurates the dreamed-of metallization of the human body. War is beautiful because it enriches a flowering meadow with the fiery orchids of machine-guns. War is beautiful because it combines gunfire, barrages, cease-fires, scents, and the fragrance of putrefaction into a symphony. War is beautiful because it creates new architectures, like those of armored tanks, geometric squadrons of aircraft, spirals of smoke from burning villages, and much more. . . . Poets and artists of Futurism,

. . . remember these principles of an aesthetic of war, that they may illumi-
nate . . . your struggles for a new poetry and a new sculpture![38]

This manifesto has the merit of clarity. The question it poses deserves to be taken up by the dialectician. To him, the aesthetic of modern warfare appears as follows: if the natural use of productive forces is impeded by the property system, then the increase in technological means, in speed, in sources of energy will press toward an unnatural use. This is found in war, and the destruction caused by war furnishes proof that society was not mature enough to make technology its organ, that technology was not sufficiently developed to master the elemental forces of society. The most horrifying features of imperialist war are determined by the discrepancy between the enormous means of production and their inadequate use in the process of production (in other words, by unemployment and the lack of markets). *Imperialist war is an uprising on the part of technology, which demands repayment in "human material" for the natural material society has denied it.* Instead of deploying power stations across the land, society deploys manpower in the form of armies. Instead of promoting air traffic, it promotes traffic in shells. And in gas warfare it has found a new means of abolishing the aura.

"Fiat ars—pereat mundus,"[39] says fascism, expecting from war, as Marinetti admits, the artistic gratification of a sense perception altered by technology. This is evidently the consummation of *l'art pour l'art.* Humankind, which once, in Homer, was an object of contemplation for the Olympian gods, has now become one for itself. Its self-alienation has reached the point where it can experience its own annihilation as a supreme aesthetic pleasure. *Such is the aestheticizing of politics, as practiced by fascism. Communism replies by politicizing art.*

Written late December 1935–beginning of February 1936; unpublished in this form in Benjamin's lifetime. *Gesammelte Schriften,* VII, 350–384. Translated by Edmund Jephcott and Harry Zohn.

Notes

This version of the essay "Das Kunstwerk im Zeitalter seiner technischen Reproduzierbarkeit" (first published in Volume 7 of Benjamin's *Gesammelte Schriften,* in 1989) is a revision and expansion (by seven manuscript pages) of the first version of the essay, which was composed in Paris in the autumn of 1935. The second version represents the form in which Benjamin originally wished to see the work published; it served, in fact, as the basis for the first publication of the es-

say—a somewhat shortened form translated into French—in the *Zeitschrift für Sozialforschung* in May 1936. The third version of the essay (1936–1939) can be found in Benjamin, *Selected Writings, Volume 4: 1938–1940* (Cambridge, Mass.: Harvard University Press, 2003), pp. 251–283.

1. Madame Claire de Duras, née Kersaint (1778–1828), the wife of Duc Amédée de Duras, field marshal under Louis XVIII, was the author of two novels, *Ourika* (1823) and *Edouard* (1825). She presided over a brilliant salon in Paris. Benjamin cites Madame de Duras in the original French.

2. Karl Marx (1818–1883) analyzed the capitalist mode of production in *Das Kapital* (3 vols., 1867, 1885, 1895), which was carried to completion by his collaborator Friedrich Engels (1820–1895).

3. Abel Gance, "Le Temps de l'image est venu!" (It Is Time for the Image!), in Léon Pierre-Quint, Germaine Dulac, Lionel Landry, and Abel Gance, *L'Art cinématographique*, vol. 2 (Paris, 1927), pp. 94–96. [Benjamin's note. Gance (1889–1981) was a French film director whose epic films *J'accuse* (1919), *La Roue* (1922), and *Napoléon* (1927) made innovative use of such devices as superimposition, rapid intercutting, and split screen.—*Trans.*]

4. Alois Riegl (1858–1905) was an Austrian art historian who argued that different formal orderings of art emerge as expressions of different historical epochs. He is the author of *Stilfragen: Grundlegungen zu einer Geschichte der Ornamentik* (Questions of Style: Toward a History of Ornament; 1893) and *Die spätrömische Kunst-Industrie nach den Funden in Österreich-Ungarn* (1901). The latter has been translated by Rolf Winkes as *Late Roman Art Industry* (Rome: Giorgio Bretschneider, 1985). Franz Wickhoff (1853–1909), also an Austrian art historian, is the author of *Die Wiener Genesis* (The Vienna Genesis; 1895), a study of the sumptuously illuminated, early sixth-century A.D. copy of the biblical book of Genesis preserved in the Austrian National Library in Vienna.

5. "Einmalige Erscheinung einer Ferne, so nah sie sein mag." At stake in Benjamin's formulation is an interweaving not just of time and space—*einmalige Erscheinung*, literally "one-time appearance"—but of far and near, *eine Ferne* suggesting both "a distance" in space or time and "something remote," however near it (the distance, or distant thing, that appears) may be.

6. Benjamin is quoting Johannes V. Jensen, *Exotische Novellen*, trans. Julia Koppel (Berlin: S. Fischer, 1919), pp. 41–42. Jensen (1873–1950) was a Danish novelist, poet, and essayist who won the Nobel Prize for Literature in 1944. See "Hashish in Marseilles" (1932), in Benjamin, *Selected Writings, Volume 2: 1927–1934* (Cambridge, Mass.: Harvard University Press, 1999), p. 677.

7. Applying Kant's idea of the pure and disinterested existence of the work of art, the French philosopher Victor Cousin made use of the phrase *l'art pour l'art* ("art for art's sake") in his 1818 lecture "Du Vrai, du beau, et du bien" (On the True, the Beautiful, and the Good). The idea was later given cur-

rency by writers such as Théophile Gautier, Edgar Allan Poe, and Charles Baudelaire.

8. The French poet Stéphane Mallarmé (1842–1898) was a central figure in the Symbolist movement, which sought an incantatory language divorced from all referential function.

9. In film, the technological reproducibility of the product is not an externally imposed condition of its mass dissemination, as it is, say, in literature or painting. *The technological reproducibility of films is based directly on the technology of their production. This not only makes possible the mass dissemination of films in the most direct way, but actually enforces it.* It does so because the process of producing a film is so costly that an individual who could afford to buy a painting, for example, could not afford to buy a [master print of a] film. It was calculated in 1927 that, in order to make a profit, a major film needed to reach an audience of nine million. Of course, the advent of sound film [in that year] initially caused a movement in the opposite direction: its audience was restricted by language boundaries. And that coincided with the emphasis placed on national interests by fascism. But it is less important to note this setback (which in any case was mitigated by dubbing) than to observe its connection with fascism. The simultaneity of the two phenomena results from the economic crisis. The same disorders which led, in the world at large, to an attempt to maintain existing property relations by brute force induced film capital, under the threat of crisis, to speed up the development of sound film. Its introduction brought temporary relief, not only because sound film attracted the masses back into the cinema but also because it consolidated new capital from the electricity industry with that of film. Thus, considered from the outside, sound film promoted national interests; but seen from the inside, it helped internationalize film production even more than before. [Benjamin's note. By "the economic crisis," Benjamin refers to the devastating consequences, in the United States and Europe, of the stock market crash of October 1929.—*Trans.*]

10. This polarity cannot come into its own in the aesthetics of Idealism, which conceives of beauty as something fundamentally undivided (and thus excludes anything polarized). Nonetheless, in Hegel this polarity announces itself as clearly as possible within the limits of Idealism. We quote from his *Vorlesungen zur Philosophie der Geschichte* [Lectures on the Philosophy of History]: "Images were known of old. In those early days piety required them for worship, but it could do without *beautiful* images. Such images might even be disturbing. In every beautiful image, there is also something external—although, insofar as the image is beautiful, its spirit still speaks to the human being. But religious worship, being no more than a spiritless torpor of the soul, is directed at a *thing.* . . . Fine art arose . . . in the church. . . , though art has now gone beyond the ecclesiastical principle." Likewise, the following passage from the *Vorlesungen über die Ästhetik* [Lectures on Aes-

thetics] indicates that Hegel sensed a problem here: "We are beyond the stage of venerating works of art as divine and as objects deserving our worship. Today the impression they produce is of a more reflective kind, and the emotions they arouse require a more stringent test." [Benjamin's note. The German Idealist philosopher Georg Wilhelm Friedrich Hegel (1770–1831) accepted the chair in philosophy at the University of Berlin in 1818. His lectures on aesthetics and the philosophy of history (delivered 1820–1829) were later published by his editors, with the text based mainly on notes taken by his students.—*Trans.*]

11. The aim of revolutions is to accelerate this adaptation. Revolutions are innervations of the collective—or, more precisely, efforts at innervation on the part of the new, historically unique collective which has its organs in the new technology. This second technology is a system in which the mastering of elementary social forces is a precondition for playing [*das Spiel*] with natural forces. Just as a child who has learned to grasp stretches out its hand for the moon as it would for a ball, so humanity, in its efforts at innervation, sets its sights as much on currently utopian goals as on goals within reach. For in revolutions, it is not only the second technology which asserts its claims vis-à-vis society. Because this technology aims at liberating human beings from drudgery, the individual suddenly sees his scope for play, his field of action [*Spielraum*], immeasurably expanded. He does not yet know his way around this space. But already he registers his demands on it. For the more the collective makes the second technology its own, the more keenly individuals belonging to the collective feel how little they have received of what was due them under the dominion of the first technology. In other words, it is the individual liberated by the liquidation of the first technology who stakes his claim. No sooner has the second technology secured its initial revolutionary gains than vital questions affecting the individual—questions of love and death which had been buried by the first technology—once again press for solutions. Fourier's work is the first historical evidence of this demand. [Benjamin's note. Charles Fourier (1772–1837), French social theorist and reformer, urged that society be reorganized into self-contained agrarian cooperatives which he called "phalansteries." Among his works are *Théorie des quatre mouvements* (Theory of Four Movements; 1808) and *Le Nouveau Monde industriel* (The New Industrial World; 1829–1830). He is an important figure in Benjamin's *Arcades Project*. The term *Spielraum*, in this note, in note 23, and in the text, literally means "playspace," "space for play."—*Trans.*]

12. Eugène Atget (1857–1927), French photographer, spent his career in obscurity making pictures of Paris and its environs. He is widely recognized as one of the leading photographers of the twentieth century. See Benjamin's "Little History of Photography" (1931), in this volume.

13. *A Woman of Paris* (1923)—which Benjamin refers to by its French title,

L'Opinion publique—was written and directed by the London-born actor and director Charlie Chaplin (Charles Spencer Chaplin; 1889–1977). Chaplin came to the United States with a vaudeville act in 1910 and made his motion picture debut there in 1914, eventually achieving worldwide renown as a comedian. He starred in and directed such films as *The Kid* (1921), *The Circus* (1928), *City Lights* (1931), *Modern Times* (1936), and *The Great Dictator* (1940). See Benjamin's short pieces "Chaplin" (1929) and "Chaplin in Retrospect" (1929), in this volume.

14. On the nineteenth-century quarrel between painting and photography, see Benjamin's "Little History of Photography" (1931), in this volume, and Benjamin, *The Arcades Project*, trans. Howard Eiland and Kevin McLaughlin (Cambridge, Mass.: Harvard University Press, 1999), pp. 684–692.

15. Abel Gance, "Le Temps de l'image est venu!" in *L'Art cinématographique*, vol. 2, p. 101. [Benjamin's note. On Gance, see note 3 above.—*Trans.*]

16. Séverin-Mars, cited ibid., p. 100. [Benjamin's note. Séverin-Mars (1873–1921) was a playwright and film actor who starred in three of Gance's films: *La Dixième Symphonie, J'accuse,* and *La Roue.*—*Trans.*]

17. Charlie Chaplin wrote and directed *The Gold Rush* in 1925. On Chaplin and *A Woman of Paris*, see note 13 above. Giovanni da Fiesole (1387–1455), known as Fra Angelico, was an Italian Dominican friar, celebrated for his "angelic" virtues, and a painter in the early Renaissance Florentine style. Among his most famous works are his frescoes at Orvieto, which reflect a characteristically serene religious attitude.

18. Franz Werfel, "Ein Sommernachtstraum: Ein Film von Shakespeare und Reinhardt," *Neues Wiener Journal*, cited in *Lu*, November 15, 1935. [Benjamin's note. Werfel (1890–1945) was a Czech-born poet, novelist, and playwright associated with Expressionism. He emigrated to the United States in 1940. Among his works are *Der Abituriententag* (The Class Reunion; 1928) and *Das Lied von Bernadette* (The Song of Bernadette; 1941). Max Reinhardt (Maximilian Goldman; 1873–1943) was Germany's most important stage producer and director during the first third of the twentieth century and the single most significant influence on the classic German silent cinema, many of whose directors and actors trained under him at the Deutsches Theater in Berlin. His direct film activity was limited to several early German silents and to the American movie *A Midsummer Night's Dream* (1935), which he codirected with William Dieterle.—*Trans.*]

19. Paavo Nurmi (1897–1973), a Finnish long-distance runner, was a winner at the Olympic Games in Antwerp (1920), Paris (1924), and Amsterdam (1928).

20. Beginning in 1917, the Italian playwright and novelist Luigi Pirandello (1867–1936) achieved a series of successes on the stage that made him world famous in the 1920s. He is best known for his plays *Sei personaggi in cerca*

d'autore (Six Characters in Search of an Author; 1921) and *Enrico IV* (Henry IV; 1922).

21. Luigi Pirandello, *Il turno* (The Turn), cited by Léon Pierre-Quint, "Significat-ion du cinéma," in *L'Art cinématographique*, vol. 2, pp. 14–15. [Benjamin's note]

22. Rudolf Arnheim, *Film als Kunst* (Berlin, 1932), pp. 176–177. In this context, certain apparently incidental details of film directing which diverge from practices on the stage take on added interest. For example, the attempt to let the actor perform without makeup, as in Dreyer's *Jeanne d'Arc*. Dreyer spent months seeking the forty actors who constitute the Inquisitors' tribu-nal. Searching for these actors was like hunting for rare props. Dreyer made every effort to avoid resemblances of age, build, and physiognomy in the actors. (See Maurice Schultz, "Le Maquillage" [Makeup], in *L'Art cinéma-tographique*, vol. 6 [Paris, 1929], pp. 65–66.) If the actor thus becomes a prop, the prop, in its turn, not infrequently functions as actor. At any rate, it is not unusual for films to allocate a role to a prop. Rather than selecting ex-amples at random from the infinite number available, let us take just one es-pecially revealing case. A clock that is running will always be a disturbance on the stage, where it cannot be permitted its role of measuring time. Even in a naturalistic play, real-life time would conflict with theatrical time. In view of this, it is most revealing that film—where appropriate—can readily make use of time as measured by a clock. This feature, more than many others, makes it clear that—circumstances permitting—each and every prop in a film may perform decisive functions. From here it is but a step to Pudovkin's principle, which states that "to connect the performance of an actor with an object, and to build that performance around the object, . . . is always one of the most powerful methods of cinematic construction" (V. I. Pudovkin, *Film Regie und Filmmanuskript* [Film Direction and the Film Script] (Berlin, 1928), p. 126). Film is thus the first artistic medium which is able to show how matter plays havoc with human beings [*wie die Materie dem Menschen mitspielt*]. It follows that films can be an excellent means of materialist ex-position. [Benjamin's note. See, in English, Rudolf Arnheim, *Film as Art* (Berkeley: University of California Press, 1957), p. 138. Arnheim (1904–2007), German-born Gestalt psychologist and critic, wrote on film, litera-ture, and art for various Berlin newspapers and magazines from the mid-1920s until 1933. He came to the United States in 1940 and taught at Sarah Lawrence, the New School for Social Research, Harvard, and the University of Michigan. Besides his work on film theory, his publications include *Art and Visual Perception* (1954), *Picasso's Guernica* (1962), and *Visual Thinking* (1969). *La Passion de Jeanne d'Arc*, directed by Carl Theodor Dreyer, was released in 1928. Dreyer (1889–1968), Danish writer-director and film critic, is known for the exacting, expressive design of his films, his subtle camera movement, and his concentration on the physiognomy and inner

psychology of his characters. Among his best-known works are *Vampyr* (1931), *Vredens Dag* (Day of Wrath; 1943), and *Ordet* (1955). Vsevolod Illarionovich Pudovkin (1893–1953), one of the masters of Soviet silent cinema, wrote and directed films—such as *Mother* (1926), *The End of St. Petersburg* (1927), and *Storm over Asia* (1928)—that showed the evolution of individualized yet typical characters in a social environment. He also published books on film technique and film acting.—*Trans.*]

23. The significance of beautiful semblance [*schöner Schein*] is rooted in the age of auratic perception that is now coming to an end. The aesthetic theory of that era was most fully articulated by Hegel, for whom beauty is "the appearance [*Erscheinung*] of spirit in its immediate . . . sensuous form, created by the spirit as the form adequate to itself" (Hegel, *Werke*, vol. 10, part 2 [Berlin, 1837], p. 121). Although this formulation has some derivative qualities, Hegel's statement that art strips away the "semblance and deception of this false, transient world" from the "true content of phenomena" (*Werke*, vol. 10, part 1, p. 13) already diverges from the traditional experiential basis [*Erfahrungsgrund*] of this doctrine. This ground of experience is the aura. By contrast, Goethe's work is still entirely imbued with beautiful semblance as an auratic reality. Mignon, Ottilie, and Helena partake of that reality. "The beautiful is neither the veil nor the veiled object but rather the object *in* its veil": this is the quintessence of Goethe's view of art, and that of antiquity. The decline of this view makes it doubly urgent that we look back at its origin. This lies in mimesis as the primal phenomenon of all artistic activity. The mime presents what he mimes merely as semblance [*Der Nachmachende macht, was er macht, nur scheinbar*]. And the oldest form of imitation had only a single material to work with: the body of the mime himself. Dance and language, gestures of body and lips, are the earliest manifestations of mimesis.—The mime presents his subject as a semblance [*Der Nachmachende macht seine Sache scheinbar*]. One could also say that he plays his subject. Thus we encounter the polarity informing mimesis. In mimesis, tightly interfolded like cotyledons, slumber the two aspects of art: semblance and play. Of course, this polarity can interest the dialectician only if it has a historical role. And that is, in fact, the case. This role is determined by the world-historical conflict between the first and second technologies. Semblance is the most abstract—but therefore the most ubiquitous—schema of all the magic procedures of the first technology, whereas play is the inexhaustible reservoir of all the experimenting procedures of the second. Neither the concept of semblance nor that of play is foreign to traditional aesthetics; and to the extent that the two concepts of cult value and exhibition value are latent in the other pair of concepts at issue here, they say nothing new. But this abruptly changes as soon as these latter concepts lose their indifference toward history. They then lead to a practical insight—namely, that what is lost in the withering of semblance and the decay of the aura in

works of art is matched by a huge gain in the scope for play [*Spiel-Raum*]. This space for play is widest in film. In film, the element of semblance has been entirely displaced by the element of play. The positions which photography had occupied at the expense of cult value have thus been massively fortified. In film, the element of semblance has yielded its place to the element of play, which is allied to the second technology. Ramuz recently summed up this alliance in a formulation which, in the guise of a metaphor, gets to the heart of the matter. He says: "We are currently witnessing a fascinating process. The various sciences, which up to now have each operated alone in their special fields, are beginning to converge in their object and to be combined into a single science: chemistry, physics, and mechanics are becoming interlinked. It is as if we were eyewitnesses to the enormously accelerated completion of a jigsaw puzzle whose first pieces took several millennia to put in place, whereas the last, because of their contours, and to the astonishment of the spectators, are moving together of their own accord" (Charles Ferdinand Ramuz, "Paysan, nature" [Peasant, Nature], *Mesure*, 4 [October 1935]). These words give ultimate expression to the dimension of play in the second technology, which reinforces that in art. [Benjamin's note. It should be kept in mind that *Schein* can mean "luster" and "appearance," as well as "semblance" or "illusion." On Hegel, see note 10 above. The poet Johann Wolfgang von Goethe (1749–1832) visited Italy in 1786–1788 and in 1790, gaining new inspiration from his encounter with Greco-Roman antiquity; a classically pure and restrained conception of beauty informs his creation of such female figures as Mignon in *Wilhelm Meisters Lehrjahre* (Wilhelm Meister's Apprenticeship; 1796), Ottilie in *Die Wahlverwandtschaften* (Elective Affinities; 1809), and Helena in *Faust*, Part II (1832). Benjamin's definition of the beautiful as "the object *in* its veil" is quoted (with the italics added) from his essay "Goethe's Elective Affinities" (1924–1925), in Benjamin, *Selected Writings, Volume 1: 1913–1926* (Cambridge, Mass.: Harvard University Press, 1996), p. 351. Charles Ferdinand Ramuz (1878–1947) was a Swiss writer resident in Paris (1902–1914), where he collaborated with the composer Igor Stravinsky, for whom he wrote the text of *Histoire du soldat* (The Soldier's Tale; 1918). He also published novels on rural life that combine realism with allegory.— Trans.]

24. The change noted here in the mode of exhibition—a change brought about by reproduction technology—is also noticeable in politics. *The crisis of democracies can be understood as a crisis in the conditions governing the public presentation of politicians.* Democracies exhibit the politician directly, in person, before elected representatives. The parliament is his public. But innovations in recording equipment now enable the speaker to be heard by an unlimited number of people while he is speaking, and to be seen by an unlimited number shortly afterward. This means that priority is

given to presenting the politician before the recording equipment. Parliaments are becoming depopulated at the same time as theaters. Radio and film are changing not only the function of the professional actor but, equally, the function of those who, like the politician, present themselves before these media. The direction of this change is the same for the film actor and the politician, regardless of their different tasks. It tends toward the exhibition of controllable, transferable skills under certain social conditions, just as sports first called for such exhibition under certain natural conditions. This results in a new form of selection—selection before an apparatus—from which the champion, the star, and the dictator emerge as victors. [Benjamin's note]

25. It should be noted in passing that proletarian class consciousness, which is the most enlightened form of class consciousness, fundamentally transforms the structure of the proletarian masses. The class-conscious proletariat forms a compact mass only from the outside, in the minds of its oppressors. At the moment when it takes up its struggle for liberation, this apparently compact mass has actually already begun to loosen. It ceases to be governed by mere reactions; it makes the transition to action. The loosening of the proletarian masses is the work of solidarity. In the solidarity of the proletarian class struggle, the dead, undialectical opposition between individual and mass is abolished; for the comrade, it does not exist. Decisive as the masses are for the revolutionary leader, therefore, his great achievement lies not in drawing the masses after him, but in constantly incorporating himself into the masses, in order to be, for them, always one among hundreds of thousands. But the same class struggle which loosens the compact mass of the proletariat compresses that of the petty bourgeoisie. The mass as an impenetrable, compact entity, which Le Bon and others have made the subject of their "mass psychology," is that of the petty bourgeoisie. The petty bourgeoisie is not a class; it is in fact only a mass. And the greater the pressure acting on it between the two antagonistic classes of the bourgeoisie and the proletariat, the more compact it becomes. In *this* mass the emotional element described in mass psychology is indeed a determining factor. But for that very reason this compact mass forms the antithesis of the proletarian cadre, which obeys a collective *ratio*. In the petty-bourgeois mass, the reactive moment described in mass psychology is indeed a determining factor. But precisely for that reason this compact mass with its unmediated reactions forms the antithesis of the proletarian cadre, whose actions are mediated by a task, however momentary. Demonstrations by the compact mass thus always have a panicked quality—whether they give vent to war fever, hatred of Jews, or the instinct for self-preservation. Once the distinction between the compact (that is, petty-bourgeois) mass and the class-conscious, proletarian mass has been clearly made, its operational significance is also clear. This distinction is nowhere more graphically illustrated than in the not

uncommon cases when some outrage originally performed by the compact mass becomes, as a result of a revolutionary situation and perhaps within the space of seconds, the revolutionary action of a class. The special feature of such truly historic events is that a reaction by a compact mass sets off an internal upheaval which loosens its composition, enabling it to become aware of itself as an association of class-conscious cadres. Such concrete events contain in very abbreviated form what communist tacticians call "winning over the petty bourgeoisie." These tacticians have a further interest in clarifying this process. The ambiguous concept of the masses, and the indiscriminate references to their mood which are commonplace in the German revolutionary press, have undoubtedly fostered illusions which have had disastrous consequences for the German proletariat. Fascism, by contrast, has made excellent use of these laws—whether it understood them or not. It realizes that the more compact the masses it mobilizes, the better the chance that the counterrevolutionary instincts of the petty bourgeoisie will determine their reactions. The proletariat, on the other hand, is preparing for a society in which neither the objective nor the subjective conditions for the formation of masses will exist any longer. [Benjamin's note. Gustave Le Bon (1841–1931), French physician and sociologist, was the author of *Psychologie des foules* (Psychology of the Crowd; 1895) and other works.—*Trans.*]

26. Benjamin alludes here to *Heinrich von Ofterdingen*, an unfinished novel by the German Romantic poet Novalis (Friedrich von Hardenberg; 1772–1801), first published in 1802. Von Ofterdingen is a medieval poet in search of the mysterious Blue Flower, which bears the face of his unknown beloved. See Benjamin's "Dream Kitsch" (1927), in this volume.

27. Rudolf Arnheim, *Film als Kunst,* p. 138. [Benjamin's note. In English in Arnheim, *Film as Art,* pp. 116–117. On Arnheim, see note 22 above.—*Trans.*]

28. Benjamin refers to Fragment 89 in the standard Diels-Kranz edition of the fragments of Heraclitus of Ephesus, the Pre-Socratic philosopher of the sixth–fifth centuries B.C. On Mickey Mouse, see the following note.

29. Of course, a comprehensive analysis of these films should not overlook their double meaning. It should start from the ambiguity of situations which have both a comic and a horrifying effect. As the reactions of children show, comedy and horror are closely related. In the face of certain situations, why shouldn't we be allowed to ask which reaction is the more human? Some recent Mickey Mouse films offer situations in which such a question seems justified. (Their gloomy and sinister fire-magic, made technically possible by color film, highlights a feature which up to now has been present only covertly, and shows how easily fascism takes over "revolutionary" innovations in this field too.) What is revealed in recent Disney films was latent in some of the earlier ones: the cozy acceptance of bestiality and violence as inevita-

ble concomitants of existence. This renews an old tradition which is far from reassuring—the tradition inaugurated by the dancing hooligans to be found in depictions of medieval pogroms, of whom the "riff-raff" in Grimm's fairy tale of that title are a pale, indistinct rear-guard. [Benjamin's note. The internationally successful Mickey Mouse cartoon series developed out of the character of Mortimer Mouse, introduced in 1927 by the commercial artist and cartoon producer Walt Disney (1901–1966), who made outstanding technical and aesthetic contributions to the development of animation between 1927 and 1937, and whose short animated films of the thirties won praise from critics for their visual comedy and their rhythmic and unconventional technical effects. See Benjamin's "Mickey Mouse" (1931), in this volume. "Riff-raff" translates "Lumpengesindel," the title of a story in Jacob and Wilhelm Grimm's collection of tales, *Kinder- und Hausmärchen* (Nursery and Household Tales; 1812, 1815).—*Trans.*]

30. "The artwork," writes André Breton, "has value only insofar as it is alive to reverberations of the future." And indeed every highly developed art form stands at the intersection of three lines of development. First, technology is working toward a particular form of art. Before film appeared, there were little books of photos that could be made to flit past the viewer under the pressure of the thumb, presenting a boxing match or a tennis match; then there were coin-operated peepboxes in bazaars, with image sequences kept in motion by the turning of a handle. Second, traditional art forms, at certain stages in their development, strain laboriously for effects which later are effortlessly achieved by new art forms. Before film became established, Dadaist performances sought to stir in their audiences reactions which Chaplin then elicited more naturally. Third, apparently insignificant social changes often foster a change in reception which benefits only the new art form. Before film had started to create its public, images (which were no longer motionless) were received by an assembled audience in the Kaiserpanorama. Here the audience faced a screen into which stereoscopes were fitted, one for each spectator. In front of these stereoscopes single images automatically appeared, remained briefly in view, and then gave way to others. Edison still had to work with similar means when he presented the first film strip—before the movie screen and projection were known; a small audience gazed into an apparatus in which a sequence of images was shown. Incidentally, the institution of the Kaiserpanorama very clearly manifests a dialectic of development. Shortly before film turned the viewing of images into a collective activity, image viewing by the individual, through the stereoscopes of these soon outmoded establishments, was briefly intensified, as it had been once before in the isolated contemplation of the divine image by the priest in the cella. [Benjamin's note. André Breton (1896–1966), French critic, poet, and editor, was the chief promoter and one of the founders of the Surrealist movement, publishing the first *Manifeste du surréalisme* in 1924. In

Zurich in 1916, an international group of exiles disgusted by World War I, and by the bourgeois ideologies that had brought it about, launched Dada, an avant-garde movement that attempted to radically change both the work of art and society. Dadaist groups were active in Berlin, New York, Paris, and elsewhere during the war and into the 1920s, recruiting many notable artists, writers, and performers capable of shocking their audiences at public gatherings. On Chaplin, see note 13 above. Thomas Alva Edison (1847–1931) patented more than a thousand inventions over a sixty-year period, including the microphone, the phonograph, the incandescent electric lamp, and the alkaline storage battery. He supervised the invention of the Kinetoscope in 1891; this boxlike peep-show machine allowed individuals to view moving pictures on a film loop running on spools between an electric lamp and a shutter. He built the first film studio, the Black Maria, in 1893, and later founded his own company for the production of projected films. The Kaiserpanorama (Imperial Panorama), located in a Berlin arcade, consisted of a dome-like apparatus presenting stereoscopic views to customers seated around it. See Benjamin's "Imperial Panorama" (Chapter 6 in this volume), excerpted from his *Berlin Childhood around 1900* (1938).—*Trans.*]

31. Hans Arp (1887–1966), Alsatian painter, sculptor, and poet, was a founder of the Zurich Dada group in 1916 and a collaborator with the Surrealists for a time after 1925. August Stramm (1874–1915) was an early Expressionist poet and dramatist, a member of the circle of artists gathered around the journal *Der Sturm* in Berlin. The French painter André Derain (1880–1954) became well known when he, Henri Matisse, and Maurice de Vlaminck were dubbed the "Fauves," or "wild beasts," at the 1905 Salon d'Automne. Rainer Maria Rilke (1875–1926), Austro-German lyric poet and writer, published his *Duineser Elegien* (Duino Elegies) and *Sonette an Orpheus* (Sonnets to Orpheus) in 1923.

32. Let us compare the screen [*Leinwand*] on which a film unfolds with the canvas [*Leinwand*] of a painting. The image on the film screen changes, whereas the image on the canvas does not. The painting invites the viewer to contemplation; before it, he can give himself up to his train of associations. Before a film image, he cannot do so. No sooner has he seen it than it has already changed. It cannot be fixed on. The train of associations in the person contemplating it is immediately interrupted by new images. This constitutes the shock effect of film, which, like all shock effects, seeks to induce heightened attention. *Film is the art form corresponding to the pronounced threat to life in which people live today.* It corresponds to profound changes in the apparatus of apperception—changes that are experienced on the scale of private existence by each passerby in big-city traffic, and on the scale of world history by each fighter against the present social order. [Benjamin's note. A more literal translation of the last phrase before the sen-

tence in italics is: "seeks to be buffered by intensified presence of mind [*Geistesgegenwart*]."—*Trans.*]

33. Sections XVII and XVIII introduce the idea of a productive "reception in distraction" *(Rezeption in der Zerstreuung)*, an idea indebted to the writings of Siegfried Kracauer and Louis Aragon. This positive idea of distraction—*Zerstreuung* also means "entertainment"—contrasts with the negative idea of distraction that Benjamin developed in such essays as "Theater and Radio" (1932) and "The Author as Producer" (1934), both in this volume; the latter idea is associated with the theory and practice of Bertolt Brecht's epic theater. See "Theory of Distraction" (1935–1936), in this volume.

34. Benjamin relates the legend of this Chinese painter in the 1934 version of his *Berlin Childhood around 1900*, in Benjamin, *Selected Writings, Volume 3: 1935–1938* (Cambridge, Mass.: Harvard University Press, 2002), p. 393.

35. The term "aesthetics" is a derivative of Greek *aisthetikos*, "of sense perception," from *aisthanesthai*, "to perceive."

36. A technological factor is important here, especially with regard to the newsreel, whose significance for propaganda purposes can hardly be overstated. *Mass reproduction is especially favored by the reproduction of the masses.* In great ceremonial processions, giant rallies and mass sporting events, and in war, all of which are now fed into the camera, the masses come face to face with themselves. This process, whose significance need not be emphasized, is closely bound up with the development of reproduction and recording technologies. In general, mass movements are more clearly apprehended by the camera than by the eye. A bird's-eye view best captures assemblies of hundreds of thousands. And even when this perspective is no less accessible to the human eye than to the camera, the image formed by the eye cannot be enlarged in the same way as a photograph. This is to say that mass movements, and above all war, are a form of human behavior especially suited to the camera. [Benjamin's note]

37. Gabriele D'Annunzio (1863–1938), Italian writer, military hero, and political leader, was an ardent advocate of Italy's entry into World War I and, a few years later, an ardent Fascist. His life and his work are both characterized by superstition, amorality, and a lavish and vicious violence. Futurism was an artistic movement aiming to express the dynamic and violent quality of contemporary life, especially as embodied in the motion and force of modern machinery and modern warfare. It was founded by the Italian writer Emilio Filippo Tomaso Marinetti (1876–1944), whose "Manifeste de Futurisme" (Manifesto of Futurism) was published in the Paris newspaper *Le Figaro* in 1909; his ideas had a powerful influence in Italy and Russia. After serving as an officer in World War I, he went on to join the Fascist party in 1919. Among his other works are a volume of poems, *Guerra sola igiene del mundo* (War the Only Hygiene of the World; 1915), and a political essay, *Futurismo e Fascismo* (1924), which argues that fascism is the natural exten-

sion of Futurism. Schwabing, a district of Munich, was much frequented by artists around the turn of the twentieth century; Hitler and other Nazi agitators met in certain of its restaurants and beer cellars and plotted the unsuccessful revolt against governmental authority known as the Beer Hall Putsch (1923).

38. Cited in *La Stampa Torino*. [Benjamin's note. The German editors of Benjamin's *Gesammelte Schriften* argue that this passage is more likely to have been excerpted from a French newspaper than from the Italian newspaper cited here.—*Trans.*]

39. "Let art flourish—and the world pass away." This is a play on the motto of the sixteenth-century Holy Roman emperor Ferdinand I: "Fiat iustitia et pereat mundus" ("Let justice be done and the world pass away").

2

Theory of Distraction

Theory of distraction[1]

Attempt to determine the effect of the work of art once its power of consecration has been eliminated

Parasitic existence of art as based on the sacred

In its concern with educational value [*Lehrwert*], "The Author as Producer" disregards consumer value [*Konsumwert*][2]

It is in film that the work of art is most susceptible to becoming worn out

Fashion is an indispensable factor in the acceleration of the process of becoming worn out

The values of distraction should be defined with regard to film, just as the values of catharsis are defined with regard to tragedy

Distraction, like catharsis, should be conceived as a physiological phenomenon

Distraction and destruction [*word conjectured*] as the subjective and objective sides, respectively, of one and the same process

The relation of distraction to absorption must be examined[3]

The survival of artworks should be represented from the standpoint of their struggle for existence

Their true humanity consists in their unlimited adaptability

The criterion for judging the fruitfulness of their effect is the communicability of this effect

The educational value and the consumer value of art may converge in certain optimal cases (as in Brecht), but they don't generally coincide

The Greeks had only one form of (mechanical) reproduction: minting coins

They could not reproduce their artworks, so these had to be lasting. Hence: eternal art

Just as the art of the Greeks was geared toward lasting, so the art of the present is geared toward becoming worn out

This may happen in two different ways: through consignment of the artwork to fashion or through the work's refunctioning in politics[4]

Reproducibility—distraction—politicization

Educational value and consumer value converge, thus making possible a new kind of learning

Art comes into contact with the commodity; the commodity comes into contact with art

Fragment written most likely in 1935–1936; unpublished in Benjamin's lifetime. *Gesammelte Schriften,* VII, 678–679. Translated by Howard Eiland.

Notes

This fragment is associated with the composition of the second version of "The Work of Art in the Age of Its Technological Reproducibility" (1935–1936), in this volume.

1. See Section XVIII of the second version of "The Work of Art in the Age of Its Technological Reproducibility" (1935–1936), in this volume. See also Section XV of the third version of the essay (1939), in Benjamin, *Selected Writings: Volume 4, 1938–1940* (Cambridge, Mass.: Harvard University Press, 2003), pp. 251–283. Benjamin's term for "distraction" is generally *Zerstreuung,* which in this context can also mean "entertainment." In a related fragment (*Gesammelte Schriften,* VII, 678), Benjamin writes: "The work of art undertakes to produce entertainment in a responsible manner."

2. See "The Author as Producer" (1934), Chapter 8 in this volume.

3. "Absorption" here translates *Einverleibung,* meaning more specifically "ingestion." Compare Benjamin's comments on reading as *Einverleibung* in his radio talk "Children's Literature," in Benjamin, *Selected Writings: Volume 2, 1927–1934* (Cambridge, Mass.: Harvard University Press, 1999), pp. 255–256.

4. "Refunctioning" translates *Umfunktionierung,* a term taken from Brecht. See "The Author as Producer" (1934), Chapter 8 in this volume.

3

To the Planetarium

If one had to expound the teachings of antiquity with utmost brevity while standing on one leg, as did Hillel that of the Jews, it could only be in this sentence: "They alone shall possess the earth who live from the powers of the cosmos." Nothing distinguishes the ancient from the modern man so much as the former's absorption in a cosmic experience scarcely known to later periods. Its waning is marked by the flowering of astronomy at the beginning of the modern age. Kepler, Copernicus, and Tycho Brahe were certainly not driven by scientific impulses alone. All the same, the exclusive emphasis on an optical connection to the universe, to which astronomy very quickly led, contained a portent of what was to come. The ancients' intercourse with the cosmos had been different: the ecstatic trance [*Rausch*]. For it is in this experience alone that we gain certain knowledge of what is nearest to us and what is remotest from us, and never of one without the other. This means, however, that man can be in ecstatic contact with the cosmos only communally. It is the dangerous error of modern men to regard this experience as unimportant and avoidable, and to consign it to the individual as the poetic rapture of starry nights. It is not; its hour strikes again and again, and then neither nations nor generations can escape it, as was made terribly clear by the last war, which was an attempt at new and unprecedented commingling with the cosmic powers. Human multitudes, gases, electrical forces were hurled into the open country, high-frequency currents coursed through the landscape, new constellations rose in the sky, aerial space and ocean depths thundered with propellers, and everywhere sacrificial shafts were dug in Mother Earth. This immense wooing of the cosmos was enacted

for the first time on a planetary scale—that is, in the spirit of technology. But because the lust for profit of the ruling class sought satisfaction through it, technology betrayed man and turned the bridal bed into a bloodbath. The mastery of nature (so the imperialists teach) is the purpose of all technology. But who would trust a cane wielder who proclaimed the mastery of children by adults to be the purpose of education? Is not education, above all, the indispensable ordering of the relationship between generations and therefore mastery (if we are to use this term) of that relationship and not of children? And likewise technology is the mastery of not nature but of the relation between nature and man. Men as a species completed their development thousands of years ago; but mankind as a species is just beginning his. In technology, a *physis* is being organized through which mankind's contact with the cosmos takes a new and different form from that which it had in nations and families. One need recall only the experience of velocities by virtue of which mankind is now preparing to embark on incalculable journeys into the interior of time, to encounter there rhythms from which the sick shall draw strength as they did earlier on high mountains or on the shores of southern seas. The "Lunaparks" are a prefiguration of sanatoria. The paroxysm of genuine cosmic experience is not tied to that tiny fragment of nature that we are accustomed to call "Nature." In the nights of annihilation of the last war, the frame of mankind was shaken by a feeling that resembled the bliss of the epileptic. And the revolts that followed it were the first attempt of mankind to bring the new body under its control. The power of the proletariat is the measure of its convalescence. If it is not gripped to the very marrow by the discipline of this power, no pacifist polemics will save it. Living substance conquers the frenzy of destruction only in the ecstasy of procreation.

Written 1923–1926; published in 1928. Excerpted from *One-Way Street. Gesammelte Schriften*, IV, 146–148. Translated by Edmund Jephcott.

4

Garlanded Entrance

ON THE "SOUND NERVES" EXHIBITION

AT THE GESUNDHEITSHAUS KREUZBERG[1]

This exhibition is a stroke of luck. It is tied to the memory of a remarkable man. Ernst Joël, the chief doctor for the Kreuzberg school district [*Stadtoberschularzt*], came up with the plan for the show and for a good while took the lead in its design. He was one of those rare people who could bring to bear, in a strictly rational and perfectly calibrated way, an unusual influence on others, a leader's energy coupled with matchless charm (which in Germany we see wasted far too often on vain, obstinate, cultish notions), in the service of a cause: thoroughgoing and logical enlightenment of the public [*Volksaufklärung*].[2] If this man left behind not merely traces but a lasting memory [*Gedächtnis*] in all the spheres he compassed in his short life, this is because he was such a salutary exception to the German situation. The fact that it is precisely the strongest and most suggestive characters who fail to find an available and appropriate place in which to exert their powers, that they seal themselves off in nonsectarian religious colonies and *völkisch* shock troops in Mazdaznan communities and dance groups, that they take comfort in fanaticism and squander their best qualities: this is the chronic catastrophe of postwar Germany.[3] Ernst Joël had all the makings of a fanatic—the conviction, the restlessness, the effectiveness. Only one thing was missing: arrogance. As a result, his superior powers could be entirely directed toward an inconspicuous but fruitful field, which remains for the most

part the uncontested domain of the bigwigs: public health education [*Medizinischer Volksaufklärung*].

The results of such a stroke of luck are apparent in this exhibition. We see not only the mastery of the notoriously painstaking work, not only the organizational side of the undertaking; we also detect in every nook and cranny a deliberation, a basic clarity—the product not of hours at the office, but of months of the most impassioned activity. Neither Joël nor any of his colleagues have been to Russia. All the more interesting, then, that a first glance into the exhibition rooms can give anyone who enters them an idea of what the Moscow "Peasants' House" or the "Red Soldiers' Club" in the Kremlin looks like: cheerful, joyful, and full of movement, as if just today, the day you've come, something really special is happening.[4] Displays and banners are arranged as if awaiting the birthday boy; facts and figures are hung like garlands from wall to wall; you can't help looking for a slot in some of the mockups—you feel the urge to drop in a coin to set them in motion, so incredible does it seem that everything here is free. Soon we catch on to one particular device: the show's artistic director, Wigmann, is a drawing teacher who asked some schoolchildren to "set down in paint" certain themes for the exhibition. Out of themes like "Day of the Superstitious" or "Our Parents' Childrearing Mistakes" came whimsical, boldly colored series of pictures; only the hurdy-gurdy texts and the *Moritat*-singer's pointer stick are missing.[5] Moreover, the prospect of seeing their efforts put to such a sensible use heightens the children's pleasure in their work. Children can impart knowledge so well here because they are the true laymen.

The show's visitors are also laymen, and ought to remain so. So runs the maxim of the new education for the masses [*Volksbildung*], in contrast to the older kind, which took erudition as its starting point and believed that, with the help of some charts and specimens, it could and should make this scholarly knowledge the property of the masses. Quality, educators used to tell themselves, would turn into quantity. The new education for the masses, conversely, proceeds from the fact that the masses attend school. The slogan now is to turn quantity into quality, a reversal that for them is identical to the conversion of theory into practice. The visitors, as stated, should remain laymen. They should leave the exhibition not more learned but more savvy. The task of real, effective presentation [*Darstellung*] is just this: to liberate knowledge from the bounds of the compartmentalized discipline [*Fach*] and make it practical.

But what is "real presentation"? In other words, what is exhibition technique? Whoever wants to know should turn to the oldest experts in

this field. We are all acquainted with them. We learned our early lessons from them. We learned from them, in the saddle, how to handle fish, mammals, and birds; we got to know all vocations and professions through the way they reacted when we took a shot at the target; we even learned to measure our own strength against "Towering Jules"—the frightening vision which, at the blow of a hammer, reared its head out of a hollow cylinder.[6] Itinerant peddlers make their living through exhibition, and their trade is old enough to have brought them a solid store of experience. From first to last, however, it centers on this bit of wisdom: you must at all costs prevent people from waxing contemplative, from engaging in detached observation—which is anathema. So there is no show without carousels, shooting galleries, and test-your-strength machines, without love thermometers, fortune-tellers, and lotteries. Those who come to gawk end up joining in—this is the categorical imperative of the fairground. What lends this exhibition its particular character is not so much its dioramas, banners, and dissolving views[7] (created, incidentally, with the most primitive means) but rather this technique of making the visitor participate actively.—You see the rubric "Vocational Counseling." A head is positioned in front of a large disk, which presents a montage of emblems and scenes from a wide variety of vocations. Set the disk turning, and it seems (though this is an optical illusion) that the head begins to move too, and its resigned swinging shows that it is in a quandary. Right next door is a row of testing apparatuses on which anyone who feels like it can assay his dexterity, his sense of color, his "trainability," his combinatory powers. The Delphic "Know thyself" beckons from every automatic scale. You encounter this at fairs, in the Devil's Chamber—the black-lined stall in which the devil's distorted face seems to move under his plumed hat. When you bend down to see who's there, you come face to face with a mirror out of which you yourself peer. Wigmann was clever; he took this, too, from the fairground. There is a room devoted to countering superstition: "Who believes that?" reads a movable panel on which pamphlets are displayed. You lift it up and see yourself revealed in the mirror behind it.

What does all this mean? It means that real presentation banishes contemplation. In order to incorporate the visitor into the show's montage, as occurs here, the optical must be carefully controlled. Any viewing [*Anschauung*] that lacks the element of surprise would result in a dumbing-down of the visitor. What there is to see must never be the same as, or even approximate, what the inscription says it is. It must bring with it something new, a twist of the obvious which fundamentally can-

not be achieved with words. One particular exhibit concerns the quarterly consumption of a heavy drinker. Now, it would have been easy to just present a sizable heap of empty wine or liquor bottles. Instead, next to the panel of text, Joël has displayed a grimy slip of paper bearing the traces of many folds—the quarterly bill from the wine merchant. And while the wine bottles do indeed illuminate the text even as they themselves are changed very little by this juxtaposition, the document, the bill, is suddenly seen in a new light. Because it works so perfectly in the montage, it gives the viewer a jolt.

Admittedly, you never see montage at fairs. But this show embraces today's canonical approach to viewing: the will to the authentic. Montage is not a stylistic principle found in handicrafts. It emerged around the end of the war, when it became clear to the avant-garde that reality could no longer be mastered. The only means we have left, for gaining time and keeping a cool head, is, above all, to let reality have its say—in its own right, disordered and anarchic if necessary. In those days, the Dadaists were the avant-garde.[8] They created montages from bits of fabric, tram tickets, shards of glass, buttons, matches—and by this means they said: You cannot cope with reality anymore. You cannot deal with these odds and ends of rubbish any better than you can with troop transports, influenza, or Reichsbank notes.[9] When the New Objectivity ventured timidly to disavow reality and establish order, this development should have gained the firmest foothold in film, which was producing such incalculably great documentary material.[10] But the titillation industry [*Amüsierindustrie*], which develops new technical possibilities only to hobble them, blocked this as well. After all, it trained the gaze for the authentic. What, then, isn't authentic, so long as we, passing by, *actually* take account of it? For one who ruthlessly makes the case against exploitation, misery, and stupidity, what doesn't become a *corpus delicti?* For the organizers of this exhibition, nothing was more important than this realization and the small shock that leaps out of things along with it. In the "Hall of Superstition" a fortune-teller is on display; almost everything in the scene is real, from the money and playing cards on the table to her yellowish-gray chignon. The viewer who stands before her doesn't feel instructed—he simply feels *found out.* Even if he has never gone to a fortune-teller before, he will "never go again."

Clever traps, which lure the attention and hold it fast. The texts that remain are slogans. "The 'breakthrough' of the eight-hour day robs the worker of the chance to participate in the achievements of culture. This is the death of all mental hygiene."[11]—Another example: Beneath a scene

showing the interior of an employment office, there's a large sheet on which the word "Wait" is printed over and over, in ten columns, from top edge to bottom. It looks like the stock quotes in the daily paper. Above, at an angle and in bold letters: "The poor man's stock listings." If anything is missing, it is at the entrance to the show, where the curators should have found a place for this sentence, borne out so brilliantly by their work: "Boredom [*Langeweile*] breeds stupidity; diversion [*Kurzweil*] enlightens."

Published in *Die literarische Welt,* January 10, 1930. *Gesammelte Schriften,* IV, 557–561. Translated by Annie Bourneuf.

Notes

1. "Gesunde Nerven," a special exhibition on the psychological stresses that social conditions inflict on urban workers and how these conditions might be altered, opened at the Gesundheitshaus Kreuzberg (Kreuzberg Health Building) in October 1929. Two contemporary reviews of the exhibition are reprinted in Margarete Exler, *Von der Jugendbewegung zu ärztlicher Drogenhilfe: Das Leben Ernst Joëls (1893–1929) im Umkreis von Benjamin, Landauer und Buber* (Berlin: Trafo, 2005), pp. 258–263. The municipal government of Kreuzberg, a working-class district of Berlin, opened the Gesundheitshaus in 1925 to educate Kreuzberg residents about disease prevention and treatment. See Martin Kahle, ed., *Das Gesundheitshaus: Einführung in das Aufgabengebiet der sozialen Hygiene unter besonderer Berücksichtigung der Gesundheitsfürsorge im Verwaltungsbezirk Kreuzberg der Stadt Berlin* (Berlin: Gesundheitshaus Kreuzberg, 1925), especially pp. 109–114; and Ernst Joël, "Ein Gesundheitshaus," *Hygienischer Wegweiser: Zentralblatt für Technik und Methodik der hygienischen Volksbelehrung,* 8–9 (1928): 204–211.

2. The physician Ernst Joël (1893–1929) supervised exhibitions at the Gesundheitshaus and worked on the effects of drug use and the treatment of addiction; he died suddenly two months before the exhibition opened. He and Benjamin were staunch opponents when both were active in the Freie Studentenschaft (Free Students' Union) at the University of Berlin just before World War I, but became friends in the late 1920s, when Benjamin served as a test subject for Joël's hashish experiments. See Exler, *Von der Jugendbewegung zu ärztlicher Drogenhilfe,* pp. 34–41 and 138–142. Benjamin cites one of his own polemics against Joël in "The Life of Students," *Selected Writings, Volume 1: 1913–1926* (Cambridge, Mass.: Harvard University Press, 1996), pp. 39–41 (trans. Rodney Livingstone). He speaks of their enmity and later friendship in "A Berlin Chronicle," *Selected*

Writings, Volume 2: 1927–1934 (Cambridge, Mass.: Harvard University Press, 1999), pp. 603–604 (trans. Edmund Jephcott), and in a January 30, 1928, letter to Gershom Scholem. On the hash experiments, see Benjamin, *On Hashish*, trans. Howard Eiland and Others (Cambridge, Mass.: Harvard University Press, 2006).

3. Mazdaznan, also known as Mazdaism, was an esoteric cult based loosely on Zoroastrianism. It was popular in Central Europe in the early twentieth century, when interest in Eastern religions was widespread.

4. See Benjamin's description of the Red Army Club in "Moscow," *Selected Writings,* vol. 2, pp. 36–37 (trans. Edmund Jephcott).

5. A *Moritat* was a popular entertainment at German fairs and markets from the sixteenth through the nineteenth centuries. The *Moritat*-singer sang the story of a murder or some other gruesome event, and his performance was usually accompanied by a barrel-organ as well as a series of related illustrations, which he pointed to with a long stick as he went along.

6. This rather obscure sentence plays on carnival metaphors: carousel rides on the backs of mammals, birds, and fish; target-shooting booths; and "ring the bell with the hammer" games.

7. The "dissolving view" *(Verwandlungsbild)* consisted of a number of nineteenth-century optical technologies (magic-lantern slides, multiple lenses, and so on) that produced narrative effects through the use of "dissolves" between images.

8. In Zurich in 1916, artists, writers, and others disgusted by World War I, as well as by the bourgeois ideologies that had brought it about, launched Dada, an avant-garde movement that attempted to radically change both society and the work of art. Dadaist groups were active in Berlin, New York, Paris, and elsewhere during the war and into the 1920s; the practice of montage was crucial for many Dadaists. See Benjamin, "The Work of Art in the Age of Its Technological Reproducibility: Second Version," section XVII, in Chapter 1 in this volume; and "The Work of Art in the Age of Its Technological Reproducibility: Third Version," *Selected Writings, Volume 4: 1938–1940* (Cambridge, Mass.: Harvard University Press, 2003), pp. 266–267 (trans. Harry Zohn and Edmund Jephcott).

9. *Reichsbanknoten,* banknotes issued by the central bank of Germany, began to lose value during World War I. The trend, caused first by government borrowing to finance the war and then by the reparations demanded by the Treaty of Versailles, accelerated in the early years of the Weimar Republic and culminated in the catastrophic hyperinflation of late 1922 and 1923.

10. "The New Objectivity [*Die Neue Sachlichkeit*]: German Painting since Expressionism" was the title of a 1925 exhibition in Mannheim of the work of artists such as George Grosz, Otto Dix, and Max Beckmann, whose coolly figurative paintings revived techniques of the Old Masters and traditional painting genres. This mode of painting was a self-conscious departure from

both Expressionism and Dada; some of its leading exponents were former Dadaists.

11. In November 1918, Germany's provisional government instituted the eight-hour day, one of the labor movement's oldest demands. As early as 1923, however, the minister of labor allowed numerous exceptions to the rule, arguing that this was necessary to increase production and stabilize the economy. In 1927, still more loopholes were written into the law; many on the left saw this as a hollowing-out of one of the most important achievements of 1918.

5

The Rigorous Study of Art

ON THE FIRST VOLUME OF

THE *KUNSTWISSENSCHAFTLICHE FORSCHUNGEN*

In the foreword to his 1898 study *Die klassische Kunst* [Classic Art], Heinrich Wölfflin made a gesture that cast aside the history of art as it was then understood by Richard Muther.[1] "Contemporary public interest" he declared, "seems nowadays to want to turn toward more specifically artistic questions. One no longer expects an art-historical book to give mere biographical anecdotes or a description of the circumstances of the time; rather, one wants to learn something about those things which constitute the value and the essence of a work of art. . . . The natural thing would be for every art-historical monograph to contain some aesthetics as well." A bit further on, one reads: "In order to be more certain of attaining this goal, the first, historical, section has been furnished with a second, systematic, section as a counterpart."[2] This arrangement is all the more indicative because it reveals not only the aims but also the limits of an endeavor which was so epoch-making in its time. And, in fact, Wölfflin did not succeed in his attempt to use formal analysis (which he placed at the center of his method) to remedy the bleak condition in which his discipline found itself at the end of the nineteenth century. He identified a dualism—a flat, universalizing history of the art of "all cultures and times," on the one hand, and an academic aesthetic, on the other—without, however, being able to overcome it entirely.

Only from the perspective of the current situation does it become evi-

dent to what extent the understanding of art history as universal history—under whose aegis eclecticism had free play—fettered authentic research. And this is true not only for the study of art. In a programmatic explanation, the literary historian Walter Muschg writes: "It is fair to say that the most essential work being done at present is almost exclusively oriented toward the monograph. To a great extent, today's generation no longer believes in the significance of an all-encompassing presentation. Instead it is grappling with figures and problems which it sees marked primarily by gaps during that era of universal histories."[3] Indeed, the "turn away from an uncritical realism in the contemplation of history and the shriveling up of macroscopic constructions"[4] are the most important hallmarks of the new research. Sedlmayr's programmatic article "Toward a Rigorous Study of Art," the opening piece in the recently published yearbook *Kunstwissenschaftliche Forschungen* [Research Essays in the Study of Art], is entirely in accord with this position:

> The currently evolving phase in the study of art will have to emphasize, in a heretofore unknown manner, the *investigation of individual works*. Nothing is more important at the present stage than an improved knowledge of the individual artwork, and it is in just this task, above all, that the extant study of art manifests its incompetence. . . . Once the individual artwork is perceived as a still unmastered task specific to the study of art, it appears powerfully new and close. Formerly a mere means to knowledge, a trace of something else which was to be disclosed through it, the artwork now appears as a self-contained *small world* of its own, particular sort.[5]

In accordance with these introductory remarks, the three essays which follow are thus rigorously monographic studies. G. A. Andreades presents the Hagia Sophia as a synthesis between Orient and Occident; Otto Pächt develops the historical task posed by Michael Pacher; and Carl Linfert explores the foundations of the architectural drawing.[6] What these studies share is a convincing love for—and a no less convincing mastery of—their subject. The three authors have nothing in common with the type of art historian "who, really convinced that artworks were meant not to be studied (but only 'experienced'), studied them nevertheless—only badly."[7] Furthermore, these authors know that headway can be made only if one considers contemplation of one's own activity—a new awareness—not as a constraint but as an impetus to rigorous study. This is particularly so because such study is not concerned with objects of pleasure, with formal problems, with giving form to experience, or any other clichés inherited from a belletristic consideration of art. Rather, this

sort of studious work considers the formal incorporation of the given world by the artist

not as a selection but rather always as an advance into a field of knowledge which did not yet "exist" prior to the moment of this formal conquest. . . . This approach becomes possible only through a frame of mind that recognizes that the realm of perception itself changes over time and in accordance with shifts in cultural and intellectual [*geistig*] direction. Such a frame of mind, however, in no way presumes objects that are always present in an unvarying manner such that their formal makeup is merely determined by a changing "stylistic drive" within perceptual surroundings that remain constant.

For "we should never be interested in 'problems of form' as such, as if a form ever arose out of formal problems alone or, to put it in other words, as if a form ever came into existence for the sake of the stimulus it would produce."

Also characteristic of this manner of approaching art is the "esteem for the insignificant" (which the Brothers Grimm practiced in their incomparable expression of the spirit of true philology).[8] But what animates this esteem, if not the willingness to push research forward to the point where even the "insignificant"—no, *precisely* the insignificant—becomes significant? The bedrock that these researchers come up against is the concrete bedrock of past historical existence [*geschichtliches Gewesenseins*]. The "insignificance" with which they are concerned is neither the nuance of new stimuli nor the characteristic trait, which was formerly employed to identify column forms much the way Linné taxonomized plants.[9] Instead it is the inconspicuous aspect—or this *and* the offensive aspect (the two together are not a contradiction)—which survives in true works and which constitutes the point where the content reaches the breaking point for an authentic researcher. One need only read a study such as the one on the Sistine Madonna published years ago by Hubert Grimme (who does not belong to this group) in order to observe how much such an inquiry, based on the most inconspicuous data of an object, can wrest from even the most worn-out things. And thus, because of the focus on materiality in such work, the precursor of this new type of art scholar is not Wölfflin but Riegl. Pächt's investigation of Pacher "is a new attempt at that grand form of presentation exemplified in Riegl's masterly command of the transition from the individual object to its cultural and intellectual [*geistig*] function, as can be seen especially in his study 'Das holländische Gruppenporträt.'"[10] One could just as well

refer to Riegl's book *Die spätrömische Kunst-Industrie* [The Late Roman Art Industry], particularly since this work demonstrates in exemplary fashion the fact that sober and simultaneously undaunted research never misses the vital concerns of its time.[11] The reader who reads Riegl's major work today, recalling that it was written at almost the same time as the work by Wölfflin cited in the opening paragraph, will recognize retrospectively how forces that are already stirring subterraneously in *Die spätrömische Kunst-Industrie* will surface a decade later in expressionism. Thus, one can assume that sooner or later contemporaneity will catch up with the studies by Pächt and Linfert as well.

There are some methodological reservations, however, regarding the advisability of the move that Sedlmayr attempts in his introductory essay, juxtaposing the rigorous study of art as a "secondary" field of study against a primary (that is, positivist) study of art. The kind of research undertaken in this volume is so dependent upon auxiliary fields of study—painting technique and painting media, the history of motifs, iconography—that it can be confusing to constitute these as a somehow separate "primary study of art." Sedlmayr's essay also demonstrates how difficult it is for a particular course of research (such as the one represented here) to establish purely methodological definitions without reference to any concrete examples whatsoever. This is difficult; but is it necessary? Is it appropriate to place this new aspiration [*Wollen*] so assiduously under the patronage of phenomenology and *Gestalt* theory? It could easily be that, in the process, one loses nearly as much as one gains. Admittedly, the references to "levels of meaning" in the works, to their "physiognomic character," to their "sense of orientation," can be useful in the polemic against positivist art chatter and even in the polemic against formalist analysis. But they are of little help to the self-definition of the new type of research. This type of study stands to gain from the insight that the more crucial the works are, the more inconspicuously and intimately their meaning-content [*Bedeutungsgehalt*] is bound up with their material content [*Sachgehalt*]. It is concerned with the correlation that gives rise to reciprocal illumination between, on the one hand, the historical process and radical change and, on the other hand, the accidental, external, and even strange aspects of the artwork. For if the most meaningful works prove to be precisely those whose life is most deeply embedded in their material contents—one thinks of Giehlow's interpretation of Dürer's *Melancolia*[12]—then over the course of their historical duration these material contents present themselves to the researcher all the more clearly the more they have disappeared from the world.

It would be difficult to find a better clarification of the implications of this train of thought than Linfert's study located at the end of the volume. As the text explains, its very subject matter, the architectural drawing, "is a marginal case."[13] But it is precisely in the investigation of the marginal case that material contents reveal their key position most decisively. If one examines the abundant plates accompanying Linfert's study, one discovers names in the captions that are unfamiliar to the layman and, to some extent, to the professional as well. As regards the images themselves, one cannot say that they *re*-produce architecture. They *produce* it in the first place, a production which less often benefits the reality of architectural planning than it does dreams. One sees, to take a few examples, Babel's heraldic, ostentatious portals, the fairy-tale castles which Delajoue has conjured into a shell, Meissonier's knickknack architecture, Boullée's conception of a library that looks like a train station, and Juvara's ideal views ["Prospettiva ideale"] that look like glances into the warehouse of a building dealer: a completely new and untouched world of images, which Baudelaire would have ranked higher than all painting.[14] In Linfert's work, however, the images are submitted to a descriptive technique that succeeds in establishing the most revealing facts in this unexplored marginal realm. There is, as is commonly known, a manner of representing buildings using purely painterly means. The architectural drawing is sharply distinguished from images of this sort and is found to have the closest affinity to nonrepresentational [*unbildmässige*] work— that is, the supposedly authentically architectonic presentations of buildings in topographic designs, prospects, and vedutas. Since in these, too, certain "errors" have survived up through the late eighteenth century despite all the progress in naturalism, Linfert takes this to be a peculiar imaginary world [*Vorstellungswelt*] of architecture, which is markedly different from that of the painters. There are various indications that confirm the existence of this world, the most important one being that such architecture is not primarily "seen," but rather is imagined as an objective entity [*Bestand*] and is sensed by those who approach or even enter it as a surrounding space [*Umraum*] *sui generis*—that is, without the distancing effect of the edge of the image space [*Bildraum*]. Thus, what is crucial in the consideration of architecture is not seeing but the apprehension [*durchspüren*] of structures. The objective effect of the buildings on the imaginative being [*vorstellungsmässige Sein*] of the viewer is more important than their "being seen." In short, the most essential characteristic of the architectural drawing is that "it does not take a pictorial detour."

So much for the formal aspects. In Linfert's analyses, however, formal questions are very closely tied to historical circumstances. His investigation deals with "a period during which the architectural drawing began to lose its principal and decisive expression."[15] But how transparent this "process of decay" becomes here! How the architectural prospects open up in order to take into their core allegories, stage designs, and monuments! And each of these forms in turn points to unrecognized aspects which appear to the researcher Linfert in their full concreteness: Renaissance hieroglyphics; Piranesi's visionary fantasies of ruins; the temples of the Illuminati, such as we know them from *Die Zauberflöte*.[16] Here it becomes evident that the hallmark of the new type of researcher is not the eye for the "all-encompassing whole" or the eye for the "comprehensive context" (which mediocrity has claimed for itself), but rather the capacity to be at home in marginal domains. The men whose work is contained in this yearbook represent the most rigorous of this new type of researcher. They are the hope of their field of study.

Written July–December 1932; abridged version published in the *Literaturblatt der Frankfurter Zeitung*, July 1933 (under the pseudonym Detlef Holz). *Gesammelte Schriften*, III, 363–369. Translated by Thomas Y. Levin.

Notes

1. Wölfflin (1864–1945), a student of Jacob Burckhardt, was the most important art historian of his period writing in German. Richard Muther (1860–1909) was an art historian and critic who is often cited as paradigmatic of the "old school" of nineteenth-century art history. His work was a mixture of religiosity, sentimentality, and eroticism.
2. Heinrich Wölfflin, *Die klassische Kunst: Eine Einführung in die italienische Renaissance* (Munich: F. Bruckmann, 1899), pp. vii–viii; translated by Linda Murray and Peter Murray as *Classic Art: An Introduction to the Italian Renaissance* (London: Phaidon, 1952), pp. xi–xii.
3. Walter Muschg, "Das Dichterporträt in der Literaturgeschichte" [The Writer's Portrait in Literary History], in Emil Ermatinger, ed. *Philosophie der Literaturwissenschaft* (Berlin: Junker und Dünnhaupt, 1930), p. 311. Compare also Benjamin's citation of the same passage in his essay "Literary History and the Study of Literature" (1931), in Benjamin, *Selected Writings, Volume 2: 1927–1934* (Cambridge, Mass.: Harvard University Press, 1999), pp. 459–465. Walter Muschg (1898–1965) was a Swiss literary historian, poet, and dramatist.
4. Muschg, "Das Dichterporträt," p. 314.
5. Hans Sedlmayr, "Zu einer strengen Kunstwissenschaft" (Toward a Rigorous

Study of Art), in Otto Pächt, ed., *Kunstwissenschaftliche Forschungen*, vol. 1 (Berlin: Frankfurter Verlags-Anstalt, 1931), pp. 19–20; translated by Mia Fineman in *The Vienna School Reader: Politics and Art Historical Method in the 1930s*, ed. Christopher S. Wood (New York: Zone Books, 2000), p. 155. Hans Sedlmayr (1896–1984) was a German art historian. Otto Pächt (1902–1988), Austrian art historian, was a leading figure in the "second Viennese school" of art history (the first school having formed around Alois Riegl at the turn of the century).

6. G. A. Andreades, "Die Sophienkathedrale von Konstantinopel" (The Hagia Sophia in Constantinople), in Pächt, ed., *Kunstwissenschaftliche Forschungen*, pp. 33–94; Otto Pächt, "Die historische Aufgabe Michael Pachers" (The Historical Task of Michael Pacher), ibid., pp. 95–132; Carl Linfert, "Die Grundlagen der Architektur-zeichnung" (Fundamentals of Architectural Drawing), ibid., pp. 133–246.

7. Pächt, ed., *Kunstwissenschaftliche Forschungen*, p. 31.

8. The phrase comes not from the Brothers Grimm but from Sulpiz Boisserée, who used it, in a letter to Goethe, to describe August Wilhelm Schlegel's review of the Grimms' book *Altdeutsche Wälder* (Old-German Woods).

9. Carl von Linné, also known as Carolus Linnaeus (1707–1778), was a Swedish naturalist credited with the founding of modern systematic botany. He based his classification of each genus and its species on the system of binomial scientific nomenclature, which he developed.

10. Alois Riegl (1858–1905) was an Austrian art historian. His book *Die spätrömische Kunst-Industrie* (The Late Roman Art Industry; 1901) effected a revolution in the study of artistic epochs previously held to be degenerate. Benjamin counted this text as one of the four most important books of the young century. Alois Riegl, "Das holländische Gruppenporträt" [The Dutch Group Portrait], *Jahrbuch der Kunsthistorischen Sammlungen des Allerhöchsten Kaiserhauses*, vol. 23, parts 3–4 (Vienna: F. Tempsky, 1902), pp. 71–278; translated by Evelyn M. Kain and David Britt as *The Group Portraiture of Holland* (Los Angeles: Getty Research Institute, 1999).

11. Alois Riegl, *Die spätrömische Kunst-Industrie nach den Funden in Oesterreich-Ungarn*, Part 1 (Vienna: K.K. Hof- und Staatsdruckerei, 1901); translated by Rolf Winkes as *Late Roman Art Industry* (Rome: Giorgio Bretschneider Editore, 1985).

12. Karl Giehlow, "Dürers Stich *Melancolia I* und der maximilianische Humanistenkreis" [Dürer's Engraving *Melancholy I* and the Humanist Circle under Maximilian], in *Mitteilungen der Gesellschaft für vervielfältigende Kunst: Beilage der "Graphischen Künste"* (Vienna, 1903). Giehlow (1863–1913) was a German art historian and a leading Dürer scholar.

13. Linfert, "Architektur-zeichnung," p. 153.

14. Paul Emile Babel (1720–1770), French designer and engraver, worked in a rococo style. Jacques Delajoue (1686–1761; also spelled "de Lajoue") did ele-

gant drawings and paintings of rococo architecture, often in fanciful pastoral settings. Juste-Aurèle Meissonnier (1675–1750) was a French painter, sculptor, and architect whose work was characterized by fantasy and arabesque. Etienne-Louis Boullée (1728–1799) was a French visionary architect, theorist, and teacher. Filippo Juvara (1678–1736) was an Italian architect and stage designer.

15. Linfert, "Architektur-zeichnung," p. 231.

16. Benjamin is probably referring to the epoch-making stage sets for Mozart's opera *Die Zauberflöte* (The Magic Flute), produced in 1816 by the eminent architect Karl Friedrich Schinkel (1781–1841), whose neoclassical exoticism became a model for many subsequent stagings. Benjamin might even have seen a performance of *Die Zauberflöte* with these Schinkel sets, since they were still being used by the Berlin State Opera as late as 1937.

6

Imperial Panorama

One of the great attractions of the travel scenes found in the Imperial Panorama was that it did not matter where you began the cycle. Because the viewing screen, with places to sit before it, was circular, each picture would pass through all the stations; from these you looked, each time, through a double window into the faintly tinted depths of the image. There was always a seat available. And especially toward the end of my childhood, when fashion was already turning its back on the Imperial Panorama, one got used to taking the tour in a half-empty room.

There was no music in the Imperial Panorama—in contrast to films, where music makes traveling so soporific. But there was a small, genuinely disturbing effect that seemed to me superior. This was the ringing of a little bell that sounded a few seconds before each picture moved off with a jolt, in order to make way first for an empty space and then for the next image. And every time it rang, the mountains with their humble foothills, the cities with their mirror-bright windows, the railroad stations with their clouds of dirty yellow smoke, the vineyards down to the smallest leaf, were suffused with the ache of departure. I formed the conviction that it was impossible to exhaust the splendors of the scene at just one sitting. Hence my intention (which I never realized) of coming by again the following day. Before I could make up my mind, however, the entire apparatus, from which I was separated by a wooden railing, would begin to tremble; the picture would sway within its little frame and then immediately trundle off to the left, as I looked on.

The art forms that survived here all died out with the coming of the twentieth century. At its inception, they found their last audience in chil-

dren. Distant worlds were not always strange to these arts. And it so happened that the longing such worlds aroused spoke more to the home than to anything unknown. Thus it was that, one afternoon, while seated before a transparency of the little town of Aix, I tried to persuade myself that, once upon a time, I must have played on the patch of pavement that is guarded by the old plane trees of the Cours Mirabeau.

When it rained, there was no pausing out front to survey the list of fifty pictures. I went inside and found in fjords and under coconut palms the same light that illuminated my desk in the evening when I did my schoolwork. It may have been a defect in the lighting system that suddenly caused the landscape to lose its color. But there it lay, quite silent under its ashen sky. It was as though I could have heard even wind and church bells if only I had been more attentive.

Written for the 1938 version of *Berliner Kindheit um neunzehnhundert;* unpublished in Benjamin's lifetime. *Gesammelte Schriften,* VII, 388–389. Translated by Howard Eiland.

Notes

The Imperial Panorama (Kaiserpanorama) was located in an arcade, the Kaiser-Galerie, built in 1869–1873, that connected the Friedrichstrasse and the Behrenstrasse. The panorama consisted of a dome-like apparatus presenting stereoscopic views to customers seated around it. For more on nineteenth-century panoramas, see Benjamin, *The Arcades Project,* trans. Howard Eiland and Kevin McLaughlin (Cambridge, Mass.: Harvard University Press, 1999), pp. 527–536, 992–993.

7

The Telephone

Whether because of the structure of the apparatus or because of the structure of memory, it is certain that the noises of the first telephone conversations echo differently in my ear from those of today. They were nocturnal noises. No muse announces them. The night from which they came was the one that precedes every true birth. And the voice that slumbered in those instruments was a newborn voice. Each day and every hour, the telephone was my twin brother. I was an intimate observer of the way it rose above the humiliations of its early years. For once the chandelier, fire screen, potted palm, console table, gueridon, and alcove balustrade—all formerly on display in the front rooms—had finally faded and died a natural death, the apparatus, like a legendary hero once exposed to die in a mountain gorge, left the dark hallway in the back of the house to make its regal entry into the cleaner and brighter rooms that now were inhabited by a younger generation. For the latter, it became a consolation for their loneliness. To the despondent who wanted to leave this wicked world, it shone with the light of a last hope. With the forsaken, it shared its bed. Now, when everything depended on its call, the strident voice it had acquired in exile was grown softer.

Not many of those who use the apparatus know what devastation it once wreaked in family circles. The sound with which it rang between two and four in the afternoon, when a schoolfriend wished to speak to me, was an alarm signal that menaced not only my parents' midday nap but the historical era that underwrote and enveloped this siesta. Disagreements with switchboard operators were the rule, to say nothing of the threats and curses uttered by my father when he had the complaints

department on the line. But his real orgies were reserved for cranking the handle, to which he gave himself up for minutes at a time, nearly forgetting himself in the process. His hand, on these occasions, was a dervish overcome by frenzy. My heart would pound; I was certain that the employee on the other end was in danger of a stroke, as punishment for her negligence.

At that time, the telephone still hung—an outcast settled carelessly between the dirty-linen hamper and the gasometer—in a corner of the back hallway, where its ringing served to multiply the terrors of the Berlin household. When, having mastered my senses with great effort, I arrived to quell the uproar after prolonged fumbling through the gloomy corridor, I tore off the two receivers, which were heavy as dumbbells, thrust my head between them, and was inexorably delivered over to the voice that now sounded. There was nothing to allay the violence with which it pierced me. Powerless, I suffered, seeing that it obliterated my consciousness of time, my firm resolve, my sense of duty. And just as the medium obeys the voice that takes possession of him from beyond the grave, I submitted to the first proposal that came my way through the telephone.

Written for the 1938 version of *Berliner Kindheit um neunzehnhundert;* unpublished in Benjamin's lifetime. *Gesammelte Schriften,* VII, 390–391. Translated by Howard Eiland.

The task is to win over the intellectuals to the working class by
making them aware of the identity of their spiritual enterprises and
of their conditions as producers.

—RAMON FERNANDEZ[1]

8

The Author as Producer

ADDRESS AT THE INSTITUTE FOR THE STUDY

OF FASCISM, PARIS, APRIL 27, 1934[2]

You will remember how Plato deals with poets in his ideal state: he ban-
ishes them from it in the public interest. He had a high conception of the
power of poetry, but he believed it harmful, superfluous—in a *perfect*
community, of course. The question of the poet's right to exist has not of-
ten, since then, been posed with the same emphasis; but today it poses it-
self. Probably it is only seldom posed in this *form,* but it is more or less
familiar to you all as the question of the autonomy of the poet, of his
freedom to write whatever he pleases. You are not disposed to grant him
this autonomy. You believe that the present social situation compels him
to decide in whose service he is to place his activity. The bourgeois writer
of entertainment literature does not acknowledge this choice. You must
prove to him that, without admitting it, he is working in the service of
certain class interests. A more advanced type of writer does recognize this
choice. His decision, made on the basis of class struggle, is to side with
the proletariat. This puts an end to his autonomy. His activity is now de-
cided by what is useful to the proletariat in the class struggle. Such writ-
ing is commonly called *tendentious.*

Here you have the catchword around which has long circled a debate
familiar to you. Its familiarity tells you how unfruitful it has been, for it
has not advanced beyond the monotonous reiteration of arguments for
and against: *on the one hand,* the correct political line is demanded of the

poet; *on the other,* one is justified in expecting his work to have quality. Such a formulation is of course unsatisfactory as long as the connection between the two factors, political line and quality, has not been *perceived.* Of course, the connection can be asserted dogmatically. You can declare: a work that shows the correct political tendency need show no other quality. You can also declare: a work that exhibits the correct tendency must of necessity have every other quality.

This second formulation is not uninteresting, and, moreover, it is correct. I adopt it as my own. But in doing so I abstain from asserting it dogmatically. It must be *proved.* And it is in order to attempt to prove it that I now claim your attention. This is, you will perhaps object, a very specialized, out-of-the-way theme. And do I intend to promote the study of fascism with such a proof? This is indeed my intention. For I hope to be able to show you that the concept of political tendency, in the summary form in which it usually occurs in the debate just mentioned, is a perfectly useless instrument of political literary criticism. I would like to show you that the tendency of a literary work can be politically correct only if it is also literarily correct. That is to say, the politically correct tendency includes a literary tendency. And I would add straightaway: this literary tendency, which is implicitly or explicitly contained in every *correct* political tendency of a work, alone constitutes the quality of that work. The correct political tendency of a work thus includes its literary quality *because* it includes its literary *tendency.*

This assertion—I hope I can promise you—will soon become clearer. For the moment, I would like to interject that I might have chosen a different starting point for my reflections. I started from the unfruitful debate on the relationship between tendency and quality in literature. I could have started from an even older and no less unfruitful debate: What is the relationship between form and content, particularly in political poetry? This kind of question has a bad name; rightly so. It is the textbook example of the attempt to explain literary connections undialectically, with clichés. Very well. But what, then, is the dialectical approach to the same question?

The dialectical approach to this question—and here I come to the heart of the matter—has absolutely no use for such rigid, isolated things as work, novel, book. It has to insert them into the living social contexts. You rightly declare that this has been done time and again among our friends. Certainly. Only they have often done it by launching at once into large, and therefore necessarily often vague, questions. Social conditions are, as we know, determined by conditions of production. And when a

work was subjected to a materialist critique, it was customary to ask how this work stood vis-à-vis the social relations of production of its time. This is an important question, but also a very difficult one. Its answer is not always unambiguous. And I would like now to propose to you a more immediate question, a question that is somewhat more modest, somewhat less far-reaching, but that has, it seems to me, more chance of receiving an answer. Instead of asking, "What is the attitude of a work to the relations of production of its time? Does it accept them, is it reactionary? Or does it aim at overthrowing them, is it revolutionary?"—instead of this question, or at any rate before it, I would like to propose another. Rather than asking, "What is the attitude of a work *to* the relations of production of its time?" I would like to ask, "What is its position *in* them?" This question directly concerns the function the work has within the literary relations of production of its time. It is concerned, in other words, directly with the literary *technique* of works.

In bringing up technique, I have named the concept that makes literary products accessible to an immediately social, and therefore materialist, analysis. At the same time, the concept of technique provides the dialectical starting point from which the unfruitful antithesis of form and content can be surpassed. And furthermore, this concept of technique contains an indication of the correct determination of the relation between tendency and quality, the question raised at the outset. If, therefore, we stated earlier that the correct political tendency of a work includes its literary quality, because it includes its literary tendency, we can now formulate this more precisely by saying that this literary tendency can consist either in progress or in regression of literary technique.

You will certainly approve if I now pass, with only an appearance of arbitrariness, to very concrete literary conditions. Russian conditions. I would like to direct your attention to Sergei Tretiakov, and to the type (which he defines and embodies) of the "operating" writer.[3] This operating writer provides the most tangible example of the functional interdependence that always, and under all conditions, exists between the correct political tendency and progressive literary technique. I admit, he is only one example; I hold others in reserve. Tretiakov distinguishes the operating writer from the informing writer. His mission is not to report but to struggle; not to play the spectator but to intervene actively. He defines this mission in the account he gives of his own activity. When, in 1928, at the time of the total collectivization of agriculture, the slogan "Writers to the *kolkhoz!*" was proclaimed, Tretiakov went to the "Communist Lighthouse" commune and there, during two lengthy stays, set

about the following tasks: calling mass meetings; collecting funds to pay for tractors; persuading independent peasants to enter the *kolkhoz* [collective farm]; inspecting the reading rooms; creating wall newspapers and editing the *kolkhoz* newspaper; reporting for Moscow newspapers; introducing radio and mobile movie houses; and so on. It is not surprising that the book *Commanders of the Field,* which Tretiakov wrote following these stays, is said to have had considerable influence on the further development of collective agriculture.

You may have a high regard for Tretiakov, yet still be of the opinion that his example does not prove a great deal in this context. The tasks he performed, you will perhaps object, are those of a journalist or a propagandist; all this has little to do with literature. But I cited the example of Tretiakov deliberately, in order to point out to you how comprehensive the horizon is within which we have to rethink our conceptions of literary forms or genres, in view of the technical factors affecting our present situation, if we are to identify the forms of expression that channel the literary energies of the present. There were not always novels in the past, and there will not always have to be; there have not always been tragedies or great epics. Not always were the forms of commentary, translation, indeed even so-called plagiarism playthings in the margins of literature; they had a place not only in the philosophical but also in the literary writings of Arabia and China. Rhetoric has not always been a minor form: in antiquity, it put its stamp on large provinces of literature. All this is to accustom you to the thought that we are in the midst of a mighty recasting of literary forms, a melting down in which many of the opposites in which we have been used to thinking may lose their force. Let me give an example of the unfruitfulness of such opposites, and of the process of their dialectical transcendence. And we shall remain with Tretiakov. For this example is the newspaper.

One left-wing author has declared:[4]

> In our writing, opposites that in happier ages fertilized one another have become insoluble antinomies. Thus, science and belles lettres, criticism and literary production, education and politics, fall apart in disorder and lose all connection with one another. The scene of this literary confusion is the newspaper; its content, "subject matter" that denies itself any other form of organization than that imposed on it by readers' impatience. And this impatience is not just that of the politician expecting information, or of the speculator looking for a stock tip; behind it smolders the impatience of people who are excluded and who think they have the right to see their

own interests expressed. The fact that nothing binds the reader more tightly to his paper than this all-consuming impatience, his longing for daily nourishment has long been exploited by publishers, who are constantly inaugurating new columns to address the reader's questions, opinions, and protests. Hand in hand, therefore, with the indiscriminate assimilation of facts goes the equally indiscriminate assimilation of readers, who are instantly elevated to collaborators. Here, however, a dialectical moment lies concealed: the decline of writing in the bourgeois press proves to be the formula for its revival in the press of Soviet Russia. For as writing gains in breadth what it loses in depth, the conventional distinction between author and public, which is upheld by the bourgeois press, begins in the Soviet press to disappear. For there the reader is at all times ready to become a writer—that is, a describer, or even a prescriber. As an expert—not perhaps in a discipline but perhaps in a post that he holds—he gains access to authorship. Work itself has its turn to speak. And its representation in words becomes a part of the ability that is needed for its exercise. Literary competence is no longer founded on specialized training but is now based on polytechnical education, and thus becomes public property. It is, in a word, the literarization of the conditions of living that masters the otherwise insoluble antinomies. And it is at the scene of the limitless debasement of the word—the newspaper, in short—that its salvation is being prepared.

I hope I have shown, by means of this quotation, that the description of the author as producer must extend as far as the press. For through the press, at any rate through the Soviet Russian press, one realizes that the mighty process of recasting that I spoke of earlier not only affects the conventional distinction between genres, between writer and poet, between scholar and popularizer, but also revises even the distinction between author and reader. Of this process the press is the decisive example, and therefore any consideration of the author as producer must include it.

It cannot, however, stop at this point. For in Western Europe the newspaper does not constitute a serviceable instrument of production in the hands of the writer. It still belongs to capital. Since, on the one hand, the newspaper, technically speaking, represents the most important literary position, but, on the other, this position is controlled by the opposition, it is no wonder that the writer's understanding of his dependent social position, his technical possibilities, and his political task has to grapple with the most enormous difficulties. It has been one of the deci-

sive processes of the last ten years in Germany that a considerable pro-
portion of its productive minds, under the pressure of economic condi-
tions, have passed through a revolutionary development in their
attitudes, without being able simultaneously to rethink their own work,
their relation to the means of production, or their technique in a really
revolutionary way. I am speaking, as you see, of so-called left-wing intel-
lectuals, and will limit myself to the bourgeois Left. In Germany the lead-
ing politico-literary movements of the last decade have emanated from
this left-wing intelligentsia. I shall mention two of them. Activism and
New Objectivity [*Neue Sachlichkeit*], using these examples to show that
a political tendency, however revolutionary it may seem, has a counter-
revolutionary function so long as the writer feels his solidarity with the
proletariat only in his attitudes, not as a producer.[5]

The catchword in which the demands of Activism are summed up is
"logocracy"; in plain language, "rule of the mind." This is apt to be
translated as "rule of the intellectuals." In fact, the concept of the intel-
lectual, with its attendant spiritual values, has established itself in the
camp of the left-wing intelligentsia, and dominates its political manifes-
tos from Heinrich Mann to Döblin.[6] It can readily be seen that this
concept has been coined without any regard for the position of intellectu-
als in the process of production. Hiller, the theoretician of Activism,
means intellectuals to be understood not as "members of certain profes-
sions" but as "representatives of a certain characterological type."[7] This
characterological type naturally stands as such between the classes. It en-
compasses any number of private individuals without offering the slight-
est basis for organizing them. When Hiller formulates his denunciation of
party leaders, he concedes them a good deal. They may be "better in-
formed in important matters . . . , have more popular appeal . . . , fight
more courageously" than he, but of one thing he is sure: they "think
more defectively." Probably. But where does this lead him, since politi-
cally it is not private thinking but, as Brecht once expressed it, the art of
thinking in other people's heads that is decisive? Activism attempted to
replace materialistic dialectics by the notion of common sense—a notion
that in class terms is unquantifiable.[8] Activism's intellectuals represent at
best a social group. In other words, the very principle on which this col-
lective is formed is reactionary. No wonder its effect could never be revo-
lutionary.

Yet the pernicious principle of such collectivization continues to oper-
ate. This could be seen three years ago, when Döblin's *Wissen und
Verändern* came out.[9] As is known, this pamphlet was written in reply to

a young man—Döblin calls him Herr Hocke—who had put to the famous author the question, "What is to be done?" Döblin invites him to join the cause of socialism, but with reservations. Socialism, according to Döblin, is "freedom, a spontaneous union of people, the rejection of all compulsion, indignation at injustice and coercion, humanity, tolerance, a peaceful disposition." However that may be, on the basis of this socialism he sets his face against the theory and practice of the radical workers' movement. "Nothing," Döblin declares, "can come out of anything that was not already in it—and from a murderously exacerbated class war, justice can come but not socialism." Döblin formulates the recommendation that, for these and other reasons, he gives Herr Hocke: "You, my dear sir, cannot put into effect your agreement in principle with the struggle [of the proletariat] by joining the proletarian front. You must be content with an agitated and bitter approval of this struggle. But you also know that if you do more, an immensely important post will remain unmanned . . . : the original communistic position of human individual freedom, of the spontaneous solidarity and union of men. . . . It is this position, my dear sir, that alone falls to you." Here it is quite palpable where the conception of the "intellectual"—as a type of person defined by his opinions, attitudes, or dispositions, but not by his position in the process of production—leads. He must, as Döblin puts it, find his place *beside* the proletariat. But what kind of place is this? That of a benefactor, of an ideological patron—an impossible place. And so we return to the thesis stated at the outset: the place of the intellectual in the class struggle can be identified—or, better, chosen—only on the basis of his position in the process of production.

To signify the transformation of the forms and instruments of production in the way desired by a progressive intelligentsia—that is, one interested in freeing the means of production and serving the class struggle—Brecht coined the term *Umfunktionierung* [functional transformation]. He was the first to make of intellectuals the far-reaching demand not to supply the apparatus of production without, to the utmost extent possible, changing it in accordance with socialism. "The publication of the *Versuche*," the author writes in his introduction to the series of writings bearing this title, "occurred at a time when certain works ought no longer to be individual experiences (have the character of works) but should, rather, concern the use (transformation) of certain institutes and institutions."[10] It is not spiritual renewal, as fascists proclaim, that is desirable: technical innovations are suggested. I shall come back to these innovations. Here I would like to content myself with a reference to the de-

cisive difference between the mere supplying of a productive apparatus
and its transformation. And I would like to preface my discussion of the
"New Objectivity" with the proposition that to supply a productive ap-
paratus without—to the utmost extent possible—changing it would still
be a highly censurable course, even if the material with which it is sup-
plied seemed to be of a revolutionary nature. For we are faced with the
fact—of which the past decade in Germany has furnished an abundance
of examples—that the bourgeois apparatus of production and publica-
tion can assimilate astonishing quantities of revolutionary themes—in-
deed, can propagate them without calling its own existence, and the exis-
tence of the class that owns it, seriously into question. This remains true
at least as long as it is supplied by hack writers, even if they are revolu-
tionary hacks. I define "hack writer" as a writer who abstains in princi-
ple from alienating the productive apparatus from the ruling class by
improving it in ways serving the interests of socialism. And I further
maintain that a considerable proportion of so-called left-wing literature
possessed no other social function than to wring from the political situa-
tion a continuous stream of novel effects for the entertainment of the
public. This brings me to the New Objectivity. Its stock in trade was re-
portage. Let us ask ourselves to whom this technique was useful.

For the sake of clarity I will place its photographic form in the fore-
ground, but what is true of this can also be applied to its literary form.
Both owe the extraordinary increase in their popularity to the technology
of publication: radio and the illustrated press. Let us think back to Dada-
ism.[11] The revolutionary strength of Dadaism consisted in testing art for
its authenticity. A still life might have been put together from tickets,
spools of cotton, and cigarette butts, all of which were combined with
painted elements. The whole thing was put in a frame. And thereby the
public was shown: Look, your picture frame ruptures time; the tiniest au-
thentic fragment of daily life says more than painting. Just as the bloody
fingerprint of a murderer on the page of a book says more than the text.
Much of this revolutionary content has gone into photomontage. You
need only think of the work of John Heartfield, whose technique made
the book cover into a political instrument.[12] But now follow the path of
photography further. What do you see? It becomes ever more *nuancé*,
ever more modern; and the result is that it can no longer record a tene-
ment block or a refuse heap without transfiguring it. Needless to say,
photography is unable to convey anything about a power station or a ca-
ble factory other than, "What a beautiful world!" *The World Is Beauti-
ful*—this is the title of the well-known picture anthology by Renger-

Patzsch, in which we see New Objective photography at its peak.[13] For it has succeeded in transforming even abject poverty—by apprehending it in a fashionably perfected manner—into an object of enjoyment. For if it is an economic function of photography to restore to mass consumption, by fashionable adaptation, subjects that had earlier withdrawn themselves from it (springtime, famous people, foreign countries), it is one of its political functions to renew from within—that is, fashionably—the world as it is.

Here we have a flagrant example of what it means to supply a productive apparatus without changing it. To change it would have meant overthrowing another of the barriers, transcending another of the antitheses, that fetter the production of intellectuals—in this case, the barrier between writing and image. What we require of the photographer is the ability to give his picture a caption that wrenches it from modish commerce and gives it a revolutionary use value. But we will make this demand most emphatically when we—the writers—take up photography. Here, too, therefore, technical progress is for the author as producer the foundation of his political progress. In other words, only by transcending the specialization in the process of intellectual production—a specialization that, in the bourgeois view, constitutes its order—can one make this production politically useful; and the barriers imposed by specialization must be breached jointly by the productive forces that they were set up to divide. The author as producer discovers—even as he discovers his solidarity with the proletariat—his solidarity with certain other producers who earlier seemed scarcely to concern him. I have spoken of the photographer; here I will very briefly insert a word of Eisler's on the musician:[14]

> In the development of music, too, both in production and in reproduction, we must learn to recognize an ever-increasing process of rationalization. . . . The phonograph record, the sound film, jukeboxes can purvey top-quality music . . . canned as a commodity. The consequence of this process of rationalization is that musical reproduction is consigned to ever-diminishing but also ever more highly qualified groups of specialists. The crisis of the commercial concert is the crisis of an antiquated form of production made obsolete by new technical inventions.

The task, therefore, consisted of an *Umfunktionierung* of the form of the concert that had to fulfill two conditions: it had to eliminate the antithesis, first, between performers and listeners and, second, between technique and content. On this, Eisler makes the following illuminating observation: "One must beware of overestimating orchestral music and

considering it the only high art. Music without words attained its great importance and its full extent only under capitalism." This means that the task of changing the concert is impossible without the collaboration of the word. It alone can effect the transformation, as Eisler formulates it, of a concert into a political meeting. But that such a transformation does indeed represent a peak of musical and literary technique, Brecht and Eisler prove with their didactic play *Die Massnahme* [The Measures Taken].

If you look back from this vantage point on the recasting of literary forms that I spoke of earlier, you can see how photography and music, and whatever else occurs to you, are entering the growing, molten mass from which the new forms are cast. You will find this confirmed: only the literarization of all the conditions of life provides an accurate conception of the range of this melting-down process, just as the state of the class struggle determines the temperature at which—more or less perfectly—it is accomplished.

I spoke of the process of a certain modish photography whereby poverty is made an object of consumption. In turning to New Objectivity as a literary movement, I must take a step further and say that it has made the *struggle against poverty* an object of consumption. The political importance of the movement was indeed exhausted in many cases by the conversion of revolutionary impulses, insofar as they occurred among bourgeoisie, into objects of distraction, of amusement, which found their way without difficulty into the big-city cabaret business. The transformation of the political struggle from a call-to-decision into an object of contemplative enjoyment, from a means of production into a consumer article, is the defining characteristic of this literature. A perceptive critic has explained this, using the example of Erich Kästner, as follows:[15]

> With the workers' movement, this left-wing radical intelligentsia has nothing in common. It is, rather, a phenomenon of bourgeois decomposition, a counterpart of the feudalistic mimicry that the Second Empire admired in the reserve officer. The radical-left publicists of the stamp of Kästner, Mehring, or Tucholsky are the proletarian mimicry of decayed bourgeois strata.[16] Their function is to produce, from the political standpoint, not parties but cliques; from the literary standpoint, not schools but fashions; from the economic standpoint, not producers but agents—agents or hacks who make a great display of their poverty, and a banquet out of yawning emptiness. One could not be more cozily accommodated in an uncozy situation.

This school, I said, made a great display of its poverty. It thereby shirked the most urgent task of the present-day writer: to recognize how poor he is and how poor he has to be in order to begin again from the beginning. For this is what is involved. The Soviet state will not, it is true, banish the poet, as Plato did; but it will—and this is why I evoked Plato's republic at the outset—assign him tasks that do not permit him to display in new masterpieces the long-since-counterfeit wealth of creative personality. To expect a renewal in terms of such personalities and such works is a privilege of fascism, which gives rise to such asinine formulations as that with which Günther Gründel, in his *Mission of the Young Generation,* rounds off the section on literature: "We cannot better conclude this . . . survey and prognosis than with the observation that the *Wilhelm Meister* and the *Green Henry* of our generation have not yet been written."[17] Nothing will be further from the author who has reflected deeply on the conditions of present-day production than to expect, or desire, such works. His work will never be merely work on products but always, at the same time, work on the means of production. In other words, his products must have, over and above their character as works, an organizing function, and in no way must their organizational usefulness be confined to their value as propaganda. Their political tendency alone is not enough. The excellent Lichtenberg has said, "What matters is not a man's opinions, but the kind of man these opinions make of him."[18] Now, it is true that opinions matter greatly, but the best are of no use if they make nothing useful out of those who hold them. The best political tendency is wrong if it does not demonstrate the attitude with which it is to be followed. And this attitude the writer can demonstrate only in his particular activity—that is, in writing. A political tendency is a necessary but never sufficient condition for the organizing function of a work. This further requires a directing, instructing stance on the part of the writer. And today this must be demanded more than ever before. *An author who teaches writers nothing teaches no one.* What matters, therefore, is the exemplary character of production, which is able, first, to induce other producers to produce, and, second, to put an improved apparatus at their disposal. And this apparatus is better, the more consumers it is able to turn into producers—that is, readers or spectators into collaborators. We already possess such an example, to which, however, I can only allude here. It is Brecht's Epic Theater.

Tragedies and operas are constantly being written that apparently have a well-tried theatrical apparatus at their disposal, but in reality do nothing but supply a derelict one. "The lack of clarity about their situa-

tion that prevails among musicians, writers, and critics," says Brecht, "has immense consequences that are far too little considered. For, thinking that they are in possession of an apparatus that in reality possesses them, they defend an apparatus over which they no longer have any control and that is no longer, as they still believe, a means for the producers, but has become a means against the producers."[19] This theater, with its complicated machinery, its gigantic supporting staff, its sophisticated effects, has become a "means against the producers" not least in seeking to enlist them in the hopeless competitive struggle in which film and radio have enmeshed it. This theater (whether in its educating or its entertaining role; the two are complementary)[20] is that of a sated class for which everything it touches becomes a stimulant. Its position is lost. Not so that of a theater that, instead of competing with newer instruments of publication, seeks to use and learn from them—in short, to enter into debate with them. This debate the Epic Theater has made its own affair. It is, measured by the present state of development of film and radio, the contemporary form.

In the interest of this debate, Brecht fell back on the most primitive elements of the theater. He contented himself, by and large, with a podium. He dispensed with wide-ranging plots. He thus succeeded in changing the functional connection between stage and public, text and performance, director and actor. Epic Theater, he declared, had to portray situations, rather than develop plots. It obtains such situations, as we shall see presently, by interrupting the plot. I remind you here of the songs, which have their chief function in interrupting the action. Here—according to the principle of interruption—Epic Theater, as you see, takes up a procedure that has become familiar to you in recent years from film and radio, literature and photography. I am speaking of the procedure of montage: the superimposed element disrupts the context in which it is inserted. But here this procedure has a special right, perhaps even a perfect right, as I will briefly show. The interruption of action, on account of which Brecht described his theater as "epic," constantly counteracts illusion on the part of the audience. For such illusion is a hindrance to a theater that proposes to make use of elements of reality in experimental rearrangements. But it is at the end, not the beginning, of the experiment that the situation appears—a situation that, in this or that form, is always ours. It is not brought home to the spectator but distanced from him. He recognizes it as the real situation—not with satisfaction, as in the theater of Naturalism, but with astonishment. Epic Theater, therefore, does not reproduce situations; rather, it discovers them. This discovery is accom-

plished by means of the interruption of sequences. Yet interruption here has the character not of a stimulant but of an organizing function. It arrests the action in its course, and thereby compels the listener to adopt an attitude vis-à-vis the process, the actor vis-à-vis his role. I would like to show you, through an example, how Brecht's discovery and use of the *gestus* is nothing but the restoration of the method of montage decisive in radio and film, from an often merely modish procedure to a human event. Imagine a family scene: the wife is just about to grab a bronze sculpture and throw it at her daughter; the father is opening the window to call for help. At this moment a stranger enters. The process is interrupted. What appears in its place is the situation on which the stranger's eyes now fall: agitated faces, open window, disordered furniture. There are eyes, however, before which the more usual scenes of present-day existence do not look very different: the eyes of the epic dramatist.

To the total dramatic artwork he opposes the dramatic laboratory. He makes use in a new way of the great, ancient opportunity of the theater: to expose what is present. At the center of his experiment stands the human being. Present-day man; a reduced man, therefore, chilled in a chilly environment. But since this is the only one we have, it is in our interest to know him. He is subjected to tests, examinations. What emerges is this: events are alterable not at their climaxes, not by virtue and resolution, but only in their strictly habitual course, by reason and practice. To construct from the smallest elements of behavior what in Aristotelian dramaturgy is called "action" is the purpose of Epic Theater. Its means are therefore more modest than those of traditional theater; likewise its aims. It is concerned less with filling the public with feelings, even seditious ones, than with alienating it in an enduring way, through thinking, from the conditions in which it lives. It may be noted, incidentally, that there is no better trigger for thinking than laughter. In particular, convulsion of the diaphragm usually provides better opportunities for thought than convulsion of the soul. Epic Theater is lavish only in occasions for laughter.

It has perhaps struck you that the train of thought which is about to be concluded presents the writer with only one demand: the demand *to think*, to reflect on his position in the process of production. We may depend on it: this reflection leads, sooner or later, for the writers who *matter* (that is, for the best technicians in their field), to observations that provide the most factual foundation for solidarity with the proletariat. Thus, I would like to conclude by adducing a topical illustration in the form of a small extract from a journal published here, *Commune*. Com-

mune circulated a questionnaire asking, "For whom do you write?" I quote from the reply of René Maublanc and from the comment added by Aragon.[21] "Unquestionably," says Maublanc, "I write almost exclusively for a bourgeois public. First, because I am obliged to" (here Maublanc is alluding to his professional duties as a grammar-school teacher), "second, because I have bourgeois origins and a bourgeois education and come from a bourgeois milieu, and so am naturally inclined to address myself to the class to which I belong, which I know and understand best. This does not mean, however, that I write in order to please or support it. I am convinced, on the one hand, that the proletarian revolution is necessary and desirable and, on the other, that it will be the more rapid, easy, and successful, and the less bloody, the weaker the opposition of the bourgeoisie. . . . The proletariat today needs allies from the camp of the bourgeoisie, exactly as in the eighteenth century the bourgeoisie needed allies from the feudal camp. I wish to be among those allies."

On this Aragon comments:

> Our comrade here touches on a state of affairs that affects a large number of present-day writers. Not all have the courage to look it in the face. . . . Those who see their own situation as clearly as René Maublanc are few. But precisely from them more must be required. . . . It is not enough to weaken the bourgeoisie from within; it is necessary to fight them *with* the proletariat. . . . René Maublanc, and many of our friends among the writers who are still hesitating, are faced with the example of the Soviet Russian writers who came from the Russian bourgeoisie and nevertheless became pioneers in the building of socialism.

Thus Aragon. But how did they become pioneers? Certainly not without very bitter struggles, extremely difficult debates. The considerations I have put before you are an attempt to draw some conclusions from these struggles. They are based on the concept to which the debate on the attitude of Russian intellectuals owes its decisive clarification: the concept of the specialist. The solidarity of the specialist with the proletariat—herein lies the beginning of this clarification—can only be a mediated one. Proponents of Activism and of the New Objectivity could gesticulate as they pleased, but they could not do away with the fact that even the proletarianization of an intellectual hardly ever makes a proletarian. Why? Because the bourgeois class gave him, in the form of education, a means of production that, owing to educational privilege, makes him feel solidarity with it, and still more it with him. Aragon was thereby entirely correct when, in another connection, he declared, "The revolutionary intellectual appears first and foremost as the betrayer of his class of ori-

gin." In the case of the writer, this betrayal consists in conduct that transforms him from a supplier of the productive apparatus into an engineer who sees it as his task to adapt this apparatus to the purposes of the proletarian revolution. This is a mediating activity, yet it frees the intellectual from that purely destructive task to which Maublanc and many of his comrades believe it necessary to confine him. Does he succeed in promoting the socialization of the intellectual means of production? Does he see how he himself can organize intellectual workers in the production process? Does he have proposals for the *Umfunktionierung* of the novel, the drama, the poem? The more completely he can orient his activity toward this task, the more correct the political tendency of his work will be, and necessarily also the higher its technical quality. And at the same time, the more exactly he is thus informed about his position in the process of production, the less it will occur to him to lay claim to "spiritual" qualities. The spirit that holds forth in the name of fascism *must* disappear. The spirit that, in opposing it, trusts in its own miraculous powers *will* disappear. For the revolutionary struggle is not between capitalism and spirit; it is between capitalism and the proletariat.

Written spring 1934; unpublished in Benjamin's lifetime. *Gesammelte Schriften*, II, 683–701. Translated by Edmund Jephcott.

Notes

1. The Mexican-born French literary critic Ramon Fernandez (1894–1944) wrote for the *Nouvelle Revue Française* in the 1920s and 1930s. In the mid-1930s, he was involved with the Communist-backed Association des Ecrivains et Artistes Révolutionnaires.

2. That the date given in the subtitle is erroneous can be gathered from a letter that Benjamin wrote to Adorno the following day (April 28, 1934), in which he mentions that the address has not yet been presented (*Gesammelte Schriften*, II, 1460–1461). Gershom Scholem claims that the twenty-seventh was the date of Benjamin's *completion* of the text, which was *never* presented; see *The Correspondence of Walter Benjamin and Gershom Scholem, 1932–1940* (New York: Schocken, 1989), p. 111n. The Institute for the Study of Fascism (Institut Pour l'Etude du Fascisme) was a Communist front organization.

3. Sergei Tretiakov (1892–1939) was a Russian writer whose work, based on a "literature of facts," was agitational and propagandistic. His book *Commanders of the Field* (1931) comprised two volumes of diaries and sketchbooks.

4. The "left-wing author" is Benjamin himself. See "The Newspaper" (1934), Chapter 39 in this volume.

5. Centered around the yearbook *Das Ziel* (The Goal), "Activism" was a political stance that fused Nietzschean ideals with a pacifist socialism. Prominent figures associated with the movement included the German author and editor Kurt Hiller (1885–1972), who edited the yearbook; the theater critic Alfred Kerr; and the novelist Heinrich Mann. The young Benjamin had been a vocal opponent of Hiller's ideas. "New Objectivity" (Neue Sachlichkeit) was the term coined by the museum curator G. F. Hartlaub for a new tendency toward figuration in postwar German painting. It gradually came to designate the Weimar "period style" in art, architecture, design, literature, and film: cool, objective, analytical.

6. Heinrich Mann (1871–1950), German novelist and essayist, was the brother of Thomas Mann. Many of the disputes between the brothers over the years stemmed from Heinrich's left-liberal activism. Alfred Döblin (1878–1957), German novelist, is best known for the novel *Berlin Alexanderplatz* (1929). He, too, was a prominent left-liberal voice in Weimar.

7. Kurt Hiller, *Der Sprung ins Helle* (Leipzig: Lindner, 1932), p. 314.

8. In place of this sentence, the original manuscript contained a different one, which was deleted: "Or, in Trotsky's words, 'If enlightened pacifists attempt to abolish war by means of rational argument, they simply make fools of themselves, but if the armed masses begin to use the arguments of reason against war, this means the end of war.'"

9. *Wissen und Verändern* (Know and Change; 1931) was Döblin's apology for his humane, party-independent, and frankly mystical socialism.

10. Bertolt Brecht, *Versuche 1–3* (Berlin: Kiepenheuer, 1930).

11. In Zurich in 1916, artists, writers, and others disgusted by World War I, and by the bourgeois ideologies that had brought it about, launched Dada, an avant-garde movement that attempted to radically change both the work of art and society. Dadaist groups were active in Berlin, New York, Paris, and elsewhere during the war and into the 1920s.

12. John Heartfield (Helmut Herzfelde; 1891–1968), German graphic artist, photographer, and designer, was one of the founders of Berlin Dada. He went on to reinvent photomontage as a political weapon.

13. Albert Renger-Patzsch, *Die Welt ist schön: Einhundert photographische Aufnahmen* (Munich: K. Wolff, 1928). In this book, the German photographer Renger-Patzsch (1897–1966) arranged his photographs of plants, animals, buildings, manufactured goods, and industrial landscapes—often close-ups of isolated details—around formal rhymes.

14. Hanns Eisler (1898–1962) was a German composer best known for his collaborations with Brecht. He became the leading composer in the German Democratic Republic, for which he wrote the national anthem.

15. The "perceptive critic" is Benjamin himself; see his essay "Left-Wing Melancholy" (1931), in *Selected Writings, Volume 2: 1927–1934* (Cambridge, Mass.: Harvard University Press, 1999), pp. 423–427. Erich Kästner (1899–

1974) was a German satirist, poet, and novelist who is especially known for his children's books. He was the most durable practitioner of the style of witty, laconic writing associated with the highbrow cabaret, the Berlin weekly *Die Weltbühne* (The World Stage), and the Neue Sachlichkeit (New Objectivity) movement of the mid-1920s.

16. Franz Mehring (1846–1919), German socialist historian and journalist, is best known for his biography of Karl Marx. Kurt Tucholsky (1890–1935) was a German satirist and journalist whose work is emblematic of the wit and savage irony of the Berlin cabaret.

17. E. Günther Gründel, *Die Sendung der jungen Generation: Versuch einer umfassenden revolutionären Sinndeutung der Krise* (Munich: Beck, 1932), p. 116. Gründel is referring to novels by Goethe and Gottfried Keller, respectively.

18. Benjamin refers to the German scientist, satirist, and aphorist Georg Christoph Lichtenberg (1742–1799).

19. Brecht, *Versuche 4–7* (Berlin: Kiepenheuer, 1930), p. 107.

20. See "Theater and Radio" (1932), in this volume.

21. René Maublanc (1891–1960) was a French Marxist historian whose books include *Fourier* (1937) and *Le Marxisme et la liberté* (1945). Louis Aragon (Louis Andrieux; 1897–1982) was a French poet, novelist, and essayist who, as a prominent Surrealist, was a political activist and spokesman for communism. Benjamin's earliest work on the Arcades Project was inspired by Aragon's books *Vague de rêves* (Wave of Dreams; 1924) and *Paysan de Paris* (Paris Peasant; 1926).

The waters are blue, the plants pink; the evening is sweet to look on;
One goes for a walk; the *grandes dames* go for a walk;
behind them stroll the *petites dames*.

—NGUYEN TRONG HIEP, *Paris, capitale de la France: Recueil
de vers* (Hanoi, 1897), poem 25[1]

9

Paris, the Capital of the Nineteenth Century

I. Fourier, or the Arcades

The magic columns of these palaces
Show to the amateur on all sides,
In the objects their porticos display,
That industry is the rival of the arts.

—NOUVEAUX TABLEAUX *de Paris* (Paris, 1828), vol. 1, p. 27

Most of the Paris arcades come into being in the decade and a half after
1822. The first condition for their emergence is the boom in the textile
trade. *Magasins de nouveautés,* the first establishments to keep large
stocks of merchandise on the premises, make their appearance.[2] They
are the forerunners of department stores. This was the period of which
Balzac wrote: "The great poem of display chants its stanzas of color
from the Church of the Madeleine to the Porte Saint-Denis."[3] The ar-
cades are a center of commerce in luxury items. In fitting them out,
art enters the service of the merchant. Contemporaries never tire of ad-
miring them, and for a long time they remain a drawing point for for-
eigners. An *Illustrated Guide to Paris* says: "These arcades, a recent
invention of industrial luxury, are glass-roofed, marble-paneled corri-
dors extending through whole blocks of buildings, whose owners have
joined together for such enterprises. Lining both sides of these corridors,

96

which get their light from above, are the most elegant shops, so that the *passage* is a city, a world in miniature." The arcades are the scene of the first gas lighting.

The second condition for the emergence of the arcades is the beginning of iron construction. The Empire saw in this technology a contribution to the revival of architecture in the classical Greek sense. The architectural theorist Boetticher expresses the general view of the matter when he says that, "with regard to the art forms of the new system, the formal principle of the Hellenic mode" must come to prevail.[4] Empire is the style of revolutionary terrorism, for which the state is an end in itself. Just as Napoleon failed to understand the functional nature of the state as an instrument of domination by the bourgeois class, so the architects of his time failed to understand the functional nature of iron, with which the constructive principle begins its domination of architecture. These architects design supports resembling Pompeian columns, and factories that imitate residential houses, just as later the first railroad stations will be modeled on chalets. "Construction plays the role of the subconscious."[5] Nevertheless, the concept of engineer, which dates from the revolutionary wars, starts to make headway, and the rivalry begins between builder and decorator, Ecole Polytechnique and Ecole des Beaux-Arts.

For the first time in the history of architecture, an artificial building material appears: iron. It serves as the basis for a development whose tempo accelerates in the course of the century. This development enters a decisive new phase when it becomes apparent that the locomotive—on which experiments had been conducted since the end of the 1820s—is compatible only with iron tracks. The rail becomes the first prefabricated iron component, the precursor of the girder. Iron is avoided in home construction but used in arcades, exhibition halls, train stations—buildings that serve transitory purposes. At the same time, the range of architectural applications for glass expands, although the social prerequisites for its widened application as building material will come to the fore only a hundred years later. In Scheerbart's *Glasarchitektur* (1914), it still appears in the context of utopia.[6]

Each epoch dreams the one to follow.
—MICHELET, "Avenir! Avenir!"[7]

Corresponding to the form of the new means of production, which in the beginning is still ruled by the form of the old (Marx), are images in the

collective consciousness in which the new is permeated with the old. These images are wish images; in them the collective seeks both to overcome and to transfigure the immaturity of the social product and the inadequacies in the social organization of production. At the same time, what emerges in these wish images is the resolute effort to distance oneself from all that is antiquated—which includes, however, the recent past. These tendencies deflect the imagination (which is given impetus by the new) back upon the primal past. In the dream in which each epoch entertains images of its successor, the latter appears wedded to elements of primal history [*Urgeschichte*]—that is, to elements of a classless society. And the experiences of such a society—as stored in the unconscious of the collective—engender, through interpenetration with what is new, the utopia that has left its trace in a thousand configurations of life, from enduring edifices to passing fashions.

These relations are discernible in the utopia conceived by Fourier.[8] Its secret cue is the advent of machines. But this fact is not directly expressed in the Fourierist literature, which takes as its point of departure the amorality of the business world and the false morality enlisted in its service. The phalanstery is designed to restore human beings to relationships in which morality becomes superfluous. The highly complicated organization of the phalanstery appears as machinery. The meshing of the passions, the intricate collaboration of *passions mécanistes* with the *passion cabaliste,* is a primitive contrivance formed—on analogy with the machine—from materials of psychology. This machinery made of men produces the land of milk and honey, the primeval wish symbol that Fourier's utopia has filled with new life.

Fourier saw, in the arcades, the architectural canon of the phalanstery. Their reactionary metamorphosis with him is characteristic: whereas they originally serve commercial ends, they become, for him, places of habitation. The phalanstery becomes a city of arcades. Fourier establishes, in the Empire's austere world of forms, the colorful idyll of Biedermeier.[9] Its brilliance persists, however faded, up through Zola, who takes up Fourier's ideas in his book *Travail,* just as he bids farewell to the arcades in his *Thérèse Raquin.*[10]—Marx came to the defense of Fourier in his critique of Carl Grün, emphasizing the former's "colossal conception of man."[11] He also directed attention to Fourier's humor. In fact, Jean Paul, in his *Levana,* is as closely allied to Fourier the pedagogue as Scheerbart, in his *Glass Architecture,* is to Fourier the utopian.[12]

II. Daguerre, or the Panoramas

Sun, look out for yourself!
—A. J. WIERTZ, *Oeuvres littéraires* (Paris, 1870), p. 374

Just as architecture, with the first appearance of iron construction, begins to outgrow art, so does painting, in its turn, with the first appearance of the panoramas.[13] The high point in the diffusion of panoramas coincides with the introduction of arcades. One sought tirelessly, through technical devices, to make panoramas the scenes of a perfect imitation of nature. An attempt was made to reproduce the changing daylight in the landscape, the rising of the moon, the rush of waterfalls. David counsels his pupils to draw from nature as it is shown in panoramas.[14] In their attempt to produce deceptively lifelike changes in represented nature, the panoramas prepare the way not only for photography but for [silent] film and sound film.

Contemporary with the panoramas is a panoramic literature. *Le Livre des cent-et-un* [The Book of a Hundred-and-One], *Les Français peints par eux-mêmes* [The French Painted by Themselves], *Le Diable à Paris* [The Devil in Paris], and *La Grande Ville* [The Big City] belong to this. These books prepare the belletristic collaboration for which Girardin, in the 1830s, will create a home in the feuilleton.[15] They consist of individual sketches, whose anecdotal form corresponds to the panoramas' plastically arranged foreground, and whose informational base corresponds to their painted background. This literature is also socially panoramic. For the last time, the worker appears, isolated from his class, as part of the setting in an idyll.

Announcing an upheaval in the relation of art to technology, panoramas are at the same time an expression of a new attitude toward life. The city dweller, whose political supremacy over the provinces is attested many times in the course of the century, attempts to bring the countryside into town. In the panoramas, the city opens out, becoming landscape—as it will do later, in subtler fashion, for the flâneurs. Daguerre is a student of the panorama painter Prévost, whose establishment is located in the Passage des Panoramas.[16] Description of the panoramas of Prévost and Daguerre. In 1839 Daguerre's panorama burns down. In the same year, he announces the invention of the daguerreotype.

Arago presents photography in a speech to the National Assembly.[17] He assigns it a place in the history of technology and prophesies its scientific applications. On the other side, artists begin to debate its artistic value. Photography leads to the extinction of the great profession of portrait miniaturist. This happens not just for economic reasons. The early photograph was artistically superior to the miniature portrait. The technical grounds for this advantage lie in the long exposure time, which requires of a subject the highest concentration; the social grounds for it lie in the fact that the first photographers belonged to the avant-garde, from which most of their clientele came. Nadar's superiority to his colleagues is shown by his attempt to take photographs in the Paris sewer system: for the first time, the lens was deemed capable of making discoveries.[18] Its importance becomes still greater as, in view of the new technological and social reality, the subjective strain in pictorial and graphic information is called into question.

The world exhibition of 1855 offers for the first time a special display called "Photography." In the same year, Wiertz publishes his great article on photography, in which he defines its task as the philosophical enlightenment of painting.[19] This "enlightenment" is understood, as his own paintings show, in a political sense. Wiertz can be characterized as the first to demand, if not actually foresee, the use of photographic montage for political agitation. With the increasing scope of communications and transport, the informational value of painting diminishes. In reaction to photography, painting begins to stress the elements of color in the picture. By the time Impressionism yields to Cubism, painting has created for itself a broader domain into which, for the time being, photography cannot follow. For its part, photography greatly extends the sphere of commodity exchange, from mid-century onward, by flooding the market with countless images of figures, landscapes, and events which had previously been available either not at all or only as pictures for individual customers. To increase turnover, it renewed its subject matter through modish variations in camera technique—innovations that will determine the subsequent history of photography.

III. Grandville, or the World Exhibitions

Yes, when all the world from Paris to China
Pays heed to your doctrine, O divine Saint-Simon,
The glorious Golden Age will be reborn.

Rivers will flow with chocolate and tea,
Sheep roasted whole will frisk on the plain,
And sautéed pike will swim in the Seine.
Fricasseed spinach will grow on the ground,
Garnished with crushed fried croutons;
The trees will bring forth apple compotes,
And farmers will harvest boots and coats.
It will snow wine, it will rain chickens,
And ducks cooked with turnips will fall from the sky.
 —LANGLÉ AND VANDERBURCH, *Louis-Bronze et le Saint-Simonien*
 (Théâtre du Palais-Royal, February 27, 1832)[20]

World exhibitions are places of pilgrimage to the commodity fetish. "Europe is off to view the merchandise," says [Hippolyte] Taine in 1855.[21] The world exhibitions are preceded by national exhibitions of industry, the first of which takes place on the Champ de Mars in 1798. It arises from the wish "to entertain the working classes, and it becomes for them a festival of emancipation."[22] The worker occupies the foreground, as customer. The framework of the entertainment industry has not yet taken shape; the popular festival provides this. Chaptal's speech on industry opens the 1798 exhibition.[23]—The Saint-Simonians, who envision the industrialization of the earth, take up the idea of world exhibitions. Chevalier, the first authority in the new field, is a student of Enfantin and editor of the Saint-Simonian newspaper *Le Globe*.[24] The Saint-Simonians anticipated the development of the global economy, but not the class struggle. Next to their active participation in industrial and commercial enterprises around the middle of the century stands their helplessness on all questions concerning the proletariat.

World exhibitions glorify the exchange value of the commodity. They create a framework in which its use value recedes into the background. They open a phantasmagoria which a person enters in order to be distracted. The entertainment industry makes this easier by elevating the person to the level of the commodity. He surrenders to its manipulations while enjoying his alienation from himself and others.—The enthronement of the commodity, with its luster of distraction, is the secret theme of Grandville's art.[25] This is consistent with the split between utopian and cynical elements in his work. Its ingenuity in representing inanimate objects corresponds to what Marx calls the "theological niceties" of the commodity.[26] They are manifest clearly in the *spécialité*—a category of goods which appears at this time in the luxuries industry. Under

Grandville's pencil, the whole of nature is transformed into specialties. He presents them in the same spirit in which the advertisement (the term *réclame* also originates at this point) begins to present its articles. He ends in madness.

> Fashion: "Madam Death! Madam Death!"
> —Leopardi, "Dialogue between Fashion and Death"[27]

World exhibitions propagate the universe of commodities. Grandville's fantasies confer a commodity character on the universe. They modernize it. Saturn's ring becomes a cast-iron balcony on which the inhabitants of Saturn take the evening air.[28] The literary counterpart of this graphic utopia is found in the books of the Fourierist naturalist Toussenel.[29]—Fashion prescribes the ritual according to which the commodity fetish demands to be worshipped. Grandville extends the authority of fashion to objects of everyday use, as well as to the cosmos. In taking it to an extreme, he reveals its nature. Fashion stands in opposition to the organic. It couples the living body to the inorganic world. To the living, it defends the rights of the corpse. The fetishism that succumbs to the sex appeal of the inorganic is its vital nerve. The cult of the commodity presses such fetishism into its service.

For the Paris world exhibition of 1867, Victor Hugo issues a manifesto: "To the Peoples of Europe." Earlier, and more unequivocally, their interests had been championed by delegations of French workers, of which the first had been sent to the London world exhibition of 1851 and the second, numbering 750 delegates, to that of 1862. The latter delegation was of indirect importance for Marx's founding of the International Workingmen's Association.[30]—The phantasmagoria of capitalist culture attains its most radiant unfolding in the world exhibition of 1867. The Second Empire is at the height of its power. Paris is acknowledged as the capital of luxury and fashion. Offenbach sets the rhythm of Parisian life.[31] The operetta is the ironic utopia of an enduring reign of capital.

IV. Louis Philippe, or the Interior

> The head . . .
> On the night table, like a ranunculus,
> Rests.
> —Baudelaire, "Une Martyre"[32]

Under Louis Philippe,[33] the private individual makes his entrance on the stage of history. The expansion of the democratic apparatus through a new electoral law coincides with the parliamentary corruption organized by Guizot.[34] Under cover of this corruption, the ruling class makes history; that is, it pursues its affairs. It furthers railway construction in order to improve its stock holdings. It promotes the reign of Louis Philippe as that of the private individual managing his affairs. With the July Revolution, the bourgeoisie realized the goals of 1789 (Marx).

For the private individual, the place of dwelling is for the first time opposed to the place of work. The former constitutes itself as the interior. Its complement is the office. The private individual, who in the office has to deal with reality, needs the domestic interior to sustain him in his illusions. This necessity is all the more pressing since he has no intention of allowing his commercial considerations to impinge on social ones. In the formation of his private environment, both are kept out. From this arise the phantasmagorias of the interior—which, for the private man, represents the universe. In the interior, he brings together the far away and the long ago. His living room is a box in the theater of the world.

Excursus on Jugendstil.[35] The shattering of the interior occurs via Jugendstil around the turn of the century. Of course, according to its own ideology, the Jugendstil movement seems to bring with it the consummation of the interior. The transfiguration of the solitary soul appears to be its goal. Individualism is its theory. With van de Velde, the house becomes an expression of the personality.[36] Ornament is to this house what the signature is to a painting. But the real meaning of Jugendstil is not expressed in this ideology. It represents the last attempted sortie of an art besieged in its ivory tower by technology. This attempt mobilizes all the reserves of inwardness. They find their expression in the mediumistic language of the line, in the flower as symbol of a naked vegetal nature confronted by the technologically armed world. The new elements of iron construction—girder forms—preoccupy Jugendstil. In ornament, it endeavors to win back these forms for art. Concrete presents it with new possibilities for plastic creation in architecture. Around this time, the real gravitational center of living space shifts to the office. The irreal center makes its place in the home. The consequences of Jugendstil are depicted in Ibsen's *Master Builder*: the attempt by the individual, on the strength of his inwardness, to vie with technology leads to his downfall.[37]

I believe . . . in my soul: the Thing.
—LÉON DEUBEL, *Oeuvres* (Paris, 1929), p. 193

The interior is the asylum of art. The collector is the true resident of the interior. He makes his concern the transfiguration of things. To him falls the Sisyphean task of divesting things of their commodity character by taking possession of them. But he bestows on them only connoisseur value, rather than use value. The collector dreams his way not only into a distant or bygone world but also into a better one—one in which, to be sure, human beings are no better provided with what they need than in the everyday world, but in which things are freed from the drudgery of being useful.

The interior is not just the universe but also the étui of the private individual. To dwell means to leave traces. In the interior, these are accentuated. Coverlets and antimacassars, cases and containers are devised in abundance; in these, the traces of the most ordinary objects of use are imprinted. In just the same way, the traces of the inhabitant are imprinted in the interior. Enter the detective story, which pursues these traces. Poe, in his "Philosophy of Furniture" as well as in his detective fiction, shows himself to be the first physiognomist of the domestic interior. The criminals in early detective novels are neither gentlemen nor apaches, but private citizens of the middle class.[38]

V. Baudelaire, or the Streets of Paris

> Everything becomes an allegory for me.
> —BAUDELAIRE, "Le Cygne"[39]

Baudelaire's genius, which is nourished on melancholy, is an allegorical genius. For the first time, with Baudelaire, Paris becomes the subject of lyric poetry. This poetry is no hymn to the homeland; rather, the gaze of the allegorist, as it falls on the city, is the gaze of the alienated man. It is the gaze of the flâneur, whose way of life still conceals behind a mitigating nimbus the coming desolation of the big-city dweller. The flâneur still stands on the threshold—of the metropolis as of the middle class. Neither has him in its power yet. In neither is he at home. He seeks refuge in the crowd. Early contributions to a physiognomics of the crowd are found in Engels and Poe.[40] The crowd is the veil through which the familiar city beckons to the flâneur as phantasmagoria—now a landscape, now a room. Both become elements of the department store, which makes use of flânerie itself to sell goods. The department store is the last promenade for the flâneur.

In the flâneur, the intelligentsia sets foot in the marketplace—ostensi-

bly to look around, but in truth to find a buyer. In this intermediate stage, in which it still has patrons but is already beginning to familiarize itself with the market, it appears as the *bohème*. To the uncertainty of its economic position corresponds the uncertainty of its political function. The latter is manifest most clearly in the professional conspirators, who all belong to the *bohème*. Their initial field of activity is the army; later it becomes the petty bourgeoisie, occasionally the proletariat. Nevertheless, this group views the true leaders of the proletariat as its adversary. The *Communist Manifesto* brings their political existence to an end. Baudelaire's poetry draws its strength from the rebellious pathos of this group. He sides with the asocial. He realizes his only sexual communion with a whore.

Easy the way that leads into Avernus.
—Virgil, *The Aeneid*[41]

It is the unique provision of Baudelaire's poetry that the image of woman and the image of death intermingle in a third: that of Paris. The Paris of his poems is a sunken city, and more submarine than subterranean. The chthonic elements of the city—its topographic formations, the old abandoned bed of the Seine—have evidently found in him a mold. Decisive for Baudelaire in the "death-fraught idyll" of the city, however, is a social, a modern substrate. The modern is a principal accent of his poetry. As spleen, it fractures the ideal ("Spleen et idéal").[42] But precisely modernity is always citing primal history. Here, this occurs through the ambiguity peculiar to the social relations and products of this epoch. Ambiguity is the appearance of dialectic in images, the law of dialectics at a standstill. This standstill is utopia and the dialectical image, therefore, dream image. Such an image is afforded by the commodity per se: as fetish. Such an image is presented by the arcades, which are house no less than street. Such an image is the prostitute—seller and sold in one.

I travel in order to get to know my geography.
—Note of a madman, in Marcel Réja, *L'Art chez les fous* (Paris, 1907), p. 131

The last poem of *Les Fleurs du Mal:* "Le Voyage." "Death, old admiral, up anchor now." The last journey of the flâneur: death. Its destination: the new. "Deep in the Unknown to find the *new!*"[43] Newness is a quality independent of the use value of the commodity. It is the origin of the sem-

blance that belongs inalienably to images produced by the collective un-
conscious. It is the quintessence of that false consciousness whose inde-
fatigable agent is fashion. This semblance of the new is reflected, like one
mirror in another, in the semblance of the ever recurrent. The product of
this reflection is the phantasmagoria of "cultural history," in which the
bourgeoisie enjoys its false consciousness to the full. The art that begins
to doubt its task and ceases to be "inseparable from . . . utility" (Baudelaire)
must make novelty into its highest value.[44] The *arbiter novarum rerum*
for such an art becomes the snob. He is to art what the dandy is to fash-
ion.—Just as in the seventeenth century it is allegory that becomes the
canon of dialectical images, in the nineteenth century it is novelty. News-
papers flourish, along with *magasins de nouveautés*. The press organizes
the market in spiritual values, in which at first there is a boom. Non-
conformists rebel against consigning art to the marketplace. They rally
round the banner of *l'art pour l'art*.[45] From this watchword derives the
conception of the "total work of art"—the *Gesamtkunstwerk*—which
would seal art off from the developments of technology. The solemn rite
with which it is celebrated is the pendant to the distraction that transfig-
ures the commodity. Both abstract from the social existence of human be-
ings. Baudelaire succumbs to the rage for Wagner.[46]

VI. Haussmann, or the Barricades

I venerate the Beautiful, the Good, and all things great;
Beautiful nature, on which great art rests—
How it enchants the ear and charms the eye!
I love spring in blossom: women and roses.
 —BARON HAUSSMANN, *Confession d'un lion devenu vieux*[47]

The flowery realm of decorations,
The charm of landscape, of architecture,
And all the effect of scenery rest
Solely on the law of perspective.
 —FRANZ BÖHLE, *Theater-Catechismus* (Munich), p. 74

Haussmann's ideal in city planning consisted of long perspectives down
broad straight thoroughfares. Such an ideal corresponds to the ten-

dency—common in the nineteenth century—to ennoble technological necessities through artistic ends. The institutions of the bourgeoisie's worldly and spiritual dominance were to find their apotheosis within the framework of the boulevards. Before their completion, boulevards were draped across with canvas and unveiled like monuments.—Haussmann's activity is linked to Napoleonic imperialism. Louis Napoleon promotes investment capital, and Paris experiences a rash of speculation.[48] Trading on the stock exchange displaces the forms of gambling handed down from feudal society. The phantasmagorias of space to which the flâneur devotes himself find a counterpart in the phantasmagorias of time to which the gambler is addicted. Gambling converts time into a narcotic. [Paul] Lafargue explains gambling as an imitation in miniature of the mysteries of economic fluctuation.[49] The expropriations carried out under Haussmann call forth a wave of fraudulent speculation. The rulings of the Court of Cassation, which are inspired by the bourgeois and Orleanist opposition, increase the financial risks of Haussmannization.[50]

Haussmann tries to shore up his dictatorship by placing Paris under an emergency regime. In 1864, in a speech before the National Assembly, he vents his hatred of the rootless urban population, which keeps increasing as a result of his projects. Rising rents drive the proletariat into the suburbs. The *quartiers* of Paris in this way lose their distinctive physiognomy. The "red belt" forms.[51] Haussmann gave himself the title of "demolition artist," *artiste démolisseur.* He viewed his work as a calling, and emphasizes this in his memoirs. Meanwhile he estranges the Parisians from their city. They no longer feel at home there, and start to become conscious of the inhuman character of the metropolis. Maxime Du Camp's monumental work *Paris* owes its inception to this consciousness.[52] The *Jérémiades d'un Haussmannisé* give it the form of a biblical lament.[53]

The true goal of Haussmann's projects was to secure the city against civil war. He wanted to make the erection of barricades in Paris impossible for all time. With the same end in mind, Louis Philippe had already introduced wooden paving. Nonetheless, barricades played a role in the February Revolution.[54] Engels studies the tactics of barricade fighting.[55] Haussmann seeks to neutralize these tactics on two fronts. Widening the streets is designed to make the erection of barricades impossible, and new streets are to furnish the shortest route between the barracks and the workers' districts. Contemporaries christen the operation "strategic embellishment."

Reveal to these depraved,
O Republic, by foiling their plots,
Your great Medusa face
Ringed by red lightning.
　　—Workers' song from about 1850, in Adolf Stahr, *Zwei Monate in Paris*
　　(Oldenburg, 1851), vol. 2, p. 199[56]

The barricade is resurrected during the Commune.[57] It is stronger and better secured than ever. It stretches across the great boulevards, often reaching a height of two stories, and shields the trenches behind it. Just as the *Communist Manifesto* ends the age of professional conspirators, so the Commune puts an end to the phantasmagoria holding sway over the early years of the proletariat. It dispels the illusion that the task of the proletarian revolution is to complete the work of 1789 hand in hand with the bourgeoisie. This illusion dominates the period 1831–1871, from the Lyons uprising to the Commune. The bourgeoisie never shared in this error. Its battle against the social rights of the proletariat dates back to the great Revolution, and converges with the philanthropic movement that gives it cover and that is in its heyday under Napoleon III. Under his reign, this movement's monumental work appears: Le Play's *Ouvriers européens.*[58] Side by side with the concealed position of philanthropy, the bourgeoisie has always maintained openly the position of class warfare.[59] As early as 1831, in the *Journal des Débats*, it acknowledges that "every manufacturer lives in his factory like a plantation owner among his slaves." If it is the misfortune of the workers' rebellions of old that no theory of revolution directs their course, it is also this absence of theory that, from another perspective, makes possible their spontaneous energy and the enthusiasm with which they set about establishing a new society. This enthusiasm, which reaches its peak in the Commune, wins over to the working class at times the best elements of the bourgeoisie, but leads it in the end to succumb to their worst elements. Rimbaud and Courbet declare their support for the Commune.[60] The burning of Paris is the worthy conclusion to Haussmann's work of destruction.[61]

My good father had been in Paris.
　　—Karl Gutzkow, *Briefe aus Paris* (Leipzig, 1842), vol. 1, p. 58

Balzac was the first to speak of the ruins of the bourgeoisie.[62] But it was Surrealism that first opened our eyes to them. The development of the

forces of production shattered the wish symbols of the previous century, even before the monuments representing them had collapsed. In the nineteenth century this development worked to emancipate the forms of construction from art, just as in the sixteenth century the sciences freed themselves from philosophy. A start is made with architecture as engineered construction. Then comes the reproduction of nature as photography. The creation of fantasy prepares to become practical as commercial art. Literature submits to montage in the feuilleton. All these products are on the point of entering the market as commodities. But they linger on the threshold. From this epoch derive the arcades and *intérieurs*, the exhibition halls and panoramas. They are residues of a dream world. The realization of dream elements, in the course of waking up, is the paradigm of dialectical thinking. Thus, dialectical thinking is the organ of historical awakening. Every epoch, in fact, not only dreams the one to follow but, in dreaming, precipitates its awakening. It bears its end within itself and unfolds it—as Hegel already noticed—by cunning. With the destabilizing of the market economy, we begin to recognize the monuments of the bourgeoisie as ruins even before they have crumbled.

Written May 1935; unpublished in Benjamin's lifetime. *Gesammelte Schriften,* V, 45–59. Translated by Howard Eiland.

Notes

Benjamin wrote this essay at the suggestion of Friedrich Pollock, codirector of the Institute for Social Research in New York, as an exposé, or synopsis, of the *Arcades Project.* Hence its highly concentrated, almost stenographic style. See Benjamin's letter to Theodor W. Adorno dated May 31, 1935, in Benjamin, *Selected Writings, Volume 3: 1935–1938* (Cambridge, Mass.: Harvard University Press, 2002), pp. 50–53.

1. Nguyen Trong Hiep (1834–1902) was a member of the Regency Council of the French protectorate of Annam (part of present-day Vietnam) from 1889 through 1897. He visited Paris on a diplomatic mission and published a book of thirty-six quatrains about his impressions of the city. Jules Claretie wrote an article about the book which cites the lines Benjamin takes as his epigraph; see Claretie, "Une description de Paris par un annamite," *Le Temps* (Paris), January 13, 1898.

2. The *magasin de nouveautés* offered a complete selection of goods in one or another specialized line of business; it had many rooms and several stories, with a large staff of employees. The first such store, Pygmalion, opened in Paris in 1793. The word *nouveauté* means "newness" or "novelty"; in the plural, it means "fancy goods." On the *magasins de nouveautés,* see Benjamin, *The Arcades Project,* trans. Howard Eiland and Kevin

McLaughlin (Cambridge, Mass.: Harvard University Press, 1999), pp. 31–61 (Convolute A).

3. Honoré de Balzac, "Histoire et physiologie des boulevards de Paris," in George Sand, Honoré de Balzac, Eugène Sue, et al., *Le Diable à Paris* (The Devil in Paris), vol. 2 (Paris, 1846), p. 91.

4. Karl Boetticher, "Das Prinzip der Hellenischen und Germanischen Bauweise hinsichtlich der Übertragung in die Bauweise unserer Tage" (The Principle of Hellenic and Germanic Building Methods in Light of Their Incorporation into the Building Methods of Today; address of March 13, 1846), in *Zum hundertjährigen Geburtstag Karl Böttichers* (Berlin, 1906), p. 46. A longer passage from Boetticher's address is cited in *The Arcades Project,* p. 150 (Convolute F1,1).

5. Sigfried Giedion, *Bauen in Frankreich* [Architecture in France] (Leipzig, 1928), p. 3.

6. See Paul Scheerbart, *Glass Architecture,* trans. James Palmes (New York: Praeger, 1972). In this work, the German writer Paul Scheerbart (1863–1915) announces the advent of a "new glass-culture." See Benjamin's discussion of Scheerbart in his essays "Experience and Poverty" (1933), in Benjamin, *Selected Writings, Volume 2: 1927–1934* (Cambridge, Mass.: Harvard University Press, 1999), pp. 733–734, and "On Scheerbart" (late 1930s or 1940), in Benjamin, *Selected Writings, Volume 4: 1938–1940* (Cambridge, Mass.: Harvard University Press, 2003), pp. 386–388.

7. Jules Michelet, "Avenir! Avenir!" (Future! Future!), *Europe,* 19, no. 73 (January 15, 1929): 6.

8. Charles Fourier (1772–1837), French social theorist and reformer, urged that society be reorganized into self-contained agrarian cooperatives which he called "phalansteries." Among his works are *Théorie des quatre mouvements* (1808) and *Le Nouveau Monde industriel* (1829–1830). See *The Arcades Project,* pp. 620–650 (Convolute W, "Fourier").

9. The period style known today as Biedermeier was popular in most of northern Europe between 1815 and 1848. In furniture and interior design, painting and literature, it was characterized by a simplification of neoclassical forms and by motifs drawn from nature. Home furnishings in this style often displayed bold color combinations and lively patterns.

10. Emile Zola published *Travail* (Labor) in 1901 and *Thérèse Raquin* in 1867. See *The Arcades Project,* pp. 203–204, 627–628.

11. The passage in question, from *Die deutsche Ideologie* (The German Ideology; 1845–1846), may be found in Marx and Engels, *Collected Works,* vol. 5 (New York: International Publishers, 1976), pp. 513–514. Carl Grün (1817–1887) was a German writer, a member of the Prussian Diet, and a follower of Feuerbach.

12. *Levana, oder Erziehungslehre* (1807) is a classic work on pedagogy. See Jean Paul, *Levana, or Doctrine of Education,* trans. Erika Casey, in *Jean Paul: A*

Reader (Baltimore: Johns Hopkins University Press, 1992), pp. 269–274. Jean Paul is the pen name of Jean Paul Friedrich Richter (1763–1825), German prose writer and humorist, whose other works include *Titan* (1800–1803) and *Vorschule der Ästhetik* (Elementary Course in Aesthetics; 1804).

13. Panoramas were large circular tableaux, usually displaying scenes of battles and cities, painted in trompe l'oeil and originally designed to be viewed from the center of a rotunda. They were introduced in France in 1799 by the American engineer Robert Fulton. Subsequent forms included the Diorama (opened by Louis Daguerre and Charles Bouton in 1822 in Paris), in which pictures were painted on cloth transparencies illuminated with various lighting effects; it was this installation that burned down in 1839.

14. That is, Jacques-Louis David (1748–1825), the neoclassical French painter.

15. Emile de Girardin (1806–1881), a member of the Chamber of Deputies, inaugurated the low-priced, mass-circulation newspaper with his editorship of *La Presse* (1836–1856, 1862–1866), at an annual subscription rate of forty francs.

16. Louis Jacques Mandé Daguerre (1787–1851), French painter and inventor, helped to develop the Diorama in Paris (1822), and collaborated with Joseph Nicéphore Niépce (1829–1833) on work leading to the discovery of the daguerreotype process, communicated to the Academy of Sciences in 1839. Pierre Prévost (1764–1823) was a French painter.

17. The French physicist and politician Dominique François Jean Arago (1786–1853) presented his expert report in favor of Daguerre's invention in 1839.

18. Nadar is the pseudonym of Gaspard-Félix Tournachon (1820–1910), French photographer, journalist, and caricaturist. In 1864–1865, he used his patented new process of photography by electric light to take photographs of the Paris sewers.

19. A. J. Wiertz, "La Photographie," in *Oeuvres littéraires* (Paris, 1870), pp. 309ff. Antoine Joseph Wiertz (1806–1865) was a Belgian painter of colossal historical scenes, lampooned by Baudelaire. See Benjamin's "Antoine Wiertz" (1929) and "Letter from Paris (2)" (1936), in this volume.

20. Ferdinand Langlé and Emile Vanderburch, *Louis-Bronze et le Saint-Simonien: Parodie de Louis XI* (Théâtre du Palais-Royal, February 27, 1832), cited in Théodore Muret, *L'Histoire par le théâtre, 1789–1851* (Paris, 1865), vol. 3, p. 191.

21. Actually, it was the French philologist and historian Ernest Renan (1823–1892), author of *La Vie de Jésus* (The Life of Jesus; 1863) and many other works, who made this statement. See *The Arcades Project*, pp. 180 (Convolute G4,5) and 197 (Convolute G13a,3).

22. Sigmund Engländer, *Geschichte der französischen Arbeiter-Associationen* (History of French Workers' Associations; 1864), vol. 4, p. 52.

23. The French chemist and industrialist Jean-Antoine Chaptal (1756–1832)

served as Minister of the Interior (1801–1809). He was the founder of the first Ecole des Arts et Métiers.

24. The Saint-Simonians were followers of the philosopher and social reformer Henri de Saint-Simon (1760–1825), considered the founder of French socialism. His works include *Du Système industriel* (1820–1823) and *Le Nouveau Christianisme* (1825). After helping to organize the constitutional monarchy of Louis Philippe (1830–1848), Saint-Simonians came to occupy important positions in nineteenth-century French industry and finance. Michel Chevalier (1806–1879), an economist and advocate of free trade, was coeditor of *Le Globe* (1830–1832) and later, under Napoleon III, a councilor of state and professor at the Collège de France. Barthélemy Prosper Enfantin (1796–1864), a Saint-Simonian leader known as "Père Enfantin," established in 1832, on his estate at Ménilmontant, a model community characterized by fantastic sacerdotalism and freedom between the sexes. He later became the first director of the Lyons Railroad Company (1845). See *The Arcades Project*, pp. 571–602 (Convolute U, "Saint-Simon, Railroads").

25. Grandville is the pseudonym of Jean-Ignace-Isidore Gérard (1803–1847), a caricaturist and illustrator whose work appeared in the periodicals *Le Charivari* and *La Caricature*. See *The Arcades Project*, pp. 171– 202 (Convolute G, "Exhibitions, Advertising, Grandville").

26. Karl Marx, *Capital*, vol. 1, trans. Samuel Moore and Edward Aveling (New York: International Publishers, 1967), p. 76.

27. Giacomo Leopardi, "Dialogo della moda e della morte" (1827). See, in English, Leopardi, *Essays and Dialogues,* trans. Giovanni Cecchetti (Berkeley: University of California Press, 1982), p. 67.

28. Benjamin refers to an illustration in Grandville's *Un Autre Monde,* reproduced in *The Arcades Project*, p. 65. See also *Fantastic Illustrations of Grandville* (New York: Dover, 1974), p. 49; this volume contains illustrations from *Un Autre Monde* and *Les Animaux.*

29. The French writer Alphonse Toussenel (1803–1885) was editor of *La Paix* and author of *L'Esprit des bêtes* (Spirit of the Beasts; 1856).

30. The International Workingmen's Association (the First International), whose General Council had its seat in London, was founded in September 1864.

31. Jacques Offenbach (1819–1880), German-born musician and composer, produced many successful operettas and *opéras bouffes* in Paris, where he managed the Gaîté-Lyrique (1872–1876).

32. Baudelaire, *Les Fleurs du Mal* (Flowers of Evil; 1857).

33. Louis Philippe (1773–1850), a descendant of the Bourbon-Orléans royal line of France, was declared "Citizen King" in the July Revolution of 1830; his reign was marked by the bourgeoisie's rise to power. He was overthrown by the February Revolution of 1848.

34. The historian and statesman François Guizot (1787–1874) became premier of France in 1847. He was forced out of office by the 1848 revolution.

35. Jugendstil is the German and Austrian variant of the Art Nouveau style of the 1890s. The movement took its name from the Munich journal *Die Jugend* (Youth).

36. The Belgian architect and interior designer Henry van de Velde (1863–1957), author of *Vom neuen Stil* (The Modern Style; 1907), was one of the leading exponents of Jugendstil.

37. Henrik Ibsen's play *The Master Builder* was produced in 1892. See *The Arcades Project,* pp. 221 (Convolute I4,4) and 551 (Convolute S4,6).

38. On the figure of the Parisian apache, who "abjures virtue and laws" and "terminates the *contrat social* forever," and on the "poetry of apachedom," see "The Paris of the Second Empire in Baudelaire" (1938), in Benjamin, *Selected Writings,* vol. 4, pp. 3–92.

39. Baudelaire, *Les Fleurs du Mal* (Flowers of Evil; 1857).

40. See the passages from Engels' *Die Lage der arbeitenden Klasse in England* (The Condition of the Working Class in England) and from Poe's story "The Man of the Crowd" cited in *The Arcades Project,* pp. 427–428 (Convolute M5a,1) and 445 (Convolute M15a,2), respectively.

41. *The Aeneid of Virgil,* trans. Allen Mandelbaum (New York: Bantam, 1971), p. 137 (book 6, line 126). Benjamin quotes the Latin.

42. "Spleen et idéal" (Spleen and Ideal) is the title of the first section of Baudelaire's *Fleurs du Mal* (Flowers of Evil; 1857).

43. Baudelaire, "Le Voyage," in *Les Fleurs du Mal* (Flowers of Evil; 1857).

44. Baudelaire, "Pierre Dupont," in *Baudelaire as a Literary Critic,* trans. Lois B. Hyslop and Francis E. Hyslop, Jr. (University Park: Pennsylvania State University Press, 1964), p. 53.

45. Applying Kant's idea of the pure and disinterested existence of the work of art, the French philosopher Victor Cousin made use of the phrase *l'art pour l'art* ("art for art's sake") in his 1818 lecture "Du Vrai, du beau, et du bien" (On the True, the Beautiful, and the Good). The idea was later given currency by writers such as Théophile Gautier, Edgar Allan Poe, and Charles Baudelaire.

46. Baudelaire's enthusiasm for Wagner's music, which he describes as a "revelation" and as specifically "modern," is expressed in his February 17, 1860, letter to Wagner, after the composer had come to Paris to direct three concerts of his music, and in his 1861 essay, "Richard Wagner et Tannhäuser à Paris" (Richard Wagner and Tannhäuser in Paris). See *The Selected Letters of Charles Baudelaire,* trans. Rosemary Lloyd (Chicago: University of Chicago Press, 1986), pp. 145–146; and Baudelaire, *The Painter of Modern Life and Other Essays,* trans. Jonathan Mayne (New York: Da Capo, 1986), pp. 111–146.

47. *Confession d'un lion devenu vieux* (Confession of a Lion Grown Old; 1888) was published anonymously by Baron Georges Eugène Haussmann (1809–1891). As Prefect of the Seine (1853–1870) under Napoleon III, Haussmann carried out a large-scale renovation of Paris, which included the construc-

tion of wide boulevards through the city and the demolition of many old Parisian neighborhoods and arcades built in the first half of the century.

48. Charles Louis Napoleon Bonaparte (1808–1873), known as Louis Napoleon, was a nephew of Napoleon I. After being elected president of the Republic at the end of 1848, he made himself dictator by a coup d'état on December 2, 1851; a year later, he proclaimed himself emperor as Napoleon III. His reign, the Second Empire, was marked by economic expansion, aggressive foreign intervention, and a wavering authoritarian tone. He was deposed by the National Assembly in 1871, following his capture at the Battle of Sedan during the Franco-Prussian War (1870–1871).

49. Paul Lafargue (1842–1911) was a French radical socialist and writer closely associated with Marx and Engels. For his comparison between the market and the gambling house, see *The Arcades Project*, p. 497 (Convolute O4,1).

50. The Court of Cassation was established in 1790 as the highest court of appeals in the French legal system. During the Second Empire, it tended to serve the interests of the bourgeoisie, which had come to power under Louis Philippe. It thus represented a check on the power of Napoleon III and Baron Haussmann.

51. The "red belt" was a name for the suburbs immediately surrounding Paris proper in the later nineteenth century. These districts were populated by many of the working class who had been displaced by Haussmann's urban renewal.

52. The French journalist Maxime Du Camp (1822–1894) wrote *Paris: Ses organes, ses fonctions et sa vie dans la seconde moitié du XIXe siècle* (1869–1875), a six-volume account of nineteenth-century Paris. See *The Arcades Project*, pp. 90–91 (Convolute C,4), on Du Camp's conception of this work.

53. Anonymous, *Paris désert: Lamentations d'un Jérémie haussmannisé* (Deserted Paris: Jeremiads of a Man Haussmannized; 1868).

54. The "February Revolution" refers to the overthrow of Louis Philippe's constitutional monarchy in February 1848.

55. Engels' critique of barricade tactics is excerpted in *The Arcades Project*, p. 123 (Convolute E1a,5).

56. The verse derives from the popular lyric poet and songwriter Pierre Dupont (1821–1870). See *The Arcades Project*, p. 710 (Convolute a7,3).

57. The Commune of Paris was the revolutionary government established in Paris on March 18, 1871, in the aftermath of the Franco-Prussian War. It was suppressed in bloody street-fighting that ended May 28, 1871, leaving 20,000 Communards dead.

58. Frédéric Le Play, *Les Ouvriers européens: Etudes sur les travaux, la vie domestique et la condition morale des populations ouvrières de l'Europe, précédées d'un exposé de la méthode d'observation* (European Workers: Studies of the Work, Domestic Life, and Moral Condition of the Laboring Populations of Europe, Prefaced by a Statement on Observational Method;

1855). Le Play (1806–1882) was an engineer and economist who, as senator (1867–1870), represented a paternalistic "social Catholicism."

59. In his second exposé to the *Arcades Project*, written in French in 1939, Benjamin apparently corrects this assertion: "Side by side with the overt position of philanthropy, the bourgeoisie has always maintained the covert position of class struggle" (*The Arcades Project*, p. 24).

60. At the age of eighteen, the French poet Rimbaud wrote from his home in northern France, in a letter of May 13, 1871: "I will be a worker. This idea holds me back when mad anger drives me toward the battle of Paris— where so many workers are dying as I write. . . . Work now?—Never, never. I am on strike." Arthur Rimbaud, *Complete Works: Selected Letters*, trans. Wallace Fowlie (Chicago: University of Chicago Press, 1966), p. 303. Gustave Courbet (1819–1877), leading French Realist painter, presided over the Committee of Fine Arts during the Commune. He was imprisoned six months for helping to destroy the column in the Place Vendôme during the uprising of 1871, and in 1875 was ordered to pay for the restoration of the column.

61. In the course of "Bloody Week" (May 21–28, 1871), the desperate Communards set fire to many public buildings, including the Tuileries Palace and the Hôtel de Ville (City Hall).

62. Balzac's comment, from 1845, is cited in *The Arcades Project*, p. 87 (Convolute C2a,8).

10

Eduard Fuchs, Collector and Historian

I

The lifework of Eduard Fuchs belongs to the recent past.[1] A look back at this work encounters all the difficulties involved in any attempt to take account of the recent past. Moreover, it is the recent past of the Marxist theory of art which is at issue here, and this fact does not simplify matters. For unlike Marxist economics, this theory still has no history. Its originators, Marx and Engels, did little more than indicate to materialist dialectics the wide range of possibilities in this area. And the first to set about exploring it—a Plekhanov, a Mehring—absorbed the lessons of these masters only indirectly, or at least belatedly.[2] The tradition that leads from Marx through Wilhelm Liebknecht to Bebel has benefited the political side of Marxism far more than the scientific or scholarly side.[3] Mehring traveled the path of nationalism before passing through the school of Lassalle; and at the time of his entrance into the Social Democratic Party, according to Kautsky, "a more or less vulgar Lassalleanism held sway. Aside from the thought of a few isolated individuals, there was no coherent Marxist theory."[4] It was only later, toward the end of Engels' life, that Mehring came into contact with Marxism. For his part, Fuchs got to know Mehring early on. In the context of their relationship, for the first time a tradition arose within the cultural [geistesgeschichtlichen] research of historical materialism. But, as both men recognized, Mehring's chosen field—the history of literature—had little in common with Fuchs's field of specialization. Even more telling was the difference in temperament. Mehring was by nature a scholar; Fuchs, a collector.

There are many kinds of collectors, and in each of them a multitude of impulses is at work. As a collector, Fuchs is primarily a pioneer. He founded the only existing archive for the history of caricature, of erotic art, and of the genre painting [*Sittenbild*]. More important, however, is another, complementary circumstance: because he was a pioneer, Fuchs became a collector. Fuchs is the pioneer of a materialist consideration of art. Yet what made this materialist a collector was his more or less clear feeling for his perceived historical situation. It was the situation of historical materialism itself.

This situation is expressed in a letter which Friedrich Engels sent to Mehring at a time when Fuchs, working in a Socialist editorial office, won his first victories as a political writer. The letter, dated July 14, 1893, among other things elaborates on the following:

> It is above all this semblance of an independent history of state constitutions, of legal systems, and of ideological conceptions in each specialized field of study which deceives most people. If Luther and Calvin "overcome" the official Catholic religion, if Hegel "overcomes" Fichte and Kant, and if Rousseau indirectly "overcomes" the constitutional work of Montesquieu with his *Contrat social*, this is a process which remains within theology, philosophy, and political science. This process represents a stage in the history of these disciplines, and in no way goes outside the disciplines themselves. And ever since the bourgeois illusion of the eternity and finality of capitalist production entered the picture, even the overcoming of the mercantilists by the physiocrats and Adam Smith is seen as a mere victory of thought—not as the reflection in thought of changed economic facts, but as the finally achieved correct insight into actual relations existing always and everywhere.[5]

Engels' argument is directed against two elements. First of all, he criticizes the convention in the history of ideas which represents a new dogma as a "development" of an earlier one, a new poetic school as a "reaction" to one preceding, a new style as the "overcoming" of an earlier one. At the same time, however, it is clear that he implicitly criticizes the practice of representing such new constructions [*Gebilde*] as completely detached from their effect on human beings and their spiritual as well as economic processes of production. Such an argument destroys the humanities' claim to being a history of state constitutions or of the natural sciences, of religion or of art. Yet the explosive force of this thought, which Engels carried with him for half a century, goes deeper.[6] It places the closed unity of the disciplines and their products in question. So far as

art is concerned, this thought challenges the unity of art itself, as well as that of those works which purportedly come under the rubric of art. For the dialectical historian concerned with works of art, these works integrate their fore-history as well as their after-history; and it is by virtue of their after-history that their fore-history is recognizable as involved in a continuous process of change. Works of art teach him how their function outlives their creator and how the artist's intentions are left behind. They demonstrate how the reception of a work by its contemporaries is part of the effect that the work of art has on us today. They further show that this effect depends on an encounter not just with the work of art alone but with the history which has allowed the work to come down to our own age. Goethe made this point in a characteristically veiled manner when, in a conversation about Shakespeare, he said to Chancellor von Müller: "Nothing that has had a great effect can really be judged any longer."[7] No statement better evokes that state of unease which marks the beginning of any consideration of history worthy of being called dialectical. Unease over the provocation to the researcher, who must abandon the calm, contemplative attitude toward his object in order to become conscious of the critical constellation in which precisely this fragment of the past finds itself with precisely this present. "The truth will not run away from us"—this statement by Gottfried Keller indicates exactly that point in historicism's image of history where the image is pierced by historical materialism.[8] For it is an irretrievable image of the past which threatens to disappear in any present that does not recognize itself as intimated in that image.

The more one considers Engels' sentences, the more one appreciates his insight that every dialectical presentation of history is paid for by a renunciation of the contemplativeness which characterizes historicism. The historical materialist must abandon the epic element in history. For him, history becomes the object of a construct whose locus is not empty time but rather the specific epoch, the specific life, the specific work. The historical materialist blasts the epoch out of its reified "historical continuity," and thereby the life out of the epoch, and the work out of the lifework. Yet this construct results in the simultaneous preservation and sublation [Aufhebung] of the lifework in the work, of the epoch in the lifework, and of the course of history in the epoch.[9]

Historicism presents the eternal image of the past, whereas historical materialism presents a given experience with the past—an experience that is unique. The replacement of the epic element by the constructive element proves to be the condition for this experience. The immense forces bound up in historicism's "Once upon a time" are liberated in this expe-

rience. To put to work an experience with history—a history that is originary for every present—is the task of historical materialism. The latter is directed toward a consciousness of the present which explodes the continuum of history.

Historical materialism conceives historical understanding as an afterlife of that which has been understood and whose pulse can be felt in the present. This understanding has its place in Fuchs's thinking, but not an undisputed one. In his thinking, an old dogmatic and naive idea of reception exists alongside the new and critical one. The first could be summarized as follows: what determines our reception of a work must have been its reception by its contemporaries. This is precisely analogous to Ranke's "how it really was," which is what "solely and uniquely" matters.[10] Next to this, however, we immediately find the dialectical insight which opens the widest horizons in the meaning of a history of reception. Fuchs criticizes the fact that, in the history of art, the question of the success of a work of art remains unexamined. "This neglect . . . mars our whole consideration of art. Yet it strikes me that uncovering the real reasons for the greater or lesser success of an artist—the reasons for the duration of his success or its opposite—is one of the most important problems . . . connected to art."[11] Mehring understood the matter in the same way. In his *Lessing-Legende,* the reception of Lessing's work by Heine, Gervinus, Stahr, Danzel, and finally Erich Schmitt becomes the starting point for his analyses.[12] And it is not without good reason that Julian Hirsch's investigation into the "genesis of fame" appeared only shortly thereafter, though Hirsch's work is notable less for its methodology than for its content.[13] Hirsch deals with the same problem that Fuchs does. Its solution provides criteria for the standards of historical materialism. This fact, however, does not justify suppression of another—namely, that such a solution does not yet exist. Rather, one must admit without reservation that only in isolated instances has it been possible to grasp the historical content of a work of art in such a way that it becomes more transparent to us *as a work of art.* All more intimate engagement with a work of art must remain a vain endeavor, so long as the work's sober historical content is untouched by dialectical knowledge. This, however, is only the first of the truths by which the work of the collector Eduard Fuchs is oriented. His collections are the practical man's answer to the aporias of theory.

II

Fuchs was born in 1870. From the outset, he was not meant to be a scholar. Nor did he ever become a scholarly "type," despite the great

learning that informs his later work. His efforts constantly extended beyond the horizon of the researcher. This is true for his accomplishments as a collector as well as for his activities as a politician. Fuchs entered the working world in the mid-1880s, during the period of the anti-Socialist laws.[14] His apprenticeship brought him together with politically concerned proletarians, who soon drew him into the struggle of those branded illegal at that time—a struggle which appears to us today in a rather idyllic light. Those years of apprenticeship ended in 1887. A few years later, the *Münchener Post,* organ of the Bavarian Social Democrats, summoned the young bookkeeper Fuchs from a printing shop in Stuttgart. Fuchs, they thought, would be able to clear up the administrative difficulties of the paper. He went to Munich, and worked closely with Richard Calver.

The publishers of the *Münchener Post* also put out the *Süddeutsche Postillion,* a Socialist magazine of political humor. It so happened that Fuchs was called to assist temporarily with the page proofs of one issue, and had to fill in gaps with some of his own contributions. The success of this issue was extraordinary. That year, Fuchs also edited the journal's May issue, which was brightly illustrated (color printing was then in its infancy). This issue sold 60,000 copies—when the average annual distribution was a mere 2,500 copies. In this way, Fuchs became editor of a magazine devoted to political satire. In addition to his daily responsibilities, Fuchs at once turned his attention to the history of his field. These efforts resulted in two illustrated studies—on the year 1848 as reflected in caricatures, and on the political affair of Lola Montez.[15] In contrast to the history books illustrated by living artists (such as Wilhelm Blos's popular books on the revolution, with pictures by Jentzsch), these were the first historical works illustrated with documentary pictures.[16] Encouraged by Harden, Fuchs even advertised his work on Lola Montez in *Die Zukunft,* and did not forget to say that it was merely part of a larger work he was planning to devote to the caricature of the European peoples.[17] The studies for this work profited from a ten-month prison sentence he served, after being convicted of *lèse majesté* for his publications. The idea seemed clearly auspicious. A certain Hans Kraemer, who had some experience in the production of illustrated housekeeping-books, introduced himself to Fuchs saying that he was already working on a history of caricature, and suggested that they combine their studies and collaborate on the work. Kraemer's contributions, however, never materialized. Soon it became evident that the entire substantial workload rested on Fuchs. The name of the presumptive collaborator was elimi-

nated from the title page of the second edition, though it had appeared on the first. But Fuchs had given the first convincing proof of his stamina and his control of his material. The long series of his major works had begun.

Fuchs's career began at a time when, as the *Neue Zeit* once put it, the "trunk of the Social Democratic Party was producing ring after ring of organic growth."[18] With this growth, new tasks in the educational work of the party came to light. The greater the masses of workers that joined the party, the less the party could afford to be content with their merely political and scientific enlightenment—that is, with a vulgarization of the theory of surplus value and the theory of evolution. The party had to direct its attention to the inclusion of historical material both in its lecture programs and in the feuilleton section of the party press. Thus, the problem of the "popularization of science" arose in its full complexity. No one found a solution. Nor could a solution even be envisioned, so long as those to be educated were considered a "public" rather than a class.[19] If the educational effort of the party had been directed toward the "class," it would not have lost its close touch with the scientific tasks of historical materialism. The historical material, turned by the plow of Marxist dialectics, would have become a soil capable of giving life to the seed which the present planted in it. But that did not occur. The Social Democrats opposed their own slogan, "Knowledge Is Power," to the slogan "Work and Education," which Schultz-Delitzsch's piously loyal unions made the banner for their workers' education.[20] But the Social Democrats did not perceive the double meaning of their own slogan. They believed that the same knowledge which secured the domination of the proletariat by the bourgeoisie would enable the proletariat to free itself from this domination. In reality, a form of knowledge which had no access to practice, and which could teach the proletariat nothing about its situation as a class, posed no danger to its oppressors. This was especially the case with the humanities. The humanities represented a kind of knowledge quite unrelated to economics, and consequently untouched by the revolution in economic theory. The humanities were content "to stimulate," "to offer diversion," and "to be interesting." History was loosened up to yield "cultural history." Here Fuchs's work has its place. Its greatness lies in its reaction to this state of affairs; its problems lie in the fact that it contributes to this state. From the very beginning, Fuchs made it a principle to aim for a mass readership.[21]

At that time, only a few people realized how much truly depended on the materialist educational effort. The hopes and (more important) the

fears of those few were expressed in a debate that left traces in the *Neue Zeit*. The most important of these is an essay by Korn entitled "Proletariat und Klassik" [Proletariat and Classicism]. This essay deals with the concept of heritage [*Erbe*], which has again become important today. According to Korn, Lassalle saw German idealism as a heritage bequeathed to the working class. Marx and Engels understood the matter differently, however.

> They did not consider the social priority of the working class as . . . a heritage; rather, they derived it from the pivotal position of the working class in the production process. How can one speak of possession, even spiritual possession, with respect to a parvenu class such as the modern proletariat? Every hour, every day, this proletariat demonstrates its "right" by means of its labor, which continuously reproduces the whole cultural apparatus. Thus, for Marx and Engels the showpiece of Lassalle's educational ideal— namely, speculative philosophy—was no tabernacle, . . . and both felt more and more drawn toward natural science. Indeed, for a class which is essentially defined by the functions it performs, natural science may be called science per se, just as for the ruling and possessing class everything that is historical comprises the given form of their ideology. In fact, history represents, for consciousness, the category of possession in the same way that capital represents, for economics, the domination over past labor.[22]

This critique of historicism has a certain weight. But the reference to natural science—as "science per se"—for the first time affords a clear view of the dangerous problematic informing the educational question. Since the time of Bebel, the prestige of natural science had dominated the debate. Bebel's main work, *Die Frau und der Sozialismus* [Woman and Socialism], sold 200,000 copies in the thirty years that passed between its first publication and the appearance of Korn's essay. Bebel's high regard for natural science rests not only on the calculable accuracy of its results, but above all on its practical usefulness.[23] Somewhat later, the natural sciences assume a similar position in Engels' thinking when he believes he has refuted Kant's phenomenalism by pointing to technology, which through its achievements shows that we do recognize "things in themselves." It is above all in its capacity as the foundation of technology that natural science, which for Korn appears as science per se, makes this possible. Technology, however, is obviously not a purely scientific development. It is at the same time a historical one. As such, it forces an examination of the attempted positivistic and undialectical separation between the natural sciences and the humanities. The questions that humanity brings to nature are in part conditioned by the level of production. This is

the point at which positivism fails. In the development of technology, it was able to see only the progress of natural science, not the concomitant retrogression of society. Positivism overlooked the fact that this development was decisively conditioned by capitalism. By the same token, the positivists among the Social Democratic theorists failed to understand that the increasingly urgent act which would bring the proletariat into possession of this technology was rendered more and more precarious because of this development. They misunderstood the destructive side of this development because they were alienated from the destructive side of dialectics.

A prognosis was due, but failed to materialize. That failure sealed a process characteristic of the past century: the bungled reception of technology. The process has consisted of a series of energetic, constantly renewed efforts, all attempting to overcome the fact that technology serves this society only by producing commodities. At the beginning, there were the Saint-Simonians with their industrial poetry.[24] Then came the realism of Du Camp, who saw the locomotive as the saint of the future.[25] Finally there was Ludwig Pfau: "It is quite unnecessary to become an angel," he wrote, "since a locomotive is worth more than the nicest pair of wings."[26] This view of technology is straight out of the *Gartenlaube*.[27] It may cause one to ask whether the complacency [*Gemütlichkeit*] of the nineteenth-century bourgeoisie did not stem from the hollow comfort of never having to experience how the productive forces had to develop under their hands. This experience was really reserved for the following century, which has discovered that the speed of traffic and the ability of machines to duplicate words and writing outstrip human needs. The energies that technology develops beyond this threshold are destructive. First of all, they advance the technology of war and its propagandistic preparation. One might say that this development (which was thoroughly class conditioned) occurred behind the back of the last century, which was not yet aware of the destructive energies of technology. This was especially true of the Social Democrats at the turn of the century. Though they occasionally took a stand against the illusions of positivism, they remained largely in thrall to them. They saw the past as having been gathered up and stored forever in the granaries of the present. Although the future held the prospect of work, it also held the certainty of a rich harvest.

III

This was the period in which Eduard Fuchs came of age, and which engendered decisive aspects of his work. To put it simply, his work partici-

pates in a problematic that is inseparable from cultural history. This problematic leads back to the quotation from Engels. One might take this quotation to be the *locus classicus* which defines historical materialism as the history of culture. Isn't this the real meaning of the passage? Doesn't the study of individual disciplines (once the semblance of their unity has been removed) inevitably coalesce in the study of cultural history as the inventory which humanity has preserved to the present day? In truth, to pose the question in this way is to replace the varied and problematic unities which intellectual history embraces (as history of literature and art, of law and religion) merely by a new and even more problematic unity. Cultural history presents its contents by throwing them into relief, setting them off. Yet for the historical materialist, this relief is illusory and is conjured up by false consciousness.[28] He thus confronts it with reservations. Such reservations would be justified by a mere perusal of that which has existed: whatever the historical materialist surveys in art or science has, without exception, a lineage he cannot observe without horror. The products of art and science owe their existence not merely to the effort of the great geniuses who created them, but also, in one degree or another, to the anonymous toil of their contemporaries. There is no document of culture which is not at the same time a document of barbarism. No cultural history has yet done justice to this fundamental state of affairs, and it can hardly hope to do so.

Nevertheless, the crucial element does not lie here. If the concept of culture is problematic for historical materialism, it cannot conceive of the disintegration of culture into goods which become objects of possession for mankind. Historical materialism sees the work of the past as still uncompleted. It perceives no epoch in which that work could, even in part, drop conveniently, thing-like, into mankind's lap. The concept of culture—as the embodiment of creations considered independent, if not of the production process in which they originate, then of a production process in which they continue to survive—has a fetishistic quality. Culture appears reified. The history of culture would be nothing but the sediment formed in the consciousness of human beings by memorable events, events stirred up in the memory by no genuine—that is to say, political—experience.

Apart from this, one cannot ignore the fact that thus far no work of history undertaken on a cultural-historical basis has escaped this problematic. It is obvious in Lamprecht's massive *Deutsche Geschichte* [German History], a book which for understandable reasons has more than once been criticized by the *Neue Zeit*. "As we know," Mehring writes, "Lamprecht is the one bourgeois historian who came closest to historical

materialism. [But] Lamprecht stopped halfway. . . . Any notion of a historical method disappears when Lamprecht treats cultural and economic developments according to a specific method and then proceeds to compile a history of simultaneous political developments from other historians."[29] To be sure, it makes no sense to present cultural history on the basis of pragmatic historiography. Yet a dialectical history of culture in itself is even more devoid of sense, since the continuum of history—once blasted apart by dialectic—is never dissipated so widely as it is in the realm known as culture.

In short, cultural history only seems to represent an advance in insight; actually, it does not entail even the semblance of an advance in the realm of dialectics. For cultural history lacks the destructive element which authenticates both dialectical thought and the experience of the dialectical thinker. It may augment the weight of the treasure accumulating on the back of humanity, but it does not provide the strength to shake off this burden so as to take control of it. The same is true for the socialist educational efforts at the turn of the century, which were guided by the star of cultural history.

IV

Against this background, the historical contours of Fuchs's work become apparent. Those aspects of his work which are likely to endure were wrested from an intellectual constellation that could hardly have appeared less propitious. This is the point where Fuchs the collector taught Fuchs the theoretician to comprehend much that the times denied him. He was a collector who strayed into marginal areas—such as caricature and pornographic imagery—which sooner or later meant the ruin of a whole series of clichés in traditional art history. First, it should be noted that Fuchs had broken completely with the classicist conception of art, whose traces can still be seen in Marx. The concepts through which the bourgeoisie developed this notion of art no longer play a role in Fuchs's work; neither beautiful semblance [der schöne Schein], nor harmony, nor the unity of the manifold is to be found there. And the collector's robust self-assertion (which alienated Fuchs from classicist theories) sometimes makes itself felt—devastatingly blunt—with regard to classical antiquity itself. In 1908, drawing on the work of Slevogt and Rodin, Fuchs prophesied a new beauty "which, in the end, will be infinitely greater than that of antiquity. Whereas the latter was only the highest animalistic form, the new beauty will be filled with a lofty spiritual and emotional content."[30]

In short, the order of values which determined the consideration of

art for Goethe and Winckelmann has lost all influence in the work of Fuchs.[31] Of course, it would be a mistake to assume that the idealist view of art was itself entirely unhinged. That cannot happen until the *disjecta membra* which idealism contains—as "historical representation" on the one hand and "appreciation" on the other—are merged and thereby surpassed. This effort, however, is left to a mode of historical science which fashions its object not out of a tangle of mere facticities but out of the numbered group of threads representing the woof of a past fed into the warp of the present. (It would be a mistake to equate this woof with mere causal connection. Rather, it is thoroughly dialectical. For centuries, threads can become lost, only to be picked up again by the present course of history in a disjointed and inconspicuous way.) The historical object removed from pure facticity does not need any "appreciation." It does not offer vague analogies to actuality, but constitutes itself in the precise dialectical problem [*Aufgabe*] which actuality is obliged to resolve. That is indeed what Fuchs intends. If nowhere else, his intention may be felt in the pathos which often makes the text read like a lecture. This fact, however, also indicates that much of what he intended did not get beyond its mere beginnings. What is fundamentally new in his intention finds direct expression primarily where the material meets it halfway. This occurs in his interpretation of iconography, in his contemplation of mass art, in his examination of the techniques of reproduction. These are the pioneering aspects of Fuchs's work, and are elements of any future materialist consideration of art.

The three abovementioned motifs have one thing in common: they refer to forms of knowledge which could only prove destructive to traditional conceptions of art. The concern with techniques of reproduction, more than any other line of research, brings out the crucial importance of reception; it thus, within certain limits, enables us to correct the process of reification which takes place in a work of art. The consideration of mass art leads to a revision of the concept of genius; it reminds us to avoid giving priority to inspiration, which contributes to the genesis of the work of art, over and against its material character [*Faktur*], which is what allows inspiration to come to fruition. Finally, iconographic interpretation not only proves indispensable for the study of reception and mass art; it prevents the excesses to which any formalism soon leads.[32]

Fuchs had to come to grips with formalism. Wölfflin's doctrine was gaining acceptance at the same time that Fuchs was laying the foundations of his own work. In *Das individuelle Problem* [The Problem of the Individual], Fuchs elaborates on a thesis from Wölfflin's *Die klassische*

Kunst [Classic Art]. The thesis runs as follows: "Quattrocento and Cinquecento as stylistic concepts cannot be characterized simply in terms of subject matter. The phenomenon . . . indicates a development of artistic vision which is essentially independent of any particular attitude of mind or any particular idea of beauty."[33] Certainly, such a formulation can be an affront to historical materialism. Yet it also contains useful elements. For it is precisely historical materialism that is interested in tracing the changes in artistic vision not so much to a changed ideal of beauty as to more elementary processes—processes set in motion by economic and technological transformations in production. In the above case, one would hardly fail to benefit from asking what economically conditioned changes the Renaissance brought about in housing construction. Nor would it be unprofitable to examine the role played by Renaissance painting in prefiguring the new architecture and in illustrating its emergence, which Renaissance painting made possible.[34] Wölfflin, of course, touches on the question only in passing. But when Fuchs retorts that "it is precisely these formal elements that cannot be explained in any other way than by a change in the mood of the times,"[35] he points directly to the dubious status of cultural-historical categories, as discussed above.

In more than one passage, it becomes clear that polemic and even discussion are not characteristic of Fuchs as a writer. As pugnacious as he may appear, his arsenal does not seem to include the eristic dialectic—the dialectic which, according to Hegel, "unites with the strength of the opponent in order to destroy him from within." Among the scholars who followed Marx and Engels, the destructive force of thought had weakened and no longer dared to challenge the century. The multitude of struggles had already slackened the tension in Mehring's work, though his *Lessing-Legende* remains a considerable achievement. In this book, he showed what enormous political, scientific, and theoretical energies were enlisted in the creation of the great works of the classic period. He thus affirmed his distaste for the lazy routine of his belletristic contemporaries. Mehring came to the bold insight that art could expect its rebirth only through the economic and political victory of the proletariat. He also arrived at the unassailable conclusion that "[art] cannot significantly intervene in the proletariat's struggle for emancipation."[36] The subsequent development of art proved him right. Such insights led Mehring with redoubled urgency to the study of science. Here he acquired the solidity and rigor which made him immune to revisionism. He thus developed traits in his character which could be called bourgeois in the best

sense of the term, though they were by no means enough to earn him the title of dialectical thinker. The same traits can be found in Fuchs. In him they may be even more prominent, insofar as they have been incorporated into a more expansive and sensualist talent. Be that as it may, one can easily imagine his portrait in a gallery of bourgeois scholars. One might hang his picture next to that of Georg Brandes, with whom he shares a rationalistic furor, a passion for throwing light onto vast historical expanses by means of the torch of the Ideal (whether of progress, science, or reason). On the other side, one could imagine the portrait of ethnologist Adolf Bastian.[37] Fuchs resembles the latter particularly in his insatiable hunger for material. Bastian was legendary for his readiness to pack a suitcase and set off on expeditions in order to resolve an issue, even if it kept him away from home for months. Similarly, Fuchs obeyed his impulses whenever they drove him to search for new evidence. The works of both these men will remain inexhaustible lodes for research.

V

The following is bound to be an important question for psychologists: How can an enthusiast, a person who by nature embraces the positive, have such a passion for caricature? Psychologists may answer as they like—but there can be no doubt in Fuchs's case. From the beginning, his interest in art has differed from what one might call "taking pleasure in the beautiful." From the beginning, he has mixed truth with play. Fuchs never tires of stressing the value of caricature as a source, as authority. "Truth lies in the extreme," he occasionally remarks. But he goes further. To him, caricature is "in a certain sense the form . . . from which all objective art arises. A single glance into ethnographic museums furnishes proof of this statement."[38] When Fuchs adduces prehistoric peoples or children's drawings, the concept of caricature is perhaps brought into a problematic context; yet his vehement interest in an artwork's more drastic aspects, whether of form or content,[39] manifests itself all the more originally. This interest runs throughout the entire expanse of his work. In the late work *Tang-Plastik* [Tang Sculpture], we can still read the following:

> The grotesque is the intense heightening of what is sensually imaginable. In this sense, grotesque figures are an expression of the robust health of an age. . . . Yet one cannot dispute the fact that the motivating forces of the grotesque have a crass counterpoint. Decadent times and sick brains also

incline toward grotesque representations. In such cases the grotesque is a shocking reflection of the fact that for the times and individuals in question, the problems of the world and of existence appear insoluble. One can see at a glance which of these two tendencies is the creative force behind a grotesque fantasy.[40]

This passage is instructive. It makes especially clear what the broad appeal and popularity of Fuchs's work rests on—namely, his gift for taking the basic concepts informing his presentation and connecting these directly with valuation. This often occurs on a massive scale.[41] Moreover, these valuations are always extreme. They are bipolar in nature, and thus polarize the concept with which they are fused. This can be seen in his depictions of the grotesque and of erotic caricature. In periods of decline, erotic caricature becomes "titillation" or "smut," whereas in better times it "expresses superabundant pleasure and exuberant strength."[42] Sometimes Fuchs bases his notions of value on the poles of "flourishing" and "decadence"; sometimes, on those of "sickness" and "health." He steers clear of borderline cases in which the problematic character of such notions might become apparent. He prefers to stick to the "truly great," for it has the prerogative of sometimes "overwhelming us through utmost simplicity."[43] He has little appreciation for disjointed periods of art such as the Baroque. For him, too, the great age is still the Renaissance. Here, his cult of creativity maintains the upper hand over his dislike of classicism.

Fuchs's notion of creativity has a strongly biological slant. Artists from whom the author distances himself are portrayed as lacking in virility, while genius appears with attributes that occasionally border on the priapic. The mark of such biologistic thinking can be found in Fuchs's judgments of El Greco, Murillo, and Ribera. "All three became classic representatives of the Baroque spirit because each in his way was a 'thwarted' eroticist."[44] One must not lose sight of the fact that Fuchs developed his categories at a time when "pathography" represented the ultimate standard in the psychology of art and Möbius and Lombroso were considered authorities.[45] Moreover, Burckhardt had greatly enriched the concept of genius with illustrative material in his influential *Kultur der Renaissance*.[46] From different sources, this concept of genius fed the same widespread conviction that creativity was above all a manifestation of superabundant strength. Similar tendencies later led Fuchs to conceptions akin to psychoanalysis. He was the first to make them fruitful for aesthetics.

The eruptive, the immediate, which in this view is characteristic of artistic creation, also dominates Fuchs's understanding of the work of art. Thus, for him, it is often no more than a quick leap from apperception to judgment. Indeed, he thinks that the "impression" is not only the self-evident impetus that a viewer receives from an artwork, but the category of contemplation itself. This is summarized in his remarks about the Ming period, whose artistic formalism he treats with critical reserve. These works "ultimately . . . no longer achieve, and sometimes do not even approach, . . . the impression that was produced . . . by the superb lines of Tang art."[47] This is how Fuchs the writer acquires his particular and apodictic (not to say rustic) style. It is a style whose characteristic quality he formulates masterfully in Die Geschichte der erotischen Kunst [The History of Erotic Art]. Here he declares: "From the correct emotion to the correct and complete deciphering of the energies operating in a work of art, there is always but a single step."[48] Not everyone can achieve such a style; Fuchs had to pay a price for it. In a word: he lacked the gift of exciting wonder. There is no doubt that he felt this lack. He tried to compensate for it in a variety of ways. Thus, he liked nothing better than to speak of the secrets he strives to uncover in the psychology of creation, or of the riddles of history that find their solution in materialism. Yet the impulse toward immediate mastery of the facts, an impulse which had already determined his notion of creativity as well as his understanding of reception, ultimately comes to dominate his analysis. The course of the history of art appears "necessary," the characteristics of style appear "organic," and even the most peculiar art forms appear "logical." One gets the impression that in the course of his analysis these terms occur less frequently than at first. In his work on the Tang period, he still says that the fairy creatures in the painting of that time seem "absolutely logical" and "organic," with their horns and their fiery wings. "Even the huge ears of the elephant have a logical effect; and the way they stand there is likewise always logical. It is never a matter of merely contrived concepts, but always of an idea which has assumed a living, breathing form."[49]

Implicit here is a series of conceptualizations which are intimately connected with the Social Democratic doctrines of the period. The profound effect of Darwinism on the development of the socialist understanding of history is well known. During the time of Bismarck's persecution of the Socialists, the Darwinian influence served to maintain the party's faith and determination in its struggle. Later, in the period of revisionism, the evolutionary view of history burdened the concept of "development" more and more as the party became less willing to risk what

it had gained in the struggle against capitalism.[50] History assumed deterministic traits: the victory of the party was "inevitable." Fuchs always remained aloof from revisionism; his political instincts and his militant nature inclined him to the left. As a theoretician, however, he could not remain free from those influences. One can feel them at work everywhere. At that time, a man like Ferri traced the principles and even the tactics of Social Democracy back to natural laws.[51] Ferri held that deficiencies in the knowledge of geology and biology were responsible for anarchistic deviations. Of course, leaders like Kautsky fought against such deviations.[52] Nevertheless, many were satisfied with theses which divided historical processes into "physiological" and "pathological" ones, or affirmed that the materialism of natural science "automatically" turned into historical materialism once it came into the hands of the proletariat.[53] Similarly, Fuchs sees the progress of human society as a process that "can no more be held back than the continuous forward motion of a glacier can be arrested."[54] Deterministic understanding is thus paired with a stalwart optimism. Yet without confidence no class could, in the long run, hope to enter the political sphere with any success. But it makes a difference whether this optimism centers on the active strength of the class or on the conditions under which the class operates. Social Democracy leaned toward the latter—questionable—kind of optimism. The vision of incipient barbarism, which flashed on the consciousness of an Engels in *Die Lage der Arbeitenden Klassen in England* [The Condition of the Working Class in England], of a Marx in his prognosis of capitalist development, and which is today familiar even to the most mediocre statesman, was denied their epigones at the turn of the century. At the time Condorcet publicized the doctrine of progress, the bourgeoisie had stood on the brink of power.[55] A century later, the proletariat found itself in a different position: for the proletariat, this doctrine could awaken illusions. Indeed, these illusions still form the background occasionally revealed in Fuchs's history of art. "Today's art," he declares, "has brought us a hundred fulfillments which in the most diverse quarters exceed the achievements of Renaissance art, and the art of the future must certainly mean something still higher."[56]

VI

The pathos running through Fuchs's conception of history is the democratic pathos of 1830. Its echo was the orator Victor Hugo. The echo of that echo consists of the books in which the orator Hugo addresses

himself to posterity. Fuchs's conception of history is the same as that which Hugo celebrates in *William Shakespeare*: "Progress is the stride of God himself." And universal suffrage appears as the world chronometer which measures the speed of these strides. With the statement "Qui vote règne" [He who votes also rules], Hugo had erected the tablets of democratic optimism. Even much later this optimism produced strange fancies. One of these was the illusion that "all intellectual workers, including persons with great material and social advantages, had to be considered proletarians." For it is "an undeniable fact that all persons who hire out their services for money are helpless victims of capitalism—from a privy councilor strutting in his gold-trimmed uniform, to the most downtrodden laborer."[57] The tablets set up by Hugo still cast their shadow over Fuchs's work. Moreover, Fuchs remains within the democratic tradition when he attaches himself to France with particular love. He admires France as the ground of three great revolutions, as the home of exiles, as the source of utopian socialism, as the fatherland of haters of tyranny such as Michelet and Quinet, and finally as the soil in which the Communards are buried.[58] Thus lived the image of France in Marx and Engels, and thus it was bequeathed to Mehring. Even to Fuchs, it still appeared as the land of "the avant-garde of culture and freedom." He compares the spirited mockery of the French with the low humor of the Germans. He compares Heine with those who remained at home. He compares German naturalism with the satirical novels of France. In this way he has been led, like Mehring, to sound prognoses, especially in the case of Gerhart Hauptmann.[59]

France is a home for Fuchs the collector as well. The figure of the collector—more attractive the longer one observes it—has up to now seldom received its due. One can imagine no figure that could be more tempting to Romantic storytellers. Yet one searches in vain among the characters of a Hoffmann, a De Quincey, or a Nerval for this type, who is motivated by dangerous though domesticated passions. Romantic figures include the traveler, the *flâneur*, the gambler, and the virtuoso; the collector is not among them. One looks in vain for him in the "physiologies," which otherwise do not miss a single figure of the Paris waxworks under Louis Philippe, from the news vendor to the literary lion. All the more important therefore is the role of the collector in the works of Balzac. Balzac raised a monument to the figure of the collector, yet he treated it quite unromantically. Balzac was never an adherent of Romanticism, anyway. There are few places in his work where his anti-Romantic stance so surprisingly claims its rights as in the portrait of Cousin Pons. One ele-

ment is particularly characteristic. Though we are given a precise inventory of the collection to which Pons dedicates his life, we learn next to nothing about the history of the acquisition of this collection. There is no passage in *Cousin Pons* that can compare with the breathtaking suspense of the Goncourt brothers' description of uncovering a rare find—a description which appears in their diaries. Balzac does not portray the collector as hunter, wandering through the game park of his inventory. Every fiber of his Pons and of his Elie Magus trembles with exultation. This exultation is the pride they feel in the incomparable treasures they protect with unflagging care. Balzac stresses exclusively his portrait of the "possessor," and the term "millionaire" seems to him a synonym for the word "collector." He says of Paris: "There, one can often meet a very shabbily dressed Pons or Elie Magus. They seem to care for nothing, to respect nothing. They notice neither women nor window displays. They walk along as if in a dream, their pockets empty, their gaze blank; and one wonders what sort of Parisian they really are. These people are millionaires. They are collectors, the most passionate people in the world."[60]

The image of the collector sketched by Balzac comes closer to the figure of Fuchs, in all its activity and abundance, than one would have expected from a Romantic. Indeed, considering the man's vital energy, one might say that as a collector Fuchs is truly Balzacian—a Balzacian figure that outgrew the novelist's own conception. What could be more in accord with this conception than a collector whose pride and expansiveness lead him to bring reproductions of his prized objects onto the market solely in order to appear in public with his treasures? The fact that in doing so he becomes a rich man is again a Balzacian turn. Fuchs displays not only the conscientiousness of a man who knows himself to be a conservator of treasures, but also the exhibitionism of the great collector, and this is what has led him to reproduce almost exclusively unpublished illustrations in each of his works. Nearly all of these illustrations have been taken from his own collections. For the first volume of his *Karikatur der europäischen Völker* [Caricature of the European Peoples] alone, he collated 68,000 pages of illustrations and then chose about 500. He did not permit a single page to be reproduced in more than one place. The fullness of his documentation and its wide-ranging effect go hand in hand. Both attest to his descent from the race of bourgeois giants of around 1830, as Drumont characterizes them. "Almost all the leaders of the school of 1830," writes Drumont, "had the same extraordinary constitution, the same fecundity, and the same tendency toward the grandiose. Delacroix paints epics on canvas; Balzac depicts a whole society;

and Dumas covers a 4,000-year expanse of human history in his nov-els. They all have backs strong enough for any burden."[61] When the revo-lution came in 1848, Dumas published an appeal to the workers of Paris in which he introduced himself as one of them. In twenty years, he said, he had written 400 novels and thirty-five plays. He had created jobs for 8,160 people—proofreaders, typesetters, machinists, wardrobe mis-tresses. Nor did he forget the claque. The feeling with which the universal historian Fuchs laid the economic basis for his magnificent collections is probably not wholly unlike Dumas' *amour-propre*. Later, this economic base made it possible for Fuchs to wheel and deal on the Paris market with almost as much sovereignty as in his own private demesne. Around the turn of the century, the dean of Paris art dealers used to say of Fuchs: "C'est le monsieur qui mange tout Paris" [That's the gentleman who's consuming all of Paris]. Fuchs exemplifies the type of the *ramasseur* [packrat]; he takes a Rabelaisian delight in huge quantities—a delight manifested in the luxurious redundancy of his texts.

VII

Fuchs's family tree, on the French side, is that of a collector; on the German side, that of a historian. The moral rigor characteristic of Fuchs the historian marks him as a German. This rigor already characterized Gervinus, whose *Geschichte der poetischen Nationalliteratur* [History of Poetic National Literature] could be called one of the first attempts at a German history of ideas.[62] It is typical for Gervinus, just as it is later for Fuchs, to represent the great creators as quasi-martial figures. This results in the dominance of their active, manly, and spontaneous traits over their contemplative, feminine, and receptive characteristics. Certainly, such a representation was easier for Gervinus. When he wrote his book, the bourgeoisie was in the ascendant; bourgeois art was full of political ener-gies. Fuchs writes in the age of imperialism; he presents the political ener-gies of art polemically to an epoch whose works display less of these en-ergies with every passing day. But Fuchs's standards are still those of Gervinus. In fact, they can be traced back even further, to the eighteenth century. This can be done with reference to Gervinus himself, whose me-morial speech for F. C. Schlosser gave magnificent expression to the mili-tant moralism of the bourgeoisie in its revolutionary period. Schlosser had been criticized for a "peevish moral rigor." Gervinus, however, de-fends him by saying that "Schlosser could and would have answered these criticisms as follows. Contrary to one's experience with novels and

stories, one does not learn a superficial joie de vivre by looking at life on a large scale, as history, even when one possesses great serenity of spirit and of the senses. Through the contemplation of history, one develops not a misanthropic scorn but a stern outlook on the world and serious principles concerning life. The greatest judges of the world and of humanity knew how to measure external life according to their own internal life. Thus, for Shakespeare, Dante, and Machiavelli, the nature of the world made an impression that always led them to seriousness and severity."[63] Here lies the origin of Fuchs' moralism. It is a German Jacobinism whose monument is Schlosser's world history—a work that Fuchs came to know in his youth.[64]

Not surprisingly, this bourgeois moralism contains elements which collide with Fuchs's materialism. If Fuchs had recognized this, he might have been able to tone down this opposition. He was convinced, however, that his moralistic consideration of history and his historical materialism were in complete accord. This was an illusion, buttressed by a widespread opinion badly in need of revision: that the bourgeois revolutions, as celebrated by the bourgeoisie itself, are the immediate source of a proletarian revolution.[65] As a corrective to this view, it is enough to look at the spiritualism woven into these revolutions. The golden threads of this spiritualism were spun by morality. Bourgeois morals function under the banner of inwardness; the first signs of this were already apparent during the Reign of Terror. The keystone of this morality is conscience, be it the conscience of Robespierre's *citoyen* or that of the Kantian cosmopolitan. The bourgeoisie's attitude was to proclaim the moral authority of conscience; this attitude proved favorable to bourgeois interests, but depended on a complementary attitude in the proletariat—one unfavorable to the interests of the latter. Conscience stands under the sign of altruism. Conscience advises the property owner to act according to concepts which are indirectly beneficial to his fellow proprietors. And conscience readily advises the same for those who possess nothing. If the latter take this advice, the advantages of their behavior for the proprietors become more obvious as this advice becomes more doubtful for those who follow it, as well as for their class. Thus it is that the price of virtue rests on this attitude.—Thus a class morality becomes dominant. But the process occurs on an unconscious level. The bourgeoisie did not need consciousness to establish this class morality as much as the proletariat needs consciousness to overthrow that morality. Fuchs does not do justice to this state of affairs, because he believes that his attack must be directed against the conscience of the bourgeoisie. He considers bourgeois

ideology to be duplicitous. "In view of the most shameless class judgments," he says, "the fulsome babble about the subjective honesty of the judges in question merely proves the lack of character of those who write or speak in this way. At best, one might ascribe it to their narrow-mindedness."[66] Fuchs, however, does not think of judging the concept of *bona fides* (good conscience) itself. Yet this will occur to historical materialists, not only because they realize that the concept is the bearer of bourgeois class morality, but also because they will not fail to see that this concept furthers the solidarity of moral disorder with economic anarchy. Younger Marxists at least hinted at this situation. Thus, the following was said about Lamartine's politics, which made excessive use of *bona fides:* "Bourgeois . . . democracy . . . is dependent on this value. A democrat is honest by trade. Thus, a democrat feels no need to examine the true state of affairs."[67]

Considerations that focus more on the conscious interests of individuals than on the behavior which is imposed on their class—imposed often unconsciously and as a result of that class's position in the production process—lead to an overestimation of conscious elements in the formation of ideology. This is evident in Fuchs's work when he declares: "In all its essentials, art is the idealized disguise of a given social situation. For it is an eternal law . . . that every dominant political or social situation is forced to idealize itself in order to justify its existence ethically."[68] Here we approach the crux of the misunderstanding. It rests on the notion that exploitation conditions false consciousness, at least on the part of the exploiter, because true consciousness would prove to be a moral burden. This sentence may have limited validity for the present, insofar as the class struggle has so decisively involved all of bourgeois life. But the "bad conscience" of the privileged is by no means self-evident for earlier forms of exploitation. Not only does reification cloud relations among human beings, but the real subjects of these relations also remain clouded. An apparatus of judicial and administrative bureaucracies intervenes between the rulers of economic life and the exploited. The members of these bureaucracies no longer function as fully responsible moral subjects, and their "sense of duty" is nothing but the unconscious expression of this deformation.

VIII

Fuchs's moralism, which has left traces in his historical materialism, was not shaken by psychoanalysis either. Concerning sexuality, he says: "All

forms of sensual behavior in which the creative element of this law of life becomes visible are justified. Certain forms, however, are evil—namely, those in which this highest of drives becomes degraded to a mere means of refined craving for pleasure."[69] It is clear that this moralism bears the signature of the bourgeoisie. Fuchs never acquired a proper distrust of the bourgeois scorn for pure sexual pleasure and the more or less fantastic means of creating it. In principle, to be sure, he declares that one can speak of "morality and immorality only in relative terms." Yet in the same passage he goes on to make an exception for "absolute immorality," which "entails transgressions against the social instincts of society and thus, so to speak, against nature." According to Fuchs, this view is characterized by the historically inevitable victory of "the masses over a degenerate individuality, for the masses are always capable of development."[70] In short, it can be said of Fuchs that he "does not question the justification for condemning allegedly corrupt drives, but rather casts doubt on beliefs about the history and extent of these drives."[71]

For this reason, it is difficult to clarify the sexual-psychological problem. But ever since the bourgeoisie came to power, this clarification has become particularly important. This is where taboos against more or less broad areas of sexual pleasure have their place. The repressions which are thereby produced in the masses engender masochistic and sadistic complexes. Those in power then further these complexes by delivering up to the masses those objects which prove most favorable to their own politics. Wedekind, a contemporary of Fuchs, explored these connections.[72] Fuchs failed to produce a social critique in this regard. Thus, a passage where he compensates for this lack by means of a detour through natural history becomes all the more important. The passage in question is his brilliant defense of orgies. According to Fuchs, "the pleasure of orgiastic rites is among the most valuable aspects of culture. It is important to recognize that orgies are one of the things that distinguish us from animals. In contrast to humans, animals do not practice orgies. When their hunger and thirst are satisfied, animals will turn away from the juiciest food and the clearest spring. Furthermore, the sexual drive of animals is generally restricted to specific and brief periods of the year. Things are quite different with human beings, and in particular with creative human beings. The latter simply have no knowledge of the concept of 'enough.'"[73] Fuchs's sexual-psychological observations draw their strength from thought processes in which he deals critically with traditional norms. This enables him to dispel certain petit-bourgeois illusions, such as nudism, which he rightly sees as a "revolution in narrow-mindedness."

"Happily, human beings are not wild animals any longer, and we . . . like to have fantasy, even erotic fantasy, play its part in clothing. What we do not want, however, is the kind of social organization of humanity which degrades all this."[74]

Fuchs's psychological and historical understanding has been fruitful for the history of clothing in many ways. In fact, there is hardly a subject apart from fashion which better suits the author's threefold concern—namely, his historical, social, and erotic concern. This becomes evident in his very definition of fashion, which, in its phrasing, reminds one of Karl Kraus. Fashion, he says in his *Sittengeschichte* [History of Manners], "indicates how people intend to manage the business of public morality."[75] Fuchs, by the way, did not make the common mistake of examining fashion only from the aesthetic and erotic viewpoints, as did, for example, Max von Boehn.[76] He did not fail to recognize the role of fashion as a means of domination. Just as fashion brings out the subtler distinctions of social standing, it keeps a particularly close watch over the coarse distinctions of class. Fuchs devoted a long essay to fashion in the third volume of his *Sittengeschichte*. The supplementary volume sums up the essay's train of thought by enumerating the principal elements of fashion. The first element is determined by "the interests of class separation." The second is provided by "the mode of production of private capitalism," which tries to increase its sales volume by manifold fashion changes. Finally, we must not forget the "erotically stimulating purposes of fashion."[77]

The cult of creativity which runs through all of Fuchs's work drew fresh nourishment from his psychoanalytic studies. These enriched his initial, biologically based conception of creativity, though they did not of course correct it. Fuchs enthusiastically espoused the theory that the creative impulse is erotic in origin. His notion of eroticism, however, remained tied to an unqualified, biologically determined sensuality. Fuchs avoided, as far as possible, the theory of repression and of complexes, which might have modified his moralistic understanding of social and sexual relationships. Just as his historical materialism derives things more from the conscious economic interest of the individual than from the class interest unconsciously at work within the individual, so his focus on art brings the creative impulse closer to conscious sensual intention than to the image-creating unconscious.[78] The world of erotic images which Freud made accessible as a symbolic world in his *Traumdeutung* [Interpretation of Dreams] appears in Fuchs's work only where his own inner involvement is most pronounced.[79] In such cases, this world fills

his writing even where explicit mention of it is avoided. This is evident in the masterful characterization of the graphic art of the revolutionary era. "Everything is stiff, taut, military. Men do not lie down, since the drill square does not tolerate any 'at ease.' Even when people are sitting down, they look as if they want to jump up. Their bodies are full of tension, like an arrow on a bowstring. . . . What is true of the lines is likewise true of the colors. The pictures give a cold and tinny impression . . . when compared to paintings of the Rococo. . . . The coloring . . . had to be hard . . . and metallic if it was to go with the content of the pictures."[80] An informative remark on the historical equivalents of fetishism is more explicit. Fuchs says that "the increase of shoe and leg fetishism indicates that the priapic cult is being superseded by the vulva cult." The increase in breast fetishism, by contrast, is evidence of a regressive development. "The cult of the covered foot or leg reflects the dominance of woman over man, whereas the cult of breasts indicates the role of woman as an object of man's pleasure."[81] Fuchs gained his deepest insights into the symbolic realm through study of Daumier. What he says about Daumier's trees is one of the happiest discoveries of his entire career. In those trees he perceives "a totally unique symbolic form, . . . which expresses Daumier's sense of social responsibility as well as his conviction that it is society's duty to protect the individual. . . . His typical manner of depicting trees . . . always shows them with broadly outspread branches, particularly if a person is standing or resting underneath. In such trees, the branches extend like the arms of a giant, and actually look as though they would stretch to infinity. Thus, the branches form an impenetrable roof which keeps danger away from all those who seek refuge under them."[82] This beautiful reflection leads Fuchs to an insight into the dominance of the maternal in Daumier's work.

IX

For Fuchs, no figure came as vividly to life as Daumier. The figure of Daumier accompanied him throughout his career, and one might almost say that this made Fuchs into a dialectical thinker. Certainly, he conceived of Daumier in all the latter's fullness and living contradiction. If he appreciates the maternal in Daumier's art and describes it with impressive skill, he was no less conversant with the other pole—the virile and aggressive side of the figure. He was right to point out the absence of idyllic elements in Daumier's work—not only landscapes, animals, and still lifes, but also erotic motifs and self-portraits. What impressed Fuchs

most was the element of strife—the agonistic dimension—in Daumier's art. Would it be too daring to seek the origin of Daumier's great caricatures in a question? Daumier seems to ask himself: "What would bourgeois people of my time look like if one were to imagine their struggle for existence as taking place in a *palaestra*, an arena?" Daumier translated the public and private life of Parisians into the language of the agon. The athletic tension of the whole body—its muscular movements—arouse Daumier's greatest enthusiasm. This is not contradicted by the fact that probably no one has depicted bodily enervation and debility as fascinatingly as Daumier. As Fuchs remarks, Daumier's conception relates closely to sculpture. Thus, he bears away the types which his age has to offer—those distorted Olympic champions—in order to exhibit them on pedestals. His studies of judges and lawyers prove particularly amenable to this kind of analysis. The elegiac humor with which Daumier likes to surround the Greek Pantheon reveals this inspiration more directly. Perhaps this is the solution to the riddle which the master posed for Baudelaire: how Daumier's caricatures, with all their trenchant, penetrating power, could remain so free of rancor.[83]

Whenever Fuchs speaks of Daumier, all his energies come to life. No other subject draws such divinatory flashes from his connoisseurship. Here, the slightest impulse becomes important. A single drawing, so casual that it would be a euphemism to call it unfinished, suffices for Fuchs to offer deep insight into Daumier's productive mania. The drawing in question represents merely the upper part of a head in which the only expressive parts are the nose and eyes. Insofar as the sketch limits itself to these features—insofar as it represents only the observer—it indicates to Fuchs that here the painter's central interest is at play. For, he assumes, every painter begins the execution of his paintings at precisely the point in which he is most compulsively interested.[84] In his work on the painter, Fuchs says: "A great many of Daumier's figures are engaged in the most concentrated looking, be it a gazing into the distance, a contemplating of specific things, or even a hard look into their own inner selves. Daumier's people look . . . almost with the tips of their noses."[85]

X

Daumier turned out to be the most auspicious subject matter for the scholar. He was also the collector's luckiest find. With justifiable pride, Fuchs mentions that it was his own initiative and not that of the government which led to the establishment of the first collections of Daumier

(and Gavarni) in Germany.[86] He is not the only great collector to feel an aversion to museums. The brothers Goncourt preceded him in their dislike, which was even more virulent than his. Public collections may be less problematic from a social point of view, and can be scientifically more useful than private ones, yet they lack the great advantages of the latter. The collector's passion is a divining rod that turns him into a discover of new sources. This holds true for Fuchs, and it explains why he felt compelled to oppose the spirit which prevailed in the museums under Wilhelm II. These museums were intent on possessing so-called showpieces. "Certainly," says Fuchs, "today's museums tend toward such a mode of collecting simply for reasons of space. But this . . . does not change the fact that, owing to this tendency, we are left with quite fragmentary . . . notions of the culture of the past. We see the past . . . in splendid holiday array, and only rarely in its mostly shabby working clothes."[87]

The great collectors distinguish themselves largely through the originality of their choice of subject matter. There are exceptions. The Goncourts started less with objects than with the whole that had to ensure the integrity of these objects. They undertook to transfigure the interior just as it was ceasing to be viable. As a rule, however, collectors have been guided by the objects themselves. The humanists at the threshold of modern history are a prime example of this. Their Greek acquisitions and journeys testify to the purposefulness with which they collected. Guided by La Bruyère, the figure of the collector was introduced into literature (albeit unflatteringly) with Marolles, who served as a model for Damocède. Marolles was the first to recognize the importance of graphic art; his collection of 125,000 prints forms the nucleus of the Cabinet des Estampes. The seven-volume catalogue of his collections, published by Count Caylus in the following century, is the first great achievement of archaeology. Stosch's collection of gems was catalogued by Winckelmann on commission by the collector himself. Even where the scientific notion supposedly buttressing the collection did not manage to last, the collection itself sometimes did. This is true of the collection of Wallraff and Boisserée. Arising out of the Romantic Nazarene theory, which viewed the art of Cologne as the heir of ancient Roman art, the founders of the collection formed the basis of Cologne's museum with their German paintings from the Middle Ages.[88] Fuchs belongs in this line of great and systematic collectors who were resolutely intent on a single subject matter. It has been his goal to restore to the work of art its existence within society, from which it had been so decisively cut off that the collector

could find it only in the art market; there—reduced to a commodity, far removed both from its creators and from those who were able to understand it—the work of art endured. The fetish of the art market is the master's name. From a historical point of view, Fuchs's greatest achievement may be that he cleared the way for art history to be freed from the fetish of the master's signature. "That is why," says Fuchs in his essay on the Tang period, "the complete anonymity of these burial gifts means that one cannot, even in a single case, know the name of the individual creator. This is an important proof of the fact that here it is never a question of individual artistic production, but rather a matter of the way in which the world and things are grasped as a whole."[89] Fuchs was one of the first to expound the specific character of mass art and thus to develop the impulses he had received from historical materialism.

Any study of mass art leads necessarily to the question of the technological reproduction of the work of art. "Every age has very specific techniques of reproduction corresponding to it. These represent the prevailing standard of technological development and are . . . the result of a specific need of that age. For this reason, it is not surprising that any historical upheaval which brings to power . . . classes other than those currently ruling . . . regularly goes hand in hand with changes in techniques of pictorial reproduction. This fact calls for careful elucidation."[90] Insights like this proved Fuchs a pioneer. In such remarks, he pointed to objects which would represent an educational gain for historical materialism if it studied them. The technological standard of the arts is one of the most important of his insights. If one keeps this standard in mind, one can compensate for many a lax construction stemming from the vague way culture is conceived in the traditional history of ideas (and occasionally even in Fuchs's own work). The fact that "thousands of simple potters were capable on the spur of the moment . . . of creating products that were both technically and artistically daring"[91] rightly appears to Fuchs as a concrete authentication of old Chinese art. Occasionally his technological reflections lead him to illuminating *aperçus* that are ahead of his time. There is no other way to view his explanation of the fact that caricature was unknown in antiquity. An idealistic understanding of history would no doubt see this as evidence for the classicist image of the Greeks and their "noble simplicity and quiet grandeur." How does Fuchs explain the matter? Caricature, he says, is a mass art. There cannot be any caricature without mass distribution of its products. Mass distribution means cheap distribution. But "except for the minting of coins, antiquity has no cheap means of reproduction."[92] The surface area of a coin is too small to allow for caricature. This is why caricature was unknown in antiquity.

Caricature was mass art, like the genre painting. In the eyes of conventional art historians, this was enough to disgrace these already questionable forms. Fuchs sees the matter differently. His interest in the scorned and apocryphal constitutes his real strength. And as a collector, he has cleared the way to these things all by himself, for Marxism showed him merely how to start. What was needed was a passion bordering on mania; such passion has left its mark on Fuchs's features. Whoever goes through the whole series of art lovers and dealers, of admirers of paintings and experts in sculpture, as represented in Daumier's lithographs, will be able to see how true this is. All of these characters resemble Fuchs, right down to the details of his physique. They are tall, thin figures whose eyes shoot fiery glances. It has been said—not without reason—that in these characters Daumier conceived descendants of those gold-diggers, necromancers, and misers which populate the paintings of the old masters.[93] As a collector, Fuchs belongs to their race. The alchemist, in his "base" desire to make gold, carries out research on the chemicals in which planets and elements come together in images of spiritual man; by the same token, in satisfying the "base" desire for possession, this collector carries out research on an art in whose creations the productive forces and the masses come together in images of historical man. Even his late works still testify to the passionate interest with which Fuchs turned toward these images. He writes: "It is not the least of the glories of Chinese turrets that they are the product of an anonymous popular art. There is no heroic lay to commemorate their creators."[94] Whether devoting such attention to anonymous artists and to the objects that have preserved the traces of their hands would not contribute more to the humanization of mankind than the cult of the leader—a cult which, it seems, is to be inflicted on humanity once again—is something that, like so much else that the past has vainly striven to teach us, must be decided, over and over, by the future.

Published in the *Zeitschrift für Sozialforschung*, fall 1937. *Gesammelte Schriften*, II, 465–505. Translated by Howard Eiland and Michael W. Jennings. A previous translation by Knut Tarnowski (New York, 1975) was consulted.

Notes

1. The German writer, collector, and cultural critic Eduard Fuchs (1870–1940) joined the Social Democratic Party in 1886 and was imprisoned in 1888–1889 for political activity. He lived in Berlin from 1900 to 1933, before emigrating to Paris. He was friends with Franz Mehring (see note 2 below) and was Mehring's literary executor after his death. He is best known for his

Illustrierte Sittengeschichte vom Mittelalter bis zur Gegenwart (An Illustrated History of Manners from the Middle Ages to the Present; 3 vols., 1909–1912; 1926) and *Die Geschichte der erotischen Kunst* (The History of Erotic Art; 3 vols., 1908; 1922–1926). Benjamin's essay on Fuchs was commissioned for the *Zeitschrift für Sozialforschung* in 1933 or 1934 by Max Horkheimer, who had testified at one of the trials in which Fuchs was prosecuted for his studies of erotic art. Benjamin, who was also personally acquainted with Fuchs, interrupted his preparatory studies for the essay several times between the summer of 1934 and the beginning of 1937; the essay was finally written in January and February 1937. Although Benjamin had repeatedly complained about his difficulties with the Fuchs project in his letters of the two years preceding, he confessed himself relatively pleased with the finished product, which contains near the beginning a concise formulation of a key aspect of his theory of "historical materialism": the process of reading by which a historical object is loosed from the traditional historicist "continuum of history" (see notes 10 and 19 below) to become part of the reader's own present-day experience, such experience constituting an "afterlife" of the object. Before publishing the essay, the editorial board of the *Zeitschrift für Sozialforschung* insisted on cutting its first paragraph, which was felt to be too exclusively oriented toward Marxism. It was restored for the essay's republication in Benjamin's *Gesammelte Schriften* in 1977. For this translation of "Eduard Fuchs, der Sammler und der Historiker," the editors consulted the translation by Kingsley Shorter (1979).

2. The work of Georgi Valentinovich Plekhanov (1856–1918), the Russian political theorist and Menshevik revolutionary, was a major influence on the development of Marxist aesthetics. Franz Mehring (1846–1919), German historian and journalist, wrote about literary history from a socialist perspective; see his *Zur Literaturgeschichte: Von Hebbel bis Gorki* (Berlin: Soziologische Verlagsanstalt, 1929) and *Aufsätze zur deutschen Literatur von Hebbel bis Schweichel* (Berlin: Dietz, 1961).

3. Wilhelm Liebknecht (1826–1900) and August Bebel (1840–1913), among others, founded the Social Democratic Workers' Party of Germany in 1869.

4. Karl Kautsky, "Franz Mehring," *Die Neue Zeit,* 22, no. 1 (Stuttgart, 1904): 103–104. [Benjamin's note. Marx viewed Ferdinand Lassalle (1825–1864), a founder of the movement for social democracy in Germany, as unacceptably reformist and opportunistic.—*Trans.*]

5. Cited in Gustav Mayer, *Friedrich Engels: Eine Biographie,* vol. 2: *Friedrich Engels und der Aufstieg der Arbeiterbewegung in Europa* [Friedrich Engels and the Rise of the Labor Movement in Europe] (Berlin, 1933), pp. 450–451. [Benjamin's note]

6. This thought appears in the earliest studies on Feuerbach and is expressed by Marx as follows: "There is no history of politics, of law, of science, . . . of art, of religion, and so on." *Marx-Engels Archiv,* vol. 1, ed. David Riazanov

(Frankfurt am Main, 1928), p. 301. [Benjamin's note. See W. Lough's translation of *The German Ideology* in Karl Marx and Frederick Engels, *Collected Works*, vol. 5 (New York: International Publishers, 1976), p. 92.—*Trans.*]

7. See Johann Wolfgang von Goethe, *Gedenkausgabe der Werke, Briefe und Gespräche*, vol. 23 (Zurich, 1950), p. 198 (letter of June 11, 1822, to F. von Müller). Friedrich von Müller (1779–1849) was the state chancellor of the Grand Duchy of Saxe-Weimar-Eisenach and a close friend of Goethe.

8. Gottfried Keller (1819–1890) was one of the great German-language prose stylists of the nineteenth century, best known for his stories and the novel Der grüne Heinrich (Green Henry; 4 vols., 1854–1855, revised version 1879–1880). See Benjamin's essay "Gottfried Keller" (1927), in Benjamin, *Selected Writings, Volume 2: 1927–1934* (Cambridge, Mass.: Harvard University Press, 1999), pp. 51–61.

9. It is the dialectical construction which distinguishes that which concerns us as originary in historical experience from the pieced-together findings of the factual. "What is original [*ursprünglich*—that is, of the origin] never allows itself to be recognized in the naked, obvious existence of the factical; its rhythm is accessible only to a dual insight. This insight . . . concerns the fore-history and after-history of the original." Walter Benjamin, *Ursprung des deutschen Trauerspiels* (Berlin, 1928), p. 32. [Benjamin's note. See Benjamin, *The Origin of German Tragic Drama*, trans. John Osborne (London: Verso, 1977), pp. 45–46.—*Trans.*]

10. *Erotische Kunst* (Erotic Art), vol. 1, p. 70 [Benjamin's note. Benjamin cites Leopold von Ranke, *Geschichte der romanischen und germanischen Völker von 1494 bis 1514* (History of the Germanic and Romance-Language Peoples from 1494 to 1514), 2nd ed. (Leipzig, 1874), p. vii. Ranke (1795–1886) was a professor of history at Berlin (1825–1871) and a founder of the modern school of historiography, which strove for a scientific objectivity grounded in source material rather than legend and tradition. The ambition to describe "how it really was" in the past, apart from the consciousness of the historian in his present day, is a defining characteristic of nineteenth-century historicism.—*Trans.*]

11. Eduard Fuchs, ed., *Gavarni: Lithographien* (Munich: Langen, 1925), p. 13. [Benjamin's note]

12. See Mehring's *Die Lessing-Legende: Eine Rettung* [The Lessing Legend: A Rescue] (Stuttgart, 1893). Mehring directed his polemic against the misuse made of the German dramatist Gotthold Ephraim Lessing (1729–1781) by patriotic German literary historians. These historians viewed the flourishing of literature in eighteenth-century Germany—exemplified by Lessing—as tied to the rise of Prussia under Frederick II. The book's aim was to rescue Lessing from the bourgeois critics' misinterpretation of him. Mehring quotes approvingly from Georg Gottfried Gervinus (1805–1871), a German histo-

rian, literary historian, and politician, who held professorships at Heidelberg and Göttingen and was a delegate to the German National Assembly in Frankfurt in 1848. Adolf Wilhelm Theodor Stahr (1805–1876) wrote a popular Lessing biography, *Lessing: Sein Leben und seine* Werke (Berlin, 1859). Theodor Wilhelm Danzel (1818–1850) wrote *Gotthold Ephraim Lessing: Sein Leben und seine Werke* (Berlin, 1880); Erich Schmidt wrote *Lessing: Geschichte seines Lebens und seiner Schriften* (Berlin, 1884).

13. See Julian Hirsch, *Die Genesis des Ruhmes: Ein Beitrag zur Methodenlehre der Geschichte* [The Genesis of Fame: A Contribution to Historical Methodology] (Leipzig, 1914).

14. The conservative government of Chancellor Otto von Bismarck (1815–1898) launched an anti-Socialist campaign in 1878. A repressive anti-Socialist bill, designed as a weapon against the Social Democrats, was passed and remained in effect through the 1880s.

15. See Eduard Fuchs, *1848 in der Karikatur* (Berlin, 1898) and "Lola Montez in der Karikatur," in *Zeitschrift für Bücherfreunde,* 3, no. 3 (1898–1899): 105–126; also, *Ein vormärzliches Tanzidyll: Lola Montez in der Karikatur* [A Prerevolutionary Dance Idyll: Lola Montez in Caricature] (Berlin, 1902). Lola Montez was the stage name of Marie Gilbert (1818?–1861), an Irish dancer and adventuress who, as mistress of Louis I of Bavaria, controlled the Bavarian government in 1847–1848.

16. See Wilhelm Blos, *Die französische Revolution: Volksthümliche Darstellung der Ereignisse und Zustände in Frankreich von 1789 bis 1804* (Stuttgart, 1888).

17. The German journalist Maximilian Harden (1861–1927) founded the weekly *Die Zukunft* in 1892.

18. A. Max, "Zur Frage der Organisation des Proletariats der Intelligenz" (On the Question of the Organization of the Proletariat of Intellectuals), *Die Neue Zeit,* 13, no. 1 (Stuttgart, 1895): 645. [Benjamin's note]

19. Nietzsche wrote as early as 1874: "As an end . . . result, we have the generally acclaimed 'popularization' . . . of science—that is, the infamous recutting of the garment of science to fit the body of a 'mixed public'—if we may here use tailor's German to describe a tailor-like activity." Friedrich Nietzsche, *Unzeitgemässe Betrachtungen* (Untimely Observations), vol. 1 (Leipzig, 1893), p. 168 ["Vom Nutzen und Nachtheil der Historie für das Leben"]. [Benjamin's note. See, in English, *On the Advantage and Disadvantage of History for Life,* trans. Peter Preuss (Indianapolis: Hackett, 1980), p. 42 (section 7). Benjamin is quoting a key work from the early period of the philosopher Nietzsche (1844–1900), one decisive for his own theory of reading. At a climactic point in section 6, Nietzsche writes, in express opposition to the historicist dogma of objectivity, that *"Only from the standpoint of the highest strength of the present may you interpret the past"* (p. 37).—Trans.]

20. Hermann Schultz-Delitzsch (1808–1883) was a German lawyer, economist,

and sociologist who worked to promote the organization of cooperative societies and people's banks. He is regarded as the founder of workingmen's cooperative associations in Germany.

21. "A cultural historian who takes his task seriously must always write for the masses." *Erotische Kunst,* vol. 2, part 1, preface. [Benjamin's note]

22. C. Korn, "Proletariat und Klassik" (Proletariat and Classicism), in *Die Neue Zeit,* 26, no. 2 (Stuttgart, 1908): 414–415. [Benjamin's note]

23. See August Bebel, *Die Frau und der Sozialismus: Die Frau in der Vergangenheit, Gegenwart und Zukunft,* 10th ed. (Stuttgart, 1891), pp. 177–179, 333–336, on the revolution in housekeeping brought about by technology; pp. 200–201, on woman as inventor. [Benjamin's note]

24. The Saint-Simonians were followers of the philosopher and social reformer Henri de Saint-Simon (1760–1825), considered the founder of French socialism. His works include *Du Système industriel* (1820–1823) and *Le Nouveau Christianisme* (1825). See Benjamin, *The Arcades Project,* trans. Howard Eiland and Kevin McLaughlin (Cambridge, Mass.: Harvard University Press, 1999), pp. 571–602 (Convolute U, "Saint-Simon, Railroads").

25. Benjamin refers to the French journalist Maxime Du Camp (1822–1894).

26. Cited in David Bach, "John Ruskin," *Die Neue Zeit,* 18, no. 1 (Stuttgart, 1900): 728. [Benjamin's note. Ludwig Pfau (1821–1894), German poet, critic, and translator, published an eyewitness account of the first public exhibition of photography, which took place in Paris in 1839. He was active in the Revolution of 1848, and founded the first illustrated journal of political caricature in Germany, *Eulenspiegel.* His writings on aesthetics were collected in *Kunst und Kritik* (Art and Criticism; 6 vols., 1888).—*Trans.*]

27. *Die Gartenlaube* (The Arbor) was a popular illustrated family magazine, in circulation between 1853 and 1937. It has lent its name to a type of sentimental novel known as the *Gartenlaubenroman.*

28. The illusory [*scheinhafte*] impulse found characteristic expression in Alfred Weber's welcoming address to a sociological convention of 1912: "Culture comes into existence only . . . when life has risen above the level of utility and of bare necessity to form a structure." This concept of culture contains seeds of barbarism, which have, in the meantime, germinated. Culture appears as something "which is superfluous for the continued existence of life, but is felt to be precisely . . . that from which life derives its purpose." In short, culture exists after the fashion of an artwork "which perhaps confounds entire modes of life and principles of living with its potentially shattering, destructive effect, but whose existence we feel to be higher than everything healthy and vital which it destroys." Alfred Weber, "Der soziologische Kulturbegriff" [The Sociological Concept of Culture], in *Verhandlungen des Zweiten Deutschen Soziologentages. Schriften der Deutschen Gesellschaft für Soziologie,* series 1, vol. 2 (Tübingen, 1913), pp. 11–12. Twenty-five years after this statement was made, culture-states

[*Kulturstaaten*] have staked their honor on resembling, on becoming, such artworks. [Benjamin's note. The German liberal economist and sociologist Alfred Weber (1868–1958) taught at Berlin, Prague, and Heidelberg.—*Trans.*]

29. Franz Mehring, "Akademisches," *Die Neue Zeit,* 16, no. 1 (Stuttgart, 1898): 195–196. [Benjamin's note. See Karl Lamprecht, *Deutsche Geschichte,* 12 vols. (Berlin, 1891–1909). Influenced by his reading of Jacob Burckhardt (see note 46 below), Lamprecht (1856–1915) upheld the theory that the science of history is social-psychological rather than exclusively political. His controversial book *Die kulturhistorische Methode* (1900) helped prompt a reexamination of historical methods and the eventual acceptance of social and cultural history as a legitimate sphere of scholarly research.—*Trans.*]

30. *Erotische Kunst,* vol. 1, p. 125. A basic impulse of Fuchs the collector is his continual allusion to contemporary art—which likewise comes to him partly through the great creations of the past. His incomparable knowledge of older caricature made possible his early recognition of the works of a Toulouse-Lautrec, a Heartfield, and a George Grosz. His passion for Daumier led him to the work of Slevogt, whose conception of Don Quixote seemed to him the only one comparable to Daumier's. His studies of ceramics gave him the authority to sponsor an Emil Pottner. Throughout his life, Fuchs had friendly relations with creative artists. Thus, it is not surprising that his approach to works of art is often more that of the artist than that of the historian. [Benjamin's note. John Heartfield (Helmut Herzfelde; 1891–1968), German graphic artist, photographer, and designer, was one of the founders of Berlin Dada. He went on to reinvent photomontage as a political weapon. The German painter George Grosz (1893–1959) was associated first with Berlin Dada and then with the Neue Sachlichkeit (New Objectivity). His scabrous paintings commented on the consequences of militarism, capitalism, and postwar conditions in Germany. The German painter Max Slevogt (1868–1932) was a prominent member of the Berlin Secession. Emil Pottner (1872–1942) was an Austrian graphic artist.—*Trans.*]

31. It is the values of "noble simplicity" and "quiet grandeur" that are at issue here. Such values inform the conception of classical Greek art propagated by the German archaeologist and art historian Johann Joachim Winckelmann (1717–1768), whose *Geschichte der Kunst des Altertums* (History of the Art of the Ancients; 1764) gave the study of art history its foundations and a scientific methodology. Goethe said that one learns nothing new when reading Winckelmann, but one "becomes a new man."

32. The master of iconographic interpretation is arguably Emile Mâle. His research is limited to French cathedral sculpture from the twelfth to the fifteenth centuries and therefore does not overlap with Fuchs's studies. [Benjamin's note. Emile Mâle (1862–1954), a French art historian and specialist in medieval French iconography, held a chair in art history at the Sorbonne. He is the author of *L'Art religieux du XIIIe siècle en France*

(1898; translated as *The Gothic Image: Religious Art in France of the Thirteenth Century*).—*Trans.*]

33. Heinrich Wölfflin, *Die klassische Kunst: Eine Einführung in die italienische Renaissance* [Classic Art: An Introduction to the Italian Renaissance] (Munich, 1899), p. 275. [Benjamin's note. Wölfflin (1864–1945), a student of Jacob Burckhardt (see note 46 below), was the most important art historian of his period writing in German. He developed his analysis of form, based on a psychological interpretation of the creative process, in books on the Renaissance and Baroque periods and on Albrecht Dürer, and synthesized his ideas into a complete aesthetic system in his chief work, *Kunstgeschichtliche Grundbegriffe* (Principles of Art History; 1915).—*Trans.*]

34. Older panel painting showed no more than the outline of a house enclosing human figures. The painters of the early Renaissance were the first to depict an interior space in which the represented figures have room to move [*Spielraum*]. This is what made Uccello's invention of perspective so overpowering both for his contemporaries and for himself. From then on, the creations of painting were increasingly devoted to people as inhabitants of dwellings (rather than people as worshipers). Paintings presented them with models of dwelling, and never tired of setting up before them perspectives of the villa. The High Renaissance, though much more sparing in its representation of real interiors, nevertheless continued to build on this foundation. "The Cinquecento has a particularly strong feeling for the relation between human being and building—that is, for the resonance of a beautiful room. It can scarcely imagine an existence that is not architecturally framed and founded." Wölfflin, *Die klassische Kunst*, p. 227. [Benjamin's note]

35. *Erotische Kunst*, vol. 2, p. 20. [Benjamin's note]

36. Franz Mehring, *Geschichte der deutschen Sozialdemokratie* (History of German Social Democracy), part 2, *Von Lassalles Offenem Antwortschreiben bis zum Erfurter Programm* (From Lassalle's Public Reply to the Erfurt Program), constituting vol. 3, part 2, of *Geschichte des Sozialismus in Einzeldarstellungen* (A Documentary History of Socialism) (Stuttgart, 1898), p. 546. [Benjamin's note]

37. Adolf Bastian (1826–1905) was a German ethnologist and traveler who, after visiting every continent (1851–1866), became a professor at the University of Berlin and director of the city's ethnological museum.

38. *Karikatur*, vol. 1, p. 4. [Benjamin's note]

39. Note the beautiful remark about Daumier's renderings of proletarian women: "Whoever regards such material as merely an occasion for fine emotion proves that the ultimate motivating powers at work in effective art are a closed book to him. . . . Precisely because . . . these pictures have to do with something quite other than . . . 'emotional subjects,' they will live eternally as . . . moving monuments to the enslavement of maternal woman in the nineteenth century." *Der Maler Daumier*, p. 28. [Benjamin's note]

40. *Tang-Plastik,* p. 44. [Benjamin's note]

41. Note his thesis on the erotic effects of the work of art: "The more intense the effect, the greater the artistic quality." *Erotische Kunst,* vol. 1, p. 68. [Benjamin's note]

42. *Karikatur,* vol. 1, p. 23. [Benjamin's note]

43. *Dachreiter,* p. 39. [Benjamin's note]

44. *Die grossen Meister der Erotik,* p. 115. [Benjamin's note]

45. Paul Julius Möbius (1853–1907) was a German neurologist known for his work relating to pathological traits in men of genius, such as Rousseau, Goethe, and Nietzsche. Cesare Lombroso (1836–1909) was an Italian physician and criminologist who held that criminals represent a distinct anthropological type, characterized by atavism and degeneracy and by specific physical and mental stigmata

46. See Jacob Burckhardt, *Die Kultur der Renaissance in Italien* [The Civilization of the Renaissance in Italy] (Basel, 1860). Burckhardt (1818–1897), a Swiss historian of art and culture, developed a general concept of a distinctively European culture in the age of the Renaissance that has been absorbed into the basic outlook of modern historiography.

47. *Dachreiter,* p. 40. [Benjamin's note]

48. *Erotische Kunst,* vol. 2, p. 186. [Benjamin's note]

49. *Tang-Plastik,* pp. 30–31. This intuitive and immediate way of perceiving becomes problematic when it attempts to fulfill the demands of a materialist analysis. It is well known that Marx never explained in any detail how the relationship between superstructure and infrastructure should be thought of in individual cases. All we can determine is that he envisaged a series of mediations—transmissions, one might say—which interpolate between the material relationships of production and the remoter domains of the superstructure, which includes art. Plekhanov says the same: "When art, which is created by the upper classes, lacks any direct relation to the process of production, this must ultimately be explained by means of economic causes. The materialist interpretation of history . . . can be applied in this case as well. It is apparent, however, that the causal connections which doubtless exist between being and consciousness—between the social relations which are founded on 'labor' on the one hand and art on the other—are not readily apparent in this case. There are some intermediate stages . . . present here." (See G. Plekhanov, "Das französische Drama und die französische Malerei im achtzehnten Jahrhundert vom Standpunkt der materialistischen Geschichtsauffassung" [French Drama and Painting of the Eighteenth Century, from the Standpoint of Materialist Historiography], *Die Neue Zeit,* 24 (Stuttgart, 1911): 543–544.) This much is clear, however: Marx's classical historical dialectic regards causal contingencies as a given in this relationship. In his later praxis, he became more lax and was often content with analogies. This may have related to his project of replacing bourgeois histo-

ries of literature and art by materialistic ones that were planned on an equally grand scale. Such projects are characteristic of the period—an aspect of the Wilhelminian spirit. Marx's project demanded tribute from Fuchs as well. One of the author's favorite ideas, which is expressed in various ways, posited periods of artistic realism for the mercantile nations—Holland of the seventeenth century, as well as China of the eighth and ninth centuries. Beginning with an analysis of Chinese garden economy, through which he explains many characteristics of the Chinese Empire, Fuchs then turns to the new sculpture which originated under Tang rule. The monumental rigidification of the Han style gave way to increasing freedom. The anonymous masters who created the pottery henceforth focused their attention on the movements of men and animals. "Time," comments Fuchs, "awoke from its long slumber in those centuries in China . . . , for trade always means intensified life—life and movement. Hence, life and movement had to enter into the art of the Tang period. This is what first strikes us about it. Whereas, for example, the entire rendering of animals in the Han period is still heavy and monumental, those of the Tang period exhibit an overall liveliness, and every limb is in motion" (*Tang-Plastik,* pp. 41–42). This mode of consideration rests on mere analogy: movement in trade paralleled movement in sculpture. We might almost call it nominalistic. His attempts at elucidating the reception of antiquity in the Renaissance are likewise trapped in analogy. "In both periods the economic basis was the same, but in the Renaissance this basis had reached a higher stage of development. Both were founded on trade in commodities" (*Erotische Kunst,* vol. 1, p. 42). Finally, trade itself appears as the subject of artistic practice. And trade, Fuchs says, "has to calculate with given quantities, can work only with concrete and verifiable quantities. This is how trade must approach the world and things if it wants to control them economically. Consequently, its aesthetic consideration of things is realistic in every respect" (*Tang-Plastik,* p. 42). We can disregard the fact that a representation which is "realistic in every respect" cannot be found in art. In principle, we would have to say that any connection which claims equal validity for the art of ancient China and for that of early modern Holland seems problematic. Indeed, such a connection does not exist. A glance at the Republic of Venice suffices: Venice's art flourished because of its trade, yet the art of Palma Vecchio, of Titian, or of Veronese could hardly be called realistic "in every respect." Life as we encounter it in this art wears a festive and representative aspect. On the other hand, working life in all stages of its development demands a solid sense of reality. From this consideration the materialist cannot draw any conclusions about manifestations of style. [Benjamin's note]

50. Charles Darwin (1809–1882) published his account of organic evolution and its operating principle, natural selection, in the world-famous *Origin of Species* (1859); he then applied the idea of evolution to human behavior in *The*

Descent of Man, and Selection in Relation to Sex (1871). The influence of Darwinism on the socialist understanding of history was already evident in Germany in the 1860s (much to the bemusement of Darwin himself); but only in the 1890s was a true "evolutionary socialism" born, with the publication of a series of articles by the political theorist Eduard Bernstein (1850–1932), who, as the "father of revisionism," envisioned a type of social democracy that combined private initiative with gradual social reform. When revisionism was incorporated into Social Democratic ideology after the turn of the century, the dogmatic Marxism of Kautsky and the eclectic Marxism of Bebel faded into the background.

51. Enrico Ferri (1856–1929) was an Italian criminologist and politician who edited the socialist organ *Avanti* (first published in 1898); he was later an adherent of fascism.

52. Karl Kautsky, "Darwinismus und Marxismus," *Die Neue Zeit,* 13, no. 1 (Stuttgart, 1895): 709–710. [Benjamin's note]

53. H. Laufenberg, "Dogma und Klassenkampf" [Dogma and Class Warfare], *Die Neue Zeit,* 27, no. 1 (Stuttgart, 1909): 574. Here the concept of the "self-acting" [*Selbsttätigkeit*] has sunk to a sad state. The heyday of this term is the eighteenth century, when the self-regulation of the market was beginning. The concept then celebrated its triumph in Kant, in the form of "spontaneity," as well as in technology, in the form of automated machines. [Benjamin's note]

54. *Karikatur,* vol. 1, p. 312. [Benjamin's note]

55. Marie Jean Antoine de Caritat, marquis de Condorcet (1743–1794), French philosopher, mathematician, and politician, outlined the progress of the human race from barbarism to enlightenment, and argued for the indefinite perfectibility of humankind, in *Esquisse d'un tableau historique des progrès de l'esprit humain* (Sketch for a Historical Picture of the Progress of the Human Mind; 1795).

56. *Erotische Kunst,* vol. 1, p. 3. [Benjamin's note]

57. A. Max, "Zur Frage der Organisation des Proletariats der Intelligenz," p. 652. [Benjamin's note]

58. *Karikatur,* vol. 2, p. 238. [Benjamin's note. Jules Michelet (1798–1874) was a French historian and professor at the Collège de France (1838–1851). Emphatically democratic and anticlerical, he was the author of such works as *Histoire de France* (1833–1867) and *Le Bible de l'humanité* (1864). Edgar Quinet (1803–1875) was a French writer and politician, and an associate of Michelet. Among his works are the epic poems *Napoléon* (1836) and *Prométhée* (1838). The Communards were those involved in the revolutionary government established in Paris in 1871, in the aftermath of the Franco-Prussian War; the Commune of Paris was suppressed in bloody street-fighting that ended in May 1871, leaving 20,000 Communards dead.—*Trans.*]

59. Mehring commented on the trial occasioned by *Die Weber* [The Weavers] in

Die Neue Zeit. Parts of the summation for the defense have regained the topicality they had in 1893. The defense attorney "had to point out that the allegedly revolutionary passages in question are countered by others of a soothing and appeasing character. The author by no means stands on the side of revolt, since he allows for the victory of order through the intervention of a handful of soldiers." Franz Mehring, "Entweder-Oder" [Either-Or], *Die Neue Zeit,* 11, no. 1 (Stuttgart, 1893): 780. [Benjamin's note. The German writer Gerhart Hauptmann (1862–1946) was a master of naturalist drama, as exemplified by *Die Weber* (1892), a dramatization of the Silesian weavers' revolt of 1844.—*Trans.*]

60. Honoré de Balzac, *Le Cousin Pons* (Paris, 1925), p. 162. [Benjamin's note. See, in English, *Cousin Pons,* trans. Herbert J. Hunt (Harmondsworth: Penguin, 1968), p. 146 (Chapter 14, "A Character from Hoffmann's Tales").—*Trans.*]

61. Edouard Drumont, *Les Héros et les pitres* [Heroes and Fools] (Paris, 1900), pp. 107–108. [Benjamin's note. Drumont (1844–1917) was an anti-Semitic and anti-Dreyfusard journalist who founded and edited *La Libre Parole.* He is the author of the influential *La France juive* (Jewish France; 1886).—*Trans.*]

62. See Georg Gottfried Gervinus, *Geschichte der poetischen Nationalliteratur der Deutschen,* 5 vols. (Leipzig, 1835–1842), specifically *Historische Schriften* (Writings on History), vols. 2–6.

63. Georg Gottfried Gervinus, *Friedrich Christoph Schlosser: Ein Nekrolog* [Obituary for Friedrich Christoph Schlosser] (Leipzig, 1861), pp. 30–31. [Benjamin's note. Schlosser (1776–1861) was a German historian, author of *Weltgeschichte für das Deutsche Volk* (World History for the German People; 19 vols., 1843–1857).—*Trans.*]

64. This aspect of Fuchs's work proved useful when the imperial prosecutors began accusing him of "distributing obscene writings." His moralism was represented especially forcefully in an expert opinion submitted in the course of one of the trials, all of which without exception ended in acquittal. This opinion was written by Fedor von Zobeltitz, and its most important passage reads: "Fuchs seriously considers himself a preacher of morals and an educator, and this deeply serious understanding of life—this intimate comprehension of the fact that his work in the service of the history of humanity must be grounded on the highest morality—is in itself sufficient to protect him from any suspicion of profit-hungry speculation. All those who know the man and his enlightened idealism would have to smile at such a suspicion." [Benjamin's note. The passage by Zobeltitz is cited in the "Mitteilung des Verlages Albert Langen in München" (Publisher's Note, from Verlag Albert Langen in Munich), at the beginning of Fuchs, *Die grossen Meister der Erotik* (Munich, 1930), p. 4.—*Trans.*]

65. This revision has been inaugurated by Max Horkheimer in his essay

"Egoismus und Freiheitsbewegung," *Zeitschrift für Sozialforschung,* 5 (1936): 161ff. The documents assembled by Horkheimer correspond to a series of interesting proofs on which the Ultra [right-wing extremist] Abel Bonnard bases his accusation of those bourgeois historians of the French Revolution whom Chateaubriand quaintly calls "l'école admirative de la Terreur" [the school of admiration for the Terror]. See Abel Bonnard, *Les Modérés* [The Moderates] (Paris, 1936), pp. 179ff. [Benjamin's note. See, in English, Max Horkheimer, "Egoism and Freedom Movements: On the Anthropology of the Bourgeois Era," in Horkheimer, *Between Philosophy and Social Science,* trans. G. Frederick Hunter, Matthew S. Kramer, and John Torpey (Cambridge, Mass.: MIT Press, 1993), pp. 49–110.—*Trans.*]

66. *Der Maler Daumier,* p. 30. [Benjamin's note]

67. Norbert Guterman and H. Lefebvre, *La Conscience mystifiée* (Paris, 1936), p. 151. [Benjamin's note. What Benjamin means by Lamartine's "excessive use of *bona fides*" can be grasped from an entry in *The Arcades Project,* p. 767 (Convolute d12,2).—*Trans.*]

68. *Erotische Kunst,* vol. 2, part 1, p. 11. [Benjamin's note]

69. *Erotische Kunst,* vol. 1, p. 43. Fuchs's moral-historical representation of the Directory has traits reminiscent of a popular ballad. "The terrible book by the Marquis de Sade, with plates as crudely executed as they are infamous, lay open in all the shopwindows." And the figure of Barras bespeaks "the dissipated imagination of the shameless libertine." *Karikatur,* vol. 1, pp. 202, 201. [Benjamin's note]

70. *Karikatur,* vol. 1, p. 188. [Benjamin's note]

71. Max Horkheimer, "Egoismus und Freiheitsbewegung," p. 166. [Benjamin's note]

72. Many of the plays of the German dramatist Frank Wedekind (1864–1918), such as *Erdgeist* (Earth Spirit; 1895) and *Die Büchse der Pandora* (Pandora's Box; 1904), set up a conflict between a desiccated, hypocritical bourgeois morality and sexual freedom.

73. *Erotische Kunst,* vol. 2, p. 283. Fuchs is on the track of something important here. Would it be too rash to connect the threshold between human and animal, such as Fuchs recognizes in the orgy, with that other threshold constituted by the emergence of upright posture? The latter brings with it a phenomenon unprecedented in natural history: partners can look into each other's eyes during orgasm. Only then does an orgy become possible. What is decisive is not the increase in visual stimuli but rather the fact that now the expression of satiety and even of impotence can itself become an erotic stimulant. [Benjamin's note]

74. *Sittengeschichte,* vol. 3, p. 234. A few pages later, this confident judgment has faded—evidence of the force with which it had to be wrested away from convention. Instead, we now read: "The fact that thousands of people become sexually excited when looking at a woman or man photographed in

the nude . . . proves that the eye is no longer capable of perceiving the harmonious whole but only the piquant detail" (ibid., p. 269). If there is anything sexually arousing here, it is more the idea that a naked body is being displayed before the camera than the sight of nakedness itself. This is probably the idea behind most of these photographs. [Benjamin's note]

75. Ibid., p. 189. [Benjamin's note. The Austrian satirist and critic Karl Kraus (1874–1936) founded the polemical review *Die Fackel* in 1899 and edited it until shortly before his death. See Benjamin's essay "Karl Kraus" (1931), in this volume.—*Trans.*]

76. The writer Max von Boehn (1860–1932) published an eight-volume study of fashion from the sixteenth through the nineteenth centuries, *Die Mode* (Fashion; 1907–1925). Among his other works are *Biedermeier* (1911), *Antike Mode* (Fashion in Antiquity; 1927), and *Puppen und Puppenspiele* (Dolls and Puppets; 1929). He is cited several times in *The Arcades Project*.

77. *Sittengeschichte*, supplementary vol. 3, pp. 53–54. [Benjamin's note]

78. For Fuchs, art is immediate sensuousness, just as ideology is an immediate offspring of interests. "The essence of art is sensuousness [*Sinnlichkeit*]. Art is sensuousness—indeed, sensuousness in its most potent form. Art is sensuousness become form, become visible, and at the same time it is the highest and noblest form of sensuousness" (*Erotische Kunst*, vol. 1, p. 61). [Benjamin's note]

79. See Sigmund Freud, *Die Traumdeutung* (Leipzig and Vienna, 1900). Freud (1856–1939), Austrian neurologist and founder of psychoanalysis, developed a theory that dreams are an unconscious representation of repressed desires, especially sexual desires.

80. *Karikatur,* vol. 1, p. 223. [Benjamin's note]

81. *Erotische Kunst,* vol. 2, p. 390. [Benjamin's note]

82. *Der Maler Daumier,* p. 30. [Benjamin's note]

83. Baudelaire discusses Daumier in his essay "Quelques caricaturistes français" (1857). See, in English, "Some French Caricaturists," in Baudelaire, *The Painter of Modern Life and Other Essays,* trans. Jonathan Mayne (1964; rpt. New York: Da Capo, 1986), pp. 171–180: "The hot-headed Achilles, the cunning Ulysses, the wise Penelope, that great booby Telemachus, and the fair Helen who ruined Troy—all of them, in fact, appear before our eyes in a farcical ugliness reminiscent of those decrepit old tragic actors whom one sometimes sees taking a pinch of snuff in the wings. . . . [Daumier's] caricature has formidable breadth, but it is quite without bile or rancor. In all his work, there is a foundation of decency and simplicity" (pp. 178–179).

84. This should be compared to the following reflection: "According to my . . . observations, it is in an artist's erotically charged pictures that the dominant elements of his palette, at any particular time, emerge most clearly. Here, . . . these elements attain . . . their greatest power of illumination" (*Die grossen Meister der Erotik,* p. 14). [Benjamin's note]

85. *Der Maler Daumier,* p. 18. Daumier's famous *Art Expert,* a watercolor that exists in several versions, depicts one such figure. One day, Fuchs was shown a previously unknown version of this work and asked to authenticate it. He obtained a good reproduction of the picture and, focusing on the main portion of the subject, embarked on a very instructive comparison. Not the slightest deviation went unnoticed; in the case of each discrepancy, he asked whether it was the product of the master's hand or that of impotence. Again and again Fuchs returned to the original, yet in a manner that seemed to say he could have easily dispensed with it; his gaze had a familiarity that could only have come from carrying the picture around with him in his head for years. No doubt this was the case for Fuchs. And only because of this was he able to discern the slightest uncertainties in the contour, the most inconspicuous mistakes in the coloring of the shadows, the minutest derailings in the movement of the line. As a result, he was able to identify the picture in question not as a forgery but as a good old copy, which might have been the work of an amateur. [Benjamin's note]

86. Paul Gavarni (Sulpice Chevalier; 1804–1866) was a French illustrator and caricaturist, best known for his sketches of Parisian life.

87. *Dachreiter,* pp. 5–6. [Benjamin's note]

88. Jean de La Bruyère (1645–1696), French moralist, was the author of one of the masterpieces of French literature, *Les Caractères de Théophraste, traduits du grec, avec les caractères ou les moeurs de ce siècle* (Characters, or The Manners of This Age, with the Characters of Theophrastus; 1688), a series of satirical portrait sketches appended to his translation of the fourth-century B.C. character writer Theophrastus. One of La Bruyère's characters is the print-collector Démocède (not "Damocède"), who appears in Chapter 13, "De la mode" (On Fashion). He is based on Michel de Marolles (1600–1681), abbé of Villeloin and an erudite translator of Latin poetry, who amassed a collection of prints numbering 123,400 items, representing more than 6,000 artists. This collection was acquired by the government of Louis XIV in 1667 and is now in the Louvre's archive of prints, the Cabinet des Estampes. Anne Claude Philippe de Tubières, comte de Caylus (1692–1765), archaeologist, engraver, and man of letters, published his seven-volume *Recueil d'antiquités égyptiennes, étrusques, grecques, romaines, et gauloises* (Collection of Egyptian, Etruscan, Greek, Roman, and Gallic Antiquities) from 1752 to 1767. Baron Philipp von Stosch (1691–1767) was a Prussian-born antiquarian, diplomat, secret agent for the English, and collector of ancient art and manuscripts; his collection of antique engraved artifacts contained more than 10,000 cameos, intaglios, and antique glass gems. Winckelmann (see note 31 above) catalogued 3,444 of these intaglios in 1758, and published his catalogue in French, *Description des pierres gravées du feu Baron de Stosch* (Description of the Engraved Gems of the Late Baron von Stosch; 1760). Ferdinand Franz Wallraf (1748–1824), a Catholic

priest and professor of philosophy and natural history at the University of Cologne, bequeathed to the city of Cologne a rich collection of works of old Rhenish art, accumulated during the period of the French Revolution; his collection forms the basis of the Wallraf-Richartz Museum in Cologne. Sulpiz Boisserée (1783–1854), a German writer and art collector, put together, with his brother Melchior (1786–1851), a collection of German and Flemish primitives which, in 1827, was sold to King Ludwig I of Bavaria for the Alte Pinakothek museum in Munich. The Nazarenes were a group of young German painters, active 1809–1830, who were intent on restoring a religious spirit to art.

89. *Tang-Plastik,* p. 44. [Benjamin's note]

90. *Honoré Daumier,* vol. 1, p. 13. Compare these observations with Victor Hugo's allegorical interpretation of the wedding at Cana. "The miracle of the loaves represents the multiplication of readers many times over. On the day that Christ discovered this symbol, he foreshadowed the printing press." Victor Hugo, *William Shakespeare,* cited in Georges Batault, *Le Pontife de la démagogie: Victor Hugo* (Paris, 1934), p. 142. [Benjamin's note]

91. *Dachreiter,* p. 46. [Benjamin's note]

92. *Karikatur,* vol. 1, p. 19. The exception proves the rule. A mechanical process of reproduction was used to produce terra cotta figures. Among these are many caricatures. [Benjamin's note]

93. See Erich Klossowski, *Honoré Daumier* (Munich, 1908), p. 113. [Benjamin's note]

94. *Dachreiter,* p. 45. [Benjamin's note]

11

Review of Sternberger's *Panorama*

Dolf Sternberger, *Panorama, oder Ansichten vom 19. Jahrhundert* [Panorama, or Views of the Nineteenth Century] (Hamburg, 1938), 238 pages.

Among the contradictions which are not unified but which are provisionally clamped together in Germany today are the reactions provoked by recollection of the Bismarck era.[1] At that time, the petty bourgeoisie entered into an apprenticeship to the powers-that-be, one which has been revived and extended under National Socialism. By comparison, the middle bourgeois strata still enjoyed much greater political power at that time. Only when they had relinquished that power was the way cleared for monopoly capitalism, and with it the national renewal. National Socialism is thus ambivalent toward the age of Bismarck. It boasts of having eradicated the slovenliness of the age—with some justification, if one considers the average level of security enjoyed by the lower classes in those days. On the other hand, the National Socialist party is well aware that it is perpetuating Wilhelmine imperialism and that the Third Reich is basking in the reflected glory of the Second. Its training of the petty bourgeoisie is based on this awareness. Thus, we have on one side the eyes raised deferentially to those above, but on the other the critical reserve (an ambivalence aptly illustrated by the way the leaders of the new Reich view those of the old army.)

Imagine this situation as a mirror image—that is, symmetrically inverted—and you have the outline of Sternberger's book.[2] Its attitude is likewise ambivalent, but in the opposite direction. When he probes the age of Bismarck critically, he touches on the features with which one feels

158

solidarity today. And when he seems to be soliciting the reader's good opinion of it, he clings to a solid, moderate standard of bourgeois morality which today's Germany has turned its back on. In other words, the critic in Sternberger can reveal his insights, and the historian his sympathies, only with the utmost caution.

This might not have been a hopeless task. But the author's aspirations went further. He wanted to fill a breach. The copious production of writings by academics eager to toe the line has its counterpart in an exodus from fields that, unnoticed by orthodox scholarship, used to be occupied by an avant-garde. This avant-garde liked to present its ideas in the form of essays. Sternberger's astonishing enterprise is to revive the form and thematic content of such works. As the book's title indicates, he wanted not to draw a map of his subject matter but to survey it from serene heights. This is confirmed by the sequence of chapters. In his efforts to maintain an essayistic stance no matter what the cost, the author casts about in all directions. The less capable he is of coming to terms with his subject matter methodologically, the more insistently he enlarges it, and the more ambitious and comprehensive it becomes.

The question of whether people's visual impressions are determined only by natural constants, or additionally by historical variables, is at the very leading edge of research. To move an inch closer to an answer is a hard-won advance. Sternberger takes this problem in his stride. Had he focused on it closely and said, for example, that light impinges on human experience only in a manner permitted by the historical constellation, one would have eagerly awaited the elaboration of this idea. Sternberger does indeed say this (p. 159), but merely in order to have his piece on this gameboard as well. His treatment of the question is hedged about with appositions, subsidiary clauses, and parentheses in which the content is lost. Moreover, he refuses to have any truck with those who, if they were allowed to do so, might express interest in an issue closely related to this question: namely, in the fact that the natural conditions of human existence are altered by human means of production.

Many topics gain a hearing, but not the one they deserve. It is often instructive to refer back to works in which motifs such as genre, allegory, and Jugendstil are dealt with in rigorous contexts.[3] Adorno, for example, has demonstrated that a late form of allegorical vision is found in Kierkegaard's writings; Giedion, in his studies of architectural history, showed that the nineteenth century felt a need to conceal its architectural achievements behind a mask of imitation; Salvador Dalí interpreted Jugendstil in terms of Surrealism.[4] Sternberger deals with all of these sub-

jects. But in his book they form motifs, in the sense of whimsically arranged ornamentation.

The essayist likes to think of himself as an artist. He can then yield to the temptation to substitute empathy (with an epoch no less than with a way of thinking) for theory. The symptoms of this dubious state of affairs are evident in Sternberger's language. An elevated, pretentious style of German is allied to the moral affectation that was characteristic of the ingratiating family novel of the 1860s. This stylistic mimicry gives rise to the most convoluted phrasing. "Since then, in general," is a favorite (vacuous) construction; "of this kind and extent" mistakes redundancy for a transition. Phrases such as "it's time to bring this digression to a close," "let us move on, however," and "it would ill befit the author" usher the reader through the book as if through a suite of stately rooms. The author's language is a vehicle of regression.

Nowadays, regression to remote spheres that do not invite political intervention is widespread in Germany. Childhood recollections and the cult of Rilke, spiritualism and Romantic medicine succeed one another as intellectual fads.[5] Sternberger regresses while holding on to the motifs of the avant-garde. His book is truly a classic case of retreating forward. Naturally, he cannot avoid colliding with the enemy. Above all, he has to contend with those who hesitate to cast a critical vote on the Gründerzeit in pursuit of their own interests.[6] The barbarism of the present was already germinating in that period, whose concept of beauty showed the same devotion to the licked-clean which the carnivore displays toward its prey. With the advent of National Socialism, a bright light is cast on the second half of the nineteenth century. Those years marked the first attempts to turn the petty bourgeoisie into a party and harness it to precise political purposes. This was done by Stoecker, in the interests of the big landowners.[7] Hitler's mandate came from a different group. Nevertheless, his ideological nucleus remained that of Stoecker's movement fifty years earlier. In the struggle against an internally colonized people, the Jews, the fawning petty bourgeois came to see himself as a member of a ruling caste and unleashed his imperial instincts. With National Socialism, a program came into force which imposed the ideals of the Gründerzeit—glowing warmly in the light of world conflagration—on the German domestic sphere, especially that of women. On July 18, 1937, in a speech delivered by the head of the party and inveighing against "degenerate art," the orientation of Germany's culture was aligned with its most servile and inferior stratum, and laid down with the authority of the state.[8] In the *Frankfurter Zeitung* on July 19, Sternberger

wrote that this speech "settled accounts . . . with the attitudes and theories that established the public tone in the art world in the era which is now behind us." This "settling of accounts," he added, is "not yet completed." He also claimed that it had been conducted "with the weapons of cutting irony and the methods of philosophical discussion." The same cannot be said of this ramble through its more distant historical background.

Sternberger's book is ornate and difficult. It diligently seeks out the arcane subject, but lacks the conceptual force to hold it together. He is unable to formulate definitions[9]—a failing that makes him all the more inclined to present the *disjecta membra* of his text to the reader as a meaningful symbol. This tendency is exacerbated by his disturbing fixation on the "allegorical." Allegory is surrounded by emblems forming a "patchwork" at its feet. Sternberger uses the term matter-of-factly in this sense, though it carries no such elaborate connotations in normal usage. The attributes he ascribes to it make us doubt whether he associates it with any clear meaning. Under the heading "The Allegory of the Steam Engine," he assembles a number of clichés extolling the locomotive: as swift as an eagle, an iron horse, a race-horse on wheels. Such clichés, he believes, create "an allegorical poetry . . . in the precise sense that elements of technology, when fused with others from living nature, take on a new, autonomous existence as a Janus figure" (p. 26). This has nothing to do with allegory. The taste guiding such language reflected the need to escape a threat. This threat was thought to lie in the "rigid," "mechanical" qualities associated with technical forms. (In reality, it was of a different kind.) What was generally felt was the oppression emanating from technology, and refuge from it was sought in Ludwig Knaus's paintings of groups of children, Grützner's monks, Warthmüller's rococo figurines, and Defregger's villagers.[10] The railway was invited to join the ensemble—but it was the ensemble of the genre painting. Genre painting documents the failed reception of technology. Sternberger introduces the concept, but his interpretation of it is entirely flawed. "In genre painting," he writes, "the onlooker's interest . . . is always actively engaged. Just as the scene that has been frozen, the living image, needs completion, so this interested onlooker is eager to fill the gaps in the painting's patchwork . . . with the joys or tears it evokes" (p. 64). As I have said, the origin of genre painting is more tangible. When the bourgeoisie lost the ability to conceive great plans for the future, it echoed the words of the aged Faust: "Linger awhile! Thou art so fair."[11] In genre painting it captured and fixed the present moment, in order to be rid of the image of its future.

Genre painting was an art which refused to know anything of history. Its infatuation with the moment is the most precise complement to the chimera of the Thousand-Year Reich. The connection between the aesthetic ideals of the Gründerzeit and the vaulting artistic aims of the National Socialist party has its basis here.[12]

Sternberger has not broken the theoretical monopoly of National Socialism. It distorts his ideas, falsifies his intentions. The falsification is manifest most clearly in his view of the dispute over vivisection in the 1870s. In the pamphlets which set off the controversy, certain errors by the vivisectors provided the catchwords for a obstinate rancor against science itself. The movement against vivisection was an offshoot of petty-bourgeois interest groups, including the opponents of immunization, who revealed their colors so openly in the attack on Calmette.[13] These groups provided recruits for "the movement." The basis for Sternberger's critical stance can be found here. Under the Third Reich, animal protection laws have been passed almost as fast as concentration camps have been opened. There is much evidence to suggest that such fanatical groups serve as cocoons for the sadomasochistic character in its pupal phase. A study that concerns itself with this but refuses to recognize the death's-head moth which has emerged from the chrysalis must expect to go astray. That is what happens in Sternberger's case. He finds no other way to attack the opponents of vivisection than to denigrate pity as such. Since animal protection is the last refuge the powers-that-be have left for pity, they are unlikely to be offended by its defamation. But in reality they have not left it even this refuge. For them, animal rights are founded on the mysticism of blood and soil.[14] National Socialism, which has evoked so much animality in human beings, thinks that it has been surreptitiously encircled by beasts. Its protection of animals springs from a superstitious fear.

One does not need to subscribe to Schopenhauer's view of pity—namely, that it is the source of people's humanity—to be suspicious of a definition which says that "altruism is as far removed from pity" as "revelation is from feeling" (p. 84). At any rate, one would do better to speak of true humanity before deriding what flows from pity as "genre-painting humanity" (p. 229). Any reader who peruses the discussion of these matters—the chapter entitled "The Religion of Tears"—and attempts to extract its philosophical content will have little to show. He will have to content himself with the assertion that pity is nothing but the "inner side or the correlative of the anger . . . felt by anyone who witnesses a scene of cruelty" (p. 87). The sentence is obscure. All the clearer, however, is the

fact that pity is mere froth for the person who washes his hands in innocence.

The unmistakable aim of this book, the cause to which the author has subscribed, can be summed up in a word: it is the art of covering traces. The trace of the origins of his ideas, the trace of the secret reservations underlying his conformist statements, and finally the trace of conformism itself, which is the hardest of all to erase. Ambiguity is Sternberger's element. He elevates it to the method that guides his investigations: "Constraint and action, compulsion and freedom, matter and spirit, innocence and guilt cannot be disentangled in the past, whose unalterable testimony, however scattered and incomplete, we have before us here. These things are always thoroughly interwoven, but the pattern woven [*das Verwirkte*] can be described" (p. 7).[15]—Sternberger's situation can be described as follows: he confiscated his ideas, and then had them confiscated. No wonder they have a boarded-up look, just as one can speak of a "shuttered" gaze. These views of the nineteenth century seem designed to block insights into the twentieth.

Written in 1938 and January 1939; submitted to the *Zeitschrift für Sozialforschung* in late 1939 but unpublished in Benjamin's lifetime. *Gesammelte Schriften*, III, 572–579. Translated by Edmund Jephcott.

Notes

1. Dolf Sternberger (1907–1989), German journalist and political scientist, was a former student of Adorno's and personally acquainted with Benjamin. He served after the war as president of the West German chapter of PEN (an international association of poets, playwrights, editors, essayists, and novelists).

2. Much of the tone of this review is explained by Benjamin's conviction, expressed in a letter to Adorno and in the draft of a letter to Sternberger himself, that the book is little more than plagiarism. Sternberger knew Benjamin personally; both had contributed to the *Frankfurter Zeitung*, as well as to Frankfurt radio. And he had studied with Adorno at the University of Frankfurt. In the letter to Adorno, Benjamin claims that Sternberger had lifted not only the topic of the study but also its methodology from Adorno, Bloch, and especially Benjamin himself. In the draft letter to Sternberger, Benjamin writes: "You succeed, in your book, in producing a synthesis between an older world of thought (which you share with Adolf Hitler) and a newer one (which you share with me). You have rendered unto the kaiser that which is the kaiser's, and taken from the exile that which you could use" (*Gesammelte Schriften*, III, 701).

3. Jugendstil is the German and Austrian variant of the Art Nouveau style of the 1890s. The movement took its name from the Munich journal *Die Jugend* (Youth).

4. Adorno does this in his book *Kierkegaard: Konstruktion des Ästhetischen* (1933); in English as *Kierkegaard: Construction of the Aesthetic*, trans. Robert Hullot-Kentor (Minneapolis: University of Minnesota Press, 1989). Siegfried Giedion (1888–1968) was a Swiss architect and architectural historian whose *Bauen in Frankreich* (Construction in France; 1928) exerted a deep influence on Benjamin. He taught at Harvard after 1938.

5. Rainer Maria Rilke (1875–1926), Austro-German writer born in Prague, was one of the great lyric poets in the German language. His *Duineser Elegien* (Duino Elegies) and *Sonette an Orpheus* (Sonnets to Orpheus) were published in 1923.

6. The Gründerzeit denotes the period of rapid industrial expansion and reckless financial speculation following the foundation of the German Empire in 1871.

7. Adolf Stoecker (1835–1909), Protestant theologian and politician, founded the profoundly conservative Christlich-soziale Arbeiterpartei (Christian-Socialist Workers' Party) in 1878. Stoecker sought to convert German workers to the virtues of a monarchical nationalism. He is primarily remembered, however, for his virulent anti-Semitism.

8. Hitler delivered a programmatic speech on Nazi art and cultural policy one day before the opening of the "Große Deutsche Kunstausstellung" (Great German Art Exhibition) at the Haus der Deutschen Kunst (House of German Art) in Munich. An exhibition titled "Entartete Kunst" (Degenerate Art) ran concurrently with "Great German Art"; it displayed 650 works confiscated from 32 German museums. Examples of Expressionism, Cubism, Dada, Surrealism, and Neue Sachlichkeit hung alongside drawings by the mentally ill and photographs of handicapped individuals.

9. Sternberger is in the invidious position of having to break off the process of thinking just where it might become fruitful. In the end, this damages his capacity for thought, as we can see from a single sentence: "It is all too easy to laugh at something which in any case is over and done with, and should therefore be regarded as a waste of wit, since wit tends to gain in brilliance as it becomes rarer" (p. 158). The first main clause contains two offenses against clearly ordered thought. First, "in any case" is out of place, because laughter does not alter the temporal location of its object. Second, the word "easy" is inappropriate. For while it might be said to be too easy to laugh about something (for example, a non sequitur) which ought rather to be analyzed by a difficult process of thought, it can never be "all too easy" to make something insignificant the subject of laughter. Laughter is not a task in which one gains credit by overcoming difficulties. In the next clause, the talk about a "waste of wit" makes any sense, however meager, only if "wit"

is used to mean "intelligence," as in the eighteenth century. One might well speak of a waste of intelligence, but one could not imagine that the person doing the wasting would laugh as a result. Probably however, the word is not being used with this old-fashioned meaning. It is more likely that, for Sternberger, the idea that wit is rare is confused with the idea that the case in question is not a subject for joking. Now, first of all, not everything one laughs about is a joke. Second, the rarity and terseness of wit cannot be used as a reason that people should find fewer occasions for laughter—even at jokes. Finally, to say that wit tends to gain brilliance [*Brillanz*] through rarity is clear but contrary to language. *Brillant* in German has only one derivation: from Brilliantine. [Benjamin's note. Brilliantine was an oily perfumed preparation designed to make hair smooth and glossy.—*Trans.*]

10. Ludwig Knaus (1829–1910), German genre painter, was a professor at the Kunstakademie in Düsseldorf; groups of children recur as a kind of signature in his art. Eduard von Grützner (1846–1925), another German genre painter, was best known for his studies of drinking and hunting scenes, as well as his depictions of monastery life. Robert Warthmüller (1859–1895), was a German genre painter who specialized in historical events of the eighteenth century, particularly the life of Frederick the Great. Franz von Defregger (1835–1921) was a German genre painter best known for his monumental history scenes, especially representations of the Tirolean war of independence.

11. Faust's wager with Mephistopheles turns on Faust's restless quest for experience. In the first part of Goethe's drama, Faust utters the famous lines, "If I say to any moment / Linger awhile! Thou art so fair! / Then you may cast me in chains." Late in life, Faust is indeed tricked into uttering these words, but is nonetheless redeemed by divine intervention.

12. Sternberger attempts to trace the triumph of genre painting in Nietzsche's writings on the revaluation of values. In referring at this point to a "recurrence of genre painting," he introduces what might have been a constructive moment. But he does nothing to develop it. He fails to decipher the historical signature of the "inverted genre," with which Nietzsche set himself in opposition to his contemporaries. This signature is to be found in Jugendstil. Against the naive vitality of genre painting, Jugendstil set the mediumistic floral arabesque; on the banality of the everyday, it turned a gaze which had just plumbed the abysses of evil; and to philistine complacency, it opposed a longing whose arms forever remain empty. [Benjamin's note]

13. Albert Léon Charles Calmette (1863–1933), French bacteriologist, developed an antitoxin for vaccination of newborn infants against tuberculosis.

14. "Blut und Boden" ("Blood and Soil") became a slogan of the National Socialists. They derived the phrase from the reactionary journal of the same name, first published in 1929.

15. Sternberger's term, *das Verwirkte,* also means "what is impounded."

II

SCRIPT, IMAGE, SCRIPT-IMAGE

In the book *One-Way Street* (written 1923–1926, published 1928)—a collection of prose writings whose form is related to German traditions of aphoristic writing and to the montage experiments of early twentieth-century modernist poetry and the visual arts—Benjamin makes a series of scandalous claims: that the most relevant form of modern writing is the engineering diagram, that the neon advertising sign is superior to the most advanced criticism. As early as 1916, in the essay "On Language as Such and on the Language of Man," he had expressed a radical skepticism regarding the capacity of human language to communicate meaning. Two modes of language are differentiated there: a privileged, self-present language given to humans in Paradise and founded on the human ability to name—an ability derived from and modeled on God's originary acts of naming—and a "bourgeois conception" in which language, "mere words," serves only to communicate knowledge of things external to language itself. For Benjamin, the fall from Paradise is in fact the fall of language: "the birth of the *human word.*"

One of the great themes of Benjamin's work is thus the exploration of the nature of language and, more generally, the investigation of the production and communication of meaning in a postlapsarian world. In his book on the German Baroque play of mourning, *Origin of German Trauerspiel,* Benjamin explores, under the rubric of the fall of language, the uses of what he calls "script" *(Schrift)* in the Baroque—that cultural epoch which began around 1600 in Italy and extended into the early eighteenth century in Germany. Intensely aware of the human drive to find meaning in our world, he uncovers strategies in the Baroque era that

aim to invest the most profane things with an elevated significance; it is this drive that informs the characteristic trope of the Baroque, allegory. Props on the stage, individual words, and graphic images were invested with a remarkable, but obscure, power as allegory endowed them with "higher" meanings not otherwise accessible. But because the relationship between meaning and sign was wholly subjective—the product of the allegorist's imagination, rather than any natural or inherent significance— the meaning of these allegorical objects was wholly arbitrary: "Any person, any thing, any relationship can mean absolutely anything else."

And what was true of such material systems as the allegorical props on a stage was all the more true of human language: "In the anagrams, the onomatopoetic turns of phrase, and many other kinds of linguistic virtuosity [of the Baroque], word, syllable, and sound are emancipated from all traditional associations of meaning and flaunt themselves as a thing that can be exploited allegorically." This "emancipation" of the elements of language from larger, meaning-producing structures was simultaneously language's "shattering" or "dismemberment." The disjointed, arbitrary elements achieve a "changed and intensified expressiveness. . . . The decimated language had, in its individual parts, ceased to serve mere communication; it places, as a newborn object, its dignity alongside that of the gods, rivers, virtues, and other similar natural forms that shimmer into the allegorical."

Individual elements of this "decimated language" attain to the condition Benjamin calls "script": a written form that "strives to become image," or a "script-image" [*Schriftbild*] that remains an "amorphous fragment." And it is from the graphic nature of the script-image, above all, that meaning "flashes up" [*aufblitzt*]—to use the term Benjamin arrived at in the 1930s when he returned to the question of the script-image and developed the related concept of the "dialectical image" in the context of the Arcades Project.[1]

For the Benjamin of the later 1920s, the theory of graphology offered one of the richest fields for the investigation of script. His 1930 article "Graphology Old and New" sketches a short history of European graphology, from the establishment of the field in the 1870s to the recent opening of Berlin's Zentral Institut für Wissenschaftliche Graphologie (Central Institute for Scientific Graphology). Like many in the early part of the twentieth century, Benjamin thought of graphology as a science, and he insisted that the "scientific experiments" of those he recognized as its serious present-day practitioners and theorists (including Anja and Georg Mendelssohn, Ludwig Klages, Robert Saudek, and Magdalene

Ivanovic) should be distinguished from "the complacency with which vulgar practitioners have appealed to the philistine's curiosity and passion for gossip." The work of the psychoanalyst and graphologist Anja Mendelssohn and her brother Georg comes in for special praise from Benjamin, who embraces its emphasis on the "pictorial dimension" of handwriting and its status as a "systematic attempt to construe the handwriting of even civilized people as a set of hieroglyphs"—an approach he opposes to the emphasis on handwriting as "fixed expressive movement," a tenet in the vitalist graphology of Klages. Where Klages' work set out to offer predictive assessments of moral character based on the analysis of the "general formal level" of an individual's handwriting, the Mendelssohns, "having learned from Freud," aimed to interpret the "unconscious image-fantasies" that handwriting "contains."

In other words, according to the graphological model Benjamin favors, handwriting does not register the inclinations of individual character, and moral disposition is not recognizable by means of an analysis of handwriting formulated in terms of metaphor or analogy (so, in Benjamin's example, cramped handwriting cannot count as evidence of a tendency "to keep one's possessions close together—or to be parsimonious"). Rather, handwriting emerges as a medium for the appearance of images that have been produced unconsciously—internalized, reconfigured, and in turn presented and contained in the shapes of letters and words on a page. That is, the images that constitute the pictorial dimension of handwriting emerge in relation to the world and the persons and things that occupy it, but not in ways that allow for the interpretation of handwriting as an expression of individual character and its moral disposition.

If, on Benjamin's reading, script remained, in the Baroque, a form reserved for the semi-sacred space of the mourning play, and, in handwriting, an image-repository of the unconscious, his own *One-Way Street* became a site for analyzing and perhaps enacting the process through which, in the context of early twentieth-century European modernity, script is "dragged out into the street by advertisements and subjected to the brutal heteronomies of economic chaos." Benjamin's emphasis on the image-character of certain forms of writing anticipates a day in which script will achieve a "new eccentric figurativeness," the power to encode and display forms of significance denied to "fallen," "bourgeois" language.

Benjamin was of course not alone in his valorization of the image-character of script in the modern era. From the typographical experi-

ments of modernist writers such as Stéphane Mallarmé and Hugo Ball, to the montage pictures of the Berlin Dadaists and the collages and "over-paintings" of the Cologne Dadaist and later Parisian Surrealist Max Ernst (with their uncanny admixture of image fragments and inscription), to the photographer Walker Evans' profound interest in the image-character of the scripts (advertisements, road signs, political slogans) that mark our buildings as sites in public space, Benjamin's contemporaries experimented with the script-image as a characteristic form of modernity. Nonetheless, as argued in the introduction to Part III below, we should take note of the ways in which, in his writings of the period 1924–1940, and especially in the second half of the 1920s, Benjamin offered a sustained and often idiosyncratic account of the inextricably intertwined nature of image-making and writing. He was tireless in his pursuit of experimental forms that combined the two, and made, over the course of his career, the short, imagistic but philosophically charged prose piece a form all his own.

His texts of this genre, which he referred to variously as "figures of thought" *(Denkbilder)* or "dialectical images," are united in their conviction that a script-image is uniquely capable of producing kinds of meaning that are otherwise inaccessible or unrepresentable. And his meditations on a wide range of media are likewise suffused with this very particular understanding of script-as-image and image-as-script. In the essays in Parts IV–VI below, on photography, film, and journalism, the concept of the script-image repeatedly emerges as the key to understanding a range of modern media.

<div align="center">MICHAEL W. JENNINGS AND BRIGID DOHERTY</div>

Notes

1. For a suggestive reading of the idea of "flashing up" that situates the concept in the philosophy of history and the history of photography, see Eduardo Cadava, *Words of Light: Theses on the Photography of History* (Princeton: Princeton University Press, 1997).

12

Attested Auditor of Books

Just as this era is the antithesis of the Renaissance in general, it contrasts in particular with the situation in which the art of printing was discovered. For whether by coincidence or not, printing appeared in Germany at a time when the book in the most eminent sense of the word—the Book of Books—had, through Luther's translation, become the people's property. Now everything indicates that the book in this traditional form is nearing its end. Mallarmé, who in the crystalline structure of his manifestly traditionalist writing saw the true image of what was to come, was in the *Coup de dés* the first to incorporate the graphic tensions of the advertisement in the printed page.[1] The typographic experiments later undertaken by the Dadaists stemmed, it is true, not from constructive principles but from the precise nervous reactions of these literati, and were therefore far less enduring than Mallarmé's, which grew out of the inner nature of his style.[2] But for this very reason they show the contemporary relevance of what Mallarmé, monadically, in his hermetic room, had discovered through a preestablished harmony with all the decisive events of our times in economics, technology, and public life. Script—having found, in the book, a refuge in which it can lead an autonomous existence—is pitilessly dragged out into the street by advertisements and subjected to the brutal heteronomies of economic chaos. This is the hard schooling of its new form. If centuries ago it began gradually to lie down, passing from the upright inscription to the manuscript resting on sloping desks before finally taking itself to bed in the printed book, it now begins just as slowly to rise again from the ground. The newspaper is read more in the vertical than in the horizontal plane, while film and advertisement force

the printed word entirely into the dictatorial perpendicular. And before a contemporary finds his way clear to opening a book, his eyes have been exposed to such a blizzard of changing, colorful, conflicting letters that the chances of his penetrating the archaic stillness of the book are slight. Locust swarms of print, which already eclipse the sun of what city dwellers take for intellect, will grow thicker with each succeeding year. Other demands of business life lead further. The card index marks the conquest of three-dimensional writing, and so presents an astonishing counterpoint to the three-dimensionality of script in its original form as rune or knot notation. (And today the book is already, as the present mode of scholarly production demonstrates, an outdated mediation between two different filing systems. For everything that matters is to be found in the card box of the researcher who wrote it, and the scholar studying it assimilates it into his own card index.) But it is quite beyond doubt that the development of writing will not indefinitely be bound by the claims to power of a chaotic academic and commercial activity; rather, quantity is approaching the moment of a qualitative leap when writing, advancing ever more deeply into the graphic regions of its new eccentric figurativeness, will suddenly take possession of an adequate material content. In this picture-writing, poets, who will now as in earliest times be first and foremost experts in writing, will be able to participate only by mastering the fields in which (quite unobtrusively) it is being constructed: statistical and technical diagrams. With the founding of an international moving script, poets will renew their authority in the life of peoples, and find a role awaiting them in comparison to which all the innovative aspirations of rhetoric will reveal themselves as antiquated daydreams.

Written 1923–1926; published in 1928. Excerpted from *One-Way Street. Gesammelte Schriften*, IV, 102–104. Translated by Edmund Jephcott.

Notes

1. The French poet Stéphane Mallarmé (1842–1898) was a central figure in the Symbolist movement, which sought an incantatory language divorced from all referential function. Benjamin refers to the typographic manipulations of his poem *Un Coup de dés jamais n'abolira le hasard* (A Throw of the Dice Will Never Eliminate Chance; 1897).
2. In Zurich in 1916, artists, writers, and others disgusted by World War I, and by the bourgeois ideologies that had brought it about, launched Dada, an avant-garde movement that attempted to radically change both the work of art and society. Dadaist groups were active in Berlin, New York, Paris, and elsewhere during the war and into the 1920s.

13

These Surfaces for Rent

Fools lament the decay of criticism. For its day is long past. Criticism is a matter of correct distancing. It was at home in a world where perspectives and prospects counted and where it was still possible to adopt a standpoint. Now things press too urgently on human society. The "unclouded," "innocent" eye has become a lie, perhaps the whole naive mode of expression sheer incompetence. Today the most real, mercantile gaze into the heart of things is the advertisement. It tears down the stage upon which contemplation moved, and all but hits us between the eyes with things as a car, growing to gigantic proportions, careens at us out of a film screen. And just as the film does not present furniture and façades in completed forms for critical inspection, their insistent, jerky nearness alone being sensational, the genuine advertisement hurls things at us with the tempo of a good film. Thereby "matter-of-factness" is finally dispatched, and in the face of the huge images spread across the walls of houses, where toothpaste and cosmetics lie handy for giants, sentimentality is restored to health and liberated in American style, just as people whom nothing moves or touches any longer are taught to cry again by films. For the man in the street, however, it is money that affects him in this way, brings him into perceived contact with things. And the paid reviewer, manipulating paintings in the dealer's exhibition room, knows more important if not better things about them than the art lover viewing them in the gallery window. The warmth of the subject is communicated to him, stirs sentient springs. What, in the end, makes advertisements so superior to criticism? Not

what the moving red neon sign says—but the fiery pool reflecting it in the asphalt.

Written 1923–1926; published in 1928. Excerpted from *One-Way Street. Gesammelte Schriften*, IV, 131–132. Translated by Edmund Jephcott.

14

The Antinomies of Allegorical Exegesis

"The many obscurities in the connection between meaning and sign . . .
did not deter but rather encouraged the use of ever remoter characteris-
tics of the represented object as symbols, so as to surpass even the Egyp-
tians with new subtleties. The dogmatic power of the meanings handed
down from the ancients also played a role here, so that one and the same
thing can just as easily symbolize a virtue as a vice, and therefore, in the
end, anything at all."[1]

This brings us to the antinomies of the allegorical, whose dialectical
treatment cannot be avoided if in fact the image of the *Trauerspiel* is to
be evoked.[2] Any person, any thing, any relationship can mean absolutely
anything else. With this possibility, an annihilating but just verdict is pro-
nounced on the profane world: it is characterized as a world in which the
detail is of no great importance. Yet it will be unmistakably apparent,
especially to anyone familiar with the exegesis of allegorical texts, that all
those signifying stage props, precisely by virtue of their pointing to some-
thing else, acquire a powerfulness that makes them appear incommensu-
rable with profane things and which can raise them to a higher plane, in-
deed sanctify them. Through allegorical observation, then, the profane
world is both elevated in rank and devalued. This religious dialectic of
content has its formal correlative in the dialectic of convention and ex-
pression. For allegory is both of these—convention and expression—and
they are inherently in conflict with each other. Yet just as Baroque doc-
trine generally conceives history as created event, allegory in particular,
though no less a convention than any other script, is viewed as created,

175

like holy scripture [*Schrift*].[3] The allegory of the seventeenth century is not convention of expression but expression of convention. Thus always also the expression of authority—secret in accordance with the dignity of its origin and public in accordance with the sphere of its validity. And it is once again this same antinomy that we encounter in plastic form in the conflict between the cold, facile technique and the eruptive expressiveness of allegorical interpretation. Here, too, there is a dialectical resolution. It lies in the nature of script itself. One can, without contradiction, imagine a lively, free usage of revealed language, a usage in which it would lose nothing of its dignity. The same cannot be said of its inscription [*Schrift*]—the form as which allegory sought to present itself. The sacredness of script is inseparable from the thought of its strict codification. For all holy scripture [*Schrift*] fixes itself in the form of complexes which in the end constitute one sole, inalterable complex—or at least seek to become such. For that reason, alphabetical script, as a combination of script-atoms, distances itself most radically from the inscription [*Schrift*] of sacred complexes. The latter take the form of hieroglyphics. If script is to be guaranteed a sacred character (the conflict between validity in the realm of the sacred and comprehensibility in the realm of the profane will always have an effect upon script), then it will press toward complexes, toward hieroglyphics. This happens in the Baroque. Externally and stylistically—in the drastic character of the typescript, as well as in the overloaded metaphor—the written presses toward image. No starker contrast with the art symbol, the plastic symbol, the image of organic totality is conceivable than this amorphous fragment, the form in which the allegorical script-image [*Schriftbild*] reveals itself. In this script-image, the Baroque shows itself the sovereign opponent of classicism; until now, only Romanticism has been recognized as such an opponent. And the temptation to seek out the constants in both should not be resisted. In both Romanticism and the Baroque, it is a matter of seeking not so much a corrective to classicism as a corrective to art itself. A higher degree of concreteness, indeed a superior authority and a more lasting validity of this correction, are all undeniably to be found in that contrastive prelude to classicism, the Baroque. Where Romanticism critically potentiates the completed work [*Gebilde*] in the name of infinity, of form, and of the idea,[4] there the profound gaze of allegory transforms things and works into arousing script. Such a penetrating gaze is still at work in Winckelmann's "Description of the Torso of Hercules in the Belvedere in Rome"[5]—in the unclassical manner in which he goes through it piece by piece, limb by limb. It is no accident that he does this on a torso. In the

field of allegorical intuition, the image is fragment, rune. Its symbolic beauty evaporates when the light of divine erudition falls upon it. The falsely lustrous appearance [*Schein*] of totality is extinguished.[6] For the *eidos* is extinguished, the simile perishes, the cosmos within it is desiccated.[7] The dried-out rebuses that remain contain insight that is still graspable by the confused brooder. By its very nature, classicism was forbidden to contemplate the lack of freedom, the imperfection, and brokenness of the sensuous, of the beautiful *physis*. But this is precisely what Baroque allegory, beneath its mad pomp, proclaims with unprecedented force. A deep-rooted intuition of the problematic of art (it was by no means merely the hesitation [*Ziererei*] of a particular social class, but rather religious scruple which assigned artistic activity to people's "leisure hours") emerges as a reaction to art's renaissanceistic self-glorification.[8] Even if the artists and thinkers of classicism did not concern themselves with what they regarded as grotesque, certain statements in neo-Kantian aesthetics give an indication of the ferocity of the controversy.[9] The dialectical character of this form of expression is misunderstood and rendered suspect as ambiguity. "Yet ambiguity—polyvalence—is the basic trait of allegory; allegory, and the Baroque, glory in the richness of meanings. Yet this ambiguity is the richness of extravagance; nature, on the other hand, is bound, according to the old rules of metaphysics and indeed no less to those of mechanics, by the law of economy. Ambiguity thus stands everywhere opposed to purity and coherence of meaning."[10] No less doctrinaire are the utterances of a student of Hermann Cohen's, Carl Horst, who was restricted by his topic—"Problems of the Baroque"—to more concrete observation. Nonetheless, he says that allegory "always reveals an 'overstepping of the boundaries of some other mode,' an incursion of the plastic arts into the realm of representation characteristic of the 'verbal' arts." The author continues:

> And such a violation of borders is punished nowhere more remorselessly than in the pure culture of feeling, which is more the province of the purely maintained "plastic arts" than of the "verbal" ones, and thus draws the former closer to music. . . . In the unemotional permeation of domineering thoughts into the most varied human modes of expression . . . the feeling for and understanding of art are diverted and violated. This is what allegory achieves in the field of the "plastic" arts. One could therefore characterize its intrusion as a gross disturbance of the peace and order of artistic rule-boundedness. Yet allegory has never been absent from this field, and the greatest artists have dedicated major works to it.[11]

This fact alone should have engendered a different attitude toward allegory. The undialectical mode of thought of the neo-Kantian school is incapable of grasping the synthesis that emerges out of the struggle between theological and artistic intention, via allegorical script—a synthesis not merely in the sense of a peace but also in the sense of a *treuga dei* between the conflicting opinions.[12]

Written in 1925; published in 1928. *Gesammelte Schriften,* I, 350–353. Excerpted from *Origin of the German Trauerspiel,* section 3, "Allegory and Trauerspiel." Translated by Michael W. Jennings. A previous translation by John Osborne (London, 1977) was consulted.

Notes

1. Giehlow, "Die Hieroglyphenkunde," p. 127. [Benjamin's note. See Karl Giehlow, "Die Hieroglyphenkunde des Humanismus in der Allegorie der Renaissance, besonders der Ehrenpforte Kaisers Maximilian I: Ein Versuch," *Jahrbuch der kunsthistorischen Sammlungen des allerhöchsten Kaiserhauses,* 32, no. 1 (1915): 1–232. This quotation concludes the preceding chapter, which bears the title "Examples and Evidence."—*Trans.*]

2. The subject of Benjamin's *Ursprung des deutschen Trauerspiels* (1925), from which this text has been excerpted, is the seventeenth-century German *Trauerspiel,* or "mourning play." Important *Trauerspiele* which Benjamin treats include *Catharina von Georgien* (1657), by Andreas Gryphius; *Mariamne* (1670), by Johann Christian Hallmann; and *Agrippina* (1665), by Daniel Casper von Lohenstein. Benjamin's study is available in English as *The Origin of German Tragic Drama,* trans. John Osborne (London: Verso, 1998).

3. The German term *Schrift* has a wide field of connotation. It can mean "text" or even "scripture," but also refers to the material, graphic *inscription* of a text. In these excerpts, we have, unless otherwise noted, translated *Schrift* as "script."

4. Cf. Benjamin, *The Concept of Criticism,* p. 105. [Benjamin's note. See "The Concept of Criticism in German Romanticism" (1920), in Benjamin, *Selected Writings, Volume 1: 1913–1926* (Cambridge, Mass.: Harvard University Press, 1996), p. 677.—*Trans.*]

5. Johann Joachim Winckelmann, *Versuch einer Allegorie besonders für die Kunst,* Säcularausg. (from the personal copy of the author, with many passages added by hand, and with previously unedited letters of Winkelmann and notes by his contemporaries regarding his last hours), ed. Albert Dressel, with a preliminary remark by Constantin Tischendorf (Leipzig, 1866), pp. 143ff. [Benjamin's note. Winckelmann's *Versuch einer Allegorie* (Attempt at an Allegory; 1766) is available in English in Winckelmann, *Writings on Art,* ed. David Irwin (London: Phaidon, 1972). The German

scholar Winckelmann (1717–1768) exerted great influence on the fields of archaeology and art history through his writings, which presented an idealized vision of classical antiquity.—*Trans.*]

6. Here and in the sections that follow, Benjamin plays on the meanings of the term *Schein*. In the idealist theory of art, the lustrousness that glimmers forth from the symbolic work of art signals to the observer that the numinous manifests itself through the work; *Schein* is in this sense the guarantor of the "intimation of immortality." In Benjamin's critique of the symbol, however, this lustrousness is exposed as mere, deceptive appearance.

7. *Eidos* is a Greek term meaning "image," "form," or "shape." It plays a prominent role in Plato's theory of ideal forms.

8. The German word *Ziererei* plays both on the verb *sich zieren* ("to hesitate," "to act coyly toward") and the noun *Zierat* ("pomp," "decoration").

9. Neo-Kantianism is the name given to the revival of interest in Kant's critical philosophy starting in the 1860s. Benjamin himself studied with Heinrich Rickert (1863–1936), a prominent figure in the southwestern German school of neo-Kantianism, which emphasized the role of normative values. The Marburg school, led by Hermann Cohen (1842–1918), attempted to extend Kantian philosophy using models derived from mathematics and the natural sciences. Benjamin engages Cohen's work on both philosophy and Jewish theology in his essay "Goethe's Elective Affinities," as well as in the *Trauerspiel* book. See "Goethe's Elective Affinities" (1924–1925), in Benjamin, *Selected Writings,* vol. 1, pp. 297–360.

10. Hermann Cohen, *Ästhetik des reinen Gefühls* [Aesthetic of Pure Feeling] II, vol. 3 in System der Philosophie (Berlin, 1912), p. 305. [Benjamin's note]

11. Carl Horst, *Barockprobleme* (Munich, 1912), pp. 39–40; cf. also pp. 41–42. [Benjamin's note]

12. The *treuga dei,* or divine truce, was the Catholic church's attempt to impose sanctions in order to limit the violence of secular warfare.

15

The Ruin

When, with the *Trauerspiel,* history wanders onto the scene, it does so as script. "History" stands written on nature's countenance in the sign-script of transience. The allegorical physiognomy of natural history, which is brought onstage in the *Trauerspiel,* is actually present as ruin. In the ruin, history has merged sensuously with the setting. And so configured, history finds expression not as a process of eternal life, but rather as one of unstoppable decline. Allegory thereby proclaims itself beyond beauty. Allegories are, in the realm of thought, what ruins are in the realm of things. Thus the Baroque cult of the ruin. Borinski, less exhaustive in his argument than accurate in his report on factual matters, knows of this cult.[1] "The broken pediment, the ruined columns should bear witness to the miraculous fact that the holy edifice has withstood even the most elemental forces of destruction—lightning and earthquake. The artificially ruined appears, then, as the last inheritance of an antiquity still visible in the modern world only in its material form, as a picturesque field of rubble."[2] A footnote adds: "The rise of this tendency can be traced to the ingenious practice of Renaissance artists who displace the birth and adoration of Christ from the medieval stable into the ruins of an antique temple. In a work by Domenico Ghirlandaio (Florence, Accademia), the ruins still consisted of flawlessly preserved showpieces; in the sculptural, colorful representations of the Nativity, the ruins become an end in themselves as picturesque settings for transient splendor."[3] The most contemporary feeling for style asserts itself here far more powerfully than the reminiscences of a false antiquity [*antikischen Reminiszenzen*]. What lies shattered amid the rubble, the highly sig-

180

nificant fragment, the scrap: this is the noblest material of Baroque creation. For it is a common feature of Baroque literature to heap up fragments—incessantly and without any strict idea of a goal—and, in the unremitting expectation of a miracle, to view stereotypes as instances of intensification. Baroque writers must have regarded the work of art as a miracle in just this sense. And if the artwork, on the other hand, beckoned to them as the calculable result of this heaping up, these two conceptions are no less commensurable than is that of the longed-for, miraculous work with the subtlest theoretical recipes in the mind of an alchemist. The experimentation of the Baroque poets resembles the practices of the adepts. What antiquity left behind is, for them, piece for piece, the elements from which the new whole is to be blended. No—is to be constructed. For the perfected vision of this new thing was: ruin. The bombastic mastering of antique elements in an edifice that, without uniting them into a whole, would still, in destroying them, prove superior to the harmonies of antiquity: this is the purpose of the technique that applies itself separately, and ostentatiously, to *realia,* rhetorical flowerings, and rules. Literature should be called *ars inveniendi.*[4] The notion of the man of genius, the master of *ars inveniendi,* is that of a man who could operate in sovereign fashion with existing models. "Imagination," what the moderns call creative capacity, was unknown as the measure of a hierarchy of mental traits. "The noblest reason that no one in German poetry has yet been able to approach our Opitz, let alone surpass him (which will not occur in the future either), is that, besides the remarkable agility of the excellent nature that inhabits him, he is as well read in the Latin and Greek texts as he is proficient in formulating and inventing."[5] The German language, however, as the grammarians of the age saw it, is in this sense only another "nature" alongside that of the ancient models. Hankamer explains their view in the following way: "Linguistic nature, like material nature, already contains every secret." The writer "brings no power to it, creates no new truth out of the self-creating soul that seeks expression."[6] The writer was not supposed to conceal his combinatory practice, since the center of all intended effects was not the mere whole but rather the work's manifest constructedness. Thus the ostentation of the craftsmanship that, especially in Calderón, shows through like the masonry wall on a building whose plaster has begun to crumble.[7] Nature has thus remained, one might say, the great teacher for the writers of this period. Yet nature appears to them not in the bud and blossom but in the overripeness and decay of its creations. Nature looms before them as eternal transience, in which the saturnine gaze of those

generations was the only one that recognized history. Dwelling in their monuments (the ruins), as Agrippa von Nettesheim put it, are the saturnine beasts.[8] In decay, solely and alone in decay, historical occurrence shrivels up and disappears into the setting. The quintessence of those decaying things is the extreme opposite of the idea of a transfigured nature as conceived by the early Renaissance. Burdach has shown that the latter idea of nature is "in no way related to ours." "For a long time it remained dependent on the linguistic usage and thought of the Middle Ages, even if the valorization of the term 'nature' and the idea of nature visibly improve. The theory of art of the fourteenth to sixteenth centuries, in any case, understands the imitation of nature as the imitation of a nature formed by God."[9] This nature, though, which bears the imprint of the course of history, is fallen nature. The Baroque preference for apotheosis runs counter to that period's characteristic mode of observing things. With the authority of their allegorical significance, things bear the seal of the all-too-earthly. Never do they transfigure themselves from within. Thus their illumination by the limelight of apotheosis. There has hardly ever been a literature whose virtuosic illusionism more thoroughly expunged from its works that transfiguring lustrous appearance [*Schein*] with which people had once sought, rightly, to define the essence of artistry. The lusterlessness of Baroque lyric can be seen as one of its primary characteristics. The drama is no different. "Thus, one must press forward through death into that life / That turns Egypt's night into Goshen's day for us / And grants us the pearl-studded robe of eternity!"[10] This is how Hallmann paints eternal life from the standpoint of the prop room. A stubborn clinging to props thwarted the portrayal of love. Unworldly lasciviousness, lost in its own fantasy, holds sway. "A lovely woman, adorned with a thousand ornaments, is an inexhaustible table that satisfies the many; / An eternal spring that always has water / indeed the sweet milk of life; As if lithe sugar / ran in a hundred canes. It is the teaching of the fiend, / the manner of nearsighted [*schelen*] envy, to deny to others / the food that comforts—and that is not consumed."[11] Any sufficient veiling of content is missing in the typical works of the Baroque. Their aspirations, even in the lesser literary forms, are so lofty as to be oppressive. And gravitation toward the small and the secret is likewise wholly absent. Attempts to replace the small and the secret with the riddling and the hidden prove to be as extravagant as they are vain. In the true work of art, delight knows how to make itself fleeting, how to live in the moment, disappear, become new. The Baroque work of art wants nothing more than to endure, and so clings with all its organs to the eter-

nal. This alone makes it possible to understand how, and with what liber-
ating sweetness, the first dalliances of the new century seduced the reader,
and how, for the Rococo period, chinoiserie became the counter-
image to hieratic Byzantinism. If the Baroque critic speaks of the
Gesamtkunstwerk [total work of art] as the summit of the period's aes-
thetic hierarchy and as the ideal of *Trauerspiel* itself,[12] he thereby re-
inforces in a new way this spirit of heaviness. As an accomplished allego-
rist, Harsdörffer was, among many theorists, the most thorough
advocate for the interweaving of all the arts.[13] For it is precisely this
that the ascendancy of allegorical contemplation dictates. Winckelmann
makes the connection only too clear when, with polemical exaggeration,
he remarks: "Vain is . . . the hope of those who believe that allegory
might be taken so far as to enable one to paint even an ode."[14] Something
even stranger must be added. How do the literary works of the century
introduce themselves? Dedications, forewords and afterwords (by the
writer, as well as by others), testimonials, and commendations of the
great masters are the rule. Like heavy, ornate framework, these short
texts inevitably surround the contents of the larger volumes and the edi-
tions of collected works. For the gaze that took satisfaction in the object
itself was a rarity. Amid the welter of daily affairs, people thought to
acquire works of art; and their engagement with them was, far less than
in later periods, a private matter free of calculation. Reading was obliga-
tory and formative [*bildend*].[15] The range of the works, their intentional
bulkiness and lack of mystery, should be understood as the correlative of
such an attitude among the public. These works seemed destined less to
be disseminated by growing over time than to fill their place in the here-
and-now. And in many respects they forfeited their reward. But just for
this reason, criticism, with rare clarity, lies unfolded in their continued
duration. From the very beginning, they aimed for that critical decompo-
sition which the passage of time inflicted on them. Beauty has, for the un-
initiated, nothing unique about it; and for such people, the German
Trauerspiel is less accessible than almost anything else. Its lustrous sem-
blance has died because of its extreme coarseness. What endures is the
odd detail of allegorical reference—an object of knowledge nesting in the
thought-out constructions of rubble. Criticism is the mortification of
works. The essence of these works accommodates this more readily than
does any other form of production. Mortification of works: not there-
fore—as the Romantics have it—the awakening of consciousness in liv-
ing works,[16] but the ensettlement of knowledge in those that have died
away. Beauty that endures is an object of knowledge. And though it is

questionable whether the beauty that endures still deserves the name, it is nevertheless certain that nothing is beautiful unless there is something worthy of knowledge in its interior. Philosophy must not attempt to deny that it reawakens the beautiful in works. "Science cannot lead to the naive enjoyment of art, any more than geologists and botanists can awaken a feeling for the beauty of landscape":[17] this assertion is as unconvincing as the analogy that aims to support it is misguided. The geologist and the botanist are perfectly capable of doing just this. Without at least an intuitive grasp of the life of the detail, as embedded in a structure, all devotion to the beautiful is nothing more than empty dreaming. In the last analysis, structure and detail are always historically charged. The object of philosophical criticism is to show that the function of artistic form is precisely this: to make historical material content [*Sachgehalte*], the basis of every significant work of art, into philosophical truth content [*Wahrheitsgehalten*].[18] This restructuring of material content into truth content makes the weakening of effect, whereby the attractiveness of earlier charms diminishes decade by decade, into the basis for a rebirth in which all ephemeral beauty completely falls away and the work asserts itself as a ruin. In the allegorical constructions of the Baroque *Trauerspiel,* these ruined forms of the redeemed work of art have always stood out clearly.

Written in 1925; published in 1928. *Gesammelte Schriften,* I, 353–358. Excerpted from *Origin of the German Trauerspiel,* section 3, "Allegory and Trauerspiel." Translated by Michael W. Jennings. A previous translation by John Osborne (London, 1977) was consulted.

Notes

1. Karl Borinski (1861–1922) was a German literary scholar who wrote on the reception and adaptation of classical art theory in German literature.

2. Borinski, *Die Antike,* I, pp. 193–194. [Benjamin's note. See Karl Borinski, *Die Antike in Poetik und Kunsttheorie von Ausgang des klassischen Altertums bis auf Goethe und Wilhelm von Humboldt,* vol. 1: *Mittelalter, Renaissance, Barock* (Leipzig: Dieterich, 1914).—Trans.]

3. Ibid., pp. 305–306n. [Benjamin's note]

4. *Ars inveniendi* is Latin for "art of inventing."

5. August Buchner, *Wegweiser zur deutschen Tichtkunst* [Guide to German Literature] (Jena, n.d. [1663]), pp. 80ff.; quoted from Borcherdt, *Augustus Buchner,* p. 81. [Benjamin's note. See Hans Heinrich Borcherdt, *Augustus Buchner und seine Bedeutung für die Literatur des siebzehnten Jahrhunderts* (Munich: Beck, 1919). The Silesian poet and civil servant Martin Opitz (1597–1639) wrote the *Buch von der deutschen Poeterey* (Book of German

Poesie), one of the first poetological treatises on vernacular literature. He was a member of the Fruchtbringende Gesellschaft (Fruitbearing Society), a group of nobles and authors dedicated to developing and promoting German as a legitimate intellectual and artistic language alongside Latin and Greek.—*Trans.*]

6. Paul Hankamer, *Die Sprache: Ihr Begriff und ihre Deutung im sechzehnten und siebzehnten Jahrhundert—Ein Beitrag zur Frage der literarhistorischen Gliederung des Zeitraums* [Language: Concept and Interpretation in the Sixteenth and Seventeenth Centuries—A Contribution to the Question of the Literary-Historical Articulation of the Period] (Bonn, 1927), p. 135. [Benjamin's note]

7. The Spanish dramatist Pedro Calderón de la Barca (1600–1681) is a major figure in Benjamin's *Trauerspiel* book. See also "Calderón's *El Mayor Monstruo, Los Celos,* and Hebbel's *Herodes und Mariamne*" (1923), in Benjamin, *Selected Writings, Volume 1: 1913–1926* (Cambridge, Mass.: Harvard University Press, 1996), pp. 363–386.

8. The German humanist, jurist, and physician Heinrich Cornelius Agrippa von Nettesheim (1486–1535) wrote many treatises on the Kabbalah, magic, and the occult.

9. Burdach, *Reformation,* p. 178. [Benjamin's note. See Konrad Burdach, *Reformation, Renaissance, Humanismus: Zwei Abhandlungen über die Grundlage moderner Bildung und Sprachkunst* (Reformation, Renaissance, Humanism: Two Essays on the Foundations of Modern Education and the Verbal Arts) (Berlin: Paetel, 1918).—*Trans.*]

10. Hallmann, "Mariamne," in *Trauer-, Freuden- und Schäferspiele* [Plays of Mourning and of Joy, and Pastorals], p. 90. [Benjamin's note. Benjamin cites the collection of Johann Christian Hallmann's *Trauerspiele* and other plays published in Breslau in 1684. Hallmann (ca. 1640–ca. 1716), a Silesian dramatist of the Baroque period, went to the same *Gymnasium* (classical secondary school) in Breslau that Martin Opitz and Daniel Caspar von Lohenstein attended.—*Trans.*]

11. Lohenstein, *Agrippina,* pp. 33–34 (II, 380ff.). [Benjamin's note. Benjamin cites the 1724 Leipzig edition of *Agrippina,* a *Trauerspiel* by Daniel Caspar von Lohenstein (1635–1683), a Silesian jurist, diplomat, and dramatist.—*Trans.*]

12. Cf. Kolitz, *Hallmanns Dramen,* pp. 166–167. [Benjamin's note. See Kurt Kolitz, *Johann Christian Hallmanns Dramen: Ein Beitrag zur Geschichte des deutschen Dramas in der Barockzeit* (Berlin: Mayer & Müller, 1911).—*Trans.*]

13. Benjamin refers to the Nuremberg poet Georg Philipp Harsdörffer (1607–1658), also a member of the Fruchtbringende Gesellschaft.

14. Winckelmann, *Versuch einer Allegorie,* p. 19. [Benjamin's note. Johann Joachim Winckelmann's *Versuch einer Allegorie besonders für die Kunst*

(Attempt at an Allegory Especially for Art) was first published in 1766; Benjamin cites an edition published in Leipzig in 1866. It is available in English in Winckelmann, *Writings on Art,* ed. David Irwin (London: Phaidon, 1972). The German archaeologist and art historian scholar Winckelmann (1717–1768) exerted great influence on the fields of archaeology and art history through his writings, which presented an idealized vision of classical antiquity in his influential writings.—*Trans.*]

15. The word *Bildung* means not merely "education," but the active and ongoing formation of the self.

16. Cf. Benjamin, *Der Begriff der Kunstkritik,* pp. 53ff. [Benjamin's note. In English: "The Concept of Criticism in German Romanticism" (1920), in Benjamin, *Selected Writings,* vol. 1, pp. 116–200.—*Trans.*]

17. Petersen, "Aufbau," p. 12. [Benjamin's note. See J. Petersen, "Der Aufbau der Literaturgeschichte," *Germanisch-romanische Monatsschrift,* 6 (1914): 12.—*Trans.*]

18. On the notion of material content and truth content, see "Goethe's Elective Affinities" (1924–1925), in Benjamin, *Selected Writings,* vol. 1, especially pp. 297–298.

16

The Dismemberment of Language

The language-theoretical principles and the practices of these dramatists combine to bring out a fundamental motif of the allegorical view in a thoroughly surprising place. In the anagrams, the onomatopoetic turns of phrase, and many other kinds of linguistic virtuosity [of the Baroque], word, syllable, and sound are emancipated from all traditional associations of meaning and flaunt themselves as a thing that can be exploited allegorically. The language of the Baroque is constantly convulsed by rebellions among its elements. And the following passage from Calderón's Herod drama is superior to related works—in particular, to those of Gryphius—only by virtue of its vividness of emphasis [*Anschaulichkeit*], which it owes to its artistry. Through a coincidence, Mariamne, Herod's wife, comes across scraps of a letter in which her husband commands that, in the event of his own death, she be put to death in order to preserve his supposedly endangered honor. She picks up these scraps from the floor and, in highly evocative lines, gives an account of their contents.

> What do these bits of paper say?
> "Death" is the very first word
> That I find; here is "honor,"
> And there I read "Mariamne."
> What is this? Heavens, save me!
> For much is said in three words,
> "Mariamne," "death," and "honor."
> Here is "in silence," here
> "Dignity," here "commands," and here "ambition";
> And here it continues "if I die . . ."

What doubt can there be? I am already informed
by the folds of the paper
that link to one another
and so unfold this outrage.
Entryway, on your green carpet
let me piece them together![1]

The words reveal themselves as fateful even in their isolation. Indeed one might say, the very fact that—isolated though they are—they still mean something lends a threatening quality to the remnant of meaning they have retained. Language is shattered in this way so that it might acquire, in its fragments, a changed and heightened expressiveness. The Baroque naturalized the capital letter in German orthography. Not only the aspiration to pomp but also the dismembering, dissociative principle of allegorical contemplation finds its sphere of validity in the capital letter. Without doubt, many of the capitalized words gave readers their first access into the allegorical. The decimated language, in its individual parts, ceased to serve as mere communication; it had its dignity, as a newborn object, alongside that of the gods, rivers, virtues, and other similar natural forms that shimmered into the allegorical. This happens in a particularly drastic way, as has been said, in the work of the young Gryphius. Though there is no counterpart to the incomparable passage in Calderón anywhere in German literature, still the force of a Gryphius does not fare badly in comparison with the Spaniard's refinement. For he has mastered to an astonishing extent the art of allowing his characters to joust as if with bits of speech that have broken free. In the "second treatise" of *Leo Arminius*, for example:

> *Leo:* This house will stand, so long as the enemies of the house fall.
> *Theodosia:* If their fall does not injure those that surround this house.
> *Leo:* Surround it with the sword.
> *Theodosia:* With which they protect us.
> *Leo:* Which they have drawn on us.
> *Theodosia:* Who have supported our throne.[2]

When the exchanges become angry and violent, one finds a preference for accumulations of dismembered parts of speech. They are more numerous in Gryphius than in later authors[3] and conform well, alongside the abrupt laconic phrases, to the overall stylistic trend of his dramas; for both convey an impression of the broken and the chaotic. Despite the success with which this technique of representing theatrical commotion

presented itself, it is not essentially dependent upon the dramatic action. In the following passage from a work by Schiebel, it functions as a device of pastoral:

> Even today, a devout Christian sometimes gleans a drop of consola-
> tion
> (perhaps just one little word
> from a spiritual song or edifying sermon)
> and swallows it, as it were, so hungrily
> that it does him good,
> stirs him inwardly,
> and so refreshes him
> that he must confess
> it contains something divine.[4]

It is no accident that, in such a turn of speech, the reception of the words is left, as it were, to the sense of taste. Sound, for the Baroque, is and remains something purely sensuous; meaning is at home in script. The vocalized word is only haunted by meaning, so to speak, as if by an inescapable illness. In the midst of being uttered it breaks off, and mourning is awakened by a damming-up of the feeling that was about to pour forth. Meaning is encountered here—and will continue to be encountered—as the ground of sorrow. The antithesis of sound and meaning is bound to be sharpest where it succeeds in giving both *in one,* without allowing them to converge as an organic linguistic structure. This deducible task is accomplished in one scene that stands out as a masterpiece in an otherwise uninteresting Viennese *Haupt- und Staatsaktion.*[5] In *The Glorious Martyr Johannes von Nepomuck* (Act I, scene 14), one of the intriguers (Zytho) functions as Echo in the mythological speeches of his victim (Quido), and answers them with intimations of mortality.[6] The reversal from the pure acoustics of creaturely speech into the irony, pregnant with significance, that echoes from the mouth of the intriguer is typical of the character's relationship to language. The intriguer is the master of meanings. In the harmless outpouring of an onomatopoetic natural language, these meanings are the inhibition and the origin of a mourning for which the intriguer, as much as the meanings, is responsible. If now it is precisely the Echo, the actual domain of a free play of sound, that is, so to speak, befallen by meaning, then it must have fully proven itself a revelation of the linguistic as that age perceived it. For that, too, a form was provided. "The Echo, which repeats the final two or three syllables of a stanza, often omitting a letter so that it sounds like an answer, warning,

or prophecy, is something very 'pleasing' and very popular." This game, like other, similar ones that were so often taken for trivialities, actually speaks to the matter itself. Bombast as verbal gesture is so uninhibited in these games that they could very well serve as illustrations of its formula. Language, which on the one hand seeks, in the fullness of sound, to assert its creaturely rights, is on the other hand bound, in the flow of the alexandrine verse, to a forced logicality. This is the stylistic law of bombast, the formula for the "Asian words"[7] of the *Trauerspiel*. The gesture that seeks to incorporate meaning in this way is of a piece with the most violent deformation of history. To adopt, in language as in life, only the typical forms of creaturely movement and yet to express the entire world of culture, from antiquity through Christian Europe—this is the extraordinary intention that is never renounced, even in the *Trauerspiel*. The same extreme longing for nature found in pastoral plays thus underlies the enormous artificiality of the *Trauerspiel*'s mode of expression. On the other hand, this very mode of expression, which only represents— represents the nature of language, that is—and so far as possible circumvents profane communication, is courtly and elegant. One really cannot say that the Baroque was truly overcome, that sound and meaning were truly reconciled, until Klopstock, thanks to what A. W. Schlegel called, figuratively, the "grammatical" tendency of his odes.[8] His bombast is based far less upon sound and image than upon the coordination of words—upon word order.

Written in 1925; published in 1928. *Gesammelte Schriften*, I, 380–384. Excerpted from *Origin of the German Trauerspiel*, section 3, "Allegory and Trauerspiel." Translated by Michael W. Jennings. A previous translation by John Osborne (London, 1977) was consulted.

Notes

1. Calderón, *Schauspiele* (trans. Gries), III, 316 (Eifersucht das größte Scheusal, II). [Benjamin's note. Benjamin cites Johann Diederich Gries's translation of Calderón's plays, published in Berlin in 1815. The Spanish dramatist Pedro Calderón de la Barca (1600–1681) is a major figure in Benjamin's *Trauerspiel* book. See also "Calderón's *El Mayor Monstruo, Los Celos*, and Hebbel's *Herodes und Mariamne*" (1923), in Benjamin, *Selected Writings, Volume 1: 1913–1926* (Cambridge, Mass.: Harvard University Press, 1996), pp. 363–386.—*Trans.*]

2. Gryphius, *Trauerspiele*, p. 62 (*Leo Armenius*, II, 455ff.). [Benjamin's note. See Andreas Gryphius, *Trauerspiele*, ed. Hermann Palm (Tübingen: Litterarischer Verein in Stuttgart, 1882). The Silesian poet and dramatist

Gryphius (1616–1664) was a member of the Fruchtbringende Gesellschaft and the author of some of the best-known *Trauerspiele*, including *Leo Armenius, Catharina von Georgien,* and *Papinian.—Trans.*]

3. Cf. Stachel, *Seneca,* p. 261. [Benjamin's note. See Paul Stachel, *Seneca und das deutsche Renaissancedrama: Studien zur Literatur- und Stilgeschichte des 16. und 17. Jahrhunderts* (Berlin: Mayer & Müller, 1907).—*Trans.*]

4. Schiebel, *Schausaal,* p. 358. [Benjamin's note. Benjamin cites Johann Georg Schiebel, *Neu-erbauter Schausaal* (Nuremberg: Johann Jonathan Felszecker, 1684).—*Trans.*]

5. Benjamin's use of the term *Haupt- und Staatsaktion*—"dramas of the state and its head"—is idiosyncratic. The term originally referred to a series of popular dramas in the early eighteenth century; although diverse in theme and tonality, each of these dramas centers around a comic figure, the *Hanswurst.* The best-known author in the genre—and the most successful actor in the role of the *Hanswurst*—was Joseph Stranitzky (1676–1726). The great literary critic Johann Christoph Gottsched (1700–1766) inveighed against the genre for its use of the most degraded remnants of Baroque drama. Benjamin, however, applies the term to the serious Baroque court drama of the seventeenth century. As a result, his judgment on the echo of these dramas in the Viennese *Haupt- und Staatsaktion* of the early eighteenth century is thoroughly positive: he calls them "parodies" whose critique of the absolutist state exerted a positive social effect.

6. Cf. *Die Glorreiche Marter Joannes von Nepomuck;* quoted from Weiss, *Staatsactionen,* pp. 148ff. [Benjamin's note. See Karl Weiss, *Die Wiener Haupt- und Staatsactionen: Ein Beitrag zur Geschichte des deutschen Theaters* (Vienna: C. Gerold, 1854).—*Trans.*]

7. Hallmann, *Trauer-, Freuden- und Schäferspiele* [Plays of Mourning and of Joy, and Pastorals], first page of the unpaginated preface. [Benjamin's note. Benjamin cites the collection of Johann Christian Hallmann's *Trauerspiele* and other plays published in Breslau in 1684. Hallmann (ca. 1640–ca. 1716), a Silesian dramatist of the Baroque period, went to the same *Gymnasium* (classical secondary school) in Breslau that Martin Opitz and Daniel Caspar von Lohenstein attended.—*Trans.*]

8. Friedrich Gottlieb Klopstock (1724–1803) was the greatest eighteenth-century German lyric poet before Goethe; he is best known for his epic poem *The Messiah* and his pastoral odes. The German scholar, poet, critic, and translator August Wilhelm Schlegel (1767–1845) was, with his brother Friedrich Schlegel, one of the founders of German Romanticism.

17

Graphology Old and New

Today scientific graphology is a good thirty years old.[1] With certain reservations, it can undoubtedly be described as a German achievement; and 1897, when the German Graphological Society was founded in Munich, can be deemed the year of its birth. It is a striking fact that academic science still withholds recognition, even though this technique has been providing proofs of the precision of its principles for the past three decades. To this day, no German university has established a chair for the interpretation of handwriting. But it is worthy of note that one of the free colleges, the Lessing-Hochschule in Berlin, has now taken the step of adopting the Central Institute for Scientific Graphology (under the direction of Anja Mendelssohn).[2] Evidently this fact has also been acknowledged abroad as a milestone in the history of graphology. At any rate, the oldest living representative of this science, Jules Crépieux-Jamin, arrived from Rouen to attend the opening of the institute.[3] We found him to be an elderly, somewhat unworldly gentleman who at first glance looked like a doctor. An important practical doctor, that is, rather than a pioneering researcher. And this would also be an apt description of Crépieux-Jamin and his disciples' position in graphology. He inherited the mantle of his teacher, Michon, who in 1872 had published his *Geheimnis der Handschrift* [Secret of Handwriting], in which the concept of graphology appears for the first time.[4] What teacher and pupil have in common is a sharp eye for handwriting and a large dose of healthy common sense, in conjunction with a gift for ingenious inference. All of this shows to advantage in their analyses, which for their part do more to satisfy the requirements of practical life than those of a science of charac-

ter. The demands of the latter were first articulated by Ludwig Klages in his fundamental works *Prinzipien der Charakterologie* [The Principles of Characterology] and *Handschrift und Charakter* [Handwriting and Character].[5] Klages takes aim at the so-called sign theory of the French school, whose proponents linked qualities of character to quite specific written signs that they used as stereotypes on which to construct their interpretations. In contrast, Klages interprets handwriting fundamentally as gesture, as expressive movement. In his writings, there is no talk of specific signs; he speaks only of the general characteristics of writing, which are not restricted to the particular form of individual letters. A special role is assigned to the analysis of the so-called formal level—a mode of interpretation in which all the characteristic features of a specimen of handwriting are susceptible to a dual evaluation—either a positive or a negative interpretation—and where it is the formal level of the script that decides which of the two evaluations should be applied in each case. The history of modern German graphology can be defined essentially by the debates surrounding Klages' theories. These debates have been initiated at two focal points. Robert Saudek criticized the lack of precision in Klages' findings concerning the physiological features of handwriting, as well as his arbitrary preoccupation with German handwriting style.[6] He himself has attempted to produce a more differentiated graphological analysis of the various national scripts, on the basis of exact measurements of handwriting motion. In Saudek, characterological problems recede into the background; whereas in a second trend, which has recently taken issue with Klages, they stand at the center of attention. This view objects to his definition of handwriting as expressive movement. Max Pulver and Anja Mendelssohn, its leading representatives, are seeking to create a space for an "ideographic" interpretation of handwriting—that is to say, a graphology that interprets script in terms of the unconscious graphic elements, the unconscious image fantasies, that it contains.[7] The background to Klages' graphology is the philosophy of life of the George circle, and behind Saudek's approach we can discern Wundt's psychophysics; whereas in Pulver's endeavors the influence of Freud's theory of the unconscious is undeniable.[8]

Published in the *Südwestdeutsche Rundfunkzeitung,* November 1930. *Gesammelte Schriften,* IV, 596–598. Translated by Rodney Livingstone.

Notes

1. Benjamin was himself an amateur graphologist. See also his review of the Mendelssohns' *Der Mensch in der Handschrift,* in Benjamin, *Selected Writ-*

ings, Volume 2: 1927–1934 (Cambridge, Mass.: Harvard University Press, 1999), pp. 131–134.

2. Anja Mendelssohn (1889–1978), who later published widely in French under her married name (and differently spelled first name), Ania Teillard, was a psychoanalyst (she trained with C. G. Jung [1875–1961] in Zurich) and graphologist; both she and her brother Georg studied with Klages.

3. Jules Crépieux-Jamin (1858–1940) was the author of many graphological treatises, including *L'Ecriture et le caractère* (Handwriting and Character; 1892), which went through numerous editions and was translated into many languages.

4. The abbé Jean Hippolyte Michon (1806–1861) published several studies of graphology, as well as work in other "border zones" such as the psychology of banditry.

5. Ludwig Klages (1872–1956), philosopher and psychologist, attempted to found a "metaphysical psychology" that would study human beings in the context of their relationship to a reality that was, for Klages, made up of archetypal images.

6. Robert Saudek (1880–1935), German novelist, playwright, and graphologist, was the author of *Wissenschaftliche Graphologie* (Scientific Graphology; 1926) and the editor of the American journal *Character and Personality*. His edition of Otto Weininger's notorious *Gedanken über Geschlechtsprobleme* (Thoughts on Sexual Problems) was published in 1907.

7. Max Pulver (1889–1952), Swiss poet, playwright, and graphologist, published his *Symbolik der Handschrift* (Symbolism of Handwriting) in 1931.

8. Stefan George (1868–1933) was a German poet and the editor of the influential journal *Blätter für die Kunst,* published from 1892 to 1919. He was the central, and indeed authoritarian, figure in a group of writers known as the George Circle; and he sought, by means of his lyric poetry and his charismatic leadership, to "purify" German language and culture around the turn of the twentieth century. George's conservative-nationalist ideas exerted a strong influence on many German intellectuals of his era. Wilhelm Max Wundt (1832–1920), German physiologist and psychologist, founded the first laboratory for experimental psychology at Leipzig in 1878.

III

PAINTING AND GRAPHICS

Connected, at one end, to Benjamin's early writings on language (1916) and, at the other, to his work on the Arcades Project (1927–1940) and the essay "The Work of Art in the Age of Its Technological Reproducibility" (1935–1936), the materials brought together in Part III provide an overview of his engagement with the visual arts, in particular the media of painting and "graphics." In the two 1917 texts with which this part opens, Benjamin uses the German word *Graphik,* which in this volume has been translated variously as "the graphic arts," "work(s) of graphic art," "graphic works," "graphic art," and, as in the title above, simply "graphics." Later texts emphasize effects of what we might call "graphicness" or "vividness," for which Benjamin's term is *Anschaulichkeit. Graphik* has been construed broadly here, as part of an effort to sketch a number of important connections among diverse writings in which Benjamin discusses painting, drawing, printmaking techniques, and the design and illustration of books. The texts in Part III demonstrate the importance of Benjamin's efforts to conceptualize the significance of painting, drawing, and graphic illustration within the shifting historical contexts in which his own work was produced and in relation to the situations of the production and initial reception of the pictures and approaches to picture-making under consideration. At the same time, they also reveal the degree to which any consideration of an "image" or "picture" *(Bild)* in Benjamin's work remains closely bound to, indeed intertwined with—we might even say determined by—his explorations of writing itself as a medium for the presentation of figural images and the communication of meaning.

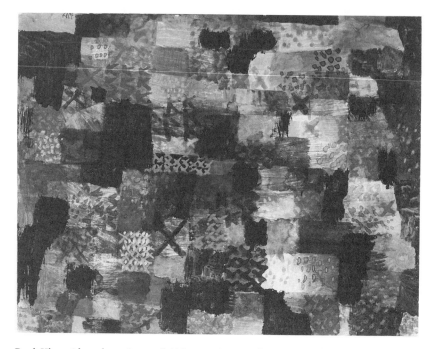

Paul Klee, *Abstraktes Aquarell* (Abstract Watercolor), 1915. Watercolor on pastel ground. Now in the Berggruen Klee Collection, Metropolitan Museum of Art, New York (accession no. 1984.351.8), where it is known by the later title *Schweres Pathos* (Deep Pathos). Photograph courtesy of the Metropolitan Museum of Art; reproduced by permission of ARS.

The untitled fragment known as "Painting and the Graphic Arts" and the related essay "On Painting, or Sign and Mark," which were composed during the summer and fall of 1917, represent a response to some of the most ambitious and challenging art of the day—including Cubism, particularly the work of Pablo Picasso (1881–1973), and the paintings of Wassily Kandinsky (1866–1944) and Paul Klee (1879–1940), who were both associated with the Munich-based artists' group Der Blaue Reiter in the early 1910s. Despite their brevity and their variously unfinished states, these texts also attempt to categorize painting *(Malerei)* and the graphic arts *(Graphik)* in terms of the essential features of each medium. Benjamin's interest in the history and theory of the visual arts was evident as early as 1915, when he attended, and expressed his extreme disappointment with, lectures by the art historian Heinrich Wölfflin (1864–1945) at the university in Munich.[1] His admiration for the work of the

Viennese art historian Alois Riegl (1853–1905) emerged around the same time, and the first line of the untitled 1917 fragment—"A picture wants to be held vertically before the viewer"—suggests a connection to Riegl's concept of *Kunstwollen,* which is typically translated as "artistic volition," and which in later works Benjamin would cite explicitly, for example in the unpublished 1929 text "Some Remarks on Folk Art." Crucial in Benjamin's use of the concept of *Kunstwollen* is that term's evocation not only of a collective human will to produce art in particular forms but also of diverse instances of will, volition, or intentionality as embodied in works of art and thus rendered potentially comprehensible to those who view the works, including historians as well as amateurs considering objects made in the distant past.

The untitled 1917 fragment on painting and graphics sets out to establish that "from the human point of view, the level of drawing is horizontal, that of painting, vertical."[2] Benjamin speaks in this regard of two "sections" or "cuts" (his word is *Schnitt*) through the "substance of the world": the "longitudinal section of painting and the transverse section of certain graphic works." The longitudinal section of painting "seems representational" insofar as it appears to "contain things," while the transverse section (or cross-section) of drawings and other graphic works seems "symbolic" insofar as it contains "signs." Although Benjamin acknowledges that it is possible to view some drawings or other graphic works by holding them out in front of us such that their vertical orientation appears analogous to that of a painting hanging on a wall (indeed his opening line suggests that all pictures have a will to be "held vertically before the viewer"), he notes that others, including children's drawings and the drawings of the German artist and future Berlin Dadaist George Grosz (1893–1959), will appear meaningless unless arranged for viewing in a horizontal position—a position, Benjamin implies, that is analogous to the one in which we would set out a text to be read. This turn to what he calls, with emphasis, "*our* reading" leads to a consideration of whether there might have existed an "originally vertical" position of writing or script *(Schrift),* perhaps in the form of engraving on stone.

All this is to say that Benjamin's earliest meditations on the media of painting and the graphic arts (and on "pictures" and "signs" broadly conceived) acknowledge—even as they move to establish "the simple principle that pictures are set vertically and signs horizontally"—that our habits of viewing and reading are historically determined. For Benjamin, it therefore follows that any analysis of works of art and of our modes of apprehending pictures and signs has to take into account the "changing

metaphysical relations" that obtain over time. This aspect of Benjamin's earliest writings on the visual arts signals both his engagement with the neo-Kantian philosophy of the day, and his inclination to modes of analysis that would later take shape in relation to historical materialism.[3]

The longer of the two early texts, "On Painting or, Sign and Mark," which was drafted in response to remarks on Cubism in a letter to Benjamin from his friend Gershom Scholem (1897–1982), represents an attempt to grasp "the unity of painting despite the apparent disparity of its various schools."[4] Prefacing his discussion of painting (again, the German word is *Malerei*) with considerations of the sign *(Zeichen)* and the mark *(Mal)*—the latter a term that is connected etymologically to *Malerei* and also has another meaning that the essay draws upon at certain points (*Mal* as a moment in time, or an instance)—Benjamin construes the mark as the "medium of painting," whereas he understands drawing and other forms composed by means of "graphic line" as belonging to the "sphere of the sign." But even as he associates painting with the mark as a visual form that appears on the human body and can thereby acquire etiological, genealogical, moral, affective, and theological meanings, he insists on the "decisive" role of language in relation to painting. If, in Benjamin's terms, the mark is the medium and thus in some sense the "visual language" of painting itself, a picture nonetheless requires a "name" in order to be conceived and comprehended in relation to the world. Thus, he asserts that the "linguistic word" *(sprachliches Wort)* enters into the "language of painting" *(malerische Sprache)* as a "higher power," even as the word as such remains invisible in the picture. This early theoretical interest in the power of the act of naming, with regard to human language in general as well as to pictures, specifically paintings, finds a counterpart in Benjamin's insistence, beginning in the mid-1920s, on the significance of captions and inscriptions broadly conceived.

"Dream Kitsch," written in 1925 and published under the title "Gloss on Surrealism" in 1927, suggests that, in contradistinction to the dreams associated in Romanticism with the imagistic fullness and metaphorical density of symbols (such as the "blue flower" which the literary hero Heinrich von Ofterdingen longs for, in Novalis' eponymous 1802 novel), present-day dreams have "grown gray." But if Benjamin believed that dreams in the context of European modernity in the late 1920s were "a shortcut to banality," he did not take that to diminish either their meaningfulness in psychic life or their potential to play a decisive role in historical events. For Benjamin, the dreams of his own era were connected not to art (as in Romanticism), but to kitsch—and dream kitsch

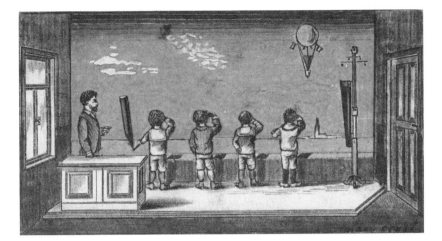

Max Ernst, frontispiece to Paul Eluard, *Répétitions* (Paris: Au Sans Pareil, 1922). Color halftone reproduction of a circa-1920 "overpainting" of gouache and ink on a printed page from a German teaching-aids catalogue *(Katalog der kölner Lehrmittel-Anstalt)*. Photograph courtesy of Houghton Library, Harvard University; reproduced by permission of ARS.

was kitsch "garnished with cheap maxims." Surrealism, a movement in literature and the visual arts that came to prominence in Paris following the dissolution of the various European Dada movements in the early 1920s, invoked Sigmund Freud's epochal *Interpretation of Dreams* (1900) and psychoanalytic theory in general as conceptual foundations for the renovation of works of art and literature and their capacity to convey meaning. Crucial in Surrealism was the reconfiguration of banal elements of everyday life in striking juxtapositions designed to transform the perceptions, the modes of feeling and cognition, and eventually the social behavior and political action of readers and viewers. In "Dream Kitsch," Benjamin associates Surrealist poetry with the aphoristic inscriptions in nineteenth-century children's books, including what are now known as "pop-up" or "pop-out" books.

In addition to his praise for the Surrealist writers André Breton (1896–1966) and Louis Aragon (1897–1982), Benjamin's essay includes a brief description of a color halftone reproduction of a 1921 gouache "overpainting"[5] by the German artist Max Ernst (1891–1976) that appeared as the frontispiece to *Répétitions*, a 1922 book of poems by Paul Eluard (Eugène Emile Paul Grindel, 1895–1952). The scene in Ernst's frontispiece is a schoolroom, and Eluard's title also invokes pedagogical

exercises.[6] Although Benjamin almost certainly would not have known the original work by Ernst, it is worth noting that the printed sheet on which the overpainting appears is an actual page taken from a catalogue of teaching aids *(Lehrmittel)* that were designed to promote the "purposeful expansion of the sensory activity of children" through an approach to pedagogy called *Anschauungsunterricht* (literally "instruction in perception") that was grounded in theories and practices developed in the first half of the nineteenth century by the Swiss philosopher and pioneer of progressive education Johann Heinrich Pestalozzi (1746–1827) and his German follower, the inventor of kindergarten, Friedrich Froebel (1782–1852). Just as the technique of photoengraving used to reproduce Ernst's frontispiece to Eluard's book harks back to a technology commonly used in the production of illustrated books and periodicals in the late nineteenth century, Benjamin's text invokes childhood of that epoch in setting the stage for his revaluation of kitsch in relation to art. According to Benjamin, despite their interest in psychoanalysis the Surrealists "are less on the trail of the psyche than on the track of things." The face they seek at the top of the "totemic tree of objects" "is that of kitsch. It is the last mask of the banal, the one with which we adorn ourselves, in dream and conversation, so as to take in the energies of an outlived world of things." And it is by means of kitsch and not art (or "what we used to call art") that, Benjamin suggests, his contemporaries can come into renewed contact with "the world of things."

As if on the model of the Leporello pop-up picture books mentioned earlier in the essay, "in kitsch the world of things advances on the human being; it yields to his uncertain grasp and ultimately fashions its figures in his interior. The new man bears within himself the very quintessence of the old forms, and what evolves in the confrontation with a particular milieu from the second half of the nineteenth century—in the dreams, as well as the words and images, of certain artists—is a creature who deserves the name of 'furnished man.'" Thus, the encounter with kitsch—and with kitsch as an element in, or potentially a medium for, works of art—transforms viewers and readers according to a model of reception in which the work approaches, and finally enters into, the person apprehending it, outfitting him or her internally with "figures" of "the world of things."

For Benjamin, it is by means of this internalization or introjection of "the quintessence of old forms" that the novelty of the "new man" or "new human being" *(neuer Mensch)* of the 1920s makes itself known. In the shape of the "furnished man" *(möblierter Mensch),* he envisions a

"creature" outfitted internally with figures of the recent past as the sub-
ject of the dreams as well as the avant-garde art and literature of his own
day. A variant ending appended by Benjamin to a manuscript copy of
"Dream Kitsch" further describes the *möblierter Mensch* as "the body
'furnished' [*meublé*] with forms and apparatuses, in the sense that, in
French, one has long spoken of the mind 'furnished' [*meublé*] with
dreams or with scientific knowledge." Derived as it is from *möblierter
Herr*—a figurative, idiomatic term that refers to a tenant of furnished
rooms as a "furnished gentleman"—the *möblierter Mensch* of "Dream
Kitsch" might be said to be "furnished" specifically with "forms and ap-
paratuses" of a past of which Benjamin took the "furnished gentleman"
who dwelled in rented rooms to be an avatar. In his writings of the late
1920s and in the Arcades Project, Benjamin would continue to explore
actual as well as potential correspondences among furnished dwellings,
"furnished" minds, and "furnished" bodies in the cultural history of
nineteenth-century Paris and the modernity of his own era.

Even if, in writing about a reproduction, he was unaware that phrases
from the teaching-aids catalogue page were legible beneath the gouache
in Ernst's original overpainting, Benjamin's choice of a picture of a group
of boys in a classroom hardly seems arbitrary, given the larger claims of
"Dream Kitsch." His conviction that the Surrealists were in pursuit of
"things"—and that it was in the context of this pursuit that the sig-
nificance of their composition of poems and pictures recalling the max-
ims and illustrations in nineteenth-century children's books emerged—
links the treatment of Surrealism in "Dream Kitsch" to the aims of
Anschauungsunterricht in its original as well as its updated forms.
Anschauungsunterricht is the name Pestalozzi gave to a method of teach-
ing he developed in the context of his efforts to make primary educa-
tion available to children of the lower social classes. Variously called,
in the context of nineteenth- and early twentieth-century progressive
education in the United States, "object teaching" or "object lessons,"
Anschauungsunterricht is a pedagogical method that stresses the pri-
macy of perception *(Anschauung)* in the development of the human ca-
pacity to acquire knowledge of the world, and that accordingly orga-
nizes its lessons first with a focus on concrete sensory experiences of
things and then with an emphasis on the perceptual and cognitive appre-
hension of representations of things in the form of captioned illustrations
presented in picture books and primers, as well as on wall charts and var-
ious forms of hand-held cards and tablets.[7] Benjamin often refers to
Anschauungsunterricht in the context of the "education of the masses"

(*Volksbildung*), but he makes clear that its perceptual and historical effects extended to bourgeois children and, at least potentially, also to adult readers of various classes. Indeed, when writing about children's books, he invokes both the experiences of his own late nineteenth-century Berlin childhood and his ongoing collecting.

Benjamin's "Gloss on Surrealism" envisions kitsch not only as a medium for the transmission of new kinds of knowledge about, and new possibilities for taking pleasure in, things, but also as an apparatus for the internal and external transformation or "furnishing" of human beings, as if the experience of "furnishing" (or, perhaps better, "refurnishing") amounted to a kind of learning, and vice versa. In a longer essay on Surrealism published in 1929, Benjamin envisions such transformations or "refurnishings" as prefigurations—in the context of the Surrealists' "radical concept of freedom" and their experiments with virtual and actual "intoxication" *(Rausch)*—of the possibility of political revolution. He speaks of "a space . . . in which political materialism and physical creatureliness share the inner man, the psyche, the individual," and he says that the Surrealists "exchange, to a man, the play of human features for the face of an alarm clock that each minute rings for sixty seconds." "To win the energies of intoxication for the revolution: this is the project on which Surrealism focuses in all its books and enterprises."[8]

Published around the time he began work on the Arcades Project in 1927, Benjamin's 1925 meditations on kitsch point to key differences that would continue to emerge between his views of the fate of the artwork in modernity and those of his friend and Frankfurt School colleague Theodor Adorno (1903–1969). Although Adorno's 1956 essay "Looking Back on Surrealism" echoes some of what Benjamin says in "Dream Kitsch," Adorno's reaction to Benjamin's writings on the great nineteenth-century Parisian poet and critic Charles Baudelaire (1821–1867), to "The Work of Art in the Age of Its Technological Reproducibility," and to the Arcades Project famously involved his pointed criticism of the philosophical as well as the political implications of Benjamin's conceptualizations regarding both works of art and dreams.[9]

"A Glimpse into the World of Children's Books," an illustrated essay that was published in a special issue of *Die literarische Welt* (December 1926) devoted to children's literature, opens with an account of what happens when children read illustrated books, a genre of unique significance to Benjamin, who possessed not only expertise but a major collection in the field. The children's book author Hans Christian Andersen (1805–1875) gets it wrong, Benjamin says, but not by much, when in one

Walter Benjamin, "Aussicht ins Kinderbuch" (A Glimpse into the World of Children's Books), *Die literarische Welt*, December 1926. Photograph courtesy of the Universitätsbibliothek der Freien Universität, Berlin.

of his stories the characters depicted in an expensive book belonging to a princess turn out to be alive (birds sing, and human figures leap out and speak to the princess as she looks at the page on which they appear, leaping back in when she turns to the next). "Things do not come out to meet the picturing child from the pages of the book," Benjamin states in his corrective. "Instead, in looking, the child enters into them as a cloud that becomes suffused with the riotous colors of the world of pictures. . . . He overcomes the illusory barrier of the book's surface and passes through colored textures and brightly painted partitions to enter a stage on which the fairy tale lives."

Although this description of the effects of reading and viewing picture books differs from the formulations in "Dream Kitsch"—Benjamin alludes here to Taoist concepts that informed classical Chinese landscape painting, in which clouds figure prominently—it is worth taking note of a similarity enclosed within that difference. Crucial in both cases is the transformation of the reader/viewer, who changes shape in response to what he reads and sees. In "Dream Kitsch," the result is a new kind of "furnished human being" *(möblierter Mensch)* outfitted by things encountered in kitsch (or rather things that come out to greet human beings from within kitsch), while in "A Glimpse into the World of Children's Books" it is a child who becomes a cloud and enters the pages of the book, and indeed perhaps passes into the things depicted on those pages.

In the 1926 essay on children's books, one of several Benjamin wrote on the subject, the child's tactile and more broadly bodily experience of the book emerges as a key concern. Children "know" the pictures in ABC-books "like their own pockets; they have turned them inside out, without neglecting the smallest thread or piece of cloth." This tactile approach to acquiring knowledge of pictures and what they represent extends to children's inclination to "complete" simple black-and-white woodblock illustrations by "scribbling" on them, as well as their pleasure in setting the scenes of "pull-out" books in motion. Benjamin's interest in the modalities of perception of colored illustrations in children's books recalls the understanding of color in German Romanticism (he cites Goethe's *Farbenlehre,* or "Theory of Color," from 1810), and he announces that "pure color is the medium of fantasy, a home in the clouds for the playful child, not the strict canon of the constructive artist") and also anticipates the treatment of color in his own writings about hashish intoxication, which in turn formed the basis of key concepts in the Arcades Project.[10]

Twice in this essay Benjamin makes explicit his felt connection to children whose learning to write about pictures in words coincides with their

scribbling on pictures in books. First he offers an invidious comparison of his own writing about children's books with the books themselves: "for those few people who as children—or even as collectors—have had the great good fortune to come into possession of magic books or puzzle books, all of the foregoing will have paled in comparison." A few lines later, he describes the moment of the composition of "A Glimpse into the World of Children's Books" as precisely this kind of scene, noting that "a quarto from the eighteenth century" lies open in front of him.

As if to underscore the historical character of his own writing, and thus to convey the urgency of his engagement with children's books that variously embody the *Kunstwollen* of Romanticism and the Biedermeier period (1815–1848), in his discussion of puzzle-pictures Benjamin makes a passing reference to "tests," by which he means vocational aptitude tests and, more generally, the "psychotechnical tests" of his own era that would assume an important place in "The Work of Art in the Age of Its Technological Reproducibility," especially in the two earliest versions of that essay.[11] Whereas the puzzle-pictures in eighteenth- and nineteenth-century *Anschauungsbücher* (roughly "perception primers") resemble a "masquerade" in which words unsystematically take on the appearance of things as if putting on costumes for performances whose techniques of play children might learn to imitate, in the systematized tests of Benjamin's day similar pictures served as diagnostic tools and models for action in kinds of work that aimed precisely to replace the inventions and transformations of play with the acquisition of habit and a capacity for uniform, repetitive action.

In the artwork essay, Benjamin compares what he calls "the test performance of the film actor," which takes place in front of the apparatus of the camera, to "a performance produced in a mechanized test," as in the testing of workers in preparation for (and indeed, as Benjamin argues, in the process of) mechanized labor. In a passage that drew especially strong criticism from Adorno, who raised the concern that Benjamin had "protected himself by elevating the feared object with a kind of inverse taboo,"[12] Benjamin proposes that the film actor should be seen as "taking revenge" on behalf of "the majority of city dwellers, [who] throughout the workday in offices and factories have to relinquish their humanity in the face of the apparatus." "In the evening," he asserts, "these same masses fill the cinemas to witness the film actor taking revenge on their behalf not only by asserting *his* humanity (or what appears to them as such) against the apparatus, but by placing that apparatus in the service of his triumph."[13]

It hardly needs saying that, as an illustrated article, Benjamin's 1926

essay on children's books has something in common with the works that are its subject. The first page of the article as it appeared in *Die literarische Welt* also makes vivid another aspect of Benjamin's writing about images, namely his insistence, in *One-Way Street* (written 1923–1926, published 1928), that the ubiquity of advertisements on display in the publications and public spaces of twentieth-century cities should be recognized not only as a symptom but also as an agent of the transformation of the those spaces and of the kinds of writing, reading, and viewing that take place within them.[14] Thus it is striking to see, in the context of Benjamin's essay, how a large illustrated advertisement for picture books *(Bilderbücher)* takes its place—with a brigade of tin soldiers standing at assembly before a tin officer mounted on a rearing toy horse—in relation to the reproductions from nineteenth-century children's books elsewhere on the page.

Another illustrated essay, "Chambermaids' Romances of the Past Century" aims to understand nineteenth-century works of literary "colportage"—that is, the sort of cheap novels that were distributed by traveling peddlers (colporteurs) at country fairs and on city streets—according to "the concept of the document," an approach that once again locates Benjamin's work in relation to the art history of Alois Riegl while now also anticipating his treatment of the ideas of the Soviet writer Sergei Tretiakov (1892–1937), the German playwright and poet Bertolt Brecht (1898–1956), and other avant-garde writers and artists in "The Author as Producer" (1934; see Part I of this volume). In "Chambermaids' Romances of the Past Century," the word "art" appears in quotation marks, while works not usually considered literature inspire Benjamin's call for a new approach to the study of the novel—an approach that would focus on the conditions and effects of its "use." The "devouring" of novels emerges as a general category of use, while the tearing-out of illustrated pages to be hung up for private display (and eventually to be consigned to the rubbish bin) appears as a specific modality of use. As in his writings on children's literature and kitsch, here Benjamin emphasizes the tactile and more generally embodied conditions of reception, conditions that similarly are central to his unpublished "Some Remarks on Folk Art," also written in 1929.

It is worth noting with regard to Benjamin's interest in captions (a concern that would emerge as crucial in his writings on photography in the early 1930s) that the illustrations to "Chambermaids' Romances of the Past Century" bear captions composed by Benjamin himself. All matter-of-fact in tone, some offering ironic synopses of the "typical subjects"

Walter Benjamin, "Dienstmädchen-Romane des vorigen Jahrhunderts" (Chambermaids' Romances of the Past Century), *Das illustrierte Blatt*, 1929. Photograph courtesy of the Universitätsbibliothek Johann Christian Senckenberg, Frankfurt am Main.

presented in the novels, the captions are at once documents of Benjamin's own "use" of these works of colportage and schematic instructions for readers who might come to the books by way of his illustrated essay.

The pictures described in "Moonlit Nights on the Rue La Boétie" have no captions. Instead, it is as if viewers were imagined to have the capacity to compose apt captions themselves in the moment of beholding the pictures. That is, in effect, what Benjamin does in his text, which all but spells out lines like "Dostoevsky on the Terrace of the Casino at Baden-Baden,"[15] apparently as a means of invoking the pictures he mostly declines otherwise to describe. Benjamin seems to suggest that his apprehension of the watercolor transparencies on display in Paris proceeded by way of a mental act that approximated the provision of a caption for the picture in view, an operation that elaborates upon the "naming" of pictorial compositions as discussed in "On Painting, or Sign and Mark."

As in his remarks on Surrealism and kitsch, in "Moonlit Nights on the Rue La Boétie" Benjamin takes pains to associate the watercolor technique used to produce the transparencies—whose appearance he describes in terms that evoke cinematographic projection—not with "art" (in "Dream Kitsch" he wrote of "what we used to call art"; here, as in "Chambermaids' Romances of the Past Century," he simply sets the word within quotation marks) but with "the practical arts," among which he includes outmoded fairground projection techniques, dioramas, and the new technological medium of television. As did Surrealism and the works of kitsch it incorporated, in whole or in part, by means of citation and ironic imitation, the paintings in "Moonlit Nights on the Rue La Boétie" have the effect of making it seem to their beholders as if events of the historical past (the viewing of the corpse of the assassinated Duc de Berry) and great works from the tradition of European art (Raphael's frescoes in the Vatican *stanze*, as seen in the early nineteenth century by the German Romantic painters known as the Nazarenes) were taking place or becoming visible before their eyes, in the space of the exhibition.

In "Some Remarks on Folk Art" and in the Arcades Project, Benjamin variously associates this peculiar effect of "making present" *(vergegenwärtigen)* with kitsch and with collecting, the latter a practice linked explicitly to the method of his own work on the Arcades Project. The remarks on folk art assert the unity of kitsch and folk art and acknowledge the dependence of each on "what is known as great art," while insisting that kitsch and folk art alter what they take from great art and make use of it in the service of their own aims—that is, according to their own

Kunstwollen. But here again Benjamin distinguishes between "great art" and those works of kitsch and folk art that, even as they display a *Kunstwollen,* orient that "will to art" or "artistic volition" not toward art but toward "much more primitive, urgent concerns." Folk art and kitsch—in tempting their viewers, readers, and listeners (Benjamin mentions the refrains of folk songs) "to throw the situation that is brought to mind around one's shoulders, like a favorite old coat"—awaken the imagination and induce a virtually physical response, a response that leads in turn to a recognition that the situation now brought to mind is something that has been experienced unconsciously in the past. This effect of *déjà-vu* depends upon a structure of viewing, reading, or listening in which the work "approaches" the viewer, reader, or listener, and not the other way around. By means of the work of folk art or kitsch, Benjamin suggests, situations or events that previously stood outside our conscious awareness acquire the potential to be integrated into present-day experience. Thus, his 1929 remarks on folk art and kitsch begin to sketch a set of ideas that would emerge in the Arcades Project as proposals for a new approach to understanding historical events of the past in relation to the lived realities and political exigencies of the present.

In the encounter staged by folk art or kitsch, we experience ourselves as dwelling within the work, but not as having arrived there by means of our own empathic projection or "feeling-in" (the German word for "empathy" in these instances would be *Einfühlung*). As Benjamin puts it in the final lines of the unpublished text: "Art teaches us to see into things. / Folk art and kitsch allow us to see outward from within things." In Surrealism Benjamin recognized a pursuit of "things" that led inevitably to kitsch and that resembled an approach to learning promoted under the rubric of *Anschauungsunterricht.* Now, in these preliminary formulations regarding the structure of beholding and the effects of making present in the reception of kitsch and folk art, he establishes terms in which to conceptualize the primitiveness as well as the urgency of a *Kunstwollen* aimed at something other than art. The *Kunstwollen* Benjamin strives to describe in his writings on the visual arts after 1924 conveys the aims of his own most ambitious work, or what Adorno called Benjamin's "most extreme theoretical experiments."[16]

Published in 1929, "Antoine Wiertz: Thoughts and Visions of a Severed Head" comprises a brief introductory paragraph by Benjamin followed by a lengthy citation from the *légende,* or caption, composed by Belgian artist Antoine Joseph Wiertz (1806–1865) for his triptych *Thoughts and Visions of a Severed Head* (1853), which notably is not re-

Antoine Joseph Wiertz, *Pensées et visions d'une tête coupée*, 1853. Tempera on canvas. Musée Wiertz, Brussels. Photograph courtesy of the Musée Wiertz.

produced as an illustration to Benjamin's article. Although it was made with the aim of taking its place in the canon of great European art—the late-Romantic painter sought to emulate in particular the works of the Flemish artist Peter Paul Rubens (1577–1640)—in Benjamin's account, Wiertz's work emerges as having "little to do with great painting—but it is all the more interesting to connoisseurs of cultural curiosities and to physiognomists of the nineteenth century." Here the connection to the aims of the Arcades Project is unmistakable, not least because the citational mode of Benjamin's presentation of Wiertz's work prefigures the method he would come to envision employing for the Arcades Project.

Consisting almost entirely of a citation of a caption, the Wiertz article does not so much reiterate as enact Benjamin's assertion of the importance of captions and inscriptions in relation to works of visual art. Indeed it would seem that Benjamin's knowledge of Wiertz and of the museum that bears his name came not from a visit to the site in Brussels that he envisions becoming an "obligatory destination for honeymooners" ("once the nineteenth century is Baedeker-ready and its ruins are ripe for moonlight"), but from the painter's posthumously published *Oeuvres littéraires* (1869), and perhaps from illustrated catalogues and brochures published by the museum. Benjamin refers to the "compositorial power" of Wiertz's *légende,* and he does not remark on the fact that the *légende* also appears, handwritten, as an element of the painted triptych itself, where it was inscribed by the artist upon a trompe-l'oeil painted frame. But even as his article on Wiertz reasserts the primacy of the written—indeed more specifically the printed—word, his praise for the painter and his writings is connected to a developing interest in the history of photography, a preoccupation that would challenge, though by no means dismantle, the terms in which the primacy of writing held sway in Benjamin's work.

Wiertz would emerge as a figure of considerable interest for the Arcades Project and for Benjamin's writings on photography, above all in connection with Wiertz's 1855 essay on that medium and its implications for painting. As a painter, Wiertz assumes a place in the Arcades Project alongside the draftsman, watercolorist, and war correspondent Constantin Guys (1802–1892), the caricaturist J. J. Grandville (Jean Ignace Isidore Gérard, 1803–1847), and the Symbolist painter and printmaker Odilon Redon (1840–1916)—the latter two artists both precursors of the Surrealists, and all three figures whose work arguably "has little to do with great painting." Adorno and others have noted that

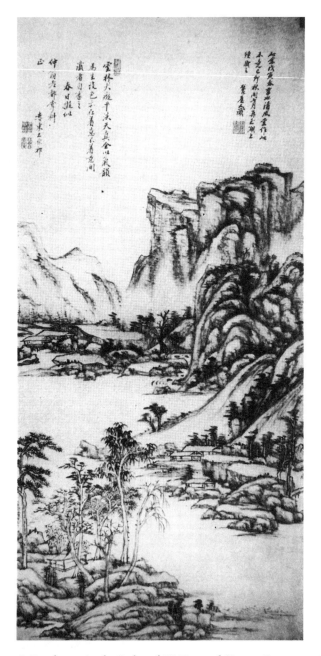

Wang Yuanqi, *Landscape in the Styles of Ni Zan and Huang Gongwang*. Hanging scroll, ink and light colors on paper, 37 ⅜ in. × 17 ⅞ in. Present location unknown; formerly in the collection of Jean-Pierre Dubosc. As reproduced in Jean-Pierre Dubosc, *Great Chinese Painters of the Ming and Ch'ing Dynasties, XV to XVIII Centuries: A Loan Exhibition* (New York: Wildenstein, 1949), catalogue no. 49.

the Arcades Project lacks any sustained engagement with the great modernist painters of Paris in the nineteenth century, Edouard Manet (1832–1883) foremost among them.[17] The absence is striking, and not to be explained away as merely a minor flaw in Benjamin's proposed approach to the Arcades Project and the century that was to be its subject.

In this context it bears noting that in turning not only to the likes of Wiertz, Redon, Grandville, and Guys (the last by means of his intensive engagement with the writings of Baudelaire, who famously dubbed Guys "the painter of modern life," a gesture perhaps recapitulated in Benjamin's nomination of Wiertz as "the painter of the arcades"), but also to illustrated children's books and colportage, Benjamin began in the late 1920s to conceive categories of works whose ambitions and effects (above all, effects of *Anschaulichkeit*—perceptibility, vividness, graphicness) he associated with *Anschauungsunterricht* as a type of pedagogy and a set of representational practices potentially to be put to more general use.

"Chinese Paintings at the Bibliothèque Nationale," a review essay originally published in French in 1938, returns to a number of key themes and topics addressed in the earlier writings in Part III. In his encounter with paintings of the Ming (1368–1644) and Qing (1644–1911) periods, Benjamin finds an occasion to address works that, as he puts it, have been "grouped together under the sign of decadence," specifically in relation to classical Chinese painting of the Song (960–1279) and Yuan (1271–1368) periods. Benjamin's interest in reconceptualizing the cultural values and aesthetic achievements of periods of decadence or decline reaches back to his study of the German Baroque *Trauerspiel* in the mid-1920s and once again connects his work to that of the art historian Riegl. In this regard it bears noting that Jean-Pierre Dubosc (1904–1988), the French diplomat and connoisseur of Chinese painting whose collection formed the basis of the October 1937 Bibliothèque Nationale (Paris) exhibition Benjamin reviewed, lamented the tendency in Western scholarship of the first half of the twentieth century to disparage the "sometimes 'baroque' tendencies" of the paintings of the Ming and Qing periods, which he believed instead "should speak in their favor."[18]

As in the *Origin of the German Trauerspiel,* in the review of Chinese paintings relations among images, script, and modes of perception and cognition emerge as key concerns. Benjamin writes in particular of the significance of the calligraphic inscriptions *(légendes)* rendered by Chinese painters within their pictures. In the Ming and Qing periods those inscriptions often made reference to the styles, and sometimes to specific works, of artists of earlier epochs; in the case of the Qing-period hang-

ing scroll reproduced here, an inscription by the artist Wang Yuanqi indicates his admiration and emulation of two masters of the Yuan period whose styles he has attempted to combine in the painting. Dubosc suggests in an essay about his collection that what we might call the "citational" mode invoked by the inscriptions in Ming- and Qing-period paintings can be understood by means of a comparison to French painting of the nineteenth century. "We should remember," Dubosc writes, "that Manet, in some of his most famous paintings, reproduced very exactly compositions by Velázquez."[19] That the question of copying or reproduction is central to the Chinese paintings that captured Benjamin's attention in the late 1930s points to a connection to the concerns of the artwork essay, while the citational mode of the calligraphic inscriptions suggests a link to the Arcades Project.

Benjamin's thoughts on the paintings in the Bibliothèque Nationale exhibition culminate in his consideration of "an antinomy which finds its 'resolution' in an intermediary element that, far from constituting a balance [un juste milieu] between literature and painting, embraces intimately the point at which they appear most irreducibly opposed—namely, thought and image" or, in French, "la pensée et l'image." Later in the review Benjamin uses the term image-pensée, which would seem to relate to the German Denkbild, a word he used to describe the genre of his own brief, meditative writings, and which is usually translated as image de pensée in French. Following the art historian Georges Salles and citing the Chinese term xieyi, Benjamin refers to the art of Chinese painting as "first and foremost the art of thinking" ("l'art de peindre est avant tout l'art de penser") or an "idea painting" ("peinture d'idée"), the latter a notion he associated, in less elevated terms, with Wiertz, whom he described in the "Little History of Photography" as an "ungainly painter of ideas" ("ungeschlachter Ideenmaler"). In the "ink-play" of the so-called "literati-artists," in which calligraphy figures prominently as a medium integral to Chinese painting, Benjamin discovers a capacity to impart to the marks that make up the image a fixity and stability that is also and at the same time fluid and changing.

"Thinking, for the Chinese painter, means thinking by means of resemblance," he writes, invoking a modality of thought central to his own work, from his earliest writings on language to the essays "On the Mimetic Faculty" and "Doctrine of the Similar" (both 1933). And since "nothing is more fleeting than the appearance of a resemblance, the fleeting character and the imprint of variation of these paintings coincides with their penetration of the real. That which they fix never has

more than the fixity of clouds." "'Why do landscape painters live to such advanced old age?' asks a painter-philosopher. 'Because the mist and the clouds offer them nourishment.' Monsieur Dubosc's collection inspires these reflections." For their part, Benjamin's writings on modern media were everywhere marked by his awareness that the landscapes of Western modernity offered no such sustenance.

<div align="right">BRIGID DOHERTY</div>

Notes

1. In late 1927, Benjamin attempted unsuccessfully—despite the submission of a letter on his behalf by the eminent Austrian writer Hugo von Hofmannsthal (1874–1929)—to forge a connection to the Hamburg-based art historians Aby Warburg (1866–1929), Erwin Panofsky (1892–1968), and Fritz Saxl (1890–1948). On Benjamin's engagement with art history, see his 1932 review essay "The Rigorous Study of Art" (in this volume), as well as the introduction to Part I above.

2. Walter Benjamin, letter to Gershom Scholem of 22 October 1917, cited in *Gesammelte Schriften*, II, 1414. For the complete text of the letter, see Benjamin, *Gesammelte Briefe*, I, ed. Christoph Gödde and Henri Lonitz (Frankfurt: Suhrkamp, 1995), pp. 388–397.

3. Both Benjamin and Scholem were trained in philosophy in various German university departments at a time when the contributions of the so-called Marburg school of neo-Kantian philosophy, which had its origins in the work of Hermann Cohen (1842–1918), were a subject of significant interest and much discussion. The exchange between Benjamin and Scholem that surrounded the composition of "Painting and the Graphic Arts" and "On Painting, or Sign and Mark" made plain the relevance of neo-Kantian aesthetic thought and Cohen's work in particular to Scholem's as well as Benjamin's thinking about Cubism and about painting in general. See Benjamin, *Gesammelte Briefe*, I, ed. Christoph Gödde and Henri Lonitz (Frankfurt: Suhrkamp, 1995), pp. 377–397; see also Scholem, *Walter Benjamin: The Story of a Friendship*, intro. Lee Siegel, trans. Harry Zohn (New York: New York Review Books, 2003), pp. 7–65.

 Historical materialism encompasses a wide range of approaches to the analysis of culture and society that variously have their origins in the work of Karl Marx (1818–1883). While many aspects of Benjamin's work share Marx's aim of promulgating a "materialist conception of history," Benjamin was emphatic in stating his intention to break with "vulgar historical materialism"—or, as he says regarding Surrealism, "to explode it from within." See Benjamin, *The Arcades Project*, trans. Howard Eiland and Kevin

McLaughlin (Cambridge, Mass.: Harvard University Press, 1999) p. 461; and Benjamin, "Surrealism: The Last Snapshot of the European Intelligentsia," in *Selected Writings, Volume 2: 1927–1934* (Cambridge, Mass.: Harvard University Press, 1999), p. 208.

4. Benjamin, *Gesammelte Schriften*, II, 1413, also citing the letter to Scholem of 22 October 1917.

5. Overpainting was a technique invented by Max Ernst in which he painted with watercolor and gouache on top of printed pages to create pictures that resembled collages. In the original 1922 edition of *Répétitions*, Ernst's illustrations are called *dessins* (drawings), while in a 1962 bilingual French-German reprint on which Ernst collaborated, they are called *collages* in French and *Collagen* in German. See Paul Eluard, *Répétitions, avec dessins de Max Ernst* (Paris: Au Sans Pareil, 1922); and Eluard, *Répétitions, mit 11 Collagen von Max Ernst,* trans. Max Ernst and Rainer Pretzell (Cologne: Galerie der Spiegel, 1962).

6. Pedagogy and domination, and pedagogy as domination, are key Surrealist themes. For example, Ernst's frontispiece and Benjamin's gloss on that picture find an echo in the opening of André Breton's 1937 Surrealist novel *L'Amour fou* (Mad Love), which refers to "boys of harsh discipline" who evoke for the narrator "certain theoretical beings, . . . key bearers, possessing the *clues to situations.*" See Breton, *Mad Love,* trans. Mary Ann Caws (Lincoln: University of Nebraska Press, 1987), p. 5.

7. Pestalozzi's conceptualization of *Anschauung* with regard to pedagogy was derived from the philosophy of Immanuel Kant (1724–1804); English translations of Kant variously render *Anschauung* as "intuition" or "perception." For Benjamin's use of the term *Anschauungsunterricht* in relation to pedagogical theories and practices of the nineteenth century as well as the 1920s, see the text of his radio broadcast "Children's Literature," *Selected Writings*, vol. 2, pp. 251–252. In a review essay called "Old Toys: The Toy Exhibition at the Märkisches Museum," which was published in the *Frankfurter Zeitung* in March 1928, and which Benjamin understood to be closely connected to the Arcades Project, he praises the exhibition organizers for the breadth of their conception of "toys," citing specifically the inclusion of "books, posters, and wall charts for *Anschauungsunterricht*" among the objects on display in the museum. See Benjamin, *Selected Writings*, vol. 2, p. 98. See also Benjamin's discussion of *Anschauung* and his comparison of old and new approaches to popular education *(Volksbildung)* in the review essay "Garlanded Entrance," in Part I of this volume.

8. Benjamin, "Surrealism: The Last Snapshot of the European Intelligentsia," *Selected Writings*, vol. 2, pp. 218–219, 215.

9. See Theodor Adorno, "Looking Back on Surrealism," in *Notes to Literature,* trans. Shierry Weber Nicholsen (New York: Columbia University Press, 1991), vol. 1, pp. 86–91; and the letters to Benjamin of 2–4 August 1935, 5 August

1935, 18 March 1936, 6 September 1936, and 10 November 1938 in Adorno and Benjamin, *The Complete Correspondence, 1928–1940,* ed. Henri Lonitz, trans. Nicholas Walker (Cambridge, Mass.: Harvard University Press, 1999), pp. 104–116, 127–134, 145–148, 280–289.

10. See Benjamin, *On Hashish,* ed. Howard Eiland (Cambridge, Mass.: Harvard University Press, 2006).

11. See the introduction to Part I of this volume.

12. Adorno, letter to Benjamin of 18 March 1936, in Adorno and Benjamin, *The Complete Correspondence,* p. 130.

13. See "The Work of Art in the Age of Its Technological Reproducibility," section X, in Part I of this volume.

14. See "Attested Auditor of Books" and "This Space for Rent," in Part II of this volume.

15. The Russian writer Fyodor Dostoevsky (1821–1881) was compelled to complete his novella *The Gambler* (1867) in a period of just a few weeks in order to pay off gambling debts incurred at the casino at Baden-Baden.

16. Adorno, letter to Benjamin of 10 November 1938, in Adorno and Benjamin, *The Complete Correspondence,* p. 285.

17. See Adorno, letter to Benjamin of 2–4 August 1935, in Adorno and Benjamin, *The Complete Correspondence,* p. 110.

18. Jean-Pierre Dubosc, "Great Chinese Painters of the Ming and Ch'ing Dynasties," in *Great Chinese Painters of the Ming and Ch'ing Dynasties XV to XVIII Centuries,* exhibition catalogue, Wildenstein Gallery, New York, 11 March to 2 April 1949 (New York: Wildenstein, 1949), p. 12. See also *Catalogue de l'Exposition des Peinture Chinoises de la Collection J. P. Dubosc,* Paris, Bibliothèque Nationale, October 1937 (Paris: Bibliothèque Nationale, 1937), foreword by Georges Salles, preface by J.-P. Dubosc. For Benjamin's perspective on related matters in the history of German literature and the place of "script" within it, see the selections from *Origin of the German Trauerspiel* and the introduction to Part II in this volume.

19. Dubosc, "Great Chinese Painters of the Ming and Ch'ing Dynasties," in *Great Chinese Painters of the Ming and Ch'ing Dynasties, XV to XVIII Centuries,* p. 11.

18

Painting and the Graphic Arts

A picture wants to be held vertically before the viewer. A floor mosaic lies horizontally at his feet. Despite this distinction, it is customary simply to view a work of graphic art as a painting. There is, however, a very important and far-reaching distinction to be made within the graphic arts: it is possible to look at the study of a head, or a Rembrandt landscape, in the same way as a painting, or in the best case to leave the sheets in a neutral horizontal position. Yet consider children's drawings: setting them before oneself vertically usually contravenes their inner meaning. It is the same with Otto Groß's drawings:[1] they have to be placed horizontally on the table. Here a profound problem of art and its mythic roots presents itself. We might say that there are two sections through the substance of the world: the longitudinal section of painting and the transverse section of certain graphic works. The longitudinal section seems representational— it somehow contains things; the transverse section seems symbolic—it contains signs. Or is it only in *our* reading that we place the pages horizontally before us? And is there such a thing as an originally vertical position for writing—say, for engraving in stone? Of course, what matters here is not the merely external fact but the spirit: Is it actually possible to base the problem on the simple principle that pictures are set vertically and signs horizontally, even though we may follow the development of this through changing metaphysical relations across the ages?

Kandinsky's pictures: the simultaneous occurrence of conjuration and manifestation [*Beschwörung und Erscheinung*].

Written in 1917; unpublished in Benjamin's lifetime. *Gesammelte Schriften*, II, 602–603. Translated by Rodney Livingstone.

Notes

1. The printed text in Benjamin's *Gesammelte Schriften* has "Groß"; that text is based on a handwritten copy of Benjamin's untitled fragment which was made by his friend Gershom Scholem (1897–1982), a philosopher and historian of Jewish mysticism. According to the editors of the *Gesammelte Schriften,* in Scholem's manuscript the artist's last name is spelled "Grozß." In this instance, Benjamin was surely not referring to the Austrian psychoanalyst and anarchist Otto Gross (1877–1920), who was connected to the circles around the Berlin-based journals *Die Aktion,* edited by Franz Pfemfert (1879–1954), and *Neue Jugend,* edited and published by the poet Wieland Herzfelde (1896–1988), his brother, artist John Heartfield (1891–1968; born Helmut Herzfeld), and the writer Franz Jung (1888–1963). Rather, he must have been alluding to the German artist George Grosz (1893–1959), who as a protest against Germany's patriotic propaganda and an expression of enthusiasm for American modernity during World War I changed the spelling of his name, which had originally been Georg Groß. Published in journals such as the Expressionist monthly *Die Weißen Blätter,* edited by René Schickele (1883–1940), and *Neue Jugend,* and in the widely advertised portfolio of lithographs *Erste George Grosz-Mappe,* issued by *Neue Jugend* and Herzfelde's Malik Verlag in Berlin in late 1916, Grosz's drawings of the period 1915–1917, which Benjamin would have known, resembled children's drawings as well as what at that time was commonly called "the art of the insane."

19

On Painting, or Sign and Mark

A. The Sign

The sphere of the sign comprises diverse fields which are characterized by the various meanings that "line" has within them. These meanings are: the geometric line, the line of script, the graphic line, and the line of the absolute sign (the magical line *as such*—that is to say, not a line made magical by whatever it happens to represent).

a., b. The line of geometry and the line of script will not be considered in what follows.

c. The graphic line. The graphic line is determined in opposition to the surface [*die Fläche*]. This opposition has not only a visual but a metaphysical dimension. The ground [*der Untergrund*] situates itself in relation to the line. The graphic line designates the surface, and in so doing determines it by attaching itself to it as its ground. Conversely, the graphic line can exist only upon this ground, so that a drawing that completely covered its ground would cease to be a drawing. The ground is thereby assigned a specific position that is indispensable to the meaning of the drawing, so that in a graphic work two lines can establish their relationship to each other only relative to the ground—an occurrence, incidentally, in which the difference between the graphic line and the geometric line emerges especially clearly.—The graphic line confers an identity on its ground. The identity of the ground of a drawing is completely different from that of the white surface on which it is located, and of which it would be deprived if one wanted to apprehend the paper surface as a surge of white waves (though these might not even be distinguishable to the naked eye). The pure drawing will not alter the graphically meaning-

221

imparting function of its ground by "leaving it blank" as a white ground; this illuminates how it can be that, in certain circumstances, the representation of clouds and sky in drawings is a risky venture and can act as a touchstone of the drawing's purity of style.

d. The absolute sign. In order to understand the absolute sign—that is to say, the mythological essence of the sign—it is necessary to know something of the sphere of the sign in general, which we mentioned at the outset. At all events this sphere is probably not a medium but instead represents an order that is probably at the moment wholly unknown to us. What is striking, however, is the opposition of the absolute sign and the absolute mark. This opposition, which metaphysically is of *enormous* importance, is not a given: it had first to be discovered. The sign appears to be more of a spatial relation and to have more reference to persons; the mark (as we shall show) is more temporal and tends to exclude the personal. Examples of absolute signs are the sign of Cain, the sign that the Israelites put on their houses during the Tenth Plague, and the presumably similar signs in *Ali Baba and the Forty Thieves;* with the necessary reservations one can deduce from these instances that the absolute sign has a predominantly spatial and personal significance.

B. The Mark

a. The absolute mark. Insofar as anything can be discovered about the nature of the absolute mark—that is to say, about the mythical essence of the mark—it will be of importance for the entire sphere of the mark, in opposition to that of the sign. The first fundamental difference is to be seen in the fact that the sign is imprinted; the mark, by contrast, emerges. This indicates that the sphere of the mark is that of a medium. Whereas the absolute sign does not appear predominantly on living beings but rather is also impressed on inanimate buildings, trees, and so forth, the mark appears principally on living beings (Christ's stigmata, blushes, perhaps leprosy and birthmarks). The opposition between mark and absolute mark does not exist, for the mark is always absolute and in its appearing is similar to nothing else. It is especially striking that, turning up as it does on the living, the mark is so often linked to guilt (blushing) or innocence (Christ's stigmata); indeed, even where the mark appears on the lifeless (the sunbeams in Strindberg's *Advent*), it is often a warning sign of guilt.[1] In that sense, however, it coincides with the sign (as in Belshazzar's Feast), and the prodigiousness of the apparition is based in large part on uniting these two structures, something of which only God

is capable.[2] Since the connection between guilt and atonement is a tempo-
ral and magical one, this *temporal* magic appears in the mark in the sense
that the resistance of the present between the past and the future is elimi-
nated, and these, magically fused, descend together on the head of the
sinner. But the medium of the mark is not confined to this temporal
meaning; rather, as comes to the fore so unsettlingly in the case of blush-
ing, it also at the same time possesses a meaning that tends to dissolve the
personality into certain of its most basic components [*Urelemente*]. This
leads us back to the connection between the mark and guilt. The sign,
however, appears not infrequently as something that distinguishes a per-
son, and this opposition between sign and mark likewise seems to belong
to the metaphysical order. As far as the sphere of the mark *in general*
(that is, the medium of the mark in general) is concerned, the only thing
that can be revealed in this connection will be stated based upon a con-
sideration of painting. As mentioned, however, everything that can be
said of the absolute mark is of great significance for the medium of the
mark in general.

b. Painting. A picture has no ground [*Untergrund*]. Nor does one
color ever lie on top of another, but instead at most appears in the me-
dium of another color. And even that is often difficult to determine, and
so in principle it is often impossible to say with regard to many paintings
whether a color belongs to the deepest or the uppermost dimension of the
ground. The question, however, is nonsensical. There is no ground in
painting, nor is there any graphic line. The reciprocal demarcations of
the colored surfaces (the composition) of a picture by Raphael are not
based on graphic line. This error stems in part from the tendency to attri-
bute aesthetic value to the purely technical fact that, before painting their
pictures, painters compose them by means of draftsmanship. But the es-
sence of such composition has nothing to do with graphic art. The only
instance in which line and color coincide is in the watercolor, in which
the contours made with the drafting pencil are visible and the paint is put
on transparently. There the ground is retained, even though it is colored.

The medium of painting is designated as the mark in the narrower
sense; for painting is a medium, a mark, since it has neither ground nor
graphic line. The problem of the painted form [*das Problem des
malerischen Gebildes*] surrenders itself only to the one who has come to
understand the nature of the mark in the narrower sense, even as he must
be astonished to find a composition in the picture that cannot be traced
back to a graphic design. The fact that such a composition does not exist
as mere semblance [*Schein*]—that, for example, the beholder of a picture

by Raphael does not perceive configurations of people, trees, and animals in the mark by chance or by mistake—becomes clear from the following consideration: if the picture were mere mark, it would be quite impossible to name it. The actual problem of painting can be discerned in the statement that a picture is indeed a mark; and, conversely, that the mark in the narrower sense exists only in the picture; and, further, that the picture, insofar as it is a mark, is only a mark in the picture itself. But on the other hand, the picture may be connected with *something that it is not*— that is to say, something that is not a mark—and indeed this connection is achieved by naming the picture. This relation to what the picture is named after, the relation to what transcends the mark, is created by the composition. This is the entry of a higher power into the medium of the mark—a power that, once there, remains in a state of neutrality, which is to say that it does not use any aspect of the graphic to explode the mark but finds its place within the mark without exploding it, because even though it is immeasurably higher than the mark, it is not hostile toward it but related to it. This power is the linguistic word, which lodges in the medium of the language of painting, invisible as such and revealing itself only in the composition. The picture is named after the composition. From what has been said, it is self-evident that mark and composition are elements of every picture that claims the right to be named. A picture that did not do this would cease to be one and would therefore enter into the realm of the mark in general; but this is something that we cannot imagine.

The great epochs of painting are distinguished according to composition and medium—that is to say, according to which word and into which mark it enters. Of course, as far as mark and word are concerned in this context, it is not a matter of the possibility of arbitrary combinations. For example, it is conceivable that in the pictures of, say, Raphael the name might predominate, and in the pictures of present-day artists the judging word might enter the mark. To understand the connection between the picture and the word, the composition—that is, the act of naming—is decisive. In general, the metaphysical location of a given painting or a school of painting is determined according to the mark and word, and requires at the very least a refined elaboration of the various forms of mark and word—an undertaking as yet barely in its infancy.

c. The mark in space. The sphere of the mark also occurs in spatial structures, just as the sign in a certain function of the line can without doubt acquire architectonic (hence also spatial) significance. Such marks [*Mäler*] in space are visibly connected in terms of meaning with the

sphere of the mark, but we need further investigation in order to say in what way. Above all, they appear as monuments to the dead or gravestones [*Toten- oder Grabmale*], but these are marks [*Mäler*] in the exact meaning of the word only if they have not been given an architectonic and sculptural shape.

Written in 1917; unpublished in Benjamin's lifetime. *Gesammelte Schriften,* II, 603–607. Translated by Rodney Livingstone.

Notes

1. In *Advent* (1899), a play by the Swedish dramatist August Strindberg (1849–1912), a judge and his wife are pursued by *solkatten* (literally "sun cats")—sunbeams that remind them of their past sins.
2. See the Book of Daniel, chapter 5.

A soft green glow in the evening red.

—C. E HEINLE

20

A Glimpse into the World of Children's Books

In one of Andersen's tales, there is a picture-book that cost "half a kingdom." In it everything was alive. "The birds sang, and people came out of the book and spoke." But when the princess turned the page, "they leaped back in again so that there should be no disorder." Pretty and unfocused, like so much that Andersen wrote, this little invention misses the crucial point by a hair's breadth. Things do not come out to meet the picturing child from the pages of the book; instead, in looking, the child enters into them as a cloud that becomes suffused with the riotous colors of the world of pictures. Sitting before his painted book, he makes the Taoist vision of perfection come true: he overcomes the illusory barrier of the book's surface and passes through colored textures and brightly painted partitions to enter a stage on which the fairy tale lives. *Hua*, the Chinese word for "painting" [*tuschen*] is much like *gua*, meaning "attach" [*anhängen*]: you attach five colors to the things. In German, the word used is *anlegen*: you "lay on" colors. In such an open, color-bedecked world where everything shifts at every step, the child is allowed to join in the game. Draped with colors of every hue that he has picked up from reading and viewing, the child stands in the center of a masquerade and joins in. While reading—for the words have all come to the masked ball, are joining in the fun and are whirling around together, like tinkling snowflakes. "'Prince' is a word with a star fastened around it," said a boy of seven. When children think up stories, they are like theater directors who refuse to submit to censoring by "sense." This is easily proved. If one gives children four or five specific words and asks them to make a short sentence on the spot, the most amazing prose comes to

226

light: not a glimpse into but a guide to children's books. At a stroke, the words throw on their costumes and in the blink of an eye they are caught up in a battle, love scenes, or a brawl. This is how children write their stories, but also how they read them. And there are rare, impassioned ABC-books that play a similar sort of game in pictures. Under Plate A, for example, one finds a higgledy-piggledy still-life that seems very mysterious until one realizes what is happening and what Apple, ABC-book, Ape, Airplane, Anchor, Ark, Arm, Armadillo, Aster, and Ax are all doing in the same place. Children know such pictures like their own pockets; they have searched through them in the same way and turned them inside out, without neglecting the smallest thread or piece of cloth. And if, in the colored engraving, the child's imagination sinks dreamily into itself, the black-and-white woodcut, the plain prosaic illustration, draws it back out of itself. Such pictures, with the urgent demand for description that lies within them, rouse the word within the child. Just as the child describes [*beschreibt*] the pictures with words, so, too, does he "inscribe" [*beschreibt*] them in a more literal sense. He scribbles on them. Unlike the colored pictures, the surface of the black-and-white illustration is arranged only suggestively and has a capacity for a certain condensation [*Verdichtung*]. So the child composes into the picture. At the same time as he learns language from them, he also learns writing [*Schrift*]: hieroglyphics. It is under this sign that, still today, the first words learned from primers are supplemented with line drawings of the things they refer to: egg, hat. The genuine value of such simple graphic children's books is far removed from the blunt urgency that led rationalist pedagogy to recommend them. "The way the child marks out a little place for himself," explores his picture landscape with his eyes and finger, can be seen in this paradigmatic nursery rhyme from an old picture-book, *Steckenpferd and Puppe* [Hobby-Horse and Doll], by J. P. Wich (Nordlingen, 1843):

> In front of the little town, there sits a little dwarf,
> Behind the little dwarf, there stands a little mountain,
> From the little mountain, there flows a little stream,
> On the little stream, there floats a little roof,
> Beneath the little roof, there stands a little room,
> Inside the little room, there sits a little boy,
> Behind the little boy, there stands a little bench,
> On the little bench, there rests a little chest,
> In the little chest, there stands a little box,
> In the little box, there lies a little nest,

Aesop's Fables, second edition. Published by Heinrich Friedrich Müller, Bookseller, Kohlmarkt 1218, Vienna, no date. Collection of Walter Benjamin.

> In front of the little nest, there stands a little cat,
> That's a lovely little place, I'll make a note of that.

In a less systematic, more capricious and boisterous way, children play with puzzle-pictures in which they set out in pursuit of the "thief," the "lazy pupil," or the "hidden teacher." Moreover, these pictures—which may seem related to those drawings full of contradictions and impossibilities which today are recognized for their usefulness as tests—are really only a masquerade, rollicking improvised burlesques in which people walk upside down, stick their arms and legs between tree branches, and

Moral sayings from the book by Jesus Sirach, Nuremberg. Collection of Walter Benjamin.

use a house roof as a coat. These carnivals overflow even into the more serious space of spelling- and reading-books. In the first half of the last century, [Paul] Renner in Nuremberg published a set of twenty-four sheets in which the letters were introduced in disguise, as it were. *F* steps out in the dress of a Franciscan, *C* as a Clerk, *P* as a Porter. The game was so pleasurable that variations on these old motifs have survived to this day. Last, the rebus rings in the Ash Wednesday of this carnival of words and letters. It is the unmasking: from the midst of the resplendent procession, the motto—the gaunt figure of Reason—gazes out at the chil-

The Book of Tales for Daughters and Sons of the Educated Classes, by Johann Peter Lyser. With eight copperplate illustrations. Leipzig: Wigand'sche Verlags-Expedition, 1834. Collection of Walter Benjamin.

dren. The rebus (a word that, curiously, was formerly traced back to *rêver* instead of to *res*) has the most distinguished origins: it descends directly from the hieroglyphics of the Renaissance, and one of its most precious printed works, the *Hypnerotomachia Poliphili,* may be described as its patent of nobility [*Adelsurkunde*]. It was perhaps never as widely known in Germany as in France, where around 1840 there was a fashion for charming collections of printed sheets on which the text was printed in picture writing [*Bilderschrift*]. Even so, German children, too, had delightful "pedagogical" rebus books. From the end of the eighteenth century, at the latest, comes the *Sittensprüche des Buchs Jesus Sirach für Kinder and junge Leute aus allen Ständen mit Bildern welche die vornehmsten Wörter ausdrücken* [Moral Sayings from the Book of Ecclesiasticus for Children and Young People of All Classes, with Pictures that Express the Most Important Words]. The text is delicately engraved in copper, and wherever possible all the nouns are represented by small, beautifully painted pictures that were either matter-of-fact

[*sachlich*] or allegorical. As late as 1842, [Benedictus Gotthelf] Teubner published a *Kleine Bibel für Kinder* [Little Bible for Children], with 460 illustrations of that sort. And just as children's books opened up a wide field for thought and the imagination, they did the same for the active hand. There are the well-known pull-out books (which have degenerated the most and seem to be the most short-lived as a genre, just as the books themselves never last for long). A delightful example was the *Livre jou-jou*, which was published by Janet in Paris, presumably in the 1840s. It is the story of a Persian prince. All the incidents of his adventures are illustrated, and each joyful episode where he is rescued can be made to appear with the wave of a magic wand, by moving the strip at the side of the page. Similar to these are the books in which the doors and curtains in the pictures can be opened to reveal pictures behind them. And finally, just as a novel has been written about a dress-up doll (*Isabellens Verwandlungen oder das Mädchen in sechs Gestalten: Ein Unterhaltendes Buch für Mädchen mit sieben kolorierten beweglichen Kupfern* [Isabella's Transformations, or The Girl in Six Shapes: An Entertaining Book for Girls, with Seven Colored Pictures that Move], published in Vienna), it so happens there are now books of those beautiful games in which little cardboard figures can be attached by means of invisible slits in the board and can be rearranged at will. Thus, the features of a landscape or a room can be altered according to the different situations that arise in the course of the story. For those few people who as children—or even as collectors—have had the great good fortune to come into possession of magic books or puzzle-books, all of the foregoing will have paled in comparison. These magic books were ingeniously contrived volumes that presented different sequences of pages, depending on where the reader held his hand. To the dexterous person familiar with such a book, it will show the same picture ten times over on continually changing pages, until his hand slips—and then, as if the book were transformed in his palm, an entirely different set of pictures will appear. A book like that (such as the eighteenth-century quarto that lies open before the present writer) seems variously to contain nothing but a flower vase, or repeated images of a grinning devil, then some parrots, followed by all black or all white pages, windmills, court jesters, pierrots, and so on. Another book shows, depending upon how one flips through it, a series of toys, tasty treats for a well-behaved child, or—if one goes through the oracle-book a different way—an array of instruments of punishment and terrifying faces for the naughty child.

The heyday of children's books, in the first half of the nineteenth cen-

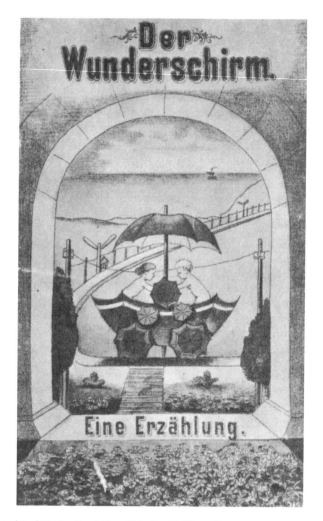

The Magical Red Umbrella: A New Tale for Children. Neuruppin Printers, and Verlag von Gustav Kühn. Collection of Walter Benjamin.

tury, probably did not result solely from the concrete pedagogical understanding of the day (which was in some respects superior to that of today), but, even more, emerged out of everyday bourgeois life as an aspect of that life. In a word, it emerged from the Biedermeier period. Even the smallest cities contained publishers whose most ordinary products were as elegant as the modest household furniture of the time, in the drawers of which their books lay untouched for a century. This is why there are

children's books not just from Berlin, Leipzig, Nuremberg, and Vienna; for the collector, works published in Meissen, Grimma, Gotha, Pirna, Plauen, Magdeburg, and Neuhaldensleben have a much more promising ring. Illustrators were at work in almost all of those towns, though the majority have remained unknown. From time to time, however, one of them is rediscovered and acquires a biographer. This was the case with Johann Peter Lyser, the painter, musician, and journalist. A. L. Grimm's *Fabelbuch* [Book of Fables] (Grimma, 1827), with Lyser's illustrations, the *Buch der Mährchen für Töchter and Söhne gebildeter Stände* [Book of Fairy Tales for Daughters and Sons of the Educated Classes] (Leipzig, 1834), with text and illustrations by Lyser, and *Linas Mährchenbuch* [Lina's Book of Fairy Tales] (Grimma, n.d.), with text by A. L. Grimm and illustrations by Lyser, contain his most beautiful work for children. The coloring of these lithographs pales beside the fiery coloring of the Biedermeier period, and matches better the haggard and often careworn figures, the shadowy landscape, and the fairy-tale atmosphere which is not without an ironic-satanic streak. The craftsmanship in these books was fully committed to the everyday life of the petty bourgeoisie; it was not there to be enjoyed but was to be used like cooking recipes or household maxims. It represents a popular, even childlike variant of the dreams that assumed their most exaggerated forms in the works of the Romantics. This is why Jean Paul is their patron saint.[1] The central-German fairy-world of his stories has found expression in their pictures. No writing is closer to their unpretentiously resplendent world of colors world than his. For his genius, like that of color itself, rests on fantasy, not creative power. When the eye sees colors, the perceptions and intuitions of the imagination [*Phantasieanschauung*], in contrast to creative conceits [*schöpferischer Einbildung*], manifest themselves as a primal phenomenon. All form, every contour that human beings perceive, corresponds to a faculty within them that enables them to reproduce it. The body in dance, the hand in drawing imitate that contour and appropriate it. But this faculty finds its limits in the world of color: the human body cannot produce color. It establishes a correspondence to it not creatively but receptively: in the eye shimmering with color. (Anthropologically, too, sight is the watershed of the senses because it perceives form and color simultaneously. Thus, the body possesses, on the one hand, faculties of active correspondences—form-seeing and movement, hearing and voice—and, on the other, those of an passive sort: the seeing of color belongs to the sensory realms of smell and taste. Language itself synthesizes this group into a unity in words like "looking," "smelling," "tasting," which apply

to the object, intransitively, and to the human subject, transitively.) In short, pure color is the medium of fantasy, a home among clouds for the playful child, not the strict canon of the constructive artist. Here is the link with its "sensuous-moral" [*sinnlich-sittlich*] effect which Goethe understood entirely in the spirit of the Romantics:

> In their illumination and their obscurity, the transparent colors are without limits, just as fire and water can be regarded as their zenith and nadir. . . . The relation of light to transparent color is, when you come to look into it deeply, infinitely fascinating, and when the colors flare up, merge into one another, arise anew, and vanish, it is like taking breath in great pauses from one eternity to the next, from the greatest light down to the solitary and eternal silence in the deepest shades. The opaque colors, in contrast, are like flowers that do not dare to compete with the sky, yet are concerned with weakness (that is to say, white) on the one side, and with evil (that is to say, black) on the other side. It is these, however, that are able . . . to produce such pleasing variations and such natural effects that . . . ultimately the transparent colors end up as no more than spirits playing above them and serve only to enhance them.[2]

With these words, the "Supplement" to the *Farbenlehre* [Theory of Color] does justice to the sensibilities of these worthy colorists and hence to the spirit of children's games. Just think of the many games that proceed from pure perception [*Anschauung*] to fantasy: soap bubbles, parlor games, the watery color of the magic lantern, watercolor painting, decals. In all of these, the color seems to hover suspended above the things. Their magic lies not in the colored thing or in the mere dead color, but in the colored glow, the colored brilliance, the ray of colored light. At the end of its panorama, the glimpse into the world of children's books culminates in a rock covered with Biedermeier flowers. Leaning on a sky-blue goddess, the poet lies there with his melodious hands. What the Muse whispers to him, a winged child sitting next to him sketches. Scattered around are a harp and a lute. Dwarves fiddle and toot in the depths of the mountain, while in the sky the sun is setting. This is how Lyser once painted the landscape, and the eyes and cheeks of children poring over books are reflected in the glory of the sunset.

Written in 1926; published in *Die literarische Welt*, 1926. *Gesammelte Schriften*, IV, pp. 609–615. Translated by Rodney Livingstone.

Notes

1. Jean Paul Richter (1763–1825) is remembered for a series of wildly extravagant, highly imaginative novels that combine fantasy and realism; they are indebted to Laurence Sterne.—Trans.
2. Johann Wolfgang von Goethe, *Zur Farbenlehre,* ed. Hans Wohlbold (Jena, 1928), pp. 440–442.—Trans.

21

Dream Kitsch

No one really dreams any longer of the Blue Flower.[1] Whoever awakes as Heinrich von Ofterdingen today must have overslept.[2] The history of the dream remains to be written, and opening up a perspective on this subject would mean decisively overcoming the superstitious belief in natural necessity by means of historical illumination. Dreaming has a share in history. The statistics on dreaming would stretch beyond the pleasures of the anecdotal landscape into the barrenness of a battlefield. Dreams have started wars, and wars, from the very earliest times, have determined the propriety and impropriety—indeed, the range—of dreams.

No longer does the dream reveal a blue horizon. The dream has grown gray. The gray coating of dust on things is its best part. Dreams are now a shortcut to banality. Technology consigns the outer image of things to a long farewell, like banknotes that are bound to lose their value. It is then that the hand retrieves this outer cast in dreams and, even as they are slipping away, makes contact with familiar contours. It catches hold of objects at their most threadbare and timeworn point. This is not always the most delicate point: children do not so much clasp a glass as snatch it up. And which side does a thing turn toward dreams? What point is its most decrepit? It is the side worn through by habit and garnished with cheap maxims. The side which things turn toward the dream is kitsch.

Chattering, the fantasy images of things fall to the ground like leaves from a Leporello picture book, *The Dream*.[3] Maxims shelter under every

leaf: "Ma plus belle maîtresse c'est la paresse," and "Une médaille vernie pour le plus grand ennui," and "Dans le corridor il y a quelqu'un qui me veut à la mort."[4] The Surrealists have composed such lines, and their allies among the artists have copied the picture book. *Répétitions* is the name that Paul Eluard gives to one of his collections of poetry, for whose frontispiece Max Ernst has drawn four small boys. They turn their backs to the reader, to their teacher and his desk as well, and look out over a balustrade where a balloon hangs in the air. A giant pencil rests on its point in the windowsill. The repetition of childhood experience gives us pause: when we were little, there was as yet no agonized protest against the world of our parents. As children in the midst of that world, we showed ourselves superior. When we reach for the banal, we take hold of the good along with it—the good that is there (open your eyes) right before you.

For the sentimentality of our parents, so often distilled, is good for providing the most objective image of our feelings. The long-windedness of their speeches, bitter as gall, has the effect of reducing us to a crimped picture puzzle; the ornament of conversation was full of the most abysmal entanglements. Within is heartfelt sympathy, is love, is kitsch. "Surrealism is called upon to reestablish dialogue in its essential truth. The interlocutors are freed from the obligation to be polite. He who speaks will develop no theses. But in principle, the reply cannot be concerned for the self-respect of the person speaking. For in the mind of the listener, words and images are only a springboard." Beautiful sentiments from Breton's *Surrealist Manifesto*. They articulate the formula of the dialogic misunderstanding—which is to say, of what is truly alive in the dialogue. "Misunderstanding" is here another word for the rhythm with which the only true reality forces its way into the conversation. The more effectively a man is able to speak, the more successfully he is misunderstood.

In his *Vague de rêves* [Wave of Dreams], Louis Aragon describes how the mania for dreaming spread over Paris. Young people believed they had come upon one of the secrets of poetry, whereas in fact they did away with poetic composition, as with all the most intensive forces of that period.[5] Saint-Pol-Roux, before going to bed in the early morning, puts up a notice on his door: "Poet at work."[6]—This all in order to blaze a way into the heart of things abolished or superseded, to decipher the contours of the banal as rebus, to start a concealed William Tell from out of wooded entrails, or to be able to answer the question, "Where is the bride?" Picture puzzles, as schemata of the dreamwork, were long ago discovered by psychoanalysis. The Surrealists, with a similar conviction,

are less on the trail of the psyche than on the track of things. They seek the totemic tree of objects within the thicket of primal history. The very last, the topmost face on the totem pole, is that of kitsch. It is the last mask of the banal, the one with which we adorn ourselves, in dream and conversation, so as to take in the energies of an outlived world of things.

What we used to call art begins at a distance of two meters from the body. But now, in kitsch, the world of things advances on the human being; it yields to his uncertain grasp and ultimately fashions its figures in his interior. The new man bears within himself the very quintessence of the old forms, and what evolves in the confrontation with a particular milieu from the second half of the nineteenth century—in the dreams, as well as the words and images, of certain artists—is a creature who deserves the name of "furnished man."[7]

Written in 1925; published in *Die neue Rundschau,* January 1927. *Gesammelte Schriften,* II, 620–622. Translated by Howard Eiland.

Notes

1. The subtitle, "Gloss on Surrealism," was used as the title of the published article in 1927.
2. *Heinrich von Ofterdingen* is the title of an unfinished novel by the German poet Novalis (Friederich von Hardenberg; 1772–1801), first published in 1802. Von Ofterdingen is a medieval poet in search of the mysterious Blue Flower, which bears the face of his unknown beloved.
3. Leporello is Don Giovanni's servant in Mozart's opera *Don Giovanni.* He carries around a catalogue of his master's conquests, which accordions out to show the many names. In the mid-nineteenth century, there was a German publishing house, Leporello Verlag, which produced such pop-out books.
4. "My loveliest mistress is idleness." "A gold medal for the greatest boredom." "In the hall, there is someone who has it in for me."
5. Reference is to the years 1922–1924. *Une vague de rêves* was first published in the fall of 1924; along with Aragon's *Paysan de Paris* (Paris Peasant; 1926), it inspired Benjamin's earliest work on the Arcades Project.
6. Saint-Pol-Roux is the pseudonym of Paul Roux (1861–1940), French Symbolist poet.
7. Benjamin's term here is "der möblierte Mensch." A variant ending of "Dream Kitsch" in a manuscript copy of the essay reads:
 "The new man bears within himself the very quintessence of the old forms, and what evolves in the confrontation with a particular milieu from the second half of the nineteenth century—in the dreams, as well as the words and images, of certain artists—is a creature who deserves the name of

'furnished man': the body 'furnished' [*meublé*] with forms and apparatuses, in the sense that, in French, one speaks of the mind 'furnished' [*meublé*] with dreams or with scientific knowledge."

See Benjamin, *Gesammelte Schriften*, II, p. 1428. The term "der möblierte Mensch" is also a play on "der möblierte Herr" ("the furnished gentleman"), a colloquial German expression that refers to the (male) tenant of a furnished room or apartment and that Benjamin put to use elsewhere in his writings of the late 1920s. Ideas about furniture and furnishing, and about habits of modern dwelling in general, would come to occupy an important place in the Arcades Project.

22

Moonlit Nights on the Rue La Boétie

At first, it is like entering an aquarium. Along the wall of the huge darkened hall, runs what appears to be a strip of illuminated water behind glass, broken at intervals by narrow joints. The play of colors in deepsea fauna could not be more fiery. But what reveals itself here are supraterrestrial, atmospheric miracles. Seraglios are mirrored in moonlit waters; nights in abandoned parks expose themselves. In the moonlight one recognizes the château of Saint Leu, where a hundred years ago the body of the last Condé was discovered hanged in a window.[1] Somewhere a light is still burning behind the curtains. A few shafts of sunlight fall at intervals. In the purer rays of a summer morning, you can peer into the *stanze* of the Vatican, as they appeared to the Nazarenes.[2] Not far off, the whole of Baden-Baden constructs itself; and if the sun were not dazzling, one might be able to recognize Dostoevsky on the casino terrace among the doll-like figures on a scale of 1:10,000. But even candlelight comes into its own. In the twilit cathedral, wax candles form a sort of *chapelle ardente* surrounding the murdered duc de Berry; and the lamps in the silken skies of an island of love almost put chubby Luna to shame.[3]

This is a unique experiment in what the Romantics called the "moonlit night of magic." It emerges triumphantly in its noble essence from every conceivable test to which its specific form of poetry has been subjected here. It is almost frightening to think of the power it must have had in its cruder, more massive state—in the magic pictures of the fairs and in dioramas. Or was this watercolor painting (done on paper that was scraped and rubbed, cut out in different places, given an underlay, and finally covered with wax in order to achieve the desired transparency)

never popular because the technique was always too expensive? Nothing is known about that. For these forty transparencies stand here in complete isolation. Nothing similar to them is known, and one knew nothing even of the present ones until recently, when they were discovered in someone's estate. They belonged to a collection assembled by a wealthy aficionado, the great-grandfather of their present owner. Every piece was made individually and specifically for him. Great artists like Géricault, David, and Boilly are said to have been involved to a greater or lesser degree. Other experts believe that Daguerre worked on these plates before he created his famous diorama (which burned down in 1839, after seventeen years).[4]

Whether the greatest artists really were involved or not is important only for the American who sooner or later will pay the one and a half million francs for which the collection can be had. For this technique has nothing to do with "art" in the strict sense—it belongs to the practical arts. Its place is somewhere among a perhaps only provisionally unordered set that extends from the practices of vision to those of the electric television. In the nineteenth century, when children were the last audience for magic, these practical arts all converged in the dimension of play. Their intensity was not thereby diminished. Anyone who takes the time to linger before the transparency of the old spa of Contrexéville soon feels as if a hundred years ago he had often strolled along this sunny path between the poplars, had brushed up against the stone wall — modest magical effects for domestic use, of a sort one otherwise only experiences in rare cases—Chinese soapstone groups, for example, or Russian lacquer paintings.

Published in *Die literarische Welt,* March 1928. *Gesammelte Schriften,* IV, 509–511. Translated by Rodney Livingstone.

Notes

1. "The last Condé" is the traditional name for Louis Henri-Joseph, duc de Bourbon (1756–1830). Having played a minor role on the side of the aristocracy in the French Revolution, he led a dissolute life in England and returned to France with his mistress, Sophie Dawes, in 1814. After he was found hanged in his château, Dawes was suspected of the murder; she was, however, released by order of Louis Philippe, and the crime remained unsolved.
2. The Nazarenes were a group of young painters, including Friedrich Overbeck (1789–1869) and Franz Pforr (1788–1812), who first met at the Academy of

Fine Arts in Vienna. The group relocated to Rome in 1810, where they studied Raphael's frescoes in the Vatican. Taking fifteenth- and early sixteenth-century German and Italian art as a model of spiritual sincerity, they developed an archaizing style of painting.

3. In Catholicism, a *chapelle ardente* is a darkened room, illuminated with candles, in which the body of a deceased person lies until placed in a casket. Charles Ferdinand de Bourbon, duc de Berry (1778–1820), served in the prince de Condé's army against the French Revolution, was exiled to England, and, after his return to France in 1815, was assassinated by Louis-Pierre Louvel, a worker obsessed with, in his own words, "exterminating the Bourbons."

4. Louis Jacques Mandé Daguerre (1787–1851) was a French painter and the inventor of the daguerreotype. In 1822, he opened the Diorama in Paris—a panorama in which pictures were painted on cloth transparencies illuminated with various lighting effects. See Benjamin's "Paris, the Capital of the Nineteenth Century" (1935), in this volume.

23

Chambermaids' Romances of the Past Century

Chambermaids' romances? Since when are works of literature categorized according to the class that consumes them? Unfortunately, they are not—or all too seldom. Yet how much more illuminating this would be than hackneyed aesthetic appreciations! Nevertheless, such a categorization would pose problems. Above all, because we so rarely obtain any insight into the relations of production. They used to be more transparent than they are in our day. This is why a start should be made with cheap fiction, with colportage, if indeed literary history is ever going to explore the geological structure of the book-alps, rather than confining itself to a view of the peaks.

Before the development of advertising, the book trade was dependent on itinerant colporteurs or booksellers for distribution of its wares among the lower classes. It is amusing to imagine the complete literary traveling salesman of that age and those classes, the man who knew how to introduce ghost stories and tales of chivalry into the servants' quarters in the cities and the peasants' cottages in the villages. To a certain extent he must have been able to become part of the stories he was selling. Not as the hero, of course, not the banished prince or the knight errant, but perhaps the ambiguous old man—warner or seducer?—who appears in many of these stories and who, in the first illustration shown here, is about to make himself scarce at the sight of a crucifix.

It is not surprising that this entire body of literature has been despised for as long as the superstitious belief in absolute "art" has existed. The concept of the document, however, which we nowadays apply to the works of primitives, children, and the sick, has also provided essential

"Swear!"
This illustration is from a medieval tale of ghosts and chivalry entitled *Adelmar von Perlstein, the Knight of the Golden Key; or, The Twelve Sleeping Maidens, Protectors of the Enchanting Young Man.*

contexts within which to consider these writings. People recognized the value of typical subjects [*typische Stoffe*], took an interest in studying the small number of truly living ones that continue to have an impact and are capable of renewal, and saw that the artistic will [*künstlerische Wille*] of

The Princess of Vengeance, Known as the Hyena of Paris
"I swear it; they shall all suffer the fate of this man!" The beauty portrayed here is a collector of preserved human heads, which she keeps on the shelves of a cupboard in her house.

different generations and classes was embodied just as decisively in their variation as in their formal language. The archive of such eternal subjects is the dream, as Freud has taught us to understand it.

Works that pander so directly to the public's hunger for stories are interesting enough in themselves; but they become even more so when the same spirit is expressed graphically and colorfully through illustrations. The very principle of such illustrations testifies to the close connection between reader and story. The reader wants to know exactly what their place is. If only we had more such pictures! But where they were not protected by the stamp of a lending library—like two of those shown here—they have followed their predestined path: from the book to the wall and from the wall to the rubbish bin.

These books raise many questions. Apart from external ones, such as matters of authorship, influence, and so on, there is the question of why, in stories that were written in the heyday of the bourgeoisie, moral au-

"My Curse upon You!"

This illustration comes from a story of recent times by O. G. Derwicz, entitled *Antonetta Czerna, the Princess of the Wild; or, The Vengeance of a Woman's Wounded Heart* (Pirna, no date). These smartly dressed ladies have turned up for the shooting of the young man as if for a garden party.

"Stand Back, Base Scoundrel!"
This is the notorious "Black Knight," who has just conquered York Castle and is about to overpower the beautiful Rebecca. One might say that the two figures are dancing a kind of country waltz of horror.

thority is always tied to a lady or gentleman of rank. Perhaps because the servant classes still felt a certain solidarity with the middle class and shared its most secret romantic ideals.

Many of these novels have a motto in verse at the head of each of their bloodthirsty chapters. There you can encounter Goethe and Schiller, and even Schlegel and Immermann, but also such leading poets as Waldau, Parucker, Tschabuschnigg, or the simple B.,[1] to whom we owe these lines:

> Alone she strays, abandoned,
> through the endless city streets,
> Every instant to fear
> the enemies she might meet.

We are still clumsy in our efforts to approach these clumsy works. We feel it is strange to take seriously books that were never part of a "library." But let us not forget that books were originally objects for use—

indeed, a means of subsistence. These were devoured. Let us use them to study novels from the point of view of their food chemistry!

Published in *Das illustrierte Blatt*, April 1929. *Gesammelte Schriften*, IV, 620–622. Translated by Rodney Livingstone.

Notes

1. Benjamin probably refers here to Friedrich Schlegel (1772–1829), the prominent Romantic theorist, translator, scholar, critic, and novelist. Karl Leberecht Immermann (1796–1840) was a German author whose novels of contemporary social analysis and village life were widely read. Max Waldau (pseudonym of Richard Georg Spiller von Hauenschild; 1825–1855) was a poet and novelist active in East Prussia; he is best-known for the novels *Nach der Natur* (After Nature; 1850) and *Aus der Junkerwelt* (From the World of the Country Squires; 1850). Adolf Ritter von Tschabuschnigg (1809–1877) was an Austrian writer and politician; after a long political career, he became minister of justice in 1870–1871. His novels *Die Industriellen* (The Industrialists; 1854) and *Sünder und Toren* (Sinners and Fools; 1875) were oriented toward societal analysis and critique.

24

Antoine Wiertz

THOUGHTS AND VISIONS OF A SEVERED HEAD

Once the nineteenth century is Baedeker-ready and its ruins are ripe for moonlight, the Musée Antoine Wiertz in Brussels will be one of the obligatory destinations for honeymooners.[1] Wiertz lived from 1806 to 1865. His work has little to do with great painting—but it is all the more interesting to connoisseurs of cultural curiosities and to physiognomists of the nineteenth century. Some titles from the catalogue of Wiertz's oeuvre will convey an idea of his specialty: *The Suicide; The Overhasty Burial; Hunger, Madness, and Crime; The Burnt Child.* Wiertz himself wrote the museum's catalogue, though admittedly without signing it. From this catalogue—published posthumously in 1870—we take the following text. It is, so to speak, the "caption" [*Beschriftung*] to his great triptych, *Thoughts and Visions of a Severed Head.*[2] The report deserves to be rescued from obscurity, not only because of its tendentiousness but also because of its grandiose costuming [*Einkleidung*] and its compositional power.

—WALTER BENJAMIN

Triptych: First Minute, Second Minute, Third Minute

Just moments ago, several heads fell under the scaffold. On this occasion, it occurred to the artist to pursue inquiries on the following question:

Does the head, after its separation from the trunk, remain for a few seconds capable of thought?

This is the report of that investigation. In the company of Monsieur . . . and Monsieur D, an expert magnetopath, I was allowed onto the scaffold. There I asked Monsieur D to put me in rapport with the cut-off head, by means of whatever new procedures seemed appropriate to him.[3] Monsieur D acquiesced. He made some preparations and then we waited, not without excitement, for the fall of a human head.

Hardly had the inevitable moment come when the dreadful blade plunged down, shaking the entire scaffold, and the head of the condemned man rolled into the terrible red sack.

Our hair stood on end at that moment, but there was no time left for us to distance ourselves. Monsieur D took me by the hand (I was under his magnetic influence), led me before the twitching head, and asked, "What do you feel? What do you see?" Agitation prevented me from answering him on the spot. But right after that I cried in the utmost horror, "Terrible! The head thinks!" Now I wanted to escape what I had to go through, but it was as if an oppressive nightmare held me in its spell. The head of the executed man saw, thought, and suffered. And I saw what he saw, understood what he thought, and felt what he suffered. How long did it last? Three minutes, they told me. The executed man must have thought: three hundred years.

What the man killed in this way suffers, no human language can express. I wish to limit myself here to reiterating the answers I gave to all questions during the time that I felt myself in some measure identical to the severed head.

First Minute: On the Scaffold

Herewith these answers: An incomprehensible noise roars in his head.—Sound of the guillotine blade coming down.—The offender thinks that lightning, not the blade, has struck him.—Astonishingly, the head lies here under the scaffold and yet still believes it is above, still believes itself to be part of the body, and still waits for the blow that will cut it off.

Horrifying suffocation.—Breathing impossible.—That comes from an inhuman, supernatural hand, heaving down like a mountain on the head and neck.—Where does this horrible inhuman hand come from? The sufferer recognizes it: its fingers touch purple and ermine.

Oh, even more horrible suffering lies before him.

Second Minute: Under the Scaffold

The pressure has turned into a slicing. Now the executed man first becomes conscious of his situation.—He measures with his eyes the space separating his head from the body and says to himself: So, my head is actually cut off.

The raging delirium increases. It seems to the executed man that his head is burning, and circling around itself. . . . And in the middle of this raging fever an ungraspable, insane, unnamable thought seizes the dying brain. Can one believe it? The man whose head is cut off continues hope. All his remaining blood pulses faster through his living veins and clings to this hope.

Now comes the moment when the executed man thinks he is stretching his cramped, trembling hands toward the dying head. It is the same instinct that drives us to press a hand against a gaping wound. And it occurs with the intention, the dreadful intention, of setting the head back on the trunk, to preserve a little blood, a little life. . . . The eyes of the martyred man roll in their bloody sockets. . . . The body becomes stiff as granite.

That is death . . .

No, not yet.

Third Minute: In Eternity

Not yet death. The head still thinks and suffers.

Suffers fire that burns, suffers the dagger that dismembers, suffers the poison that cramps, suffers in the limbs, as they are sawn through, suffers in his viscera, as they are torn out, suffers in his flesh, as it is hacked and trampled down, suffers in his bones, which are slowly boiled in bubbling oil. All this suffering put together still cannot convey any idea of what the executed man is going through.

And here a thought makes him stiff with terror:

Is he already dead and must he suffer like this from now on? Perhaps for all eternity? . . .

Now, however, human existence fades away from him. It seems to him slowly to become one with the night. Now just a faint mist—but even that recedes, dissipates, and disappears. Everything goes black. . . . The beheaded man is dead.

Published in *Das Tagebuch*, 1929. *Gesammelte Schriften*, IV, 805–808. Translated by Annie Bourneuf.

Notes

The text Benjamin presents here is a partial translation of the caption *(légende)* that the late-Romantic Belgian painter Antoine Joseph Wiertz (1806–1865) composed for his 1853 triptych, *Pensées et visions d'une tête coupée,* as published posthumously in Wiertz's *Oeuvres littéraires* (Brussels: Parent et Fils, 1869), pp. 491–495. Benjamin was working from an edition published in Paris (Librairie Internationale, 1870). The *légende* also appears within the triptych itself in the form of a painted inscription on a trompe-l'oeil frame, the latter a device Wiertz frequently used in his work.

In his translation, Benjamin abbreviates sections of Wiertz's text and omits the artist's introductory remarks on the painting, as well as his lengthy descriptions of the visions of the subject (a guillotined man) in the last two sections. Although Benjamin's translation renders Wiertz's title as "Gedanken und Gesichte eines Geköpften" (Thoughts and Visions of a Beheaded Man), the present English translation returns to Wiertz's original French in referring to "a severed head" ("une tête coupée"). This choice was made for two reasons: first, because Benjamin's translation of "d'une tête coupée" as "eines Geköpften" in the German title is both inaccurate and inconsistent with the rest of his translation of Wiertz's text; and, second, because an accurate translation of "eines Geköpften," which refers to the person (and the body) of the executed man ("a beheaded one"), rather than to a severed head (as in the French "une tête coupée"), would have introduced into the English title an awkwardness present neither in the original French nor in the inaccurate but felicitous German. See the introduction to Part IV of this volume for some remarks on what may be at stake in the inconsistency of Benjamin's translation of Wiertz's text.

1. A branch of the Musées Royaux des Beaux-Arts de Belgique since 1868, the Musée Wiertz is housed in Brussels at 62 rue Vautier—a neoclassical building which the Belgian government constructed for Wiertz in 1850 as a studio-museum, in exchange for a number of his monumental history paintings and the promised bequest of the entire body of work in his possession. Wiertz maintained his studio in the building until the time of his death, at which point his estate became national property.

 Benjamin cites Wiertz's 1855 essay on photography in *The Arcades Project,* where he describes the artist as "the painter of the arcades" and "the first to demand, if not actually foresee, the use of photographic montage for political agitation." Benjamin, *The Arcades Project* (Cambridge, Mass.: Harvard University Press, 1999), pp. 845, 671 (Convolute Y1,1), and 6. See also the references to Wiertz in "Letter from Paris (2)" and "Little History of Photography," in this volume.

2. The triptych, which today hangs behind a counter in the main gallery of the Musée Wiertz, where postcards as well as copies of Wiertz's *légende* are displayed for sale, is made up of three panels of roughly equal size. The first

shows spectators pointing up at the headless body on the scaffold. The second, from another vantage point, shows the executioner hoisting the body up from the scaffold as the head, which emits rays that may signal a rapport between the head and the author of the text, rolls to the ground. The third shows smoke and flames swirling in a location that is no longer identifiable.

Using a process of his own invention, Wiertz blended his pigments with turpentine rather than oil to achieve a matte surface. The triptych is now in poor condition due to the instability of the medium.

There were widespread doubts in the nineteenth century as to whether death by guillotine—favored by the Jacobins during the French Revolution as a speedy, egalitarian, and therefore "humane" means of execution—was really instantaneous, along with speculations as to whether consciousness could abide in a severed head.

3. In the nineteenth century, in the wake of the theories of "animal magnetism" promulgated by Franz Anton Mesmer (1734–1815) and others, the phenomena of hypnotism and magnetism were understood as closely linked, and the language of magnetism was often used to describe hypnotic rapport and influence.

25

Some Remarks on Folk Art

Folk art and kitsch ought for once to be regarded as a single great movement that passes certain themes from hand to hand, like batons, behind the back of what is known as great art. They both depend on great art at the level of individual works, but apply what they have taken in their own way and in the service of their own goals, their *Kunstwollen.*[1]

What is the direction of this *Kunstwollen*? Well, certainly not toward art, but toward something far more primitive, yet more compelling. If we ask ourselves what "art" in the modern sense means to folk art on the one hand and to kitsch on the other, the answer would be: all folk art draws the human being into itself. It addresses him only so that he must answer. Moreover, he answers with questions: "Where and when was it?" The idea surfaces in him that this space and this moment and this position of the sun must have existed once before. To throw the situation that is brought to mind here around one's shoulders, like a favorite old coat—this is the deepest temptation awakened by the refrain of a folk song, in which a basic feature of all folk art may be perceived.

It is not just that our image of our character is so discontinuous, so much a matter of improvisation, that we are eager to fall in with every suggestion made by the graphologist, the palm-reader, and similar practitioners. Rather, our destiny may be said to be governed by the same intensive imagination that illuminates in a flash the dark corners of the self, of our character, and creates a space for the interpolation of the most unexpected dark or light features. When we are in earnest, we discover our conviction that we have experienced infinitely more than we know about.

This includes what we have read, and what we have dreamed, whether awake or in our sleep. And who knows how and where we can open up other regions of our destiny?

What we have experienced unconsciously echoes, after its own fashion, wherever we enter the world of primitives: their furniture, their ornaments, their songs and pictures. "After its own fashion"—this means in an entirely different manner from the way in which great art affects us. As we stand in front of a painting by Titian or Monet, we never feel the urge to pull out our watch and set it by the position of the sun in the picture. But in the case of pictures in children's books, or in Utrillo's paintings, which really do recuperate the primitive, we might easily get such an urge. This means that we find ourselves in a situation of the kind we are used to, and it is not so much that we compare the position of the sun with our watch as that we use the watch to compare this position of the sun with an earlier one. The *déjà vu* is changed from the pathological exception that it is in civilized life to a magical ability at whose disposal folk art (and kitsch no less so) places itself. It can do so because the *déjà vu* really is quite different from the intellectual recognition that the new situation is the same as the old one. It would be more accurate to say: is *fundamentally* the old one. But even this is mistaken. For the situation is not experienced as if by someone standing outside it: it has pulled itself over us; we have encased ourselves within it. However one grasps it, it amounts to the same thing: the primal fact of the mask. In this way the primitive, with all its devices and pictures, opens us to an endless arsenal of masks—the masks of our fate—by means of which we stand apart from moments and situations that have been lived through unconsciously but that are here finally reintegrated.

Only impoverished, uncreative man knows of no other way to transform himself than by means of disguise. Disguise seeks the arsenal of masks within us. But for the most part, we are very poorly equipped with them. In reality, the world is full of masks; we do not suspect the extent to which even the most unpretentious pieces of furniture (such as Romanesque armchairs) used to be masks, too. Wearing a mask, man looks out on the situation and builds up his figures within it. To hand over these masks to us, and to form the space and the figure of our fate within it—this is what folk art approaches us with. Only from this vantage point can we say clearly and fundamentally what distinguishes it from actual "art," in the narrower sense.

Art teaches us to see into things.

Folk art and kitsch allow us to see outward from within things.

Fragment written in 1929; unpublished in Benjamin's lifetime. *Gesammelte Schriften,* VI, pp. 185–187. Translated by Rodney Livingstone.

Notes

1. On the term *Kunstwollen,* see the introduction to Part I in this volume.

26

Chinese Paintings at the Bibliothèque Nationale

A noteworthy collection of Chinese paintings belonging to Monsieur J.-P. Dubosc was exhibited last October at the Bibliothèque Nationale.[1] There the public was able to see masterpieces that it rarely encounters, while connoisseurs took advantage of the occasion to mark a shift in values that is currently taking place in this field. We should recall here the 1936 Oslo exhibition curated by Dr. O. Sirén, which already garnered attention for Chinese painting from the sixteenth, seventeenth, and eighteenth centuries.[2]

The stature of the paintings from these periods is solidly established in China and Japan; yet here in the West, because of a certain bias and a certain ignorance, we have lauded above all Chinese painting from the Song period (tenth, eleventh, and twelfth centuries), and accorded equal regard to that of the Yuan period (thirteenth and fourteenth centuries), which is viewed as a continuation of the former. This somewhat confused admiration for the "Song-Yuan" used to turn abruptly into contempt at the mere mention of the Ming and Qing dynasties.

It should first be noted, however, that the authenticity of many supposed Song and Yuan paintings is questionable. Mr. Arthur Waley and Dr. Sirén have shown persuasively in their books that few paintings can be attributed with certainty to the so-called classic period of Chinese painting.[3] It seems we have been swooning mainly over copies. Yet without prejudging the real greatness of Chinese painting from the Song and Yuan periods, we can, on the basis of the Bibliothèque Nationale exhibition, revise our superficial assessment of the Chinese painters from the Ming and Qing dynasties. To tell the truth, there was never any question

of naming even a single one of these painters. No one bothered. The condemnation fell wholesale on "Ming painting," on "Qing painting"—grouped together under the sign of decadence.

Yet Monsieur Georges Salles, who has earned our gratitude for introducing us to Monsieur Dubosc's collection, stresses that the more recent painters maintained the ancient mastery.[4] They practiced, he says, "an art that became a fixed profession—Mallarméan facets cut skillfully onto the old alexandrine."[5]

This exhibition interested us from another perspective as well, one more closely tied to the personality of the collector himself. Monsieur Dubosc, who lived for about ten years in China, became an eminent connoisseur of Chinese art by virtue of an aesthetic education that was essentially Western. His preface makes clear in an unobtrusive way how valuable the teachings of Paul Valéry, in particular, were for him.[6] We are not surprised, then, to learn that he was interested in the literary profession, which, in China, is inseparable from the profession of the painter.

Here is a fact that is at once of utmost importance and somewhat strange in the eyes of Europeans: the link that has been revealed between the thought of a Valéry, who says that Leonardo da Vinci "takes painting as his philosophy," and the synthetic view of the universe which is characteristic of the painter-philosophers of China. "Painter and great man of letters," "calligrapher, poet, and painter"—such designations are common for the master painters. The paintings prove them well founded.

A great number of paintings feature important captions. If we set aside the ones added later by collectors, the most interesting are those that come from the hand of the artists themselves. The subjects of these calligraphies, which constitute, in a way, part of the painting, are multiple. They sometimes contain commentaries and references to illustrious masters. Even more often, they consist solely of personal remarks. Here are some that could just as easily have been taken from a diary as from a collection of lyric poetry:

> On the trees, the snow still remains frozen . . .
> I could gaze at this sight, unwearied, for an entire day.
> —Ts'ien Kiang

> In a pavilion at the water's heart, where no one goes,
> I finished reading the songs of "Pin,"
> Those of the seventh month.
> —Lieou Wang-Ngan

"These painters are literati," says Monsieur Dubosc. He adds: "Their painting is, however, the opposite of all literature."

The antinomy he indicates in these terms might well constitute the threshold that genuinely gives access to this painting—an antinomy which finds its "resolution" in an intermediary element that, far from constituting a balance [*un juste milieu*] between literature and painting, embraces intimately the point at which they appear most irreducibly opposed— namely, thought and image. Here, we should speak of Chinese calligraphy. "Chinese calligraphy, as an art," says the erudite Lin Yutang, "implies . . . the cult and appreciation of the abstract beauty of line and composition in the characters, when these are assembled in such a way that they give the impression of an unstable equilibrium. . . . In this search for every theoretically possible type of rhythm and structure that appears in the history of Chinese calligraphy, we see that practically all the organic forms and all the movements of living beings that exist in nature have been incorporated and assimilated. . . . The artist . . . seizes upon the stork's thin stilts, the hare's bounding contours, the tiger's massive paws, the lion's mane, the elephant's ponderous walk—and weaves them into a web of magical beauty."[7]

Chinese calligraphy—this "ink-play," to borrow the phrase that Monsieur Dubosc uses to designate the paintings—thus appears as something eminently in motion. Although the signs have a fixed connection and form on the paper, the many "resemblances" they contain set them moving. Expressed in every stroke of the brush, these virtual resemblances form a mirror where thought is reflected in this atmosphere of resemblance, or resonance.

Indeed, these resemblances are not mutually exclusive; they become intermingled, constituting a whole that solicits thought the way a breeze beckons to a veil of gauze. The term *xieyi* ("idea painting"), which the Chinese reserve for this notation, is significant in this regard.

An essential feature of the image is that it incorporates something eternal. This eternal quality expresses itself in the fixity and stability of the stroke, but it is also manifest, more subtly, thanks to the fact that the image embodies something that is fluid and ever-changing. It is from this blending of the fixed and the mutable that Chinese painting derives all its meaning. It goes in search of the thought-image. "In China," says Monsieur Salles, "the art of painting is first and foremost the art of thinking." And thinking, for the Chinese painter, means thinking by means of resemblance. Moreover, just as resemblance always appears to us like a flash of lightning (since nothing is more transient than the appearance of

a resemblance), the fleeting and changeful character of these paintings merges with their penetration of the real. That which they fix is no more immutable than a cloud. And this is their true and enigmatic substance— it consists of change, like life.

Why do landscape painters live to such advanced old age? asks a philosophical painter. "Because the mist and the clouds offer them nourishment."

Monsieur Dubosc's collection inspires these reflections. It evokes many other thoughts as well. It adds immensely to our knowledge of the East. It deserves a long life. The Musée du Louvre, by acquiring it, has confirmed its merit.

Written in French; first published in *Europe: Revue Mensuelle*, 181 (January 1, 1938). *Gesammelte Schriften*, IV, 601–605. Translated by Timothy J. Attanucci.

Notes

1. Jean-Pierre Dubosc (1904–1988) was a French diplomat and connoisseur of Chinese painting whose collection formed the basis of the October 1937 exhibition at the Bibliothèque Nationale in Paris.
2. Osvald Sirén (1879–1966) was a prominent Swedish art historian who specialized at the outset of his career in the painting of the early Italian Renaissance and later became an internationally renowned expert on Chinese art. Benjamin refers here to Sirén's catalogue *An Exhibition of Chinese Paintings in the National Museum, Stockholm, April–May 1936*, National Museum exhibition catalogue no. 54 (Stockholm: Nordisk Rotogravyr, 1936).
3. Arthur Waley (Arthur David Schloss, 1889–1966) was a distinguished British sinologist. He acquired his knowledge of Chinese painting while serving as Assistant Keeper of Oriental Prints and Manuscripts at the British Museum beginning in 1913; he was later a lecturer at the School of Oriental and African Studies, London. He is best known for his translations of Chinese and Japanese poetry. Benjamin presumably refers here to *An Introduction to the Study of Chinese Painting* (New York: Scribner's, 1923).
4. Georges Salles (1889–1966) was curator of Asian art at the Musée du Louvre, where in April 1937 he organized an exhibition of ancient Chinese art that Benjamin probably visited; see the exhibition catalogue *Arts de la Chine ancienne*, intro. Georges Salles (Paris: Musée de l'Orangerie, 1937). From 1941 to 1945 he was director of the Musée Guimet, and from 1945 to 1957 he was director of the Musées de France. Salles's work was important to Benjamin in the late 1930s. See Benjamin's review of *Le Regard: La Collection—le musée—la fouille—une journée—l'école* (Paris: Plon, 1939), which appeared in the *Gazette des Amis des Livres* in May 1940. Benjamin, *Gesammelte Schriften*, III, pp. 589–595.

5. The French poet Stéphane Mallarmé (1842–1898) was a central figure in the Symbolist movement.

6. Paul Valéry (1871–1945), French poet and essayist, is best known for essayistic fictions such as *La Soirée avec Monsieur Teste* (1896) and major poems of the Symbolist and post-Symbolist period.

7. Lin Yutang (1895–1976), a prolific Chinese poet, novelist, historian, and cultural critic, was educated in China, the United States, and Germany. His interpretations of Chinese culture and customs for a Western audience were widely read and enormously influential. Benjamin may be quoting here from the French translation of *My Country and My People* (New York: Reynal & Hitchcock, 1935).

IV

PHOTOGRAPHY

Benjamin's initial engagement with photography took place in 1922, during a period of intensive work on the great French poet Charles Baudelaire. In two short texts written in preparation for a public address on the poet, Benjamin presents Baudelaire as a privileged reader of a special body of photographic work: photographic plates upon which time itself has precipitated the "essence of things." These plates are negatives, and, while "no one can deduce from the negative . . . the true essence of things as they really are," Benjamin nonetheless attributes to Baudelaire not the ability to develop such a negative, but rather a "presentiment of its real picture." In these earliest evocations of photographic images, then, Benjamin stresses the capacity of the photograph to grant access to a deep stratum that is unavailable to unaided vision.

This notion is in fact at the center of his first published statements on photography, the little essay "News about Flowers," a review of Karl Blossfeldt's book *Urformen der Kunst* (Originary Forms of Art; 1928). Blossfeldt, an instructor at the Berlin College of Art, was convinced that his students could best learn to draw by imitating forms that recur in the natural world. Over the course of several years, he set plant parts—twig ends, seed pods, tendrils, leaf buds, and so on—against starkly neutral backgrounds and photographed them with extreme magnification.

What for Blossfeldt was evidence of nature's status as the master teacher was for Benjamin the portal into a hitherto unanticipated aspect of reality: "a geyser of new image-worlds hisses up at points in our existence where we would least have thought them possible." The metaphorical reference to a geyser-like eruption of images triggered by the viewing

of photographs inevitably entails the sense that they are produced, at least in part, in the unconscious. What, though, is the nature of these "image-worlds"? Benjamin stresses that they are not solely subjective phenomena: he refers to them as "image imperatives," implying that some part of their character is objective and inherent in the photographic image itself. The images that spring out of *us* are inevitably subjective, but our perception of them is conditioned by something objective, grounded as it is within the encounter with a specific photograph.

This early interest in the individual's encounter with the photograph gives way, in the magisterial "Little History of Photography," to broader concerns. This essay, for all its brevity, is one of the earliest histories of the medium.[1] Benjamin's history sets itself apart as the first important social history of photography; consonant with his more general practice, Benjamin here forcibly breaks the photograph out of the context provided by an examination of the photographer and his or her style, and examines its embeddedness within economic, social, technological, and political practices. It is precisely new ideas about the technology of the photograph, in fact, that allow Benjamin to build here upon his earlier, apodictic claim that the photograph harbors image-worlds. In the "Little History," the image-world emerges as a place in every photograph which encodes not just the specific character of a past moment (the "suchness" of that moment), but also "the future." If the "Little History" provides little information as to the nature and significance of this revealed "future," the essay "The Work of Art in the Age of Its Technological Reproducibility" might be said to center on this problem of the artwork's encoding of the relationship between two apparently unrelated historical moments.[2]

In attempting to elucidate the manner in which these image-worlds might play a role in the transformation of human sensory and cognitive capacities, Benjamin in this essay introduces two of his most frequently cited—if least understood—concepts. First, and most generally, Benjamin links the emergence of a photograph's image-world to the way in which photographs—like film and other photo-based media—make possible for us the experience of the "optical unconscious." With this term, Benjamin points toward the capacity of the camera to fix within the photographic emulsion an image of a nature—the material world before the lens, and especially the spatial and temporal relationships among its elements—which is different from the one that "speaks . . . to the eye." To put this another way, in the optical unconscious the world presents itself to the photographic apparatus in an aspect different from any it could ever

present to the unaided human senses. Benjamin's primary example here, the photographic "freezing" of one instant in which a human is caught in mid-stride, refers silently to the famous series of motion studies by the photographer Eadward Muybridge (1830–1904) in which the camera reveals the orientation of the body as it moves through space over time.

But the optical unconscious clearly entails much more than the revelation of physical and temporal aspects of nature through the use of specific photographic techniques such as stop-motion photography or the enlargement practiced by Blossfeldt. In the "Little History," Benjamin claims that it is the optical unconscious alone, as it operates within a wide range of photographs, that can mark the "difference between technology and magic visible as a thoroughly historical variable." Benjamin's use of the term "magic" here points to the embeddedness of these arguments within his general thinking about the problem of commodity fetishism. Marx, in *Capital,* had attributed to the commodity—an apparently "easily understood, trivial thing"—"sensuous, yet extrasensory [*sinnlich übersinnlich*] properties. Commodities appear to be "granted a life of their own, they become independent entities which stand in relationship to one another and to men."³ Commodities act precisely as do fetishes. They are man-made objects that appear to have supernatural or magic powers and as such wield power over humans: commodities have a debilitating effect upon the human perceptual apparatus and intellect. As noted in the general introduction to this volume, Benjamin calls this effect of commodities working in networks "phantasmagoria." And it is precisely to photography that Benjamin first attributes the power to identify phantasmagoria and reveal its effects as magical. The photograph aids, in other words, in the process of the disenchantment of the world as it makes visible the effects of magic—unreason—upon human nature and human social interaction.⁴

If Benjamin implies that all photographs potentially provide access to the optical unconscious, the second key term around which the essay is organized—"aura"—is itself a thoroughly "historical variable." The aura emerges as the sign of the convergence of two things: the historical conditions of possibility of a certain kind of photograph, and the self-consciousness of a certain class, the bourgeoisie, at a particular moment of its development.⁵ The long exposure times required for early portrait photography led to the development of a series of artificial aids—invisible props that held the sitter motionless, remote or unusual sites such as the cemetery where neither man nor beast would enter the frame, and so on—which ensured that the images were "built to last," and indeed that

every detail of the sitters and their clothing were imbued with an unmistakable "permanence." But Benjamin makes clear in the "Little History" that this permanence, as well as other class attributes such as the ability to generate an "animated conviviality," were also objective attributes of the class, and not merely photographic artifacts. "These pictures were made in rooms where every client was confronted, in the person of the photographer, with a technician of the latest school; whereas the photographer was confronted, in the person of every client, with a member of a rising class equipped with an aura that had seeped into the very folds of the man's frock coat or floppy cravat."

The aura, in other words, is at one and the same time the "breathy halo" so evident in many daguerreotypes and early salt prints *and* an objective attribute of a class that developed at a particular historical moment. As Benjamin puts it, "in this early period subject and technique were as exactly congruent as they became incongruent in the period of decline that immediately followed."

That "period of decline" was the period of modernist photography; the incongruence contrasts the ongoing decline of human history into barbarism with the increasing ability of modernist photographers to use photographic technique for social and political ends. If the first part of the essay is given over to an examination of photography as the *representative form* of the bourgeoisie in the mid-nineteenth century, the latter half attempts to provide examples of photographic practices that are turned back against the hegemonic class. Two modern photographers are here made to occupy exemplary positions: Eugène Atget emerges as the liberator of the world of things from thrall in which they are held by aura, and August Sander wrenches the representation of the human countenance free from the musty conventions of bourgeois portraiture.

Atget's 4,000 images of Paris and its surroundings capture not its beauty or picturesqueness, but its empty spaces and discarded objects. His dispassionate survey of a terrain substitutes for the "exotic, romantically sonorous" texture of early photography a "salutary estrangement between man and his surroundings." Benjamin's Atget steps forth from his images as a kind of photographic Brecht, able to shake the observer free from the participatory reverie suggested by earlier photographs, and to create, by defamiliarizing the most familiar things, a neutral space for the development of critical capacities.

August Sander's photographic practice in some ways parallels that of Atget. He had produced, by the early 1930s, thousands of images of Germans from every social group and employment type. The great taxonomy

of German society that Sander hoped to produce bore the working title *Menschen des 20. Jahrhunderts* (Citizens of the Twentieth Century). In these remarkable images, Sander draws upon the appeal of the human face in all its singularity in order to achieve something seemingly very different: a characterization of that face's representativeness. Benjamin saw in Sander's typological approach a powerful political tool. His images were a "training manual" that could provide political operatives with vital information on a citizen's "provenance" during "sudden shifts of power." Photography, in other words, marks the site of a shift toward a politics genuinely attuned to collective concerns and collective power.

The final pages of the "Little History" deal, surprisingly, with the issue of art as photography and photography as art. Freed from political and social interest, photography becomes "creative" and serves only to confirm things as they are. The concluding section begins with a glancing attack on "creative" photography—a critique that is developed at greater length in other essays included in this volume: the specific polemic against Albert Renger-Patzsch, a proponent of the photography of "New Objectivity," and against his influential photo book *Die Welt ist schön* is taken up again in "The Author as Producer"; and the problem of "art photography" stands at the center of the essay "Letter from Paris (2): Painting and Photography." In the "Letter from Paris," Benjamin shows, for the first time anywhere, that "photography's claim to be art was contemporaneous with its emergence as a commodity." Photography's ability to represent commodities, and to reproduce and disseminate such representations, ensured that certain goods were placed into circulation "which had more or less escaped it up to then." Just as photography holds the potential to open the optical unconscious to the viewer and in so doing open the door to a reform of perception that might lead to social change, so too does it hold the potential to make "segments of the field of optical perception into saleable commodities."

In the "Little History" *and* in the "Letter from Paris," Benjamin concludes his consideration of photography by opening a tantalizing vantage point toward what he sees as its future. He puts the problem confronting the medium succinctly. The images produced by the camera have a "shock effect" that "paralyzes the associative mechanisms in the beholder." Benjamin here derives a set of claims from what is most often ascribed to photography as its sole capacity: the ability to capture things "as they are" and in so doing to replicate the apparently fixed, immutable quality of the world in a fixed and immutable sensory apparatus in the beholder. How, though, are we to see the world "otherwise"? That is,

not as phantasmagoria, but in ways that might be liberating? For Benjamin, this hidden capacity of photography is related to the power of association. Benjamin's contemporary, the great Austrian novelist Robert Musil, in his book *The Man without Qualities,* made a distinction between "reality-sense" and "possibility-sense."

> Whoever has [possibility-sense] does not say, for instance: Here this or that has happened, will happen, must happen; but he invents: Here this or that might, could, or ought to happen. If he is told that something is the way it is, he will think: Well, it could probably just as well be otherwise. So the sense of possibility could be defined outright as the ability to conceive of everything there might be just as well, and to attach no more importance to what is than to what is not.[6]

Musil's possibilist is content to inhabit "a more delicate medium, a hazy medium of mist, fantasy, daydreams, and the subjunctive mood." The "associative mechanisms" Benjamin evokes, in contrast, lead to political agency. But Benjamin would explore the implications of photography's associative capacities, and the politics that proceed from them, only much later, in the essay "The Work of Art in the Age of Its Technological Reproducibility."

<div align="right">MICHAEL W. JENNINGS</div>

Notes

1. Josef Maria Eder had published a technical history of photography, based on extensive research into photochemistry, as early as 1905; but the end of the 1920s and the early 1930s saw the first real surge of interest in the history of the medium. Georges Potonnié's *Histoire de la découverte de la photographie* (History of the Discovery of Photography; 1925) and Wilhelm Dost's *Vorläufer der Photographie* (Precursors of Photography; 1932) investigated the early history of the medium; and Beaumont Newhall's *History of Photography,* the first comprehensive history of the medium, appeared a few years later, in 1937. For a comprehensive survey of photographic histories, see Douglas R. Nickel, "History of Photography: The State of Research," *Art Bulletin,* 83, no. 3 (September 2001): 548–558.
2. On the capacity of the artwork to make history present, see the general introduction to this volume.
3. Karl Marx, "The Fetishism of Commodities and the Secret Thereof," excerpt from *Capital,* in *The Marx-Engels Reader,* ed. Robert C. Tucker (New York: Norton, 1972), pp. 215–216.

4. On Benjamin's commitment to disenchantment, see the general introduction to this volume and especially Jürgen Habermas' seminal early article "Consciousness-Raising or Rescuing Critique," in Gary Smith, ed., *On Walter Benjamin: Critical Essays and Recollections* (Cambridge, Mass.: MIT Press, 1988), pp. 90–128.

5. For a discussion of Benjamin's use of the term "aura" within a more general theory of the work of art, see the introduction to Part I in this volume.

6. Robert Musil, *The Man without Qualities,* trans. Sophie Wilkins (New York: Vintage International, 1996), p. 11.

27

News about Flowers

Karl Blossfeldt, *Urformen der Kunst: Photographische Pflanzenbilder* [Originary Forms of Art: Photographic Images of Plants], edited and with an introduction by Karl Nierendorf (Berlin: Ernst Wasmuth, 1928), 120 pages.

Criticism is a sociable art.[1] A healthy reader mocks the reviewer's judgment. But what pleases that reader most deeply is the delicious bad taste of taking part uninvited when someone else reads. Opening a book so that it beckons like a table already set, a table at which we are about to take our place with all of our insights, questions, convictions, quirks, prejudices, and thoughts, so that the couple of hundred readers (are there that many?) in this society disappear and just for that reason allow us to enjoy life—this is criticism. Or at least the only form of criticism that gives a reader an appetite for a book.

If we can agree on this, then the table is set with the one hundred twenty plates in this book, inviting countless observations from countless observers. Yes, we really wish this rich book (poor only in words) that many friends. The silence of the scholar who presents these images must really be honored; perhaps his knowledge is of the kind that makes the one who possesses it mute. And here, doing is more important than knowing. The person who created this collection of plant photos can eat more than bread. He has done more than his share of that great stocktaking of the inventory of human perception that will alter our image of the world in as yet unforeseen ways. He has proven how right the pioneer of the new light-image, Moholy-Nagy, was when he said: "The limits of photography cannot be determined. Everything is so new here that even the search leads to creative results. Technology is, of course, the

271

pathbreaker here. It is not the person ignorant of writing but the one ignorant of photography who will be the illiterate of the future."[2] Whether we accelerate the growth of a plant through time-lapse photography or show its form in forty-fold enlargement, in either case a geyser of new image-worlds hisses up at points in our existence where we would least have thought them possible.

These photographs reveal an entire, unsuspected horde of analogies and forms in the existence of plants. Only the photograph is capable of this. For a bracing enlargement is necessary before these forms can shed the veil that our stolidity throws over them. What is to be said of an observer to whom these forms already send out signals from their veiled state? Nothing can better portray the truly new objectivity of his procedure than the comparison with that highly personal but ever so brilliant procedure by means of which the equally revered and misunderstood Grandville, in his *Fleurs animées,* made the entire cosmos emanate from the world of plants.[3] Grandville took hold of the procedure—God knows, not gently—from the opposite end. He stamped the punitive mark of creatureliness, the human visage, directly onto the blossom of these pure children of nature. This great pioneer in the field of the advertisement mastered one of its fundamental principles, graphic sadism, as hardly any other of its adepts has done. Isn't it odd now to find here another principle of advertisement, the enlargement of the plant world into gigantic proportions, gently healing the wounds opened by caricature?

Originary Forms of Art—certainly. What can this mean, though, but originary forms of nature? Forms, that is, which were never a mere model for art but which were, from the beginning, at work as originary forms in all that was created. Moreover, it must be food for thought in even the most sober observer that the enlargement of what is large—the plant, or its buds, or the leaf, for example—leads us into a wholly different realm of forms than does the enlargement of what is small—the plant cell under the microscope, say. And if we have to tell ourselves that new painters like Klee and even more Kandinsky have long been at work establishing friendly relations between us and the realms into which the microscope would like to seduce us—crudely and by force—we instead encounter in these enlarged plants vegetal "Forms of Style."[4] One senses a gothic *parti pris* in the bishop's staff which an ostrich fern represents, in the larkspur, and in the blossom of the saxifrage, which also does honor to its name in cathedrals as a rose window which breaks through the wall. The oldest forms of columns pop up in horsetails; totem poles appear in chestnut and maple shoots enlarged ten times; and the shoots of a monk's-hood unfold like the body of a gifted dancer. Leaping to-

ward us from every calyx and every leaf are inner image-imperatives [*Bildnotwendigkeiten*], which have the last word in all phases and stages of things conceived as metamorphoses. This touches on one of the deepest, most unfathomable forms of the creative, on the variant that was always, above all others, the form of genius, of the creative collective, and of nature. This is the fruitful, dialectical opposite of invention: the *Natura non facit saltus* of the ancients.[5] One might, with a bold supposition, name it the feminine and vegetable principle of life. The variant is submission and agreement, that which is flexible and that which has no end, the clever and the omnipresent.

We, the observers, wander amid these giant plants like Lilliputians. It is left, though, to fraternal great spirits—sun-soaked eyes, like those of Goethe and Herder—to suck the last sweetness from these calyxes.

Published in *Die literarische Welt*, November 1928. *Gesammelte Schriften*, III, 151–153. Translated by Michael W. Jennings.

Notes

1. Karl Blossfeldt (1865–1932) was a German photographer and art teacher whose entire photographic output was devoted to the representation of plant parts: twig ends, seed pods, tendrils, leaf buds, and so on. These he meticulously arranged against stark backgrounds and photographed with magnification, so that unfamiliar shapes from the organic world were revealed as startling, elegant architectural forms. Blossfeldt originally produced his work as a study aid for his students at the Berlin College of Art; he believed that the best human art was modeled on forms preexisting in nature.

2. Benjamin refers to the Hungarian photographer and painter László Moholy-Nagy (1895–1946).

3. Grandville is the pseudonym of Jean-Ignace-Isidore Gérard (1803–1847), a caricaturist and illustrator whose work appeared in the periodicals *Le Charivari* and *La Caricature*; his book *Les Fleurs animées* was published in 1847.

4. Benjamin is referring to *Stilfragen: Grundlegungen zu einer Geschichte der Ornamentik* (Questions of Style: Toward a History of Ornament; 1893), a work by the Austrian art historian Alois Riegl (1858–1905). It traces the influence of natural forms such as the acanthus through a series of stylistic periods in the ancient world.

5. *Natura non facit saltus*: Latin for "nature does not make a leap." In rationalist philosophy, the phrase expresses the notion that God leaves no gaps in nature.

28

1931.

Little History of Photography

The fog that surrounds the beginnings of photography is not quite as thick as that which shrouds the early days of printing; more obviously than in the case of the printing press, perhaps, the time was ripe for the invention, and was sensed by more than one—by men who strove independently for the same objective: to capture the images in the camera obscura, which had been known at least since Leonardo's time. When, after about five years of effort, both Niépce and Daguerre simultaneously succeeded in doing this, the state, aided by the patenting difficulties encountered by the inventors, assumed control of the enterprise and made it public, with compensation to the pioneers.[1] This paved the way for a rapid ongoing development which long precluded any backward glance. Thus it is that the historical or, if you like, philosophical questions suggested by the rise and fall of photography have gone unheeded for decades. And if they are beginning to enter into consciousness today, there is a definite reason for it. The latest writings on the subject point up the fact that the flowering of photography—the work of Hill and Cameron, Hugo and Nadar—came in its first decade.[2] But this was the decade which preceded its industrialization. Not that hucksters and charlatans did not appropriate the new techniques for gain, even in that early period; indeed, they did so en masse. But that was closer to the arts of the fairground, where photography is at home to this day, than to industry. Industry made its first real inroads with the visiting-card picture, whose first manufacturer, significantly, became a millionaire. It would not be surprising if the photographic methods which today, for the first time, are harking back to the preindustrial heyday of photography had an under-

ground connection with the crisis of capitalist industry. But that does not make it any easier to use the charm of old photographs, available in fine recent publications,[3] for real insights into their nature. Attempts at theoretical mastery of the subject have so far been entirely rudimentary. And no matter how extensively it may have been debated in the last century, basically the discussion never got away from the ludicrous stereotype which a chauvinistic rag, the *Leipziger Stadtanzeiger*, felt it had to offer in timely opposition to this black art from France. "To try to capture fleeting mirror images," it said, "is not just an impossible undertaking, as has been established after thorough German investigation; the very wish to do such a thing is blasphemous. Man is made in the image of God, and God's image cannot be captured by any machine of human devising. The utmost the artist may venture, borne on the wings of divine inspiration, is to reproduce man's God-given features without the help of any machine, in the moment of highest dedication, at the higher bidding of his genius." Here we have the philistine notion of "art" in all its overweening obtuseness, a stranger to all technical considerations, which feels that its end is nigh with the alarming appearance of the new technology. Nevertheless, it was this fetishistic and fundamentally antitechnological concept of art with which the theoreticians of photography sought to grapple for almost a hundred years, naturally without the smallest success. For they undertook nothing less than to legitimize the photographer before the very tribunal he was in the process of overturning. Far different is the tone of the address which the physicist Arago, speaking on behalf of Daguerre's invention, gave in the Chamber of Deputies on July 3, 1839.[4] The beautiful thing about this speech is the connections it makes with all aspects of human activity. The panorama it sketches is broad enough not only to make the dubious project of authenticating photography in terms of painting—which it does anyway—seem beside the point; more important, it offers an insight into the real scope of the invention. "When inventors of a new instrument," says Arago, "apply it to the observation of nature, what they expect of it always turns out to be a trifle compared with the succession of subsequent discoveries of which the instrument was the origin." In a great arc Arago's speech spans the field of new technologies, from astrophysics to philology: alongside the prospects for photographing the stars and planets we find the idea of establishing a photographic record of the Egyptian hieroglyphs.

Daguerre's photographs were iodized silver plates exposed in the camera obscura, which had to be turned this way and that until, in the proper light, a pale gray image could be discerned. They were one of a

kind; in 1839 a plate cost an average of 25 gold francs. They were not infrequently kept in a case, like jewelry. In the hands of many a painter, though, they became a technical adjunct. Just as seventy years later Utrillo[5] painted his fascinating views of Paris not from life but from picture postcards, so the highly regarded English portrait painter David Octavius Hill based his fresco of the first general synod of the Church of Scotland in 1843 on a long series of portrait photographs. But these pictures he took himself. And it is they, unpretentious makeshifts meant for internal use, that gave his name a place in history, while as a painter he is forgotten. Admittedly a number of his studies lead even deeper into the new technology than this series of portraits—anonymous images, not posed subjects. Such figures had long been the subjects of painting. Where the painting remained in the possession of a particular family, now and then someone would ask about the person portrayed. But after two or three generations this interest fades; the pictures, if they last, do so only as testimony to the art of the painter. With photography, however, we encounter something new and strange: in Hill's Newhaven fishwife, her eyes cast down in such indolent, seductive modesty, there remains something that goes beyond testimony to the photographer's art, something that cannot be silenced, that fills you with an unruly desire to know what her name was, the woman who was alive there, who even now is still real and will never consent to be wholly absorbed in "art."

> And I ask: How did the beauty of that hair,
> those eyes, beguile our forebears?
> How did that mouth kiss, to which desire
> curls up senseless as smoke without fire?[6]

Or one turns up the picture of Dauthendey the photographer, the father of the poet, from the time of his engagement—to the woman he later discovered, on a day shortly after the birth of her sixth child, lying in the bedroom of their Moscow house with her veins slashed. Here she can be seen with him. He seems to be holding her, but her gaze passes him by, absorbed in an ominous distance. Immersed long enough in such a picture, one recognizes to what extent opposites touch, here too: the most precise technology can give its products a magical value, such as a painted picture can never again possess for us. No matter how artful the photographer, no matter how carefully posed his subject, the beholder feels an irresistible compulsion to search such a picture for the tiny spark of contingency, the here and now, with which reality has, so to speak, seared through the image-character of the photograph, to find the incon-

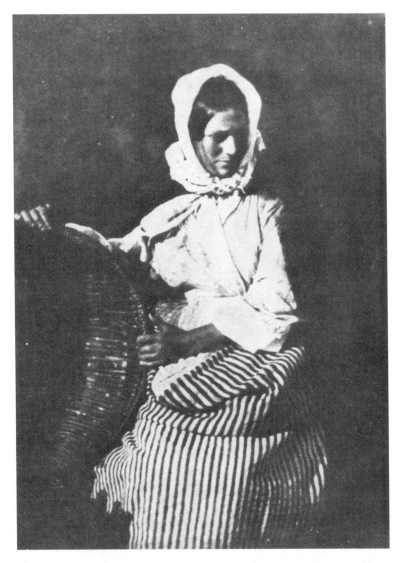

Newhaven Fishwife. Photo by David Octavius Hill.

spicuous place where, within the suchness [*Sosein*] of that long-past min-
ute, the future nests still today—and so eloquently that we, looking back,
may rediscover it. For it is another nature that speaks to the camera
rather than to the eye; "other" above all in the sense that a space in-
formed by human consciousness gives way to one informed by the un-

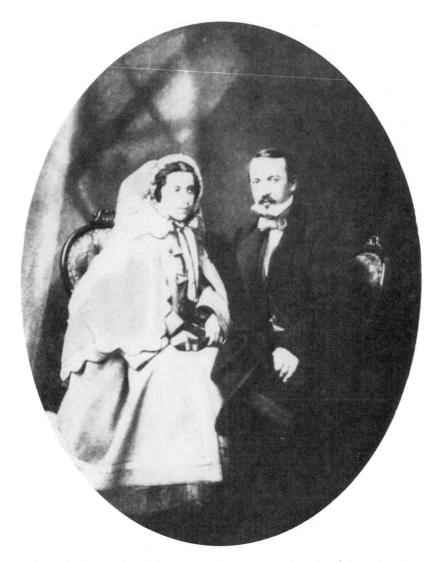

Karl Dauthendey (Father of the Poet), with His Fiancée. Photo by Karl Dauthendey.

conscious. While it is common that, for example, an individual is able
to offer an account of the human gait (if only in general terms), that same
individual has no knowledge at all of human posture during the frac-
tion of a second when a person begins to take a step. Photography, with
its devices of slow motion and enlargement, reveals this posture to him.
He first learns of this optical unconscious through photography, just

as he learns of the instinctual unconscious through psychoanalysis. Details of structure, cellular tissue, with which technology and medicine are normally concerned—all this is, in its origins, more closely related to the camera than is the emotionally evocative landscape or the soulful portrait. Yet at the same time, photography reveals in this material physiognomic aspects, image worlds, which dwell in the smallest things—meaningful yet covert enough to find a hiding place in waking dreams, but which, enlarged and available for formulation, make the difference between technology and magic visible as a thoroughly historical variable. Thus, Blossfeldt with his astonishing plant photographs[7] reveals the forms of ancient columns in horse willow, a bishop's crosier in the ostrich fern, totem poles in tenfold enlargements of chestnut and maple shoots, and gothic tracery in the fuller's thistle. Hill's subjects, too, were probably not far from the truth when they described "the phenomenon of photography" as still being "a great and mysterious experience"— even if, for them, this was no more than the consciousness of "standing before an apparatus which in the briefest time could produce a picture of the visible environment whose effects were as lively and realistic as those of nature itself." It has been said of Hill's camera that it kept a discreet distance. But his subjects, for their part, are no less reserved; they maintain a certain shyness before the camera, and the watchword of a later photographer from the heyday of the art, "Don't look at the camera," could be derived from their attitude. But that did not mean the "They're looking at you" of animals, people, and babies, which so distastefully implicates the buyer and to which there is no better counter than the way old Dauthendey talks about daguerreotypes: "We didn't trust ourselves at first," he reported, "to look long at the first pictures we developed. We were abashed by the distinctness of those human images, and believed that the little tiny faces in the picture could look back at us, so baffling were the effects on everyone of the unusual clarity and the unusual fidelity to nature of the first daguerreotypes."

The first reproduced human beings entered the viewing space of photography [Blickraum der Photographie] with integrity—or rather, without inscription. Newspapers were still a luxury item which people seldom bought, looking at them more often in the coffeehouse; the photographic process had not yet become the tool of the newspaper, and very few human beings had hitherto seen their names in print. The human countenance had a silence about it in which the gaze rested. In short, all the potentialities of this art of portraiture rest on the fact that contact between actuality and photo had not yet been established. Many of Hill's portraits

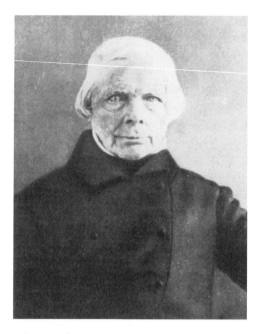

The Philosopher Schelling, ca. 1850. Photographer (German) unknown.

were made in the Edinburgh Greyfriars cemetery—and nothing is more characteristic of this early period, except perhaps the way his subjects were at home there. And indeed the cemetery itself, in one of Hill's pictures, looks like an interior, a separate closed-off space where the gravestones propped against gable walls rise up from the grass, hollowed out like chimneypieces, with inscriptions inside instead of flames. But this setting could never have been so effective if it had not been chosen on technical grounds. The low light-sensitivity of the early plates made prolonged exposure outdoors a necessity. This in turn made it desirable to take the subject to some out-of-the-way spot where there was no obstacle to quiet concentration. "The synthetic character of the expression which was dictated by the length of time the subject had to remain still," says Orlik of early photography, "is the main reason these photographs, apart from their simplicity, resemble well-drawn or well-painted pictures and produce a more vivid and lasting impression on the beholder than more recent photographs."[8] The procedure itself caused the subjects to live their way into, rather than out of, the moment; during the long duration of the exposure, they grew into the picture, in the sharpest contrast with appearances in a snapshot—which correspond to that altered environ-

ment where, as Kracauer has aptly noted, the split second of the exposure determines "whether an athlete becomes so famous that photographers start taking his picture for the illustrated papers." Everything about these early pictures was built to last. Not only the incomparable groups in which people came together—and whose disappearance was surely one of the most precise symptoms of what was happening in society in the second half of the century—but the very creases in people's clothes held their shape longer. Just consider Schelling's coat. It will surely pass into immortality along with him: the contours it has borrowed from its wearer are not unworthy of the creases in his face. In short, everything suggests that Bernard von Brentano was right in his view that "a photographer of 1850 was on a par with his instrument"—for the first time, and for a long while the last.[9]

To appreciate the powerful impact made by the daguerreotype in the age of its discovery, one should also bear in mind that *plein air* painting was then opening up entirely new perspectives for the most advanced painters. Conscious that in this very area photography had to take the baton from painting, even Arago, in his historical review of the early attempts of Giovanni Battista Della Porta, explicitly commented: "As regards the effect produced by the imperfect transparency of our atmosphere (which has been inaptly termed 'atmospheric perspective'), not even experienced painters expect the camera obscura"—i.e., the copying of images appearing in it—"to help them render it accurately."[10] At the moment when Daguerre succeeded in fixing the images of the camera obscura, painters parted company on this point with technicians. The real victim of photography, however, was not landscape painting but the portrait miniature. Things developed so rapidly that by 1840 most of the innumerable miniaturists had already become professional photographers, at first only as a sideline, but before long exclusively. Here the experience of their original livelihood stood them in good stead, and it is not their artistic background so much as their training as craftsmen that we have to thank for the high level of their photographic achievement. This transitional generation disappeared very gradually; indeed, there seems to have been a kind of biblical blessing on those first photographers: the Nadars, Stelzners, Piersons, Bayards all lived well into their eighties and nineties.[11] In the end, though, businessmen invaded professional photography from every side; and when, later on, the retouched negative, which was the bad painter's revenge on photography, became ubiquitous, a sharp decline in taste set in. This was the time photograph albums came into vogue. They were most at home in the chilliest spots,

on occasional tables or little stands in the drawing room—leatherbound tomes with repellent metal hasps and those gilt-edged pages as thick as your finger, where foolishly draped or corseted figures were displayed: Uncle Alex and Aunt Riekchen, little Trudi when she was still a baby, Papa in his first term at university . . . and finally, to make our shame complete, we ourselves—as a parlor Tyrolean, yodeling, waving our hat before a painted snowscape, or as a smartly turned-out sailor, standing rakishly with our weight on one leg, as is proper, leaning against a polished door jamb. The accessories used in these portraits, the pedestals and balustrades and little oval tables, are still reminiscent of the period when, because of the long exposure time, subjects had to be given supports so that they would remain fixed in place. And if, at first, "head clamps" and "knee braces" were felt to be sufficient, "further impedimenta were soon added, such as could be seen in famous paintings and therefore had to be 'artistic.' First it was columns, or curtains." The most capable started resisting this nonsense as early as the 1860s. As an English trade journal of the time put it, "in painting the column has some plausibility, but the way it is used in photography is absurd, since it usually stands on a carpet. But anyone can see that columns of marble or stone are not erected on a foundation of carpeting." This was the period of those studios—with their draperies and palm trees, their tapestries and easels—which occupied so ambiguous a place between execution and representation, between torture chamber and throne room, and to which an early portrait of Kafka bears pathetic witness. There the boy stands, perhaps six years old, dressed up in a humiliatingly tight child's suit overloaded with trimming, in a sort of greenhouse landscape. The background is thick with palm fronds. And as if to make these upholstered tropics even stuffier and more oppressive, the subject holds in his left hand an inordinately large broad-brimmed hat, such as Spaniards wear. He would surely be lost in this setting were it not for his immensely sad eyes, which master this landscape predestined for them.

This picture, in its infinite sadness, forms a pendant to the early photographs in which people did not yet look out at the world in so castaway and godforsaken a manner as this boy. There was an aura about them, a medium that endowed their gaze with fullness and security even as their gaze penetrated the medium itself. And once again the technical equivalent is obvious: it consists in the absolute continuum from brightest light to darkest shadow. Here, too, we see in operation the law that new advances are prefigured in older techniques, for the earlier art of portrait painting, before its disappearance, had produced the strange flower of

the mezzotint. The mezzotint process was of course a technique of reproduction, which was only later combined with the new photographic reproduction. The way light struggles out of darkness in the work of a Hill is reminiscent of mezzotint: Orlik talks about the "comprehensive illumination" brought about by the long exposure times, which "gives these early photographs their greatness."[12] And among the invention's contemporaries, Delaroche had already noted the "unprecedented and exquisite" general impression, "in which nothing disturbs the tranquillity of the composition."[13] So much for the technical determinedness of the auratic appearance. Many group photos in particular still preserve an air of animated conviviality for a brief time on the plate, before being ruined by the "original print" [Originalaufnahme]. It was this breathy halo that was sometimes captured with delicacy and depth by the now old-fashioned oval frame. That is why it would be a misreading of these incunabula of photography to make too much of their "artistic perfection" or their "taste." These pictures were made in rooms where every client was confronted, in the person of the photographer, with a technician of the latest school; whereas the photographer was confronted, in the person of every client, with a member of a rising class equipped with an aura that had seeped into the very folds of the man's frock coat or floppy cravat. For this aura was by no means the mere product of a primitive camera. Rather, in this early period subject and technique were as exactly congruent as they become incongruent in the period of decline that immediately followed. For soon advances in optics made instruments available that wholly overcame darkness and recorded appearances as faithfully as any mirror. After 1880, though, photographers made it their business to simulate the aura which had been banished from the picture with the suppression of darkness through faster lenses, exactly as it was being banished from reality by the deepening degeneration of the imperialist bourgeoisie. They saw it as their task to simulate this aura using all the arts of retouching, and especially the so-called gum print. Thus, especially in Jugendstil [Art Nouveau], a penumbral tone, interrupted by artificial highlights, came into vogue. Notwithstanding this fashionable twilight, however, a pose was more and more clearly in evidence, whose rigidity betrayed the impotence of that generation in the face of technical progress.

And yet, what is again and again decisive for photography is the photographer's attitude to his techniques. Camille Recht has found an apt metaphor: "The violinist," he says, "must first produce the note, must seek it out, find it in an instant; the pianist strikes the key and the note

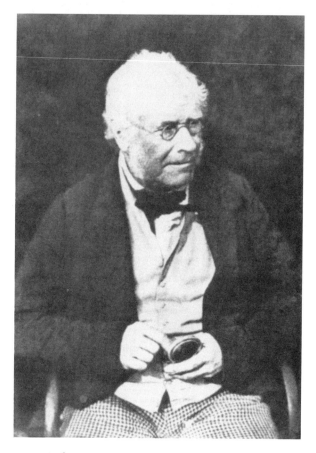

Robert Bryson. Photo by David Octavius Hill.

rings out. The painter and the photographer both have an instrument at their disposal. Drawing and coloring, for the painter, correspond to the violinist's production of sound; the photographer, like the pianist, has the advantage of a mechanical device that is subject to restrictive laws, while the violinist is under no such restraint. No Paderewski will ever reap the fame, ever cast the almost fabulous spell, that Paganini did."[14] There is, however—to continue the metaphor—a Busoni of photography, and that is Atget.[15] Both were virtuosos, but at the same time precursors. The combination of unparalleled absorption in their work and extreme precision is common to both. There was even a facial resemblance. Atget was an actor who, disgusted with the profession, wiped off the mask and then set about removing the makeup from reality too. He lived in Paris poor

aura

and unknown, selling his pictures for a trifle to photographic enthusiasts scarcely less eccentric than himself; he died recently, leaving behind an oeuvre of more than 4,000 pictures. Berenice Abbott from New York has gathered these together, and a selection has just appeared in an exceptionally beautiful volume published by Camille Recht.[16] The contemporary journals "knew nothing of the man, who for the most part hawked his photographs around the studios and sold them for next to nothing, often for the price of one of those picture postcards which, around 1900, showed such pretty town views, bathed in midnight blue, complete with touched-up moon. He reached the Pole of utmost mastery; but with the bitter modesty of a great craftsman who always lives in the shadows, he neglected to plant his flag there. Therefore many are able to flatter themselves that they have discovered the Pole, even though Atget was there before them." Indeed, Atget's Paris photos are the forerunners of Surrealist photography—an advance party of the only really broad column Surrealism managed to set in motion. He was the first to disinfect the stifling atmosphere generated by conventional portrait photography in the age of decline. He cleanses this atmosphere—indeed, he dispels it altogether: he initiates the emancipation of object from aura, which is the most signal achievement of the latest school of photography. When avant-garde periodicals like *Bifur* or *Variété* publish pictures that are captioned "Westminster," "Lille," "Antwerp," or "Breslau" but that show only details, here a piece of balustrade, there a treetop whose bare branches crisscross a gas lamp, or a gable wall, or a lamppost with a life buoy bearing the name of the town—this is nothing but a literary refinement of motifs that Atget discovered. He looked for what was unremarked, forgotten, cast adrift. And thus such pictures, too, work against the exotic, romantically sonorous names of the cities; they suck the aura out of reality like water from a sinking ship.—What is aura, actually? A strange web of space and time: the unique appearance of a distance, no matter how close it may be. While at rest on a summer's noon, to trace a range of mountains on the horizon, or a branch that throws its shadow on the observer, until the moment or the hour becomes part of their appearance—this is what it means to breathe the aura of those mountains, that branch. Now, "to bring things closer" to us, or rather to the masses, is just as passionate an inclination in our day as the overcoming of whatever is unique in every situation by means of its reproduction. Every day the need to possess the object, from the closest proximity, in a picture—or rather a copy—becomes more imperative. And the difference between the copy, which illustrated papers and newsreels keep in readiness, and the original picture

is unmistakable. Uniqueness and duration are as intimately intertwined in the latter as are transience and reproducibility in the former. The peeling away of the object's shell, the destruction of the aura, is the signature of a perception whose sense for all that is the same in the world[17] has grown to the point where even the singular, the unique, is divested of its uniqueness—by means of its reproduction. Atget almost always passed by the "great sights and so-called landmarks." What he did not pass by was a long row of boot lasts; or the Paris courtyards, where from night to morning the handcarts stand in serried ranks; or the tables after people have finished eating and left, the dishes not yet cleared away—as they exist by the hundreds of thousands at the same hour; or the brothel at No. 5, Rue ——, whose street number appears, gigantic, at four different places on the building's façade. Remarkably, however, almost all of these pictures are empty. Empty is the Porte d'Arcueil by the fortifications, empty are the triumphal steps, empty are the courtyards, empty, as it should be, is the Place du Tertre. They are not lonely, merely without mood; the city in these pictures looks cleared out, like a dwelling that has not yet found a new tenant. It is in these achievements that Surrealist photography sets the scene for a salutary estrangement between man and his surroundings. It gives free play to the politically educated eye, under whose gaze all intimacies are sacrificed to the illumination of detail.

It is obvious that this new way of seeing stands to gain least in an area where there has been the greatest self-indulgence: commercial, conventional portrait photography. On the other hand, to do without people is for photography the most impossible of renunciations. And anyone who did not know it was taught by the best Russian films that milieu and landscape, too, reveal themselves most readily to those photographers who succeed in capturing their anonymous physiognomy, as it were presenting them at face value. Whether this is possible, however, depends very much on the subject. The generation that was not obsessed with going down to posterity in photographs, rather shyly drawing back into their private space in the face of such proceedings—the way Schopenhauer withdrew into the depths of his chair in the Frankfurt picture, taken about 1850—for this very reason allowed that space, the space in which they lived, to join them on the plate. That generation did not pass on its virtues. So the Russian feature film was the first opportunity in decades to put before the camera people who had no use for their photographs. And immediately the human face appeared on film with new and immeasurable significance. But it was no longer a portrait. What was it? It is the outstanding service of a German photographer to

have answered this question. August Sander[18] has compiled a series of faces that is in no way inferior to the tremendous physiognomic gallery mounted by an Eisenstein or a Pudovkin, and he has done it from a scientific viewpoint.[19] "His complete work comprises seven groups which correspond to the existing social order, and is to be published in some forty-five folios containing twelve photographs each." So far we have a sample volume containing sixty reproductions, which offer inexhaustible material for study. "Sander starts off with the peasant, the earthbound man, takes the observer through every social stratum and every walk of life up to the highest representatives of civilization, and then goes back down all the way to the idiot." The photographer did not approach this enormous undertaking as a scholar, or with the advice of ethnographers and sociologists, but, as the publisher says, "from direct observation." It was assuredly a very impartial, indeed bold sort of observation, but delicate too, very much in the spirit of Goethe's remark: "There is a delicate empiricism which so intimately involves itself with the object that it becomes true theory." So it was quite in order for an observer like Döblin to have hit on precisely the scientific aspects of this work, commenting: "Just as there is comparative anatomy, which helps us to understand the nature and history of organs, so this photographer is doing comparative photography, adopting a scientific standpoint superior to that of the photographer of detail."[20] It would be a pity if economic considerations should prevent the continuing publication of this extraordinary body of work. Apart from this basic encouragement, there is a more specific incentive one might offer the publisher. Work like Sander's could overnight assume unlooked-for topicality. Sudden shifts of power such as are now overdue in our society can make the ability to read facial types a matter of vital importance. Whether one is of the Left or the Right, one will have to get used to being looked at in terms of one's provenance. And one will have to look at others the same way. Sander's work is more than a picture book. It is a training manual.

"In our age there is no work of art that is looked at so closely as a photograph of oneself, one's closest relatives and friends, one's sweetheart," wrote Lichtwark back in 1907, thereby moving the inquiry out of the realm of aesthetic distinctions into that of social functions.[21] Only from this vantage point can it be carried further. It is indeed significant that the debate has raged most fiercely around the aesthetics of photography-as-art, whereas the far less questionable social fact of art-as-photography was given scarcely a glance. And yet the impact of the photographic reproduction of artworks is of very much greater importance for

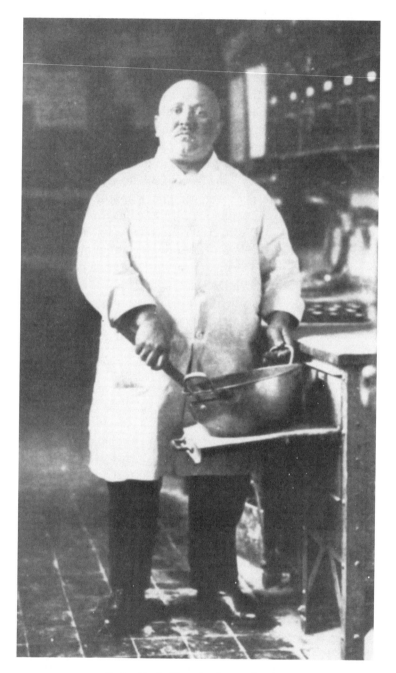

Pastry Cook. Photo by August Sander.

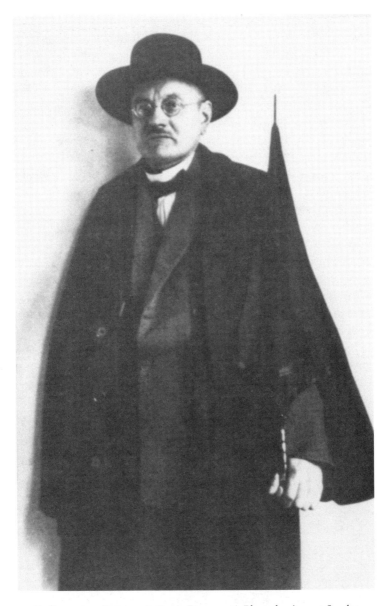

Parliamentary Representative (a Democrat). Photo by August Sander.

the function of art than the greater or lesser artistry of a photography
that regards all experience as fair game for the camera. The amateur who
returns home with great piles of artistic shots is in fact no more appealing
a figure than the hunter who comes back with quantities of game that is

useless to anyone but the merchant. And the day does indeed seem to be at hand when there will be more illustrated magazines than game merchants. So much for the snapshot. But the emphasis changes completely if we turn from photography-as-art to art-as-photography. Everyone will have noticed how much more readily apprehensible a picture, above all a sculpture, and indeed also architecture are in a photo than in reality. It is all too tempting to blame this squarely on the decline of artistic appreciation, on a failure of contemporary sensibility. But one is brought up short by the way the understanding of great works was transformed at about the same time the techniques of reproduction were being developed. Such works can no longer be regarded as the products of individuals; they have become a collective creation, a corpus so vast it can be assimilated only through miniaturization. In the final analysis, methods of mechanical reproduction are a technique of diminution that helps people to achieve a degree of mastery over works of art—mastery without which the works could no longer be put to use.

If one thing typifies present-day relations between art and photography, it is the unresolved tension between the two introduced by the photography of works of art. Many of those who, as photographers, determine the current face of this technology started out as painters. They turned their back on painting after making attempts to bring its means of expression into a living and unequivocal connection with modern life. The keener their feel for the temper of the times, the more problematic their starting point became for them. For once again, as eighty years before, photography has taken the baton from painting. As Moholy-Nagy has said:

> The creative potential of the new is for the most part slowly revealed through old forms, old instruments and areas of design which in their essence have already been superseded by the new, but which under pressure from the new as it takes shape are driven to a euphoric efflorescence. Thus, for example, futurist (static) painting brought forth the clearly defined problematic of the simultaneity of motion, the representation of the instant, which was later to destroy it—and this at a time when film was already known but far from being understood. . . . Similarly, some of the painters (neoclassicists and verists) today using representational-objective methods can be regarded—with caution—as forerunners of a new representational optical form which will soon be making use only of mechanical, technical methods.[22]

And Tristan Tzara, 1922: "When everything that called itself art was stricken with palsy, the photographer switched on his thousand-

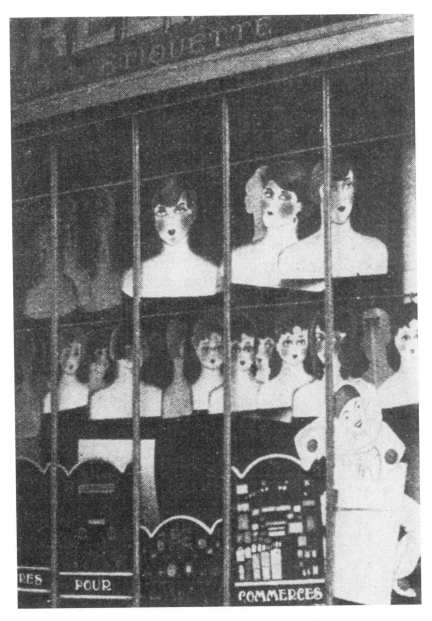

Display Window. Photo by Germaine Krull.

candlepower lamp and gradually the light-sensitive paper absorbed the
darkness of a few everyday objects. He had discovered what could be
done by a pure and sensitive flash of light—a light that was more impor-
tant than all the constellations arranged for the eye's pleasure."[23] The

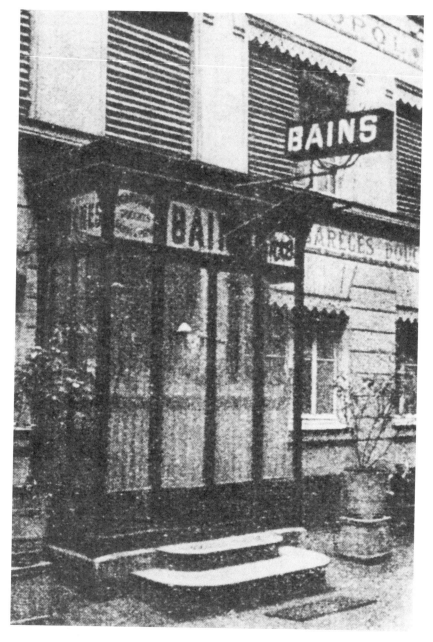

Storefront. Photo by Germaine Krull.

photographers who went over from figurative art to photography not on opportunistic grounds, not by chance, not out of sheer laziness, today constitute the avant-garde among their colleagues, because they are to some extent protected by their background against the greatest danger facing photography today: the touch of the commercial artist. "Photography-as-art," says Sascha Stone, "is a very dangerous field."[24]

When photography takes itself out of context, severing the connections illustrated by Sander, Blossfeldt, or Germaine Krull, when it frees itself from physiognomic, political, and scientific interest, it becomes "creative."[25] The lens now looks for "interesting juxtapositions"; photography turns into a sort of arty journalism. "The spirit, vanquishing mechanics, translates its exact results into parables of life." The more far-reaching the crisis of the present social order, and the more rigidly its individual components are locked together in their death struggle, the more the creative—in its deepest essence a variant (contradiction its father, imitation its mother)—becomes a fetish, whose lineaments live only in the fitful illumination of changing fashion. The creative in photography is its capitulation to fashion. "The world is beautiful"—this, precisely, is its motto.[26] In it is unmasked the posture of a photography that can endow any soup can with cosmic significance but cannot grasp a single one of the human connections in which it exists, even when this photography's most dream-laden subjects are a forerunner more of its salability than of any knowledge it might produce. But because the true face of this kind of photographic creativity is the advertisement or association, its logical counterpart is the act of unmasking or construction. As Brecht says: "The situation is complicated by the fact that less than ever does the mere 'reproduction of reality' say anything about reality. A photograph of the Krupp works or the AEG reveals next to nothing about these institutions.[27] Actual reality has slipped into the functional. The reification of human relations—the factory, say—means that they are no longer explicit. So in fact 'something must be built up,' something 'artificial,' 'posed.'" We must credit the Surrealists with having trained the pioneers of such photographic construction. A further stage in this contest between creative and constructive photography is typified by Russian film. It is not too much to say that the great achievements of Russian directors were possible only in a country where photography sets out not to charm or persuade, but to experiment and instruct. In this sense, and in this only, there is still some meaning in the grandiloquent salute offered to photography in 1855 by that ungainly painter of ideas Antoine Wiertz.[28]

For some years now the glory of our age has been a machine which daily amazes the mind and startles the eye. Before another century is out, this machine will be the brush, the palette, the colors, the craft, the experience, the patience, the dexterity, the sureness of touch, the atmosphere, the luster, the exemplar, the perfection, the very essence of painting. . . . Let no one suppose that daguerreotype photography will be the death of art. . . . When the daguerreotype, that infant prodigy, has grown to its full stature, when all its art and strength have been revealed, then will Genius seize it by the scruff of the neck and shout: "Come with me—you are mine now! We shall work together!"

How sober—indeed, pessimistic—by contrast are the words in which Baudelaire announced the new technology to his readers, two years later, in his *Salon of 1859*. Like the preceding quotation, they can be read to-day only with a subtle shift of emphasis. But as a counterpart to the above, they still make sense as a violent reaction to the encroachments of artistic photography. "In these sorry days, a new industry has arisen that has done not a little to strengthen the asinine belief . . . that art is and can be nothing other than the accurate reflection of nature. . . . A vengeful god has hearkened to the voice of this multitude. Daguerre is his messiah." And: "If photography is permitted to supplement some of art's functions, they will forthwith be usurped and corrupted by it, thanks to photography's natural alliance with the mob. It must therefore revert to its proper duty, which is to serve as the handmaiden of science and the arts."

One thing, however, both Wiertz and Baudelaire failed to grasp: the lessons inherent in the authenticity of the photograph. These cannot be forever circumvented by a commentary whose clichés merely estab-lish verbal associations in the viewer. The camera is getting smaller and smaller, ever readier to capture fleeting and secret images whose shock effect paralyzes the associative mechanisms in the beholder. This is where inscription must come into play, by means of which photography inter-venes as the literarization of all the conditions of life, and without which all photographic construction must remain arrested in the approximate. It is no accident that Atget's photographs have been likened to those of a crime scene. But isn't every square inch of our cities a crime scene? Every passer-by a culprit? Isn't it the task of the photographer—descendant of the augurs and haruspices—to reveal guilt and to point out the guilty in his pictures? "It is not the person ignorant of writing but the one igno-rant of photography," somebody has said, "who will be the illiterate of

the future."[29] But mustn't the photographer who is unable to read his own pictures be no less deemed an illiterate? Isn't inscription bound to become the most essential component of the photograph? These are the questions in which the span of ninety years that separates contemporary photography from the daguerreotype discharges its historical tension. It is in the illumination of these sparks that the first photographs emerge, beautiful and unapproachable, from the darkness of our grandfathers' day.

Published in *Die literarische Welt*, September–October 1931. *Gesammelte Schriften*, II, 368–385. Translated by Edmund Jephcott and Kingsley Shorter.

Notes

1. Joseph Nicéphore Niépce (1765–1833), French inventor, succeeded in making the first permanent photographic image. In 1826–1827, he used a camera to produce a view from his studio that was captured on a pewter plate. His death cut off his collaboration with the French painter and inventor Louis Jacques Mandé Daguerre (1787–1851), who, continuing Niépce's line of experimentation, found a way to reduce the exposure time from Niépce's eight hours to twenty minutes. Daguerre sold the rights to his invention, the daguerreotype—the first practical photographic process—to the French government in 1839.

2. David Octavius Hill (1802–1870), Scottish painter and photographer, collaborated with the chemist Robert Adamson on a series of remarkable portraits. Julia Margaret Cameron (1815–1879), English photographer, was, unlike many of the most important early photographers, an amateur. She is considered one of the greatest portrait photographers of the nineteenth century. The French Romantic writer Victor Hugo (1802–1885) and his entire family were enthusiastic amateur photographers and produced a sizable body of work. Nadar (Gaspard-Félix Tournachon; 1820–1910), French writer, caricaturist, and photographer, emerged from a large group of Parisian studio portraitists as one of the great portraitists of the century. Among his many innovations are his natural posing of his subjects, a patent on the use of photographs in mapmaking and surveying, the first aerial photograph (from a balloon), and the first photographic interview: twenty-one images of the scientist Eugène Chevreul, accompanied by text.

3. Helmut Bossert and Heinrich Guttmann, *Aus der Frühzeit der Photographie, 1840–1870: Ein Bildbuch nach 200 Originalen* (Frankfurt: Societäts Verlag, 1930). Heinrich Schwarz, *David Octavius Hill: Der Meister der Photographie* (Leipzig: Insel, 1931), with 80 plates. [Benjamin's note]

4. Dominique François Jean Arago (1786–1853), French physicist and politi-

cian, was active in the study of light. He devised an experiment that proved the wave theory of light and contributed to the discovery of the laws of light polarization.

5. Maurice Utrillo (1883–1955), French painter, was known for his Montmartre street scenes.

6. Stefan George, *Der Teppich des Lebens und die Lieder von Traum und Tod* (The Carpet of Life and the Songs of Dream and Death), "Standbilder, das Sechste," verses 13–16.

7. Karl Blossfeldt, *Urformen der Kunst: Photographische Pflanzenbilder,* edited and with an introduction by Karl Nierendorf (Berlin: Ernst Wasmuth, 1928), with 120 plates. [Benjamin's note. Blossfeldt (1865–1932), a professor of drawing and painting in Berlin, created a sensation in the 1920s with the publication of his magnified photos of plant parts; see "News about Flowers" (1928), in this volume.—*Trans.*]

8. Emil Orlik, *Kleine Aufsätze* (Berlin: Propyläen Verlag, 1924), pp. 38ff. Orlik (1870–1932) was a German graphic artist and painter whose work was influenced by Jugendstil (Art Nouveau).

9. Bernard von Brentano (1901–1964), leftist novelist and journalist, wrote for the *Frankfurter Zeitung* and the *Berliner Tageblatt.* He is perhaps best known for the historical novel *Theodor Chindler,* which depicts the transition from the empire to the Weimar Republic.

10. Giovanni Battista (Giambattista) Della Porta (1535–1615) was an Italian physicist and dramatist whose works contain descriptions of the camera obscura, as well as of a special lens he developed for it.

11. Carl Ferdinand Stelzner (ca. 1805–1895) was a German painter and photographer who, like many miniaturist painters, turned to daguerreotypy; together with Hermann Biow, he shot some of the earliest news photographs. Pierre-Louis Pierson (1822–1913) was a prominent French studio portraitist; his firm, Mayer and Pierson, catered to high society and the court. In 1862 Pierson and his partners, the brothers Léopold Ernest Mayer and Louis Frédéric Mayer, were named official photographers to Napoleon III. Hippolyte Bayard (1801–1887), French photographer, was active as an inventor in the earliest days of photography. He is widely regarded as one of photography's first significant artists, and held the first known photographic exhibition, displaying thirty of his own works.

12. Orlik, *Kleine Aufsätze,* p. 38.

13. Paul Delaroche, cited in Schwarz, *David Octavius Hill,* p. 39. Delaroche (1757–1859) was a French academic painter who specialized in historical subjects.

14. Eugène Atget, *Lichtbilder,* with an introduction by Camille Recht (Paris and Leipzig, 1930), p. 10. [Benjamin's note]

15. Eugène Atget (1857–1927), French photographer, spent his career in obscurity making pictures of Paris and its environs. He is widely recognized as one of the leading photographers of the twentieth century.

16. Berenice Abbott (1898–1991), American photographer, preserved Atget's work and oversaw its earliest publication. She undertook, very much in the spirit of Atget, a photographic documentation of New York City in the 1930s and 1940s.

17. Benjamin is quoting Johannes V. Jensen, *Exotische Novellen*, trans. Julia Koppel (Berlin: S. Fischer, 1919), pp. 41–42. Jensen (1873–1950) was a Danish novelist, poet, and essayist who won the Nobel Prize for Literature in 1944. See "Hashish in Marseilles" (1932), in Benjamin, *Selected Writings, Volume 2: 1927–1934* (Cambridge, Mass.: Harvard University Press, 1999), p. 677.

18. August Sander, *Das Antlitz der Zeit: Sechzig Aufnahmen deutscher Menschen des 20. Jahrhunderts,* with an introduction by Alfred Döblin (Munich, 1929). [Benjamin's note. Sander (1876–1964), a German photographer, sought to compile a photographic portrait of the German people; *Das Antlitz der Zeit* (The Face of Our Time) was the first precipitate of this sociologically oriented project, which included portraits of peasants, workers, artisans, businessmen, and artists, among many others.—*Trans.*]

19. The Soviet filmmaker and theorist Sergei Mikhailovich Eisenstein (1898–1948) directed *Battleship Potemkin* (1925), *Strike* (1925), *October* (1927), *Alexander Nevsky* (1938), and *Ivan the Terrible* (released in two parts, 1944 and 1958). Vsevolod Illarionovich Pudovkin (1893–1953), also an important Soviet filmmaker and theorist, directed *Mother* (1926), *The End of St. Petersburg* (1927), and *Storm over Asia* (1928).

20. Alfred Döblin, introduction to Sander, *Antlitz der Zeit,* p. vi. The German writer Alfred Döblin (1878–1957) is best known for his novel *Berlin Alexanderplatz* (1929).

21. Alfred Lichtwark, introduction to Fritz Matthies-Masuren, *Künstlerische Photographie: Entwicklung und Einfluss in Deutschland* [Artistic Photography: Development and Influence in Germany] (Berlin: Marrquardt, 1907), p. 16.

22. László Moholy-Nagy, *Malerei Fotographie Film* (Munich: Langen, 1925). Moholy-Nagy (1895–1946), Hungarian painter, photographer, and art teacher, emerged as a dominant figure at the Bauhaus, where he was responsible for the famous Preliminary Course. As a photographer, he moved freely between the abstract photogram and representational photography. He was arguably the most influential photographer of the 1920s in Europe.

23. Tristan Tzara, "La Photographie à l'envers" (Photography from the Verso), translated by Benjamin as "Die Photographie von der Kehrseite," in *G: Zeitschrift für elementare Gestaltung* (July 1924): 30. Tzara (1896–1963), Romanian-born French poet and essayist, was one of the founders of Dada in Zurich. He carried Dada ideas to Paris after World War I.

24. Sascha Stone (Alexander Sergei Steinsapir; 1895–1940), German-Jewish photographer, worked as a professional photographer in Berlin, primarily for the illustrated magazines published by Ullstein Verlag. Stone was active at

the borders of the group around the journal *G*, which included Moholy-Nagy, Mies van der Rohe, Hans Richter, El Lissitzky, and Walter Benjamin. He created the photomontage for the book jacket of Benjamin's *Einbahnstraße* (One-Way Street; 1928).

25. Germaine Krull (1897–1985), German photographer, emigrated to Paris in 1924, where she became known for her work in portraiture, as well as in architectural, industrial, and fashion photography.

26. *Die Welt ist schön* (The World Is Beautiful) is the title of a photo volume published in 1928 by the German photographer Albert Renger-Patzsch (1897–1966); it became the most influential of all the photo essays published in the Weimar Republic. In this book, Renger-Patzsch arranged his photographs of plants, animals, buildings, manufactured goods, and industrial landscapes—often close-ups of isolated details—around formal rhymes. Benjamin was involved in a long-standing polemic against his work. See especially "The Author as Producer" (1934), in this volume.

27. The Krupp works at Essen was the original plant in the Krupp steel, armaments, and shipbuilding empire, founded in 1811 by Friedrich Krupp. The AEG is the Allgemeine Elektricitäts Gesellschaft, or General Electric Company, founded in Berlin in 1833 by the industrialist Emil Rathenau; it was largely responsible for building the electrical infrastructure of modern Germany.

28. Antoine Joseph Wiertz (1806–1865) was a Belgian painter of colossal historical scenes, lampooned by Baudelaire. See Benjamin's "Antoine Wiertz" (1929) and "Letter from Paris (2)" (1936), in this volume.

29. Benjamin is paraphrasing Moholy-Nagy here; see Benjamin's "News About Flowers," in this volume.

29

Letter from Paris (2)

PAINTING AND PHOTOGRAPHY

Taking a stroll in the Parisian neighborhoods of Montparnasse or Montmartre on Sundays or public holidays when the weather is bearable, you come across, at various points where the streets widen, canvas-covered stalls, either in rows or forming a little maze. There you will find people selling paintings of a certain kind, intended for the "best room": still lifes and seascapes, nudes, genre paintings, and interiors. The painter, not infrequently sporting a slouch hat and velvet jacket in the Romantic style, has installed himself next to his paintings on a little folding stool. His art is addressed to middle-class families out for a walk. They might well be struck more by his presence and imposing attire than by the paintings on display. But one would probably be overestimating the business acumen of the painters if one supposed that their personal appearance is designed to attract customers.

Such painters were certainly far from the minds of the participants in the major debates which have been waged recently concerning the situation of painting.[1] The only connection between their work and painting as art is that the products of both are intended more and more for the market in the most general sense. But the more distinguished painters do not need to market themselves in person. They can use art dealers and salons. All the same, what their itinerant colleagues put on show is something more than painting in its most debased state. These painters demonstrate that the ability to wield palette and brush with moderate skill is widespread. And to this extent they have a place in the debates just men-

tioned. This is conceded by André Lhote, who writes: "Anyone who takes an interest in painting today sooner or later starts painting too. . . . Yet from the day an amateur takes up his brush, painting ceases to attract him with the quasi-religious fascination it has for the layman" (*Entretiens*, p. 39).[2] To find an epoch when a person could be interested in painting without getting the idea that he himself should paint, we would have to go back to the time of the guilds. And just as it is often the fate of the liberal (Lhote is a liberal spirit in the best sense) to have his ideas taken to their logical conclusion by the fascist, we learn from Alexandre Cingria that things began to go wrong with the abolition of the guild system—that is, with the French Revolution.[3] Without the guilds, artists could present themselves "like wild animals," disregarding all discipline (*Entretiens*, p. 96). As for their public, the bourgeoisie, "after being ejected in 1789 from an order based politically on hierarchy and spiritually on an intellectual structure of values," they "had less and less appreciation for the cynical, mendacious, amoral, and useless form of production which now determines artistic laws" (*Entretiens*, p. 97).

We can see that fascism spoke openly at the Venice conference. That this conference was being held in Italy was no less natural than it was characteristic of the Paris conference to have been convened by the Maison de la Culture. So much for the official temper of these events. Anyone who studies the speeches more closely, however, will find considered, thoughtful reflections on the situation of art at the Venice conference (which, of course, was an international event), whereas not all the participants at the Paris conference were able to keep the debate entirely free of stereotypes. It is significant that two of the most important speakers in Venice took part in the Paris conference and were able to feel at home in its atmosphere; these were Lhote and Le Corbusier.[4] The former took the opportunity to look back on the Venetian event. "Sixty of us came together," he said, "in order to . . . try to understand these questions somewhat more clearly. I would not dare to claim that a single one of us really succeeded" (*La Querelle*, p. 93).

That the Soviet Union was not represented at all in Venice, and Germany by only one person (though this person was Thomas Mann), is regrettable.[5] But it would be a mistake to suppose that advanced positions were completely neglected. Scandinavians like Johnny Roosval and Austrians like Hans Tietze, not to mention the Frenchmen named above, occupied at least some of them.[6] In Paris the avant-garde took precedence in any case. It was made up of painters and writers in equal proportions, so as to emphasize the importance of restoring sensible communication between painting and the spoken and written word.

The theory of painting has split off from painting itself to become a special field of art criticism. Underlying this division of labor is the collapse of the solidarity which once existed between painting and public affairs. Courbet was perhaps the last painter in whom this solidarity was highly developed. Theory about his painting gave answers to problems touching on areas other than painting. Among the Impressionists, the argot of the studio was already repressing genuine theory; and from there things have steadily evolved to the stage where an intelligent and well-informed observer can conclude that painting "has become a completely esoteric and antiquated affair, . . . no longer commanding any interest in itself or its problems." It is "almost a relic of a past era; and to be a part of it, . . . a personal misfortune."[7] Such views are the fault not so much of painting as of art criticism. While appearing to serve the public, in reality it serves the art trade. It has no concepts—just a kind of jargon which changes from season to season. It is no accident that Waldemar George, for years the most influential Paris art critic, took a fascist stance in Venice.[8] His snobbish prattle can command attention only as long as the current forms of the art business flourish. One understands how he has reached a point where he awaits the salvation of French painting from some coming "leader" (see *Entretiens,* p. 71).

The interest of the Venice debate lay in the contributions of those who uncompromisingly described the crisis of painting. This applies especially to Lhote. His statement that "we face the question of the *useful* image" (*Entretiens,* p. 47) indicates where the Archimedean point of the debate is to be sought. Lhote is both a painter and a theoretician. As a painter, he derives from Cézanne; as a theoretician, he works within the framework of the *Nouvelle Revue Française.*[9] He is by no means on the extreme left. So the need to reflect on the "use" of the image is felt in other quarters as well. The concept of the "use" of the image does not refer only to usefulness in relation to painting or the enjoyment of art. (Rather, its purpose is to help us decide precisely what such uses are.) It is impossible to construe the notion of use too broadly. To consider only the direct use a work might have through its subject would obstruct progress completely. History shows that painting has often performed general social functions through its indirect effects. The Viennese art historian Tietze pointed to these when he defined the use of the image as follows: "Art helps us understand reality. . . . The artists who provided humanity with the first conventions of visual perception were of no less use than those geniuses of prehistoric times who formed the first words" (*Entretiens,* p. 34). Lhote traces the same line within historical time. Underlying each new technology, he notes, is a new optics. "We know the delirium that accom-

panied the invention of perspective, which was the decisive discovery of
the Renaissance. Paolo Uccello was the first to hit on its laws, and his en-
thusiasm was such that he woke his wife in the middle of the night to
bring her the tremendous news. I could," Lhote continues, "elucidate the
different stages in the development of visual perception, from primitive
societies up to today, by the simple example of the plate. The primitive
would have drawn it, like a child, as a circle; a contemporary of the Re-
naissance, as an oval; and the modern artist, who can be exemplified by
Cézanne, . . . would present it as an extraordinarily complex figure, of
which you may get some idea by thinking of the lower part of the oval as
flattened and one of its sides as swollen" (*Entretiens*, p. 38). It might per-
haps be objected that the usefulness of such achievements in painting
does not apply to perception itself but attaches only to its more or less ex-
pressive reproduction. Yet even then it would be authenticated in fields
outside art. For such reproduction operates through numerous chan-
nels—commercial drawings and advertising images, popular and scien-
tific illustrations—which influence the standard of production and educa-
tion within society itself.

The basic concept one may have of the usefulness of the image has
been considerably expanded by photography. This expanded state is the
one current now. The high point in the present debate is reached when
photography is included in the analysis, in order to clarify its relationship
to painting. Though this was not the case in Venice, the omission was
made good by Aragon in Paris.[10] As he later observed, this took a certain
courage. Some of the painters present were affronted by his attempt to
found ideas about the history of painting on the history of photography.
"Imagine a physicist being offended because someone talks to him about
chemistry," Aragon comments.[11]

Study of the history of photography began about eight or ten years
ago. We have a number of publications, mostly illustrated, on its infancy
and early masters.[12] But only one of the most recent of them has treated
the subject in conjunction with the history of painting. That this attempt
was made in the spirit of dialectical materialism gives new confirmation
of the highly original perspectives this method can open. Gisèle Freund's
study *La Photographie en France au dix-neuvième siècle* describes the
rise of photography in tandem with the rise of the bourgeoisie; the con-
nection is exemplified in a particularly successful way by the history of
the portrait.[13] Starting from the expensive ivory miniature (the portrait
technique most widely used under the *ancien régime*), the author de-
scribes the various procedures which contributed to making portrait pro-
duction quicker and cheaper, and therefore more widespread, around

1780, sixty years before the invention of photography. Her description of the "physiognotrace" as an intermediate form between the portrait miniature and the photograph has the merit of a discovery.[14] The author then shows how, with photography, technical development in art converged with the general technical standard of society, bringing the portrait within the means of wider bourgeois strata. She shows that the miniaturists were the first painters to fall victim to photography. Finally, she reports on the theoretical dispute between painting and photography around the middle of the century.

In the theoretical sphere, the dispute between photography and painting focused on the question of whether photography is an art. The author points out that the answers to this question gave rise to a peculiar constellation. She notes the high artistic standard of a number of early photographers who went about their work without artistic pretensions and were known to only a small circle of friends. "Photography's claim to be an art was raised precisely by those who were turning photography into a business" (Freund, p. 49). In other words, photography's claim to be an art was contemporaneous with its emergence as a commodity.

This circumstance is not without its dialectical irony: the very procedure which was later to call into question the concept of the artwork itself, by accentuating its commodity character through reproduction, claimed to be artistic.[15] This later development begins with Disdéri.[16] He knew that the photograph is a commodity. But it shares this property with all the products of our society. (The painting, too, is a commodity.) Disdéri also knew what services photography is able to render the commodity economy. He was the first to use photography to draw certain goods (primarily works of art) into the process of circulation—goods which had more or less escaped it up to then. He had the shrewd idea of acquiring a state monopoly on the reproduction of works in the Louvre's collection. Since then, photography has made more and more segments of the field of optical perception into saleable commodities. It has conquered for commodity circulation objects which up to then had been virtually excluded from it.

This development falls outside the framework of Gisèle Freund's study. She is concerned primarily with the epoch in which photography began its triumphant progress. It is the epoch of the *juste milieu*.[17] With regard to the aesthetic standpoint of that movement, as characterized by the author, it is of more than anecdotal interest that one celebrated master of the time regarded the exact depiction of fish scales as a supreme goal of painting. This school saw its ideals realized overnight by photography. A contemporary painter, Galimard, naively concedes this when

he writes in a review of Meissonier's paintings: "The public will not con-
tradict us if we express our admiration for a subtle painter who . . . this
year has given us a picture which yields nothing in accuracy to the da-
guerreotype."[18] The painting of the *juste milieu* was simply waiting to be
towed along by photography. Not surprisingly, it contributed nothing, or
at least nothing good, to the development of the photographic craft.
Wherever that craft came under its influence, we find photographers as-
sembling stage props and walk-ons in their studios, in an attempt to
emulate the history painters who were decorating Versailles with frescoes
for Louis Philippe. They did not hesitate to photograph the sculptor
Callimachus in the act of inventing the Corinthian capital as he caught
sight of an acanthus plant; they composed a scene in which "Leonardo"
is seen painting the *Mona Lisa,* and then photographed that scene.—The
painting of the *juste milieu* had its adversary in Courbet; with him, the
relationship between painter and photographer was temporarily re-
versed. In his famous painting *La Vague* [The Wave], a photographic
subject is discovered through painting.[19] In Courbet's time, both the en-
larged photo and the snapshot were unknown. His painting showed
them the way. It equipped an expedition to explore a world of forms and
structures which were not captured on the photographic plate until a de-
cade later.

Courbet's special position was that he was the last who could at-
tempt to surpass photography. Later painters tried to evade it—first and
foremost the Impressionists. The painted image slipped its moorings in
draftsmanship; thereby, to some extent, it escaped competition with the
camera. The proof was seen around the turn of the century, when pho-
tography, in turn, tried to emulate the Impressionists. It resorted to gum
bichromate prints—and we know how low it sank with this technique.
Aragon observed astutely: "Painters . . . saw the camera as a competitor.
. . . They tried not to do things the way it did. That was their great idea.
But to refuse in this way to recognize an important achievement of man-
kind . . . must lead to reactionary behavior. In the course of time, paint-
ers—even the most gifted of them—. . . became true ignoramuses."[20]

Aragon has explored the questions raised by painting's most recent
developments in his 1930 study entitled *La Peinture au défi.*[21] The chal-
lenge to painting is posed by photography. The treatise deals with the
events that led painting, which hitherto had avoided a collision with pho-
tography, to confront it head on. Aragon describes how this happened in
connection with works by his Surrealist friends of that time. They made
use of various procedures. "A piece of a photograph was glued into a

painting or a drawing, or something was drawn or painted on a photo-graph" (Aragon, p. 22). Aragon mentions further procedures, such as cutting photos into the shape of something other than what they represent. (A locomotive can be cut out of a photograph of a rose.) Aragon saw this technique, which has a clear connection to Dadaism, as proof of the revolutionary energy of the new art. He contrasted it with traditional art. "Painting has long been leading a comfortable life; it flatters the cultured connoisseur who pays for it. It is a luxury article. . . . In these new experiments, artists can be seen emancipating themselves from domestication by money. For this collage technique is poor in resources. And its value will go unrecognized for a long time to come" (Aragon, p. 19).

That was in 1930. Aragon would not make these statements today. The Surrealists' attempt to master photography by "artistic" means has failed. The error of the decorative-art photographers with their philistine creed, which provided the title for Renger-Patzsch's well-known collection of photographs *Die Welt ist schön* [The World is Beautiful], was their error, too.[22] They failed to recognize the social impact of photography, and therefore the importance of inscription—the fuse guiding the critical spark to the image mass (as is seen best in Heartfield). Aragon has very recently written about Heartfield;[23] and he has taken other opportunities to point to the critical element in photography. Today he detects this element even in the seemingly formal work of a virtuoso photographer like Man Ray.[24] In Man Ray's work, he argued in the Paris debate, photography succeeds in reproducing the style of the most modern painters. "Anyone unfamiliar with the painters to whom Man Ray alludes could not fully appreciate his achievement" (*La Querelle*, p. 60).

Let us take leave of the exciting story of the meeting of painting and photography by quoting an appealing formulation by Lhote. To him it seems beyond dispute "that the much-discussed replacement of painting by photography has its proper place in what might be called the 'ongoing business' of painting. But that still leaves room for painting as the mysterious and inviolable domain of the purely human" (*La Querelle*, p. 102). Unfortunately, this interpretation is no more than a trap which, snapping shut behind the liberal thinker, delivers him up defenselessly to fascism. How much more far-sighted was the ungainly painter of ideas, Antoine Wiertz, who wrote, almost a hundred years ago, on the occasion of the first World Exhibition of Photography:

A few years ago a machine was born to us which is the glory of our age, and which daily amazes our minds and startles our eyes. Before another

century has passed, this machine will be the paintbrush, the palette, the paints, the skill, the experience, the patience, the dexterity, the accuracy, the color sense, the glaze, the model, the perfection, the essence of painting. . . . Let no one believe that the daguerreotype will kill art. . . . Once the daguerreotype, this titan child, has grown up, once all its art and strength have been unfolded, genius will grab it by the nape of the neck and cry: "This way! You're mine now. We're going to work together."[25]

Anyone who has Wiertz's grand paintings before him will know that the genius he refers to is a political one. In the flash of a great social inspiration, he believed, painting and photography must one day fuse together. There was truth in his prophecy; yet it is not within works but within major artists that the fusion has taken place. They belong to the generation of Heartfield, and have been changed from painters into photographers by politics.

The same generation has produced painters like George Grosz and Otto Dix, who have worked toward the same goal.[26] Painting has not lost its function. The important thing is not to block our own view of this function—as Christian Gaillard does, for example: "If social struggles were to be the subject of my work," he says, "I would need to be moved by them visually" (La Querelle, p. 190). For contemporary fascist states, where "peace and order" reign in the towns and villages, this is a very problematic formulation. Shouldn't Gaillard have the opposite experience? Shouldn't his social emotion be converted into visual inspiration? Such is the case with the great caricaturists, whose political knowledge permeates their physiognomic perception no less deeply than the experience of the sense of touch imbues the perception of space. Masters like Bosch, Hogarth, Goya, and Daumier pointed the way. "Among the most important works of painting," wrote René Crevel, who died recently, "have always been those which, merely by pointing to corruption, indicted those responsible. From Grünewald to Dalí, from the putrid Christ to the *Stinking Ass,*[27] . . . painting has always been able to discover new truths which were not truths of painting alone" (La Querelle, p. 154).

It is in the nature of the situation in western Europe that precisely where painting is most accomplished it has a destructive, purging effect. This may not emerge as clearly in a country which still[28] has democratic freedoms as it does in countries where fascism is in control. In the latter countries, there are painters who have been forbidden to paint. (And it is usually the artists' style, not their subject matter, which brings the prohi-

bition—so deeply does their way of seeing strike at the heart of fascism.) The police visit these painters to check that nothing has been painted since the last roundup. The painters work by night, with draped windows. For them the temptation to paint "from nature" is slight. And the pallid landscapes of their paintings, populated by phantoms or monsters, are taken not from nature but from the class state. Of these painters there was no mention in Venice—or, sadly, in Paris. They know what is useful in the image today: every public or secret mark which demonstrates that within human beings fascism has come up against limits no less insuperable than those it has encountered across the globe.

Written November–December 1936; unpublished in Benjamin's lifetime. *Gesammelte Schriften*, III, 495–507. Translated by Edmund Jephcott.

Notes

This was the second of two reports Benjamin prepared on contemporary Parisian arts and letters. The first "Pariser Brief," subtitled "André Gide und sein neuer Gegner" (André Gide and His New Adversary), originally published in 1936, is reprinted in Benjamin's *Gesammelte Schriften*, III, 482–495.

1. *Entretiens: L'Art et la réalité; L'Art et l'état* (Conversations: Art and Reality; Art and the State), with contributions by Mario Alvera, Daniel Baud-Bovy, Emilio Bodrero, et al. (Paris: Institut Internationale de Coopération Intellectuelle, 1935). *La Querelle du réalisme: Deux débats par l'Association des peintures et sculptures de la maison de la culture* (The Question of Realism: Two Debates Presented by the Association of Painting and Sculpture at the Maison de la Culture), with contributions by Lurçat, Granaire, et al. (Paris: Editions Socialistes Internationales, 1936). [Benjamin's note]

2. The French painter and critic André Lhote (1885–1962) was associated with Cubism.

3. Alexandre Cingria (1879–1945), a Swiss-born painter, mosaicist, and glassmaker, was the author of *La Décadence de l'art sacré* (The Decadence of Sacred Art; 1917) and *Souvenirs d'un peintre ambulant* (Memoirs of an Itinerant Painter; 1933).

4. Le Corbusier (Charles Edouard Jeanneret; 1887–1965) was one of the most important twentieth-century architects and city planners, known for his distinctive combination of functional and expressive forms. He is the author of *Après le Cubisme* (After Cubism; 1918), *Vers une architecture* (Toward a New Architecture; 1923), and *Urbanisme* (The City of Tomorrow; 1925).

5. Thomas Mann (1875–1955) won the Nobel Prize for literature in 1929 and left Germany for the United States in 1933. He is the author of

Buddenbrooks (1901), *Der Zauberberg* (The Magic Mountain; 1924), *Doktor Faustus* (1947), and other well-known stories, novels, and essays.

6. On the other hand, remnants of past intellectual epochs—vestiges truly worthy of a museum—could also be encountered in Venice. For example, this definition by Salvador de Madariaga: "True art is the product of a combination of thought with space, a combination possible in various situations; and false art is the result of such a combination in which thought impairs the artwork" (*Entretiens*, p. 160). [Benjamin's note. Salvador de Madariaga y Rojo (1886–1978) was a Spanish writer and diplomat, the Spanish Republic's chief delegate to the League of Nations (1931–1936), and the author of novels, plays, poetry, literary criticism, and historical studies. Johnny Roosval (1879–1965) was a Swedish art historian, educated in Berlin, who took a narrative and poetic approach to his specialty, the churches of Gotland. Hans Tietze (1880–1954), an Austrian art scholar and professor of the history of art at Vienna, celebrated modern art in such works as *Lebendige Kunstwissenschaft* (Living Aesthetics; 1925). He and his wife are the subjects of a famous painting by Oskar Kokoschka (1909).—*Trans.*]

7. Hermann Broch, *James Joyce und die Gegenwart: Rede zu Joyce's 50. Geburtstag* [James Joyce and the Present Day: A Speech in Honor of Joyce's Fiftieth Birthday] (Vienna, Leipzig, and Zurich, 1936), p. 24. [Benjamin's note. The Austrian novelist Hermann Broch (1886–1951) wrote *Die Schlafwandler* (The Sleepwalkers; 1931–1932) and *Der Tod des Virgil* (The Death of Virgil; 1945). Broch spent five months in a Nazi prison in 1935; his release was secured through an international effort by friends and fellow writers, including James Joyce.—*Trans.*]

8. Waldemar George (Georges Jarocinski; 1893–1970), born in Poland to a Jewish family, was an art historian who lived in Paris from 1911, publishing works on such painters as Picasso, Rouault, Matisse, and Utrillo. His defense of modern art in terms of a revolutionary antirationalist ideal took on new meaning after 1930, when he openly embraced Italian fascism.

9. Lhote (see note 2 above) was an art critic for the leading Paris journal *Nouvelle Revue Française* until 1940.

10. The French poet, novelist, and essayist Louis Aragon (Louis Andrieux; 1897–1982) was a prominent Surrealist.

11. Louis Aragon, "Le Réalisme à l'ordre du jour," in *Commune*, 4, series 37 (September 1936): 23. [Benjamin's note]

12. See, among other works, Helmut Theodor Bossert and Heinrich Guttman, *Aus der Frühzeit der Photographie 1840–1870* [The Early Years of Photography, 1840–1870] (Frankfurt am Main, 1930); Camille Recht, *Die alte Photographie* [Early Photography] (Paris, 1931); Heinrich Schwarz, *David Octavius Hill, der Meister der Photographie* [David Octavius Hill, Master Photographer] (Leipzig, 1931). In addition, there are two important source works: [Adolphe-Eugène] Disdéri, *Manuel opératoire de photographie*

[Handbook of Photography] (Paris, 1853), and Nadar [Gaspard-Félix Tournachon], *Quand j'étais photographe* [When I Was a Photographer] (Paris, 1900). [Benjamin's note]

13. Gisèle Freund, *La Photographie en France au dix-neuvième siècle* [Photography in France during the Nineteenth Century] (Paris, 1936). The author, a German emigrant, was awarded a doctorate at the Sorbonne for this study. Anyone who witnessed the public disputation which concluded the examination must have taken away a strong impression of the vision and liberality of the examiners. A methodological objection to this deserving book may be mentioned here. "The greater the genius of the artist," writes the author, "the better his work reflects the tendencies of the society of his time—precisely through what is original in the form of his work" (Freund, p. 4). What seems dubious about this statement is not the attempt to relate the artistic qualities of a work to the social structure at the time of its production; it is the assumption that this structure appears as constant over time. In reality, the view of it is likely to change from epoch to epoch. Hence, if the significance of an artwork is defined in relation to the social structure at the time it is produced, then its ability to make the time of its production accessible to remote and alien epochs could be determined from the history of its effects. Dante's poem, for example, had this ability for the twelfth century; Shakespeare's work, for the Elizabethan period. Clarification of this methodological question is the more important since Freund's formulation leads straight back to the position which was given its most radical—and at the same time most questionable—expression by Plekhanov, who declared: "The greater a writer is, the more strongly and clearly the character of his work depends on the character of his time, or, *in other words* [my italics], the less the element which might be called 'the personal' can be found in his works." Georgi Plekhanov, "Les Jugements de Lanson sur Balzac et Corneille," in *Commune,* 16, series 2 (December 1934): 306. [Benjamin's note. Gisèle Freund (1908–2000) studied sociology with Norbert Elias and Karl Mannheim before working as a photographer in Berlin. She emigrated to France in 1933, becoming friends with Benjamin, whom she photographed. See Benjamin's 1938 review of *La Photographie en France,* in this volume. The work of Georgi Valentinovich Plekhanov (1856–1918), the Russian political theorist and Menshevik revolutionary, was a major influence on the development of Marxist aesthetics.—*Trans.*]

14. The physiognotrace, invented in 1783–1784 by Gilles-Louis Chrétien, was a machine for tracing a subject's profile, which it reproduced mechanically on a piece of paper affixed to the center of the instrument.

15. The following is a similarly ironic constellation in the same field. The camera, as a highly standardized tool, is not much more suited to expressing national peculiarities through its product than is a rolling mill. To a degree previously unknown, it makes image production independent of national con-

ventions and styles. It therefore perturbed theoreticians, who are committed to such conventions and styles. The reaction was prompt. As early as 1859, we read in a review of a photographic exhibition: "Specific national character emerges . . . clearly in the works of the different countries. . . . A French photographer will never be confused . . . with an English colleague" (Louis Figuier, *La Photographie au salon de 1859* [Paris, 1860], p. 5). And in the very same vein, more than seventy years later, Margherita Sarfatti said at the Venice conference: "A good portrait photograph will tell us at first glance the nationality not of the sitter but of the photographer" (*Entretiens*, p. 87). [Benjamin's note. The Italian journalist Margherita Sarfatti (1886–1961) was an art critic for *Il Popolo d'Italia*, a literary critic for *La Stampa*, and the author of a best-selling biography of Mussolini.—*Trans.*]

16. André-Adolphe-Eugène Disdéri (1818–1889) was a French entrepreneur who introduced mass-manufacturing principles into portrait photography in 1859, and amassed a fortune before the collapse of the Second Empire in 1871. He was the inventor of the popular *carte-de-visite* photograph (pocket-size portrait). See Benjamin, *The Arcades Project,* trans. Howard Eiland and Kevin McLaughlin (Cambridge, Mass.: Harvard University Press, 1999), pp. 671–692 (Convolute Y, "Photography").

17. A reference to the reign of Louis Philippe in France (1830–1848). Proclaimed "Citizen King" during the July Revolution in 1830, Louis Philippe sought to portray his constitutional monarchy as middle-of-the-road: "We must not only cherish peace," he said in a speech in 1831, "we must avoid everything that might provoke war. As regards domestic policy, we will endeavor to maintain a *juste milieu* [happy medium]." His regime was marked by the rise of the bourgeoisie to power, mainly through its domination of industry and finance.

18. Auguste Galimard, *Examen du salon de 1849* (Paris, n.d.), p. 95. [Benjamin's note. Nicolas-Auguste Galimard (1813–1880) was a French painter who wrote reviews for *L'Artiste*, *La Patrie*, and *La Revue des deux mondes*. The French painter Jean-Louis-Ernest Meissonier (1815–1891) was acclaimed by many of his contemporaries for his painstaking attention to detail in his military subjects and genre scenes.—*Trans.*]

19. Courbet's *La Vague* (1870) hangs in the Louvre.

20. *La Querelle*, p. 64. Compare Derain's malicious assertion: "The great danger for art is an excess of culture. The true artist is an uncultured person" (*La Querelle*, p. 163). [Benjamin's note. The French painter André Derain (1880–1954) became well known when he, Henri Matisse, and Maurice de Vlaminck were dubbed the "Fauves," or "wild beasts," at the 1905 Salon d'Automne.—*Trans.*]

21. Louis Aragon, *La Peinture au défi* [The Challenge to Painting] (Paris, 1930). [Benjamin's note]

22. Albert Renger-Patzsch, *Die Welt ist schön: Einhundert photographische*

Aufnahmen (Munich: K. Wolff, 1928). In this book, the German photographer Renger-Patzsch (1897–1966) arranged his photographs of plants, animals, buildings, manufactured goods, and industrial landscapes—often close-ups of isolated details—around formal rhymes. See "The Author as Producer" (1934), in this volume.

23. Aragon, "John Heartfield et la beauté révolutionnaire," in *Commune*, 2 (May 1935): 21. [Benjamin's note. John Heartfield (Helmut Herzfelde; 1891–1968), German graphic artist, photographer, and designer, was one of the founders of Berlin Dada. He went on to reinvent photomontage as a political weapon.—*Trans.*]

24. The American photographer and painter Man Ray (Emmanuel Radnitzky; 1890–1976), an influential member of Dadaist and Surrealist circles in Paris in the 1920s and 1930s, was well known for his use of unusual photographic techniques, as in his photograms.

25. A. J. Wiertz, *Oeuvres littéraires* (Paris, 1870), p. 309. [Benjamin's note. Antoine Joseph Wiertz (1806–1865) was a Belgian painter of colossal historical scenes, lampooned by Baudelaire. See Benjamin's "Antoine Wiertz" (1929), in this volume.—*Trans.*]

26. The German painters George Grosz (1893–1959) and Otto Dix (1891–1969) were associated first with Berlin Dada and then with the Neue Sachlichkeit (New Objectivity). Their scabrous paintings commented on the consequences of militarism, capitalism, and postwar conditions in Germany.

27. A painting by Dalí. [Benjamin's note]

28. "Still": On the occasion of the great Cézanne exhibition, the Paris newspaper *Choc* set about putting an end to the "bluff" of Cézanne. The exhibition had been arranged by the left-wing French government, it claimed, "in order to drag the artistic sensibility of its own people, and of all other peoples, into the mire." So much for criticism. There are also painters who are prepared for all eventualities. They follow the example of Raoul Dufy, who writes that if he were a German and had to celebrate the triumph of Hitler, he would do it in the same way that certain medieval artists painted religious images, without themselves being believers (see *La Querelle*, p. 187). [Benjamin's note. The French painter Raoul Dufy (1877–1953) is best known for his refined, witty views of regattas and race-courses.—*Trans.*]

30

Review of Freund's
Photographie en France au dix-neuvième siècle

Gisèle Freund, *La Photographie en France au dix-neuvième siècle: Essai de sociologie et d'esthétique* [Photography in France in the Nineteenth Century: An Essay in Sociology and Aesthetics] (Paris: La Maison des Amis du Livre, 1936), 154 pages.

Study of the history of photography began about eight or ten years ago. We have a number of publications, mostly illustrated, on its infancy and its early masters. But only this most recent study has treated the subject in conjunction with the history of painting. Gisèle Freund's study describes the rise of photography as conditioned by that of the bourgeoisie, successfully illustrating the causal connection by examining the history of the portrait.[1] Starting from the expensive ivory miniature (the portrait technique most widely used under the *ancien régime*), the author describes the various procedures which contributed to making portrait production quicker and cheaper, and therefore more widespread, around 1780, sixty years before the invention of photography. Her description of the "physiognotrace" as an intermediate form between the portrait miniature and the photograph shows in exemplary fashion how technical factors can be made socially transparent.[2] The author then explains how, with photography, technical development in art converged with the general technical standard of society, bringing the portrait within the means of wider bourgeois strata. She shows that the miniaturists were the first painters to fall victim to photography. Finally, she reports on the theoretical dispute between painting and photography around the middle of the century.

The question of whether photography was an art was debated at that time, with passionate contributions from Lamartine, Delacroix, and Baudelaire.[3] But the more fundamental question—whether the invention of photography had not changed the entire character of art—was not raised. The author has perceived the decisive issue clearly. She notes the high artistic standard of a number of early photographers, who went about their work without artistic pretensions and were known to only a small circle of friends. "Photography's claim to be an art was raised precisely by those who were turning photography into a business" (p. 49). In other words, photography's claim to be an art is contemporaneous with its emergence as a commodity. This is consistent with the influence which photography, as a technique of reproduction, had on art itself. It isolated art from the patron, delivering it up to the anonymous market and its demand.

The book's method is based on the materialist dialectic, and discussion of the volume could further development of the latter. For this reason, I would touch on an objection which might also help to define the position of Freund's research in scholarship. "The greater the genius of an artist," writes the author, "the better his work reflects the tendencies in the society of his time—and precisely through what is original in the form of his work" (p. 4). What seems dubious about this statement is not the attempt to relate the artistic scope of a work to the social structure at the time of its production, but the assumption that this structure appears always with the same configuration. In reality, its configuration is likely to change with the different periods in which it is observed. Defining the significance of an artwork in relation to the social structure that prevailed at the time it was produced therefore amounts to determining a distinctive capability of the artwork—namely, its ability to make the period of its production accessible to the most remote and alien epochs—in terms of the history of its influence. Dante's poem, for example, manifested such a capability for the twelfth century, just as Shakespeare's work did for the Elizabethan period.

Clarification of the question touched upon here is all the more important since Freund's formulation threatens to lead straight back to the position which was given its most radical, and questionable, expression by Plekhanov. "The greater a writer is," Plekhanov wrote in his polemic against Lanson, "the more strongly and clearly the character of his work depends on the character of his time, *or, in other words* (reviewer's italics): the less the element which might be called the 'personal' can be found in his works."[4]

Written ca. November 1937; published in the *Zeitschrift für Sozialforschung*, fall 1938. *Gesammelte Schriften*, III, 542–544. Translated by Edmund Jephcott.

Notes

1. This review is an adaptation of a section of Benjamin's "Letter from Paris (2)" (1936), in this volume. Gisèle Freund (1908–2000) studied sociology with Norbert Elias and Karl Mannheim before working as a photographer in Berlin. She emigrated to France in 1933, becoming friends with Benjamin, whom she photographed.

2. The physiognotrace, invented in 1783–1784 by Gilles-Louis Chrétien, was a machine for tracing a subject's profile, which it reproduced mechanically on a piece of paper affixed to the center of the instrument.

3. On the nineteenth-century French debate about the artistic status of photography, see Benjamin, *The Arcades Project,* trans. Howard Eiland and Kevin McLaughlin (Cambridge, Mass.: Harvard University Press, 1999), pp. 671–692 (Convolute Y, "Photography").

4. In his "Letter from Paris (2)," Benjamin cites a French translation of the polemic in question: Georgi Plekhanov, "Les Jugements de Lanson sur Balzac et Corneille," *Commune,* 16, series 2 (December 1934): 306. The work of Georgi Valentinovich Plekhanov (1856–1918), Russian political theorist and Menshevik revolutionary, was a major influence on the development of Marxist aesthetics. Gustave Lanson (1857–1934), French critic, was the author of *Histoire de la littérature française* (1894) and other works of literary history.

V

FILM

For Walter Benjamin the category of the aesthetic, the focus of much of his work, must be understood not in the simple sense of a theory of the (beautiful) arts but rather in terms of the original meaning of the Greek root *aisthetikos* ("of sense perception") which comes from *aisthanesthai* ("to perceive"). For it is as a theory of perception *(Wahrnehmung)* that aesthetics is so central to Benjamin's oeuvre and—in light of a modernity where perception has increasingly been shaped by technology—has effectively become the study of media. In "The Work of Art in the Age of Its Technological Reproducibility" Benjamin is explicit on this matter, insisting that "film . . . proves to be the most important subject matter, at present, for the theory of perception which the Greeks called aesthetics" (section XVIII). Moreover, as Benjamin remarked in a note jotted down during the composition of the artwork essay: "So long as art theory is unable to find an example in film for every one of its elements, it is in need of improvement."[1] The question therefore is not whether film is art but rather, as Benjamin reminds us, how our very conception and practice of art has changed in light of the cinema.

One of the many issues that the still rather new medium of film brought so sharply into focus in the late 1920s and early 1930s was the historicity of human sense perception. As Benjamin noted on numerous occasions, major historical shifts in our mode of existence (from agricultural to industrial, for example) are paralleled by equally dramatic changes in the very way we see the world.[2] Among the signature features of the modern "mode of existence" is, of course, technology. The question of how to conceptualize the reciprocal determinations between his-

315

torically variable forms of perception and changes in technology is one
that Benjamin addressed repeatedly. Along the lines first sketched by
the sociologist Georg Simmel in his canonical 1903 text "The Metropolis
and Mental Life," Benjamin observed how the tempo and altitude of
modern means of transportation such as the railroad and the airplane,
for example, generate "a heightened need for ever-changing impres-
sions."[3] Or, in the early drafts of the Arcades Project from the late 1920s,
he drew a connection between the "rhythms of today" and those of film:
"Very characteristic is the opposition, in film, between the downright
jerky rhythm of the image sequence, which satisfies the deep-seated need
of this generation to see the 'flow' of 'development' disavowed, and the
continuous musical accompaniment."[4] Like the highly pulsating experi-
ence of the city and the disjointed montage of the cinema, these new tech-
nological forms also provoked radically new modes of apprehending
space and time. In the process, as Benjamin put it in his 1939 essay "On
Some Motifs in Baudelaire," such technology "has subjected the human
sensorium to a complex kind of training."[5]

It is in the context of this sensory recalibration that Benjamin locates
the importance of the new cinematic medium, which is cast alternately as
a *symptom* or *embodiment* of, or as a *school* for, this "decisive refunc-
tioning of the human perceptual apparatus."[6] In some essays Benjamin
reads film as a *materialization* of the new perceptual conditions of mo-
dernity: "There came a day when a new and urgent need for stimuli was
met by film. In a film, perception conditioned by shock [*chockförmige
Wahrnehmung*] was established as a formal principle."[7] In other texts he
compares the character of cinematic spectatorship (structured as it is by
the mechanical conditions of the cinema's projection) with the Taylorized
labor characteristic of the assembly line.[8] Given that for Benjamin the
cinematic medium gives expression to those fundamental transforma-
tions in the domains of form, perception, and even experience that are
the signature of a new era, its political ramifications are unambiguous.

Thus, if Benjamin turns his critical attention to film on a number of
occasions, this is not least because film stages most dramatically the inter-
face of aesthetics and politics. As Benjamin puts it in "Reply to Oscar
A. H. Schmitz" (Chapter 32 below), his polemical response to Schmitz's
conservative review of Sergei Eisenstein's film *Potemkin*:

> Why does [Schmitz] make such a fuss about the political deflowering of
> art? . . . The claim that political tendencies are implicit in every artwork of
> every epoch—since these are, after all, historical creations of conscious-

ness—is a platitude. But just as deeper layers of rock come to light only at points of fracture [*Bruchstellen*], the deeper formation of a political position [*Tendenz*] becomes visible only at fracture points in the history of art (and in artworks). The technical revolutions—these are fracture points in artistic development where political positions, exposed bit by bit, come to the surface. In every new technical revolution, the political position is transformed—as if on its own—from a deeply hidden element of art into a manifest one. And this brings us ultimately to film.

Among the points of fracture in artistic formations, film is one of the most dramatic.

Perhaps the most prominent feature of the challenge posed by film is what Benjamin refers to as the "shock-character" produced by montage, the radical juxtaposition of discontinuous elements.

The shock-quality of the montage in certain types of filmic image-sequences is crucial for Benjamin because, on the one hand, in their refusal of facile continuity, they correspond to a collective, distracted model of reception that serves as an alternative to the individual absorption and contemplation characteristic of the bourgeoisie's cult of art.[9] The filmic experience of shock has a productive dimension as well, in that it "routinizes" the spectator for the staccato sense-perceptions that are so pervasive in late industrial culture, thereby serving as a sort of "training" for the new tempo and quality of experience in late capitalist urbanism. Seen in this light, cinema's sensorial recalibration can be read as an urgent practical and political empowerment: "The function of film is to train human beings in the apperceptions and reactions needed to deal with a vast apparatus whose role in their lives is expanding almost daily" ("The Work of Art," section VI).

On the other hand, the same "training" could also be said to have an acclimatizing function. The contemporary analogy would be the function of video games as a further recalibration of the perceptual apparatus in an age of heightened (electronic rather than mechanical) shocks, readying a younger generation for the psycho-sensorial demands of twenty-first-century military and industrial conditions. To the extent that cinema "prepares" viewers for new modes of production, one could argue that it is simply quietist, enabling alienated workers to cope with their alienation rather than transforming the conditions that produced it. Yet even here, Benjamin sees a utopian potential for such viewers as well: "Dealing with this apparatus also teaches them that technology will release them from their enslavement to the powers of the apparatus only when

humanity's whole constitution has adapted itself to the new productive forces which the second technology has set free" ("The Work of Art," section VI). Thus, shock training by the cinema can be read as preparation for a new technical mastery that could, at least potentially, be enlisted in the service of a progressive project. Redemption here is sought not in the nostalgic longing for outdated forms of experience—aesthetic or otherwise—but through vanguard technological expertise.[10]

It is in this context that one must situate Benjamin's reading of the film actor's work as an allegory of mastery over the apparatus. Unlike the stage actor, Benjamin insists, the challenge facing the film actor is to resist allowing the cinematic apparatus to destroy his humanity. The performance of the film actor—confronting not an audience (and the reciprocity of its gaze) but spotlights, cameras, crew, microphones, and so on—is what he calls a test achievement, or test performance: to meet this challenge means "to preserve one's humanity in the face of that apparatus" ("The Work of Art," section X). This achievement, Benjamin goes on to note, has great appeal for the masses, whose humanity is subjugated by apparatuses daily in urban factories and production jobs: "In the evening these same masses fill the cinemas, to witness the film actor taking revenge on their behalf not only by asserting *his* humanity (or what appears to them as such) against the apparatus, but by placing that apparatus in the service of his triumph" (section X). The stardom of the star stages the triumph of humanity over a technology that (for most of the audience) is experienced as oppressive. The star, in turn, becomes an allegory for victory over, and appropriation of, a technology that, in its quotidian Taylorist manifestations, is usually an instrument of subjugation. This is the basis of Benjamin's unambiguous enthusiasm for Charlie Chaplin and sympathy for Mickey Mouse. Even as Benjamin also recognizes that the star-cult simultaneously functions as a means by which the film industry precludes the realization of certain of the medium's most critical and progressive potentials—notably the masses' understanding of itself as a class[11]—he insists that even within this reification there is a progressive moment as well: "The representation of human beings by means of an apparatus has made possible a highly productive use of the human being's self-alienation" ("The Work of Art," section XII).

The "training" envisioned in the artwork essay of course takes place in the cinema. And it enables the formation of a new, decisively broadened situation of spectatorship: Benjamin opposes the "concentration" of the art lover to the supposedly vulgar "distraction" of the masses.[12] In line with earlier sections of the essay (III–IV) in which he discusses the

auratic quality of the autonomous work, he argues that concentration on the auratic work enables only the viewer's absorption *into* the work, while distraction enables members of the massed audience to absorb the work into themselves.[13] In a telling fragment from *The Arcades Project*, Benjamin characterizes this active appropriation of the work by the mass audience as a *making present* of something past: "The true method of making things present is to represent them in our space (not to represent ourselves in their space). . . . The same method applies, in essence, to the consideration of great things from the past—the cathedral of Chartres, the temple of Paestum—when, that is, a favorable prospect presents itself: the method of receiving the things into our space. We don't displace our being into theirs; they step into our life."[14] In the artwork essay, architecture is put forward as the "prototype" of a work received by the collective in distraction. Benjamin privileges certain traditional modes of the reception of a building—its use, which is tactile and immediate, versus the building as viewed, which is distanced and contemplative—and asserts that this mode of reception occurs through habit and not through a local awareness.

Only in the "simultaneous collective reception" (section XV) that is distraction, then, can "the desire of the present-day masses to 'get closer' to things" (section IV) be realized. At the heart of Benjamin's artwork essay is the conviction that film, in its combination of "the shooting by the specially adjusted photographic device and the assembly of that shot with others of the same kind," offers the audience "a pure view of that reality, free of the foreign body of equipment" (section XIV). This apparently "equipment-free aspect of reality" is of course the "height of artifice"—the product of a highly subjective viewing angle, of the distortion inherent in photographic representation, and, above all, of editing. Benjamin is under no illusion regarding the objectivity of the images of things that are actually brought closer to an audience.

Yet, in satisfying the desire for such images, film is able to do other, more significant work. It offers the audience insights into the "necessities governing our lives" by revealing otherwise hidden, but enormously constraining and inhibiting aspects of the world through which we move. Film has the potential, in other words, not so much to penetrate reality as to penetrate the phantasmagoria that distorts and conceals reality from the human sensory and cognitive capacities; it has the unique capacity to bring the conditions that actually obtain to the level of consciousness. And, in what is perhaps the essay's most utopian moment, Benjamin ascribes to film the ability "to assure us of a vast and unsuspected field of

action [*Spielraum*]" (section XVI). This field of action is the space in which a cinematic audience is transformed through "simultaneous collective reception" into a mass—indeed, a mass that bears the potential for social change. As he did in "Little History of Photography," Benjamin remarks on the effects—slow motion, close-ups, enlargement, and so on—that make all this possible, and subsumes them under the notion of the "optical unconscious."[15] In the artwork essay, though, he ascribes to the optical unconscious not just the power of disenchantment (the unmasking of "the necessities governing our lives" and with them phantasmagoria) but the power to inform masses of viewers, schooled in distraction, of the political powers that lie open to them: a political power derived from discovering the explosive potential of that which is inconspicuous and apparently meaningless—in short, the stuff of a habituated yet tactile and immediate experience of the modern world.

"The Work of Art in the Age of Its Technological Reproducibility" plays, then, on a series of reversals: the seemingly banal and worthless work that has been technologically reproduced is favored over the privileged, autonomous work; a habituated and distracted mode of reception is favored over the kind of concentration and absorption long held to be the only reception adequate to the demands of high art. Benjamin effects these reversals for explicitly political ends, as he makes plain in section XVIII of the essay: "The tasks which face the human apparatus of perception at historical turning points cannot be performed solely by optical means—that is, by way of contemplation. They are mastered gradually—taking their cue from tactile reception—through habit."

THOMAS Y. LEVIN

Notes

1. Walter Benjamin, *Gesammelte Schriften*, VII, p. 678.
2. See especially the introduction to Part I in this volume.
3. Benjamin, *Gesammelte Schriften*, III, 583. Benjamin goes on to cite a text by the French psychologist, philosopher, and politician Henry Wallon (1898–1962) on the transformation of vision through the advent of the airplane. Wallon notes: "It thus appears to be indisputable that these technological inventions have effects right down into our muscular system, our sensory faculties, and ultimately our intelligence." Henry Wallon, "Psychologie et Technique," in: *A la lumière du Marxisme* (Paris, 1935), pp. 145, 147.
4. Benjamin, *The Arcades Project*, trans. Howard Eiland and Kevin McLaughlin (Cambridge, Mass.: Harvard University Press, 1999), p. 845, Convolute H°,16.

5. Benjamin, "On Some Motifs in Baudelaire," in *Selected Writings, Volume 4: 1938–1940* (Cambridge, Mass.: Harvard University Press, 2003), p. 328.

6. Benjamin, *Gesammelte Schriften*, I, 1049.

7. Benjamin, "On Some Motifs in Baudelaire," p. 328.

8. Frederick Winslow Taylor (1856–1915) established the discipline of business administration and was a pioneer in the study of corporate rationalization and management efficiency. "Taylorism" and "Taylorization" were slogans, particularly in Europe, for a more general industrial modernization.

9. See especially Benjamin's strategic endorsement of a new experiential "poverty" and of a "positive barbarism": Benjamin, "Experience and Poverty," in *Selected Writings, Volume 2: 1927–1934* (Cambridge, Mass.: Harvard University Press, 1999), pp. 731–736. For an extended and suggestive discussion of the place of the artwork essay in Benjamin's theory of experience, see Miriam Bratu Hansen, "Benjamin and Cinema: Not a One-Way Street," *Critical Inquiry*, 25 (Winter 1999): 306–343.

10. In a central fragment on film from *The Arcades Project*, Benjamin is explicit in his rejection of a political agenda that includes the "education" of a mass audience toward high art:

"On the political significance of film. Socialism would never have entered the world if its proponents had sought only to excite the enthusiasm of the working classes for a better order of things. What made for the power and authority of the movement was that Marx understood how to interest the workers in a social order which would both benefit them and appear to them as just. It is exactly the same with art. At no point in time, no matter how utopian, will anyone win the masses over to a higher art; they can be won over only to one nearer to them. And the difficulty consists precisely in finding a form for art such that, with the best conscience in the world, one could hold that it *is* a higher art. This will never happen with most of what is propagated by the avant-garde of the bourgeoisie. Here, what Berl advances is perfectly correct: 'The confusion over the word "revolution"—which, for a Leninist, signifies the acquisition of power by the proletariat, and which elsewhere signifies the overturning of recognized spiritual values—is sufficiently attested by the surrealists in their desire to establish Picasso as a revolutionary. . . . Picasso deceives them. . . . A painter is not more revolutionary for having "revolutionized" painting than a tailor like Poiret is for having "revolutionized" fashion, or than a doctor is for having "revolutionized" medicine.'" Benjamin is here quoting Emmanuel Berl, "Premier pamphlet," *Europe*, 75 (1929): 401.

Benjamin continues: "The masses positively require from the work of art (which, for them, has its place in the circle of consumer items) something that is warming. Here the flame most readily kindled is that of hatred. Its heat, however, burns or sears without providing the 'heart's ease' which qualifies art for consumption. Kitsch, on the other hand, is nothing more than art with a one-hundred-per-cent, absolute and instantaneous availabil-

ity for consumption. Precisely within the consecrated forms of expression, therefore, kitsch and art stand irreconcilably opposed. For developing, living forms, however, what matters is that they have within them something stirring, useful, ultimately heartening—that they take 'kitsch' dialectically up into themselves, and hence bring themselves near to the masses while yet surmounting kitsch. Today, perhaps, film alone is equal to this task—or, at any rate, more ready for it than any other art form. And whoever has recognized this will be inclined to disallow the pretensions of abstract film, as important as its experiments may be. He will call for a closed season on—a natural preserve for—the sort of kitsch whose providential site is the cinema. Only film can detonate the explosive stuff which the nineteenth century has accumulated in that strange and perhaps formerly unknown material which is kitsch. But, just as with the political structure of film, so also with the other distinctively modern means of expression (such as lighting or plastic design): abstraction can be dangerous."

Benjamin, *The Arcades Project,* pp. 395–396, Convolute K3a,1. On the explosive power of kitsch, see the introduction to Part III in this volume.

11. In "The Work of Art in the Age of Its Technological Reproducibility," Benjamin states very clearly that, under the conditions of capital, film cannot realize its most progressive potential, and he goes to some lengths to enumerate the means that the film industry uses to its ends, foremost among them a powerful publicity apparatus which enlists the careers and the love-lives of the stars in its service: "All this in order to distort and corrupt the original and justified interest of the masses in film—an interest in understanding themselves and therefore their class" (section XIII). Indeed, Benjamin concludes, the tendency so characteristic of fascism—to secretly exploit the undeniable desire for new social formations in the interest of a minority of owners—is particularly true of film capital. This makes the "expropriation of film capital" a task of central importance (section XIII).

12. For a contemporary discussion of the aesthetic politics of distraction, see Siegfried Kracauer's 1926 essay "Cult of Distraction," in Kracauer, *The Mass Ornament,* trans. and ed. Thomas Y. Levin (Cambridge, Mass: Harvard University Press, 1995), pp. 323–326. For an extended discussion of the role of distraction in Benjamin's late work, see Howard Eiland, "Reception in Distraction," *boundary 2,* 30, no. 1 (2003): 51–66.

13. On the concept of the aura, see Miriam Bratu Hansen, "Benjamin's Aura," *Critical Inquiry,* 34 (Winter 2008): 336–375.

14. Benjamin, *The Arcades Project,* p. 206, Convolute H2,3.

15. On the optical unconscious, see the introduction to Part IV in this volume.

31

On the Present Situation of Russian Film

The greatest achievements of the Russian film industry can be seen more readily in Berlin than in Moscow. What one sees in Berlin has been preselected, while in Moscow this selection still has to be made. Nor is obtaining advice a simple matter. The Russians are fairly uncritical about their own films. (For example, it is a well-known fact that *Potemkin* owes its great success to Germany.)[1] The reason for this insecurity in the matter of judgment is that the Russians lack European standards of comparison. Good foreign films are seldom seen in Russia. When buying films, the government takes the view that the Russian market is so important for the competing film companies of the world that they really have to supply it at reduced prices with what are in effect advertising samples. Obviously, this means that good, expensive films are never imported. For individual Russian artists, the resulting ignorance on the part of the public has its agreeable side. Iljinsky works with a very imprecise copy of Chaplin and is regarded as a comedian only because Chaplin is unknown here.[2]

At a more serious, general level, internal Russian conditions have a depressing effect on the average film. It is not easy to obtain suitable scenarios, because the choice of subject matter is governed by strict controls. Of all the arts in Russia, literature enjoys the greatest freedom from censorship. The theater is scrutinized much more closely, and control of the film industry is even stricter. This scale is proportional to the size of the audiences. Under this regimen the best films deal with episodes from the Russian Revolution; films that stretch further back into the Russian past constitute the insignificant average, while, by European standards, come-

323

dies are utterly irrelevant. At the heart of the difficulties currently facing Russian producers is the fact that the public is less and less willing to follow them into their true domain: political dramas of the Russian civil war. The naturalistic political period of Russian film reached its climax around a year and a half ago, with a flood of films full of death and terror. Such themes have lost all their attraction in the meantime. Now the motto is internal pacification. Film, radio, and theater are all distancing themselves from propaganda.

The search for conciliatory subject matter has led producers to resort to a curious technique. Since film versions of the great Russian novels are largely ruled out on political and artistic grounds, directors have taken over well-known individual types and built up new stories around them. Characters from Pushkin, Gogol, Goncharov, and Tolstoy are frequently taken over in this way, often retaining their original names.[3] This new Russian film is set by preference in the far eastern sections of Russia. This is as much as to say, "For us there is no 'exoticism.'" "Exoticism" is thought of as a component of the counterrevolutionary ideology of a colonial nation. Russia has no use for the Romantic concept of the "Far East." Russia is close to the East and economically tied to it. Its second message is: we are not dependent on foreign countries and natures—Russia is, after all, a sixth of the world! Everything in the world is here on our own soil.

And in this spirit the epic film of the new Russia, entitled *The Soviet Sixth of the Earth*, has just been released. It must be admitted that Vertov, the director, has not succeeded in meeting his self-imposed challenge of showing through characteristic images how the vast Russian nation is being transformed by the new social order.[4] The filmic colonization of Russia has misfired. What he has achieved, however, is the demarcation of Russia from Europe. This is how the film starts: in fractions of a second, there is a flow of images from workplaces (pistons in motion, laborers bringing in the harvest, transport works) and from capitalist places of entertainment (bars, dance halls, and clubs). Social films of recent years have been plundered for fleeting individual excerpts (often just details of a caressing hand or dancing feet, a woman's hairdo or a glimpse of her bejeweled throat), and these have been assembled so as to alternate with images of toiling workers. Unfortunately, the film soon abandons this approach in favor of a description of Russian peoples and landscapes, while the link between these and their modes of production is merely hinted at in an all too shadowy fashion. The uncertain and tentative nature of these efforts is illustrated by the simple fact that pictures of cranes hoisting equipment and transmission systems are accompanied by

an orchestra playing motifs from *Tannhäuser* and *Lohengrin.*[5] Even so, these pictures are typical in their attempts to make film straight from life, without any decorative or acting apparatus. They are produced with a "masked" apparatus. That is to say, amateurs adopt various poses in front of a dummy camera, but immediately afterward, when they think that everything is finished, they are filmed without being aware of it. The good, new motto "Away with all masks!" is nowhere more valid than in Russian film. It follows from this that nowhere are film stars more superfluous. Directors are not on the lookout for an actor who can play many roles, but opt instead for the characters needed in each particular instance. Indeed, they go even further. Eisenstein, the director of *Potemkin,* is making a film about peasant life in which he intends to dispense with actors altogether.

The peasants are not simply one of the most interesting subjects for a film; they are also the most important audience for the Russian cultural film. Film is being used to provide them with historical, political, technical, and even hygienic information. Up to now, however, the problems encountered in this process have left people feeling fairly perplexed. The mode of mental reception of the peasant is basically different from that of the urban masses. It has become clear, for example, that the rural audience is incapable of following *two simultaneous narrative strands* of the kind seen countless times in film. They can follow only a single series of images that must unfold chronologically, like the verses of a street ballad. Having often noted that serious scenes provoke uproarious laughter and that funny scenes are greeted with straight faces or even genuine emotion, filmmakers have started to produce films directly for those traveling cinemas that occasionally penetrate even the remotest regions of Russia for the benefit of people who have seen neither towns nor modern means of transport. To expose such audiences to film and radio constitutes one of the most grandiose mass-psychological experiments ever undertaken in the gigantic laboratory that Russia has become. Needless to say, in such rural cinemas the main role is played by educational films of every kind. Such films range from lessons in how to deal with plagues of locusts or use tractors, to films concerned with cures for alcoholism. Even so, much of the program of these itinerant cinemas remains incomprehensible to the great majority and can be used only as training material for those who are more advanced—that is to say, members of village soviets, peasant representatives, and so on. At the moment, the establishment of an "Institute for Audience Research" in which audience reactions could be studied both experimentally and theoretically is being considered.

In this way, film has taken up one of the great slogans of recent times:

"With our faces toward the village!" In film as in writing, politics provides the most powerful motivation: the Central Committee of the party hands down directives every month to the press, the press passes them on to the clubs, and the clubs pass them on to the theaters and cinemas, like runners passing a baton. By the same token, however, such slogans can also lead to serious obstacles. The slogan "Industrialization!" provided a paradoxical instance. Given the passionate interest in everything technical, it might have been expected that the slapstick comedy would be highly popular. In reality, however, for the moment at least, that passion divides the technical very sharply from the comic, and the eccentric comedies imported from America have definitely *flopped*. The new Russian is unable to appreciate irony and skepticism in technical matters. A further sphere denied to the Russian film is the one that encompasses all the themes and problems drawn from bourgeois life. Above all, this means: *They won't stand for dramas about love. The dramatic and even tragic treatment of love is rigorously excluded from the whole of Russian life.* Suicides that result from disappointed or unhappy love still occasionally occur, but Communist public opinion regards them as the crudest excesses.

For film—as for literature—all the problems that now form the focus of debate are problems of subject matter. Thanks to the new era of social truce, they have entered a difficult stage. The Russian film can reestablish itself on firm ground only when Bolshevist society (and not just the state!) has become sufficiently stable to enable a new "social comedy" to thrive, with new characters and typical situations.

Published in *Die literarische Welt*, March 1927. *Gesammelte Schriften*, II, 747–751. Translated by Rodney Livingstone.

Notes

1. Benjamin refers to *Battleship Potemkin* (1925), directed by the Soviet filmmaker and theorist Sergei Mikhailovich Eisenstein (1898–1948). Eisenstein's large body of work includes the films *Strike* (1925), *October* (1927), *Alexander Nevsky* (1938), and *Ivan the Terrible* (released in two parts, 1944 and 1958).
2. Igor Vladimirovich Iljinsky (1901–1987) was a Russian actor, well known for his comic portrayals of buffoons, vagabonds, rogues, and urban hustlers. The London-born actor and director Charlie Chaplin (Charles Spencer Chaplin; 1889–1977) came to the United States with a vaudeville act in 1910 and made his motion picture debut there in 1914, eventually achieving

worldwide renown as a comedian. He starred in and directed such films as *The Kid* (1921), *The Circus* (1928), *City Lights* (1931), *Modern Times* (1936), and *The Great Dictator* (1940). See Benjamin's short pieces "Chaplin" (1929) and "Chaplin in Retrospect" (1929), in this volume.

3. Ivan Alexandrovich Goncharov (1812–1891) was a Russian novelist whose works include *Oblomov* (1859) and *The Precipice* (1869).

4. The Soviet director Dziga Vertov (Denis Arkadyevich Kaufman; 1896–1954) is best known for his film *Man with the Movie Camera* (1929).

5. Benjamin refers to Richard Wagner's operas *Tannhäuser* (1845) and *Lohengrin* (1850).

32

Reply to Oscar A. H. Schmitz

There are replies that come close to being an act of impoliteness toward the public. Shouldn't we simply allow our readers to make up their own minds about a lame argument full of clumsy concepts? In this instance, they would not even need to have seen *Battleship Potemkin*.[1] Any more than Schmitz did.[2] For whatever he knows about the film he could have gleaned from the first newspaper notice that came to hand. But that is what characterizes the cultural Philistine: others read the notice and think themselves duly warned; he, however, has to "form his own opinion." He goes to see the film and imagines that he is in a position to translate his embarrassment into objective knowledge. This is a delusion. *Battleship Potemkin* can be objectively discussed either as film or from a political point of view. Schmitz does neither. He talks about his recent reading. Unsurprisingly, this leads him nowhere. To take this rigorous depiction of a class movement that has been wholly shaped according to the principles of the film medium and try to see how it measures up to bourgeois novels of society betrays an ingenuousness that is quite disarming. The same cannot quite be said of his onslaught on tendentious art. Here, where he marshals some heavy artillery from the arsenal of bourgeois aesthetics, plain speaking would be more appropriate. Why does he make such a fuss about the political deflowering of art, while faithfully tracking down all the sublimations, libidinous vestiges, and complexes through two thousand years of artistic production? How long is art supposed to act the well-brought-up young lady who knows her way around all the places of ill-repute yet wouldn't dream of asking about politics? But it's no use: she has always dreamed about it. The

claim that political tendencies are implicit in every artwork of every ep-
och—since these are, after all, historical creations of consciousness—is a
platitude. But just as deeper layers of rock come to light only at points of
fracture, the deeper formation of a political position becomes visible only
at fracture points in the history of art (and in artworks). The technical
revolutions—these are fracture points in artistic development where po-
litical positions, exposed bit by bit, come to the surface. In every new
technical revolution, the political position is transformed—as if on its
own—from a deeply hidden element of art into a manifest one. And this
brings us ultimately to film.

Among the points of fracture in artistic formations, film is one of the
most dramatic. We may truly say that with film a *new realm of con-
sciousness* comes into being. To put it in a nutshell, film is the prism
in which the spaces of the immediate environment—the spaces in which
people live, pursue their avocations, and enjoy their leisure—are laid
open before their eyes in a comprehensible, meaningful, and passion-
ate way. In themselves these offices, furnished rooms, saloons, big-city
streets, stations, and factories are ugly, incomprehensible, and hopelessly
sad. Or rather, they were and seemed to be, until the advent of film. The
cinema then exploded this entire prison-world with the dynamite of its
fractions of a second, so that now we can take extended journeys of ad-
venture between their widely scattered ruins. The vicinity of a house, of a
room, can include dozens of the most unexpected stations, and the most
astonishing station names. It is not so much the constant stream of im-
ages as the sudden change of place that overcomes a milieu which has re-
sisted every other attempt to unlock its secret, and succeeds in extracting
from a petty-bourgeois dwelling the same beauty we admire in an Alfa
Romeo. And so far, so good. Difficulties emerge only with the "plot."
The question of a meaningful film plot is as rarely solved as the abstract
formal problems that have arisen from the new technology. And this
proves *one* thing beyond all others: the vital, fundamental advances in art
are a matter neither of new content nor of new forms—the technological
revolution takes precedence over both. But it is no accident that in film
this revolution has not been able to discover either a form or a content
appropriate to it. For it turns out that with the untendentious play of
forms and the untendentious play of the plot, the problem can be re-
solved only on a case-by-case basis.

The superiority of the cinema of the Russian Revolution, like that of
the American slapstick comedy, is grounded on the fact that in their dif-
ferent ways they are both based on tendencies to which they constantly

recur. For the slapstick comedy is tendentious too, in a less obvious way. Its target is technology. This kind of film is comic, but only in the sense that the laughter it provokes hovers over an abyss of horror. The obverse of a ludicrously liberated technology is the lethal power of naval squadrons on maneuver, as we see it openly displayed in *Potemkin*. The international bourgeois film, on the other hand, has not been able to discover a consistent ideological formula. This is one of the causes of its recurrent crises. For the complicity of film technique with the milieu that constitutes its most essential project is incompatible with the glorification of the bourgeoisie. The proletariat is the hero of those spaces that give rise to the adventures to which the bourgeois abandons himself in the movies with beating heart, because he feels constrained to enjoy "beauty" even where it speaks of the annihilation of his own class. The proletariat, however, is a collective, just as these spaces are collective spaces. And only here, in the human collective, can the film complete the prismatic work that it began by acting on that milieu. The epoch-making impact of *Potemkin* can be explained by the fact that it made this clear for the first time. Here, for the first time, a mass movement acquires the wholly architectonic and by no means monumental (i.e., UFA) quality that justifies its inclusion in film.[3] No other medium could reproduce this collective in motion. No other could convey such beauty or the currents of horror and panic it contains. Ever since *Potemkin*, such scenes have become the undying possession of Russian film art. What began with the bombardment of Odessa in *Potemkin* continues in the more recent film *Mother* with the pogrom against factory workers, in which the suffering of the urban masses is engraved in the asphalt of the street like running script.[4]

Potemkin was made systematically in a collective spirit. The leader of the mutiny, Lieutenant Commander Schmidt, one of the legendary figures of revolutionary Russia, does not appear in the film. That may be seen as a "falsification of history," although it has nothing to do with the estimation of his achievements. Furthermore, why the actions of a collective should be deemed unfree, while those of the individual are free—this abstruse variant of determinism remains as incomprehensible in itself as in its meaning for the debate.

It is evident that the character of the opponents must be made to match that of the rebellious masses. It would have been senseless to depict them as differentiated individuals. The ship's doctor, the captain, and so on had to be types. Bourgeois types—this is a concept Schmitz will have nothing to do with. So let us call them sadistic types who have been summoned to the apex of power by an evil, dangerous apparatus. Of

course, this brings us face to face with a political formulation. An outcome which is unavoidable because it is true. There is nothing feebler than all the talk of "individual cases." The individual may be an individual case—but the uninhibited effects of his diabolical behavior are something else; they lie in the nature of the imperialist state and—within limits—the state as such. It is well known that many facts gain their meaning, their relief, only when they are put in context. These are the facts with which the field of statistics concerns itself. If a Mr. X happens to take his own life in March, this may be a supremely unimportant fact in itself. But it becomes quite interesting if we learn that suicides reach their annual peak during that month. In the same way, the sadistic acts of the ship's doctor may be isolated incidents in his life, the result of a poor night's sleep, or a reaction to his discovery that his breakfast egg is rotten. They become interesting only if we establish a relationship between the medical profession and the state. During the last years of the Great War, there was more than one highly competent study of this topic, and we can only feel sorry for the wretched little sadist of *Potemkin* when we compare his actions and his just punishment with the murderous services performed—unpunished—a few years ago by thousands of his colleagues on the sick and crippled at the behest of the general staff.

Potemkin is a great film, a rare achievement. To protest against it calls for the courage born of desperation. There is plenty of bad tendentious art, including bad socialist tendentious art. Such works are determined by their effects; they work with tired reflexes and depend on stereotyping. This film, however, has solid concrete foundations ideologically; the details have been worked out precisely, like the span of a bridge. The more violent the blows that rain down upon it, the more beautifully it resounds. Only if you touch it with kid gloves do you hear and move nothing.

Published (along with Oscar A. H. Schmitz's "Potemkin and Tendentious Art") in *Die literarische Welt*, March 1927. *Gesammelte Schriften*, II, 751–755. Translated by Rodney Livingstone.

Notes

1. Benjamin refers to *Battleship Potemkin* (1925), directed by the Soviet filmmaker and theorist Sergei Mikhailovich Eisenstein (1898–1948). Eisenstein's large body of work includes the films *Strike* (1925), *October* (1927), *Alexander Nevsky* (1938), and *Ivan the Terrible* (released in two parts, 1944 and 1958).

2. Oscar Adolf Hermann Schmitz (1873–1931), a playwright and essayist, maintained close contact with the circle around Stefan George. Benjamin's reply to Schmitz exemplifies the tenor of the arguments over *Battleship Potemkin*.

3. UFA (Universum-Film AG), the largest firm in the German film industry, was founded in 1917. Vertically integrated, UFA owned everything from machine shops and film laboratories to production and distribution facilities. It was acquired by the Hugenberg Group in 1927, nationalized by the German Reich in 1936–1937, and dismantled by the Allies in 1945.

4. The film *Mother* (1926), based on Gorky's novel, was made by the Soviet director and film theorist Vsevolod Illarionovich Pudovkin (1893–1953).

33

Chaplin

After a showing of *The Circus*.[1] Chaplin never allows the audience to smile while watching him. They must either double up laughing or be very sad.

Chaplin greets people by taking off his bowler, and it looks like the lid rising from the kettle when the water boils over.

His clothes are impermeable to every blow of fate. He looks like a man who hasn't taken his clothes off for a month. He is unfamiliar with beds; when he lies down, he does so in a wheelbarrow or on a seesaw.

Wet through, sweaty, in clothes far too small for him, Chaplin is the living embodiment of Goethe's *aperçu:* Man would not be the noblest creature on earth if he were not too noble for it.

This film is the first film of Chaplin's old age. He has grown older since his last films, but he also acts old. And the most moving thing about this new film is the feeling that he now has a clear overview of the possibilities open to him, and that he is resolved to work exclusively within these limits to attain his goal.

At every point the variations on his greatest themes are displayed in their full glory. The chase is set in a maze; his unexpected appearance would astonish a magician; the mask of noninvolvement turns him into a fair-ground marionette. The most wonderful part is the way the end of the film is structured. He strews confetti over the happy couple, and you think: This must be the end. Then you see him standing there when the circus procession starts off; he shuts the door behind everyone, and you think: This must be the end. Then you see him stuck in the rut of the circle earlier drawn by poverty, and you think: This must be the end. Then

you see a close-up of his completely bedraggled form, sitting on a stone in the arena. Here you think the end is absolutely unavoidable, but then he gets up and you see him from behind, walking further and further away, with that gait peculiar to Charlie Chaplin; he is his own walking trademark, just like the company trademark you see at the end of other films. And now, at the only point where there's no break and you'd like to be able to follow him with your gaze forever—the film ends!

Fragment written in 1928 or early 1929; unpublished in Benjamin's lifetime. *Gesammelte Schriften*, VI, 137–138. Translated by Rodney Livingstone.

Notes

1. The London-born actor and director Charlie Chaplin (Charles Spencer Chaplin; 1889–1977) came to the United States with a vaudeville act in 1910 and made his motion picture debut there in 1914, eventually achieving worldwide renown as a comedian. Besides *The Circus* (1928), he starred in and directed such films as *The Kid* (1921), *City Lights* (1931), *Modern Times* (1936), and *The Great Dictator* (1940). See also Benjamin's "Chaplin in Retrospect" (1929), in this volume.

34

Chaplin in Retrospect

The Circus is the first product of the art of film that is also the product of old age.[1] Charlie has grown older since his last film. But he also acts old. And the most moving thing about this new film is the feeling that Chaplin now has a clear overview of his possibilities and is resolved to work exclusively within these limits to attain his goal. At every point the variations on his greatest themes are displayed in their full glory. The chase is set in a maze; his unexpected appearance would astonish a magician; the mask of noninvolvement turns him into a fairground marionette. . . .

The lesson and the warning that emerge from this great work have led the poet Philippe Soupault to attempt the first definition of Chaplin as a historical phenomenon. In November the excellent Paris review *Europe* (published by Rieder, Paris), to which we shall return in greater detail, presented an essay by Soupault containing a number of ideas around which a definitive picture of the great artist will one day be able to crystallize.[2]

What he emphasizes there above all is that Chaplin's relation to the film is fundamentally not that of Chaplin the actor, let alone the star. Following Soupault's way of thinking, we might say that Chaplin, considered as a total phenomenon, is no more of an actor than was William Shakespeare. Soupault insists, rightly, that "the undeniable superiority of Chaplin's films . . . is based on the fact that they are imbued with a poetry that everyone encounters in his life, admittedly without always being conscious of it." What is meant by this is of course *not* that Chaplin is the "author" of his film *scripts*. Rather, he is simply the author of his own films—that is to say, their director. Soupault has realized that Chaplin

was the first (and the Russians have followed his example) to construct a film with a theme and variations—in short, with the element of composition—and that all this stands in complete opposition to films based on action and suspense. This explains why Soupault has argued more forcefully than anyone else that the pinnacle of Chaplin's work is to be seen in *A Woman of Paris*. This is the film in which, as is well known, he does not even appear and which was shown in Germany under the idiotic title *Die Nächte einer schönen Frau* [Nights of a Beautiful Woman]. (The Kamera Theater ought to show it every six months. It is a foundation document of the art of film.)

When we learn that 125,000 meters of film were shot for this 3,000-meter work, we get some idea of the capital that this man requires, and that is at least as necessary to him as to a Nansen or an Amundsen if he is to make his voyages of discovery to the poles of the art of film.[3] We must share Soupault's concern that Chaplin's productivity may be paralyzed by the dangerous financial claims of his second wife, as well as by the ruthless competition of the American trusts. It is said that Chaplin is planning both a Napoleon-film and a Christ-film. Shouldn't we fear that such projects are no more than giant screens behind which the great artist conceals his exhaustion?

It is good and useful that at the moment old age begins to show itself in Chaplin's features, Soupault should remind us of Chaplin's youth and of the territorial origins of his art. Needless to say, these lie in the metropolis of London.

> In his endless walks through the London streets, with their black-and-red houses, Chaplin trained himself to observe. He himself has told us that the idea of creating his stock character—the fellow with the bowler hat, jerky walk, little toothbrush moustache, and walking stick—first occurred to him on seeing office workers walking along the Strand. What he saw in their bearing and dress was the attitude of a person who takes some pride in himself. But the same can be said of the other characters that surround him in his films. They, too, originate in London: the shy, young, winsome girl; the burly lout who is always ready to use his fists and then to take to his heels when he sees that people aren't afraid of him; the arrogant gentleman who can be recognized by his top hat.

Soupault appends to this portrait a comparison between Dickens and Chaplin that is worth reading and exploring further.

With his art, Chaplin confirms the old insight that only an imaginative world that is firmly grounded in a society, a nation, and a place will suc-

ceed in evoking the great, uninterrupted, yet highly differentiated reso-
nance that exists between nations. In Russia, people wept when they
saw *The Pilgrim;* in Germany, people are interested in the theoretical
implications of his comedies; in England, they like his sense of humor. It
is no wonder that Chaplin himself is puzzled and fascinated by these dif-
ferences. Nothing points so unmistakably to the fact that the film will
have immense significance as that it neither did nor could occur to any-
one that there exists any judge superior to the actual audience. In his
films, Chaplin appeals both to the most international and the most revo-
lutionary emotion of the masses: their laughter. "Admittedly," Soupault
says, "Chaplin merely makes people laugh. But aside from the fact that
this is the hardest thing to do, it is socially also the most important."

Published in *Die literarische Welt,* February 1929. *Gesammelte Schriften,* III, 157–159.
Translated by Rodney Livingstone.

Notes

1. The London-born actor and director Charlie Chaplin (Charles Spencer Chap-
 lin; 1889–1977) released *The Circus* in 1928. Chaplin came to the United
 States with a vaudeville act in 1910 and made his motion picture debut there
 in 1914, eventually achieving worldwide renown as a comedian. He starred
 in and directed such films as *The Kid* (1921), *City Lights* (1931), *Modern
 Times* (1936), and *The Great Dictator* (1940). See also Benjamin's "Chap-
 lin" (1929), in this volume.
2. Philippe Soupault, "Charlie Chaplin," *Europe: Revue Mensuelle,* 18 (No-
 vember 1928): 379–402.
3. Fridtjof Nansen (1861–1930) and Roald Amundsen (1872–1928) were Nor-
 wegian explorers of the polar regions.

35

Mickey Mouse

From a conversation with Gustav Glück and Kurt Weill.[1]—Property relations in Mickey Mouse cartoons: here we see for the first time that it is possible to have one's own arm, even one's own body, stolen.

The route taken by a file in an office is more like that taken by Mickey Mouse than that taken by a marathon runner.

In these films, mankind makes preparations to survive civilization.

Mickey Mouse proves that a creature can still survive even when it has thrown off all resemblance to a human being. He disrupts the entire hierarchy of creatures that is supposed to culminate in mankind.

These films disavow experience more radically than ever before. In such a world, it is not worthwhile to have experiences.

Similarity to fairy tales. Not since fairy tales have the most important and most vital events been evoked more unsymbolically and more unatmospherically. There is an immeasurable gulf between them and Maeterlinck or Mary Wigman.[2] All Mickey Mouse films are founded on the motif of leaving home in order to learn what fear is.[3]

So the explanation for the huge popularity of these films is not mechanization, their form; nor is it a misunderstanding. It is simply the fact that the public recognizes its own life in them.

Fragment written in 1931; unpublished in Benjamin's lifetime. *Gesammelte Schriften*, VI, 144–145. Translated by Rodney Livingstone.

Notes

1. Gustav Glück (1902–1973), perhaps Benjamin's closest friend during the 1930s, was director of the foreign section of the Reichskreditgesellschaft (Imperial Credit Bank) in Berlin until 1938. He was able to arrange the transfer to Paris of the fees Benjamin received from his occasional contributions to German newspapers until 1935. In 1938 Glück emigrated to Argentina; after World War II, he was a board member of the Dresdner Bank. The German composer Kurt Weill (1900–1950) is best known for his collaborations with Bertolt Brecht, including *Die Dreigroschenoper* (The Threepenny Opera; 1928) and *Aufstieg und Fall der Stadt Mahagonny* (Rise and Fall of the City of Mahagonny; 1930).

2. Maurice Maeterlinck (1862–1949), Belgian writer and dramatist, was one of the leading figures of the Symbolist movement at the end of the nineteenth century. The German dancer and choreographer Mary Wigman (1886–1973) developed an Expressionist style of dance. She and her company often performed in silence or to percussion only; the idea was that the shape of the dance would emerge from the dancer's own rhythmic movement.

3. Benjamin refers to one of the fairy tales collected by the Brothers Grimm, "The Boy Who Left Home in Order to Learn the Meaning of Fear."

36

The Formula in Which the Dialectical Structure of Film Finds Expression

The formula in which the dialectical structure of film—film considered in its technological dimension—finds expression runs as follows. Discontinuous images replace one another in a continuous sequence. A theory of film would need to take account of both these facts. First of all, with regard to continuity, it cannot be overlooked that the assembly line, which plays such a fundamental role in the process of production, is in a sense represented by the filmstrip in the process of consumption. Both came into being at roughly the same time. The social significance of the one cannot be fully understood without that of the other. At all events, our understanding of this is in its infancy.—That is not quite the case with the other element, discontinuity. Concerning its significance we have at least one very important pointer. It is the fact that Chaplin's films have met with the greatest success of all, up to now.[1] The reason is quite evident. Chaplin's way of moving [*Gestus*] is not really that of an actor. He could not have made an impact on the stage. His unique significance lies in the fact that, in his work, the human being is integrated into the film image by way of his gestures—that is, his bodily and mental posture. The innovation of Chaplin's gestures is that he dissects the expressive movements of human beings into a series of minute innervations. Each single movement he makes is composed of a succession of staccato bits of movement. Whether it is his walk, the way he handles his cane, or the way he raises his hat—always the same jerky sequence of tiny movements applies the law of the cinematic image sequence to human motorial functions. Now, what is it about this behavior that is distinctively comic?

Fragment written in fall 1935; unpublished in Benjamin's lifetime. *Gesammelte Schriften*, I, 1040. Translated by Edmund Jephcott.

Notes

1. The London-born actor and director Charlie Chaplin (Charles Spencer Chaplin; 1889–1977) came to the United States with a vaudeville act in 1910 and made his motion picture debut there in 1914, eventually achieving worldwide renown as a comedian. He starred in and directed such films as *The Kid* (1921), *The Circus* (1928), *City Lights* (1931), *Modern Times* (1936), and *The Great Dictator* (1940). See Benjamin's short pieces "Chaplin" (1929) and "Chaplin in Retrospect" (1929), in this volume.

VI

THE PUBLISHING INDUSTRY AND RADIO

Benjamin's writings on journalism display a finely judged balance. On the one hand, they express a clear-eyed skepticism regarding the ways in which capital influences the mass media—"it is virtually impossible," according to Benjamin, "to write a history of information separately from a history of the corruption of the press."[1] On the other, they credit the newspaper with the potential for social change. Benjamin believed that the newspaper could be refunctioned as an organ of emancipatory communication; yet he also saw that, like all modern mass media, it too often served as a panacea, purveying "soothing little remedies"[2] that hid and ameliorated the dehumanizing effects of urban capitalism. A fragment from *The Arcades Project* is perhaps the best indication of Benjamin's fundamental position: "The ideologies of the rulers are by their nature more changeable than the ideas of the oppressed. For not only must they, like the ideas of the latter, adapt each time to the situation of social conflict, but they must glorify that situation as fundamentally harmonious."[3] If the newspaper conveys images of harmony and consolation disguised as information, then the reader must be equipped (as Benjamin maintains in his 1929 essay on Surrealism), with a generous supply of pessimism. "Mistrust in the fate of literature, mistrust in the fate of freedom, mistrust in the fate of European humanity, but three times mistrust in all reconciliation: between classes, between nations, between individuals. And unlimited trust only in IG Farben and the peaceful perfecting of the air force."[4]

Benjamin never theorized the mechanisms through which such skepticism could be inculcated in the readers of the modern newspaper. Instead,

he evoked one towering figure who could embody his scalding mistrust of the press: Karl Kraus. The Austrian journalist and author Kraus published his journal *Die Fackel* (The Firebrand) almost single-handedly from 1899 until shortly before his death in 1936. His bitter "struggle against the empty phrase" took the form of satire: the journal was relentless in its attacks on and parodies of the mainstream press and the public figures Kraus deemed responsible for the evisceration of language. Not surprisingly, *Die Fackel* was the object of libel litigation from its earliest issues. Benjamin is hardly content, though, simply to repeat the frequent characterizations of Kraus as the satirical scourge of the Austrian press. Such was Benjamin's respect for the gravity of the *general* problem of language as it was deployed in the press that he ascribed to Kraus the sort of extraordinary status that alone might transcend the contemporary situation: the status not of an avenging angel but of an obsessive, consumed, and inhuman monster. In highlighting Kraus's confession that he "shares the guilt," Benjamin ranks Kraus alongside the great poet Charles Baudelaire—figures who embody an age not because they rise above it or present its characteristic features in concentrated form but because, in life, they were capable of allowing the character of a historical moment to inscribe itself in their very flesh. Bertolt Brecht said it best about Kraus: "When the age laid hands upon itself, he was the hands."[5] The portrait of Kraus as the scourge of journalism is the culmination of Benjamin's lifelong fascination with the problem of mortification. Benjamin's Kraus is anything but a reformer, anything but a savior. He is the principle of the annihilation of journalistic language.

Yet Benjamin's critique of the publishing industry is more than an extension of his theory of language; it had important political dimensions. From his earliest essays on the press, he focused on the problem of the exclusion of large segments of the population not merely from the quite limited forms of authorship within which their interests might find expression, but, more perniciously, from the control of the apparatus itself. This dimension of Benjamin's thought is often referred to as Brechtian, in acknowledgment of Benjamin's sometime approach to the engaged politics advocated by his friend, the great dramatist Bertolt Brecht (1898–1956).[6] In a conversation with Brecht about Benjamin's essay "The Author as Producer" (Part I above), Benjamin reiterated its central claim: "that a decisive criterion of a revolutionary function of literature lies in the extent to which technical advances lead to a transformation of artistic forms and hence of intellectual means of production." Brecht counters Benjamin's position, with its emphasis on the politics of form, with a

much more radical notion of how the apparatus of production might be modified. "Brecht was willing to concede the validity of this thesis only for a single type—namely, the upper-middle-class writer, a type he thought included himself. 'Such a writer,' he said, 'experiences solidarity with the interests of the proletariat at a single point: the issue of the development of his means of production. But if solidarity exists at this single point, he is, as producer, totally proletarianized. This total proletarianization at a single point leads to a solidarity all along the line.'"[7]

Brecht's emphasis on the emergence of producers within a broad apparatus of production had important consequences for Benjamin. Much of his writing on the newspaper focuses precisely on the problem of how to turn a reader—understood as a passive receiver of information—into a producer. One solution would entail providing the working class with access to writing. As Benjamin says at the end of "The Newspaper" (Chapter 39 in this volume):

> Work itself has its turn to speak. And its representation in words becomes a part of the ability that is needed for its exercise. Literary competence is no longer founded on specialized training but is now based on polytechnical education, and thus becomes public property. It is, in a word, the literarization of the conditions of living that masters the otherwise insoluble antinomies. And it is at the scene of the limitless debasement of the word—the newspaper, in short—that its salvation is being prepared.

Part of Benjamin's critique involves the democratization of the processes of literary production. In sections of the paper such as the letters to the editor, control of writing is wrenched from the grasp of a specially trained elite and passed to the hands of a broad public with a very different—but no less important—training. Benjamin clearly hoped that this process might transform the newspaper from the inside out. The concept of "literarization" he invokes, though, marks a shift in the argument toward even broader political implications. If political antinomies (competing class interests, radically unequal access to capital, and so on) remain insoluble within "the conditions of living," Benjamin places—here and throughout his late work—enormous hope in the transformed processes of reading and writing that he calls "literarization." *Texts themselves* might provide spaces for the productive confrontation with issues of class conflict, as the newspaper becomes a public forum. The term "polytechnical," however, suggests a broader context, evoking as it does the "technical diagrams" mentioned in "Attested Auditor of Books"

(Chapter 12 above) and thus the concept of script, as well as the notion of "polytechnical training" toward a new form of spectatorship described in the artwork essay.[8]

"Literarization" is thus a textual condition in which readers of all classes are exposed to "flashes" of insight that might themselves make recognizable the otherwise hidden, fundamental contradictions in the "conditions of living." And this recognition is the precondition for any form of social change. Thus, the dense passage quoted above suggests that the reading public might become more than passive receivers of information (or rather ideology disguised as information): it might progress to a state in which it becomes a public of *producers* and *readers* of script—the graphic figure that may bear an emancipatory charge. Such a transformation, for Benjamin, would constitute a revolution in the control of the apparatus of production.[9]

Just as Benjamin's reflections on the newspaper as medium were informed by his own extensive experience publishing in mass-circulation venues such as the *Frankfurter Zeitung,* his theoretical texts on radio were intimately linked to his sizable (though much less well-known) body of broadcast work. Like the newspaper, the new medium of radio seemed to hold out great promise for fundamental transformations in various domains, with all sorts of far-reaching sociopolitical ramifications. For example, the very character of "the popular," Benjamin argues (in the essay "Two Types of Popularity," below), undergoes a massive shift with the advent of radio. Whenever you consider broadcasting something on the airwaves, the conditions of such dissemination require that you fundamentally rethink the material in terms of a new kind of audience: "Thanks to the technological possibility [radio] opened up of addressing unlimited masses simultaneously, the practice of popularizing developed beyond the character of a well-intentioned philanthropic intention and became a task with its own types of formal and generic laws." What would it mean to write for radio in a manner adequate to these new conditions?

Benjamin was intimately familiar with the difficulty posed by this challenge, not only as a theoretical but also as a practical matter. Nearly two years after his radio debut on March 23, 1927, with a program entitled "Young Russian Poets," Benjamin's intensive engagement with radio is effectively announced by the appearance, in late August 1929, of his "Conversation with Ernst Schoen" (Chapter 43 below), a dialogue with the new director of Südwestdeutscher Rundfunk (Southwest German Ra-

dio) on the possibilities and current state of public broadcasting.[10] This text marks the first of a series of essays that Benjamin would write about the medium that had begun to provide one of his most regular sources of income.[11] In slightly more than three years, beginning in the summer of 1929, Benjamin created eighty-six programs for Radio Frankfurt under Schoen. These included readings of his own essays and book reviews (a practice popular among Weimar authors such as Thomas Mann, Alfred Döblin, and many others), lectures on various topics (including Brecht, Kafka, and Kracauer), stories, discussion programs, and a large number of broadcasts (almost two-thirds of his total radio output) for the *Jugendstunde*, or Youth Hour.[12] Scholars have speculated that Benjamin recorded more than sixty of these programs himself, but unfortunately not one of these traces of his "full, beautiful voice" (as his collaborator the journalist Wolf Zucker once described it) has survived.[13]

Given the extent of his involvement with the fledgling national broadcast medium—which did not exist in Germany until 1923—it seems strange that Benjamin, who was famous for cataloguing everything he did (compiling lists of books he had read, essays written, and so on), was almost completely silent about his radio work. Indeed, the few references to his broadcasts in his correspondence are almost always disparaging, dismissing as an annoying wage-earning obligation what was in fact—as evidenced by the broadcast manuscripts and other documentation that have survived—quite a passionate engagement. To understand Benjamin's seeming ambivalence concerning his involvement with radio, one must place his work in the context of the nascent state of German radio in the later years of the Weimar Republic.[14] Founded for political reasons as an exclusively "cultural" (which is to say explicitly nonpolitical) entity, German *Rundfunk* was a very curious institution. Every sort of cultural organization, no matter how banal, was allotted its own regular broadcast slot; there was no live reportage (except for the occasional sports broadcast); and all programs were subject to meticulous and usually provincial censorship. Despite its potential, radio in the late Weimar Republic was, in short, not a medium that could readily lend itself to the kind of avant-garde experimentation and compelling actuality that was characteristic of other contemporary technical media, such as photography and film.

This is the polemical context for the "Conversation with Ernst Schoen," and especially for the very risky insistence that quality programming would be possible only after one abandoned the model of radio as a "huge public education enterprise" whose exclusive content was "Cul-

ture with a massive capital C" and grasped it instead as a means to explore daily life, to undertake the analysis of current events—in short, to assume the challenge posed by being political. Radio, Benjamin insisted, should take up the mantle from earlier political stage cabarets, such as Le Chat Noir in Paris and Die Elf Scharfrichter in Munich, but in a manner specific to the new medium. It was just this challenge that Hans Flesch effectively attempted to translate into reality when he took over the direction of Radio Berlin, instituting a department for current events, broadcasting important trials, parliamentary debates, and local fare from new mobile radio studios, and producing the very first on-air political debates. While Benjamin's comparatively modest innovations were not on the order of such fundamental institutional interventions, his broadcasts—with titles like "Postage Stamp Scams," "The Tenements," "True Stories about Dogs," and "Visit to a Brass Factory," to take just a few examples—did push the boundaries of his ostensibly literary rubric in the direction of what today we would call "cultural criticism." He also coauthored with Wolf Zucker a new type of nonliterary radio play called a *Hörmodell* ("listening model") which, unlike the traditional *Hörspiel* ("listening play"), focused on practical problems of contemporary life presented in a "casuistic" fashion. One of the first of these was "Gehaltserhöhung?! Wo denken Sie hin?" (A Raise?! Where Did You Get That Idea?), which explores techniques for negotiating an increase in pay and does so by staging two contrasting versions of the same situation. In a typescript that refers to this listening model and two others—"Der Junge sagt einem kein wahres Wort" (The Boy Tells Nothing But Lies) and "Kannst du mir bis Donnerstag aushelfen?" (Can You Help Me Out Till Thursday?)—and that may have served as an introduction to the broadcast by Radio Frankfurt of all three pieces in 1931–1932, Benjamin explains their common structural logic as follows:

> The fundamental purpose of these models is didactic. The focus of instruction consists in the confrontation of an example and a counter-example.
>
> In each of the listening models, the speaker appears three times: at the outset he introduces the listeners to the subject that will be explored, then introduces to the audience the two dialogue partners who appear in the first part of the *Hörmodell*. This initial section presents the counter-example: *this* is not the way to do it. Following the conclusion of the first part, the speaker returns and points out the mistakes that were made. He then introduces the listeners to a new character who will appear in the second part and will demonstrate the right way to deal with the same situation. At

the end the speaker compares the incorrect method with the correct one and formulates a conclusion. Thus, no listening model has more than four principle roles: (1) the speaker; (2) the model figure, who is the same in the first and the second parts; (3) the clumsy partner in the first part; (4) the smart partner in the second part.[15]

As is evident from the dialectical character of this genre experiment, Benjamin understood radio as an important opportunity for the Brechtian refunctioning of an entire medium. The point was not simply to deliver material to the radiophonic apparatus in its current state, but to transform the apparatus itself by taking full advantage of opportunities that the new medium made possible but that were still largely unexploited or even unrecognized. However, unlike Brecht's call for radio to be converted from a one-way distribution technology into a two-way medium of communication (a utopian demand that Brecht himself acknowledged was pragmatically impossible under current conditions),[16] Benjamin's interventions were focused on making more attainable changes at the level of programming. The listening models attempted to do just that, provoking the listeners in their refusal to develop character psychology, providing them with practical models with which to confront the very real problems of their current situation, and, on at least one occasion, giving them the opportunity to come to the studio and talk about the program (and then broadcasting that discussion). When the radio station would forward piles of (mostly furious) listener mail, Benjamin's responses would invariably thank the letter writers for their interest and would agree with their objections, since, for Benjamin, as his collaborator Zucker recalled, in the business of the listening model the customer was always right. This is precisely the "thorough refashioning and reconstellation of the material from the perspective of popularity" which Benjamin saw (in "Two Types of Popularity," below) as the salutary consequence of radio's mass listenership. As he goes on to say there, "What is at stake here is a popularity that not only orients knowledge toward the public sphere, but also simultaneously orients the public sphere toward knowledge. In a word: the truly popular interest is always active."

If German radio was slowly beginning to change, these incremental reforms did not survive the shifting political climate of 1932: almost overnight, the tentatively political character of the airwaves was eliminated altogether. As a consequence, Benjamin's final radio broadcast tactically adopted a rather traditional format—a reading of some excerpts

from his *Berlin Childhood around 1900*. It aired on January 29, 1933, the day before the German airwaves transmitted the very first nationwide live broadcast, violating every rule and censorship dictate of the medium—the Nazi torchlight parade celebrating the appointment of Hitler as chancellor of Germany. It is hardly surprising that Benjamin's last commissioned radio play, a "cross-section" through the work of the Enlightenment writer, astronomer, and physicist Georg Christoph Lichtenberg (1742–1799), had to be completed in February 1933 in exile on the Balearic Islands and was never broadcast. Set on the Moon, in a lunar crater actually named after Lichtenberg, this ironic diasporic allegory tells the tale of the meeting of the "Moon Committee for Earth Research" which is studying the human race, as exemplified by Lichtenberg. Perplexed by the fact that mankind has amounted to so little, the committee members review Lichtenberg's case and decide that his achievements do in fact merit recognition. As Benjamin writes in a corrosive draft that makes clear the political stakes of this interplanetary perspective: "The Moon Committee recalls the appropriate manner of celebrating honored citizens of the Earth who indeed depend on this, so long as the earth itself is not yet at a stage where it is able to accord its subjects their civic rights."[17]

It is against this background that we must situate Benjamin's last text on radio, "On the Minute" (Chapter 45)—a retrospective meditation on his very first in-studio performance, published in the *Frankfurter Zeitung* on December 6, 1934, under the pseudonym Detlef Holz. Beyond its astute characterization of the medium-specific differences between a lecture delivered to an audience and one spoken over the radio, "On the Minute" describes the dramatic consequences of his nervous misreading of the studio clock. In light of Benjamin's serious interest in new media in general, and his rather fraught engagement with the medium of radio in particular, it is tempting to read this account as an allegory of his failed attempt to transform—that is, politicize—the medium. The essay concludes with a remark by a friend who heard the broadcast and mistook Benjamin's performative failure (a long silence in the course of his delivery) as merely an all-too-familiar malfunction of the radio medium: he assumed that the silence was due simply to a faulty receiver.

But what is this, if not a comment on how what is perceived as a technological failure is in fact the result of human deficiency? In other words, the failings of Weimar radio were not a (mal-)function of the technology, but a result of an all-too-human failure to develop the medium's substantial potential. This fact would also explain Benjamin's curious silence

about his large corpus of radio broadcasts. His reticence thus bespeaks not an ambivalence about the medium as such, but rather his enormous frustration at his inability—despite passionate engagement—to transform it into the empowering vehicle he knew it could be.

THOMAS Y. LEVIN AND MICHAEL W. JENNINGS

Notes

1. Walter Benjamin, "The Paris of the Second Empire in Baudelaire," in *Selected Writings, Volume 4: 1938–1940* (Cambridge, Mass.: Harvard University Press, 2003), p. 13.

2. Ibid., p. 21. Benjamin often used Bertolt Brecht's term *umfunktionieren* ("to refunction"), which means to wrest a tool, an idea, a phrase from its original context and, while retaining its "use value," to invest it with a new, usually political capacity.

3. Benjamin, *The Arcades Project,* trans. Howard Eiland and Kevin McLaughlin (Cambridge, Mass.: Harvard University Press, 1999), p. 364, Convolute J77,1.

4. Benjamin, "Surrealism," in *Selected Writings, Volume 2: 1927–1934* (Cambridge, Mass.: Harvard University Press, 1999), pp. 216–217. IG Farben (the acronym for Interessen-Gemeinschaft Farbenindustrie AG, or "Syndicate of Dyestuff Corporations") was a conglomerate of German companies, founded in the wake of World War I, which expanded from its initial concentration on paints and dyes to become the dominant chemical industry. It was infamous for its manufacture of the poison gas Zyklon B, used in German concentration camps during the National Socialist regime.

5. Benjamin, "Karl Kraus," Chapter 40 in this volume.

6. The direct, engaged, "Brechtian" element of Benjamin's thought became, in the course of the 1930s, a source of tension between Benjamin and his Frankfurt School colleagues Theodor Adorno and Max Horkheimer. For an account of these tensions, see Ernst Bloch, Theodor Adorno, Walter Benjamin, Bertolt Brecht, et al., *Aesthetics and Politics,* ed. Ronald Taylor, afterword by Fredric Jameson (London: New Left Books, 1977).

7. Benjamin, "Notes from Svendborg, Summer 1934," *Selected Writings,* vol. 2, p. 783.

8. See the introductions to Parts I and II in this volume.

9. On the problem of "recognizability," see especially Convolute N of *The Arcades Project,* and the essay "On the Concept of History" in *Selected Writings,* vol. 4.

10. Ernst Schoen (1894–1960)—the successor to Hans Flesch, the pioneering first director of the Radio Frankfurt station, who had left to run the Funk-Stunde AG (Radio Hour Ltd.) in Berlin—was one of the very few friends Benjamin

had kept from his schooldays. They remained close despite Schoen's affair with Benjamin's wife, Dora, in the early 1920s.

11. Besides "Reflections on Radio" (Chapter 41 below), "Theater and Radio" (Chapter 42 below), "Two Types of Popularity" (Chapter 44 below), and "On the Minute" (Chapter 45 below), Benjamin's writings on radio include the fragmentary sketch "Situation im Rundfunk" and an exchange of letters between Benjamin and Schoen in April 1930 dealing with broadcast matters. See *Gesammelte Schriften*, II, 1497ff. (April 4 and April 10, 1930).

12. Sabine Schiller-Lerg's pathbreaking 1984 study *Walter Benjamin und der Rundfunk: Programmarbeit zwischen Theorie und Praxis* (Munich: Saur, 1984) remains the definitive resource on the radiophonic dimension of Benjamin's corpus; see also her essay "Walter Benjamin, Radio Journalist: Theory and Practice of Weimar Radio," *Journal of Communication Inquiry*, 13 (1989): 43–50. To the extent that they have survived, Benjamin's texts for radio are collected in *Gesammelte Schriften*, VII, 68–294. Examples of Benjamin's radio broadcasts in translation include "Children's Literature" (1929), "An Outsider Makes His Mark" (1930), "Bert Brecht" (1931), "Unpacking My Library" (1931), "Franz Kafka: *Beim Bau der Chinesischen Mauer*" (1931), "The Lisbon Earthquake" (1931), and "The Railway Disaster at the Firth of Tay" (1932), in *Selected Writings*, vol. 2, pp. 250–256, 305–311, 365–371, 486–493, 494–500, 536–540, 563–568. See also Jeffrey Mehlman, *Walter Benjamin for Children: An Essay on His Radio Years* (Chicago: University of Chicago Press, 1993).

13. Late in his life, Zucker published an account of his radio collaborations with Benjamin: Wolfgang M. Zucker, "So entstanden die Hörmodelle," *Die Zeit*, 47 (November 24, 1972), Literary Supplement, p. 7.

14. On the history of Weimar radio, see Winfried B. Lerg, *Rundfunkpolitik in der Weimarer Republik*, vol. 1 of Hans Bausch, ed., *Rundfunk in Deutschland* (Munich: Deutscher Taschenbuch Verlag, 1980). For a discussion of early German radio in its contemporary cultural context, see Christopher Hailey, "Rethinking Sound: Music and Radio in Weimar Germany," in Bryan Gilliam, ed., *Music and Performance during the Weimar Republic* (Cambridge: Cambridge University Press, 1994), pp. 13–36.

15. Benjamin, "Hörmodelle," *Gesammelte Schriften*, IV, 628.

16. For Brecht's position on radio, see his 1932 text "The Radio as an Apparatus of Communication," in Anton Kaes et al., eds., *The Weimar Republic Sourcebook* (Berkeley: University of California Press, 1994), pp. 615–616.

17. Commissioned by Radio Berlin, which paid Benjamin for the piece even though it never aired, "Lichtenberg: Ein Querschnitt" (Lichtenberg: A Cross-Section) grew out of a vast bibliography of Lichtenberg's writings which Benjamin had been working on since 1931 for the lawyer and Lichtenberg collector Martin Domke (1892–1980), whom he had known from his schooldays. See *Gesammelte Schriften*, IV, 696–720; and VII, 837–845.

37

Journalism

Alongside all the solemnity that frames Lindbergh's flight across the Atlantic, we may allow ourselves the arabesque of a joke—the amusing pendant to the regrettable frivolity with which the Paris evening papers prematurely announced the triumph of Nungesser and Coli.[1] The same papers are now exposed for the second time. They owe this to an idea conceived by a student at the Ecole Normale—an idea that Karl Kraus might envy.[2] As is well known, this Ecole Normale is the celebrated French state school that every year admits only an elite group of applicants, after the stiffest entrance examinations. On the afternoon of the first day Charles Lindbergh spent in Paris, someone telephoned all the newspaper editors with the news that the Ecole Normale had resolved to declare the aviator "a former student." And all the papers printed the announcement. Among the medieval Scholastics, there was a school that described God's omnipotence by saying: He could alter even the past, unmake what had really happened, and make real what had never happened. As we can see, in the case of enlightened newspaper editors, God is not needed for this task; a bureaucrat is all that is required.

Published in *Die literarische Welt*, June 1927. *Gesammelte Schriften*, IV, 454. Translated by Rodney Livingstone.

Notes

1. On May 21, 1927, the American aviator Charles Augustus Lindbergh (1902–1974) landed in Paris, winning the prize of $25,000 offered by the hotel owner Raymond Orteig for the first nonstop flight between New York and

Paris. Less than two weeks before Lindbergh's arrival, the French aviators Charles Nungesser (1892–1927) and François Coli (1881–1927) disappeared over the North Atlantic during their attempt to win the prize.

2. Benjamin refers to the Austrian satirist and critic Karl Kraus (1874–1936). See Benjamin's "Karl Kraus" (1931), in this volume.

38

A Critique of the Publishing Industry

Writers are among the most backward sectors of the population when it comes to exploiting their own social experience. They regard one another simply as colleagues; their readiness to form judgments and protect their own interests is, as in all people concerned with status, far prompter toward those beneath them than toward those higher up. They do sometimes manage to obtain a good deal from a publisher. But for the most part they are unable to give an account of the social function of their writing, and it follows that in their dealings with publishers they are no better able to reflect on their function to any effect. There are undoubtedly publishers who take a naive view of their own activities and who genuinely believe that their only moral task is to distinguish between good books and bad, and that their only commercial task is to distinguish books that will sell from those that will not. In general, however, a publisher has an incomparably clearer idea of the circles to whom he is selling than writers have of the audience for whom they write. This is why they are no match for him and are in no position to control him. And who else should do that? Certainly not the reading public; the activities of publishers fall outside their field of vision. This leaves the retailer as the only court of appeal. It is superfluous to remark how problematic retailers' control must be, if only because it is irresponsible and secret.

What is called for is obvious. That it cannot happen overnight, and that it can never be fully implemented in the capitalist economic system, should not prevent us from stating it. As a prerequisite for everything else, what is indispensable is a statistical survey of the capital at work in the publishing world. From this platform, the investigation should pro-

ceed in two directions. On the one hand, as a follow-up to the question: What is the source of these capital sums? In other words, how much capital has migrated into publishing from the banking, textile, coal, steel, and printing industries? On the other hand, what does publishing capital supply to the book market? It would be but a short step from there to combine these questions and investigate whether, when capital flows into publishing, it is directed at specific customer strata and trends that correspond, say, to coal and steel, as opposed to textiles. But the statistical foundations of this third area are too difficult to obtain for there to be any prospects of undertaking such a project soon. In contrast, the more unreliable opinion surveys of the public and of booksellers could easily be supplemented by information gathered at intervals from the publishers themselves about the sales figures in different markets for their main products. Since publishers already inform us about the size of editions, this should not prove to be such a perilous step, or so one might think. Of the very greatest interest, furthermore, would be statistical information about the relation between the size of an edition and advertising costs; likewise, a statistical picture of the relation between commercial success (sales figures) and literary success (critical reception in the press). Last, and the most difficult of all: the percentages of successful books and failures among all the titles issued annually by individual publishers and by the German book trade as a whole.

The objection that such methods would lead to thinking that commercial success is the only criterion relevant to books is as obvious as it is false. Of course, there are valuable books that fail to sell, and that a good publisher will nevertheless wish to sell not only as a matter of honor but on publishing principles. (In the same way, confectioners will put sugaricing castles and candy towers in their shop windows without any intention of selling them.) But of course the analysis we are calling for, and which has the additional benefit of being the most reliable method of making use of books to inquire into the spiritual currents of the nation, also has the particular merit of eliminating the most common—and most erroneous—view of publishing in vogue at present. According to this view, a publishing house is a combined operation, consisting of organized patronage on the one hand and a lottery on the other, in which every new book is a number and the reading public acts as banker. From the players' (in other words, the publishers') winnings, a part is used to bet on numbers that look splendid and significant but that scarcely figure in the roulette of the reading public. In short, this is the abstract view of publishing: on the one hand, the publisher as a broker between individual

manuscripts; on the other, "the" reading public. But this view is false through and through, because the publisher is not in a position to form an opinion in a vacuum about either the ideal value or the commercial value of a book. In the final analysis, a publisher has to have a close relationship with specific literary fields—within which he does not need to follow any particular line—because this is the only way for him to maintain contact with his reading public, without which his business is doomed to failure. Obvious though this is, it is no less striking that in Germany, which possesses a number of physiognomically clearly defined publishing houses—Insel, Reclam, S. Fischer, Beck, and Rowohlt—no attempt has ever been made to undertake a sociological study, let alone a critique of these institutions. Yet this would be the only way to measure the gulf that divides our great publishing houses from those dilettantish private operations that disappear every year by the dozen, only to be replaced by similar firms that open up in their wake. Moreover, it would be hard to resist the observation that even the straightforward commercial satisfaction of demand would be, if not exactly laudable, at any rate far more respectable than a pretentious idealism that floods the market with meaningless books, tying up capital in them that could be much better invested for nonliterary purposes.

Only experience will enable us to discover the benefits of an annual critical survey of German publishing policy. Such a critique, in which literary standards would have to take a back seat to sociological ones—which, themselves, would be only one aspect—would lay bare the antinomy between what might be called constructive and organic publishing policies. A publisher may construct his operations so as to encompass and establish certain sectors. But he can also let his business develop organically out of loyalty to particular authors or schools. These two approaches cannot always go hand in hand. This very fact ought to lead a publisher to make a definite business plan and approach writers with specific projects. Not that such an approach is entirely unknown. But in an age in which both economic production and intellectual production have been rationalized, it should become the norm. One reason there is no sign of it at present lies in the general underestimation of the role of publishers' referees. The time when a Julius Elias or a Moritz Heimann could exercise a decisive influence on a publisher appears to be over.[1] But publishers are making a great mistake when they treat their referees merely as gatekeepers or else as naysayers, instead of as experts in publishing policy who are intelligent enough to solicit usable manuscripts rather than merely sifting through useless ones. And for their part, the editors are

wrong to set their own idealism against publishers' materialism, instead of treating ideas in such a way that the publisher will be tied to them for the sake of his material interests. It may lend additional weight to these brief proposals if publishers come to see that the leaders among them will benefit more in terms of both honor and profit from a sound criticism of their activities than from a case-by-case opinion of their products or their sense of fair play.

Published in the *Literaturblatt der Frankfurter Zeitung*, November 1930. *Gesammelte Schriften*, II, 769–772. Translated by Rodney Livingstone.

Notes

1. Julius Elias (1861–1927), German historian of art and literature, was a champion of Impressionism and the editor of Ibsen's collected works. Moritz Heimann (1868–1925), senior editor at Fischer Verlag, furthered the careers of such authors as Gerhart Hauptmann, Hermann Hesse, and Thomas Mann.

39

The Newspaper

In our writing, opposites that in happier ages fertilized one another have become insoluble antinomies.[1] Thus, science and belles lettres, criticism and literary production, culture and politics, fall apart in disorder and lose all connection with one another. The scene of this literary confusion is the newspaper; its content, "subject matter" that denies itself any other form of organization than that imposed on it by the reader's impatience. For impatience is the state of mind of the newspaper reader. And this impatience is not just that of the politician expecting information, or of the speculator looking for a stock tip; behind it smolders the impatience of people who are excluded and who think they have the right to see their own interests expressed. The fact that nothing binds the reader more tightly to his paper than this all-consuming impatience, his longing for daily nourishment, has long been exploited by publishers, who are constantly inaugurating new columns to address the reader's questions, opinions, and protests. Hand in hand, therefore, with the indiscriminate assimilation of facts goes the equally indiscriminate assimilation of readers, who are instantly elevated to collaborators. Here, however, a dialectical moment lies concealed: the decline of writing in this press turns out to be the formula for its restoration in a different one. For since writing gains in breadth what it loses in depth, the conventional distinction between author and public that the press has maintained (although it is tending to loosen it through routine) is disappearing in a socially desirable way. The reader is at all times ready to become a writer—that is, a describer or even a prescriber. As an expert—not perhaps in a discipline, but perhaps in a post that he holds—he gains access to authorship. Work itself has its

turn to speak. And its representation in words becomes a part of the ability that is needed for its exercise. Literary competence is no longer founded on specialized training but is now based on polytechnical education, and thus becomes public property. It is, in a word, the literarization of the conditions of living that masters the otherwise insoluble antinomies. And it is at the scene of the limitless debasement of the word—the newspaper, in short—that its salvation is being prepared.

Published in *Der öffentliche Dienst* (Zürich), March 1934. *Gesammelte Schriften,* II, 628–629. Translated by Rodney Livingstone. A portion of this essay was incorporated into "Der Autor als Produzent" (April 1934). A previous translation of that portion, done by Edmund Jephcott (New York, 1978), was consulted.

Notes

1. The following passage is a modification of similar ideas expressed in "Diary from August 7, 1931, to the Day of My Death" (1931), in Benjamin, *Selected Writings, Volume 2: 1927–1934* (Cambridge, Mass.: Harvard University Press, 1999), pp. 501–506. Benjamin also cites from this essay in "The Author as Producer" (1934), in this volume.

40

Karl Kraus

Dedicated to Gustav Glück[1]

1. Cosmic Man [*Allmensch*]

How noisy everything grows.
—KRAUS, *Words in Verse*, II

In old engravings, there is a messenger who rushes toward us crying aloud, his hair on end, brandishing a sheet of paper in his hands—a sheet full of war and pestilence, of cries of murder and pain, of danger from fire and flood—spreading everywhere the Latest News. "News" in this sense, in the sense that the word has in Shakespeare, is disseminated by *Die Fackel* [The Torch].[2] Full of betrayal, earthquakes, poison, and fire from the *mundus intelligibilis*. The hatred with which it pursues the tribe of journalists that swarms into infinity is not only a moral hatred but a vital one, such as is hurled by an ancestor upon a race of degenerate and dwarfish rascals that has sprung from his seed. The very term "public opinion" outrages Kraus. Opinions are a private matter. The public has an interest only in judgments. Either it is a judging public, or it is none. But it is precisely the purpose of the public opinion generated by the press to make the public incapable of judging, to insinuate into it the attitude of someone irresponsible, uninformed. Indeed, what is even the most precise information in the daily newspapers in comparison to the hair-raising meticulousness observed by *Die Fackel* in the presentation of legal,

361

linguistic, and political facts? *Die Fackel* need not trouble itself about public opinion, for the blood-steeped novelties of this "newspaper" demand a passing of judgment. And on nothing more impetuously, urgently, than on the press itself.

A hatred such as that which Kraus has heaped on journalists can never be founded simply on what they do—however obnoxious this may be; this hatred must have its reason in their very being, whether it be antithetical or akin to his own. In fact, it is both. His most recent portrait, in its very first sentence, characterizes the journalist as "a person who has little interest either in himself and his own existence, or in the mere existence of things, but who feels things only in their relationships, above all where these meet in events—and only in this moment become united, substantial, and alive." What we have in this sentence is nothing other than the negative of an image of Kraus. Indeed, who could have shown a more burning interest in himself and his own existence than the writer who is never finished with this subject? Who, a more attentive concern for the mere existence of things, their origin? Whom does that coincidence of the event with the date, the witness, or the camera cast into deeper despair than him? In the end, he brought together all his energies in the struggle against the empty phrase, which is the linguistic expression of the despotism with which, in journalism, topicality sets up its dominion over things.

This side of his struggle against the press is illuminated most vividly by the life's work of his comrade-in-arms, Adolf Loos. Loos found his providential adversaries in the arts-and-crafts mongers and architects who, in the ambit of the "Vienna Workshops," were striving to give birth to a new art industry.[3] He sent out his rallying cry in numerous essays—particularly, in its enduring formulation, in the article "Ornamentation and Crime," which appeared in 1908 in the *Frankfurter Zeitung*. The lightning flash ignited by this essay described a curiously zigzag course. "On reading the words with which Goethe censures the way the philistine, and thus many an art connoisseur, run their fingers over engravings and reliefs, the revelation came to him that what may be touched cannot be a work of art, and that a work of art must be out of reach." It was therefore Loos's first concern to separate the work of art from the article of use, as it was that of Kraus to keep apart information and the work of art. The hack journalist is, in his heart, at one with the ornamentalist. Kraus did not tire of denouncing Heine as an ornamentalist, as one who blurred the boundary between journalism and literature, as the creator of the feuilleton in poetry and prose; indeed, he

later placed even Nietzsche beside Heine as the betrayer of the aphorism to the impression. "It is my opinion," he says of the former, "that to the mixture of elements . . . in the decomposing European style of the last half century, he added psychology, and that the new level of language he created is the level of essayism, as Heine's was that of feuilletonism." Both forms appear as symptoms of the chronic sickness of which all attitudes and standpoints merely mark the temperature curve: inauthenticity. It is from the unmasking of the inauthentic that this battle against the press arose. "Who was it that brought into the world this great excuse: 'I can do what I am not'?"

The empty phrase. It, however, is an abortion of technology. "The newspaper industry, like a factory, demands separate areas for working and selling. At certain times of day—twice, three times in the bigger newspapers—a particular quantity of work has to have been procured and prepared for the machine. And not from just any material: everything that has happened in the meantime, anywhere, in any region of life—politics, economics, art, and so on—must by now have been reached and journalistically processed." Or, as Kraus so splendidly sums it up: "It ought to throw light on the way in which technology, while unable to coin new platitudes, leaves the spirit of mankind in the state of being unable to do without the old ones. In this duality of a changed life dragging on in unchanged forms, the world's ills grow and prosper." In these words, Kraus deftly tied the knot binding technology to the empty phrase. True, its untying would have to follow a different pattern, journalism being clearly seen as the expression of the changed function of language in the world of high capitalism. The empty phrase of the kind so relentlessly pursued by Kraus is the label that makes a thought marketable, the way flowery language, as ornament, gives a thought value for the connoisseur. But for this very reason the liberation of language has become identical with that of the empty phrase—its transformation from reproduction to productive instrument. *Die Fackel* itself contains models of this, even if not the theory: its formulas are the kind that tie up, never the kind that untie. The intertwining of biblical magniloquence with stiff-necked fixation on the indecencies of Viennese life—this is its way of approaching phenomena. It is not content to call on the world as witness to the misdemeanors of a cashier; it must summon the dead from their graves.—Rightly so. For the shabby, obtrusive abundance of these scandals in Viennese coffeehouses, the press, and society is only a minor manifestation of a foreknowledge that then, more swiftly than anyone could perceive, suddenly arrived at its true and original subject: two

months after the outbreak of war, Kraus called this subject by its name in his speech "In These Great Times," with which all the demons that inhabited this possessed man passed into the herd of swine who were his contemporaries.

In these great times, which I knew when they were small, which will again be small if they still have time, and which, because in the field of organic growth such transformations are not possible, we prefer to address as fat times and truly also as hard times; in these times, when precisely what is happening could not be imagined, and when what must *happen* can no longer be *imagined,* and if it could it would not happen; in these grave times that have laughed themselves to death at the possibility of growing serious and, overtaken by their own tragedy, long for distraction and then, catching themselves in the act, seek words; in these loud times, booming with the fearful symphony of deeds that engender reports, and of reports that bear the blame for deeds; in these unspeakable times, you can expect no word of my own from me. None except this, which just preserves silence from misinterpretation. Too deeply am I awed by the unalterability of language, the subordination of language to misfortune. In the empires bereft of imagination, where man is dying of spiritual starvation though feeling no spiritual hunger, where pens are dipped in blood and swords in ink, that which is not thought must be done, but that which is only thought is inexpressible. Expect from me no word of my own. Nor should I be capable of saying anything new; for in the room where someone writes, the noise is great, and whether it comes from animals, from children, or merely from mortars shall not be decided now. He who addresses deeds violates both word and deed and is twice despicable. This profession is not extinct. Those who now have nothing to say because it is the turn of deeds to speak, talk on. Let him who has something to say step forward and be silent!

Everything Kraus wrote is like that: a silence turned inside out, a silence that catches the storm of events in its black folds and billows, its livid lining turned outward. Notwithstanding their abundance, each of the instances of this silence seems to have broken upon it with the suddenness of a gust of wind. Immediately, a precise apparatus of control is brought into play: through a meshing of oral and written forms, the polemical possibilities of every situation are totally exhausted. With what precautions this is surrounded can be seen from the barbed wire of editorial pronouncements that encircles each edition of *Die Fackel,* as from

the razor-sharp definitions and provisos in the programs and lectures accompanying his readings from his own work. The trinity of silence, knowledge, and alertness constitutes the figure of Kraus the polemicist. His silence is a dam before which the reflecting basin of his knowledge is constantly deepened. His alertness permits no one to ask it questions, forever unwilling to conform to principles offered to it. Its first principle is, rather, to dismantle the situation, to discover the true question the situation poses, and to present this in place of any other to his opponents. If in Johann Peter Hebel we find, developed to the utmost, the constructive, creative side of tact, in Kraus we see its most destructive and critical face.[4] But for both, tact is moral alertness—Stössl calls it "conviction refined into dialectics"—and the expression of an unknown convention more important than the acknowledged one.[5] Kraus lived in a world in which the most shameful act was still the faux pas; he distinguishes between degrees of the monstrous, and does so precisely because his criterion is never that of bourgeois respectability, which, once above the threshold of trivial misdemeanor, becomes so quickly short of breath that it can form no conception of villainy on a world-historical scale.

Kraus knew this criterion from the first; moreover, there is no other criterion for true tact. It is a theological criterion. For tact is not—as narrow minds imagine it—the gift of allotting to each, on consideration of all relationships, what is socially befitting. On the contrary, tact is the capacity to treat social relationships, though not departing from them, as natural, even paradisal, relationships, and so not only to approach the king as if he had been born with the crown on his brow, but the lackey like an Adam in livery. Hebel possessed this *noblesse* in his priestly bearing; Kraus, in armor. His concept of creation contains the theological inheritance of speculations that last possessed contemporary validity for the whole of Europe in the seventeenth century. At the theological core of this concept, however, a transformation has taken place that has caused it, quite without constraint, to coincide with the cosmopolitan credo of Austrian worldliness, which made creation into a church in which nothing remained to recall the rite except an occasional whiff of incense in the mists. Stifter gave this creed its most authentic stamp, and his echo is heard wherever Kraus concerns himself with animals, plants, children. Stifter writes:

> The stirring of the air, the rippling of water, the growing of corn, the tossing of the sea, the verdure of the earth, the shining of the sky, the twinkling

of the stars, I hold great. The thunderstorm approaching in splendor, the lightning flash that cleaves houses, the storm driving the surf, the mountains spewing fire, the earthquake laying waste to countries, I do not hold greater than the former phenomena; indeed, I believe them smaller, because they are only effects of far higher laws. . . . When man was in his infancy, his spiritual eye not yet touched by science, he was seized by what was close at hand and obtrusive, and was moved to fear and admiration; but when his mind was opened, when his gaze began to be directed at the connections between things, particular phenomena sank from sight and the law rose even higher, miracles ceased, and wonder increased. . . . Just as in nature the general laws act silently and incessantly, and conspicuous events are only single manifestations of these laws, so the moral law acts silently, animating the soul through the infinite intercourse of human beings, and the miracles of the moment when deeds are performed are merely small signs of this general power.[6]

Tacitly, in these famous sentences, the holy has given place to the modest yet questionable concept of law. But this nature of Stifter's and his moral universe are transparent enough to escape any confusion with Kant, and to be still recognizable in their core as creation. This insolently secularized thunder and lightning, storms, surf, and earthquakes—cosmic man has won them back for creation by making them its world-historical answer to the criminal existence of men. Only the span between Creation and the Last Judgment here finds no redemptive fulfillment, let alone a historical overcoming. For as the landscape of Austria fills unbroken the captivating expanse of Stifter's prose, so for him, Kraus, the terrible years of his life are not history but nature, a river condemned to meander through a landscape of hell. It is a landscape in which every day fifty thousand trees are felled for sixty newspapers. Kraus imparted this information under the title "The End." For the fact that mankind is losing the fight against the creaturely is to him just as certain as the fact that technology, once deployed against creation, will not stop short of its master, either. His defeatism is of a supranational—that is, planetary—kind, and history for him is merely the wilderness dividing his race from creation, whose last act is world conflagration. As a deserter to the camp of animal creation—so he measures out this wilderness. "And only the animal that is conquered by humanity is the hero of life": never was Adalbert Stifter's patriarchal credo given so gloomy and heraldic a formulation.

It is in the name of the creature that Kraus again and again inclines to-

ward the animal and toward "the heart of all hearts, that of the dog," for him creation's true mirror of virtue, in which fidelity, purity, gratitude smile from times lost and remote. How lamentable that people usurp its place! These are his followers. More numerously and eagerly than about their master, they throng with unlovely sniffings about the mortally wounded opponent. Indeed, it is no accident that the dog is the emblematic beast of this author: the dog, the epitome of the follower, who is nothing except devoted creature. And the more personal and unfounded this devotion, the better. Kraus is right to put it to the hardest test. But if anything makes plain what is infinitely questionable in these creatures, it is that they are recruited solely from those whom Kraus himself first called intellectually to life, whom he conceived and convinced in one and the same act. His testimony can determine only those for whom it can never become generative.

It is entirely logical that the impoverished, reduced human being of our day, the contemporary, can seek sanctuary in the temple of living things only in that most withered form: the form of a private individual. How much renunciation and how much irony lie in the curious struggle for the "nerves"—the last root fibers of the Viennese to which Kraus could still find Mother Earth clinging. "Kraus," writes Robert Scheu, "discovered a great subject that had never before set in motion the pen of a journalist: the rights of the nerves. He found that they were just as worthy an object of impassioned defense as were property, house and home, political party, and constitution. He became the advocate of the nerves and took up the fight against petty, everyday imitations; but the subject grew under his hands, became the problem of private life. To defend this against police, press, morality, and concepts, and ultimately against neighbors in every form, constantly finding new enemies, became his profession." Here, if anywhere, is manifest the strange interplay between reactionary theory and revolutionary practice that we find everywhere in Kraus. Indeed, to secure private life against morality and concepts in a society that perpetrates the political radioscopy of sexuality and family, of economic and physical existence, in a society that is in the process of building houses with glass walls, and terraces extending far into the living rooms that are no longer living rooms—such a watchword would be the most reactionary of all, were not the private life that Kraus made it his business to defend precisely that which, unlike the bourgeois form, is in strict accordance with this social upheaval; in other words, the private life that is dismantling itself, openly shaping itself, that of the poor, from

whose ranks came Peter Altenberg, the agitator, and Adolf Loos. In this fight—and only in this fight—his followers also have their uses, since it is they who most sublimely ignore the anonymity with which the satirist has tried to surround his private existence, and nothing holds them in check except Kraus's decision to step in person before his threshold and pay homage to the ruins in which he is a "private individual."

As decisively as he makes his own existence a public issue when the fight demands it, he has always just as ruthlessly opposed the distinction between personal and objective criticism—a distinction which has been used to discredit polemics, and which is a chief instrument of corruption in our literary and political affairs. That Kraus attacks people less for what they are than for what they do, more for what they say than for what they write, and least of all for their books, is the precondition of his polemical authority, which is able to lift the intellectual universe of an author—all the more surely the more worthless it is, with confidence in a truly prestabilized, reconciling harmony—whole and intact from a single fragment of sentence, a single word, a single intonation. But the coincidence of personal and objective elements, not only in his opponents but above all in himself, is best demonstrated by the fact that he never puts forward an opinion. For opinion is false subjectivity that can be separated from the person and incorporated in the circulation of commodities. Kraus has never offered an argument that did not engage his whole person. Thus, he embodies the secret of authority: never to disappoint. Authority has no other end than this: it dies or it disappoints. It is not in the least undermined by what others must avoid: its own despotism, injustice, inconsistency. On the contrary, it would be disappointing to observe how it arrived at its pronouncements—by fairness, for example, or even self-consistency. "For a man," Kraus once said, "being right is not an erotic matter, and he gladly prefers others' being right to his being wrong." To prove his manhood in this way is denied to Kraus; his existence demands that at most the self-righteousness of others is opposed to his wrongness, and how right he then is to cling to this. "Many will be right one day. But it will be a rightness resulting from my wrongness today." This is the language of true authority. Insight into its operations can reveal only one thing: that it is binding, mercilessly binding, toward itself in the same degree as toward others; that it does not tire of trembling before itself, though never before others; that it never does enough to satisfy itself, to fulfill its responsibility toward itself; and that this sense of responsibility never allows him to accept arguments derived from his private constitution or even from the limits of human capacity, but al-

ways only from the matter at hand, however unjust it may be from a private point of view.

The characteristic of such unlimited authority has for all time been the union of legislative and executive power. But it was never a more intimate union than in the theory of language. This is therefore the most decisive expression of Kraus's authority. Incognito like Haroun al Rashid, he passes by night among the sentence constructions of the journals, and, from behind the petrified façades of phrases, he peers into the interior, discovering in the orgies of "black magic" the violation, the martyrdom, of words:

> Is the press a messenger? No: it is the event. Is it speech? No: life. The press not only claims that the true events are its news of events, but it also brings about a sinister identification that constantly creates the illusion that deeds are reported before they are carried out, and frequently also the possibility of a situation (which in any case exists) that when war correspondents are not allowed to witness events, soldiers become reporters. I therefore welcome the charge that all my life I have overestimated the press. It is not a servant—How could a servant demand and receive so much? It is the event. Once again the instrument has run away with us. We have placed the person who is supposed to report outbreaks of fire, and who ought doubtless to play the most subordinate role in the State, in power over the world, over fire and over the house, over fact and over our fantasy.

Authority and word against corruption and magic—thus are the catchwords distributed in this struggle. It is not idle to offer a prognosis. No one, Kraus least of all, can leave the utopia of an "objective" newspaper, the chimera of an "impartial transmission of news," to its own devices. The newspaper is an instrument of power. It can derive its value only from the character of the power it serves; not only in what it represents, but also in what it does, it is the expression of this power. When, however, high capitalism defiles not only the ends but also the means of journalism, then a new blossoming of paradisal, cosmic humanity can no more be expected of a power that defeats it than a second blooming of the language of Goethe or Claudius.[7] From the one now prevailing, it will distinguish itself first of all by putting out of circulation ideals that debase the former. This is enough to give a measure of how little Kraus would have to win or lose in such a struggle, of how unerringly *Die Fackel* would illuminate it. To the ever-repeated sensations with which the daily press serves its public, he opposes the eternally fresh "news" of the history of creation: the eternally renewed, uninterrupted lament.

2. Demon

Have I slept? I am just falling asleep.
 —KRAUS, *Words in Verse*, IV

It is deeply rooted in Kraus's nature, and the stigma of every debate concerning him, that all apologetic arguments miss their mark. The great work of Leopold Liegler springs from an apologetic posture. To certify Kraus as an "ethical personality" is his first objective. This cannot be done. The dark background from which Kraus's image detaches itself is not formed by his contemporaries, but is the primeval world [*Vorwelt*], or the world of the demon. The light of the day of Creation falls on him—thus he emerges from this darkness. But not in all parts; others remain that are more deeply immersed in it than one suspects. An eye that cannot adjust to this darkness will never perceive the outline of this figure. On it will be wasted all the gestures that Kraus tirelessly makes in his unconquerable need to be perceived. For, as in the fairy tale, the demon in Kraus has made vanity the expression of his being. The demon's solitude, too, is felt by him who gesticulates wildly on the hidden hill: "Thank God nobody knows my name is Rumpelstiltskin." Just as this dancing demon is never still, in Kraus eccentric reflection is in continuous uproar. "The patient of his gifts," Berthold Viertel called him. In fact, his capacities are maladies; and over and above the real ones, his vanity makes him a hypochondriac.

If he does not see his reflection in himself, he sees it in the adversary at his feet. His polemics have been, from the first, the most intimate intermingling of a technique of unmasking that works with the most advanced means, and a self-expressive art that works with the most archaic. But in this zone, too, ambiguity, the demon, is manifest: self-expression and unmasking merge in it as self-unmasking. Kraus has said, "Anti-Semitism is the mentality that offers up and means seriously a tenth of the jibes that the stock-exchange wit holds ready for his own blood"; he thereby indicates the nature of the relationship of his own opponents to himself. There is no reproach to him, no vilification of his person, that could not find its most legitimate formulation in his own writings, in those passages where self-reflection is raised to self-admiration. He will pay any price to get himself talked about, and is always justified by the success of these speculations. If style is the power to move freely in the

length and breadth of linguistic thinking without falling into banality, it
is attained chiefly by the cardiac strength of great thoughts, which drives
the blood of language through the capillaries of syntax into the remotest
limbs. While such thoughts are quite unmistakable in Kraus, the power-
ful heart of his style is nevertheless the image he bears of himself in his
own breast and exposes in the most merciless manner. Yes, he is vain. As
such he has been portrayed by Karin Michaelis, who describes how he
crosses a room with swift, restless bounds to reach the lecture podium.
And if he then offers a sacrifice to his vanity, he would not be the demon
that he is were it not finally himself, his life and his suffering, that he ex-
poses with all its wounds, all its nakedness. In this way his style comes
into being, and with it the typical reader of *Die Fackel,* for whom in a
subordinate clause, in a particle, indeed in a comma, fibers and nerves
quiver; from the obscurest and driest fact, a piece of his mutilated flesh
hangs. Idiosyncrasy as the highest critical organ—this is the hidden logic
of that self-reflection and the hellish state known only to a writer for
whom every act of gratification becomes at the same time a station of his
martyrdom, a state experienced, apart from Kraus, by no one as deeply
as by Kierkegaard.

"I am," Kraus has said, "perhaps the first instance of a writer who si-
multaneously writes and experiences his writing theatrically." Thus he
shows his vanity its most legitimate place: in mime. His mimetic genius,
imitating while it glosses, pulling faces in the midst of polemics, is fes-
tively unleashed in the readings of dramas whose authors, with good rea-
son, occupy a peculiarly intermediate position: Shakespeare and Nestroy,
dramatists and actors; Offenbach, composer and conductor.[8] It is as if the
demon in the man sought the tumultuous atmosphere of these dramas,
shot through with all the lightning flashes of improvisation, because it
alone offered him the thousand opportunities to break out, teasing, tor-
menting, threatening. In them his own voice tries out the abundance of
personae inhabiting the performer ("persona": that through which sound
passes), and about his fingertips dart the gestures of the figures populat-
ing his voice. But in his polemics, too, mimesis plays a decisive role. He
imitates his subjects in order to insert the crowbar of his hate into the
finest joints of their posture. This quibbler, probing between syllables,
digs out the larvae that nest there in clumps. The larvae of venality and
garrulity, ignominy and bonhomie, childishness and covetousness, glut-
tony and dishonesty. Indeed, the exposure of inauthenticity—more dif-
ficult than that of the merely bad—is here performed behavioristically.
The quotations in *Die Fackel* are more than documentary proof: they are

the props with which the quoter unmasks himself mimetically. Admittedly, what emerges in just this connection is how closely the cruelty of the satirist is linked to the ambiguous modesty of the interpreter, which in his public readings is heightened beyond comprehension. "To creep"—this is the term used, not without cause, for the lowest kind of flattery; and Kraus creeps into those he impersonates, in order to annihilate them. Has courtesy here become the mimicry of hate, hate the mimicry of courtesy? However that may be, both have attained perfection, absolute pitch. "Torment," of which there is so much talk in Kraus in such opaque allusions, here has its seat. His protests against letters, printed matter, documents are nothing but the defensive reaction of a man who is himself implicated. But what implicates him so deeply is more than deeds and misdeeds; it is the language of his fellow men. His passion for imitating them is at the same time the expression of and the struggle against this implication, and also the cause and the result of that ever-watchful guilty conscience in which alone the demon is in his element.

The economy of his errors and weaknesses—more a fantastic edifice than the totality of his gifts—is so delicately and precisely organized that all outward confirmation only disrupts it. Well it may, if this man is to be certified as the "pattern of a harmoniously and perfectly formed human type," if he is to appear—in a term as absurd stylistically as semantically—as a philanthropist, so that anyone listening to his "hardness" with "the ears of the soul" would find the reason for it in compassion. No! This incorruptible, piercing, resolute assurance does not spring from the noble poetic or humane disposition that his followers are so fond of attributing to him. How utterly banal, and at the same time how fundamentally wrong, is their derivation of his hatred from love, when it is obvious how much more elemental are the forces here at work: a humanity that is only an alternation of malice and sophistry, sophistry and malice, a nature that is the highest school of aversion to mankind and a pity that is alive only when interlaced with vengeance. "Oh, had I only been left the choice / to carve the dog or the butcher, / I should have chosen." Nothing is more perverse than to try to fashion him after the image of what he loves. Rightly, Kraus the "timeless world-disturber" has been confronted with the "eternal world-improver," on whom benign glances not infrequently fall.

"When the age laid hands upon itself, he was the hands," Brecht said. Few insights can stand beside this, and certainly not the comment of his friend Adolf Loos. "Kraus," he declares, "stands on the threshold of a

new age." Alas, by no means.—For he stands on the threshold of the Last
Judgment. Just as, in the most opulent examples of Baroque altar paint-
ing, saints hard-pressed against the frame extend defensive hands toward
the breathtakingly foreshortened extremities of the angels, the blessed,
and the damned floating before them, so the whole of world history
presses in on Kraus in the extremities of a single item of local news, a sin-
gle phrase, a single advertisement. This is the inheritance that has come
down to him from the sermons of Abraham a Sancta Clara. Thence the
overwhelming immediacy, the ready wit, of the wholly uncontemplative
moment; and the inversion that allows his will only theoretical, his
knowledge only practical, expression. Kraus is no historic type. He does
not stand on the threshold of a new age. If he ever turns his back on cre-
ation, if he breaks off in lamentation, it is only to file a complaint at the
Last Judgment.

Nothing is understood about this man until it has been perceived that,
of necessity and without exception, everything—language and fact—
falls, for him, within the sphere of justice. All his fire-eating, sword-swal-
lowing philology in the newspapers pursues justice just as much as lan-
guage. It is to misunderstand his theory of language to see it as other than
a contribution to the linguistic rules of court, the word of someone else in
his mouth as other than a *corpus delicti,* and his own as other than a
judging word. Kraus knows no system. Each thought has its own cell.
But each cell can in an instant, and apparently almost without cause, be-
come a chamber, a legal chamber over which language presides. It has
been said of Kraus that he has to "suppress the Jewishness in himself,"
even that he "travels the road from Jewishness to freedom"; nothing
better refutes this than the fact that, for him, too, justice and language re-
main founded in each other. To worship the image of divine justice in lan-
guage—even in the German language—this is the genuinely Jewish *salto
mortale* by which he tries to break the spell of the demon. For this is the
last official act of this zealot: to place the legal system itself under accusa-
tion. And not in a petty-bourgeois revolt against the enslavement of the
"free individual" by "dead formulas." Still less in the posture of those
radicals who storm the legal code without ever for a moment having
taken thought of justice. Kraus accuses the law in its substance, not in its
effect. His charge: high treason of the law against justice. More exactly,
betrayal of the word by the concept, which derives its existence from the
word: the premeditated murder of imagination, which dies of the absence
of a single letter and for which, in his "Elegy on the Death of a Sound,"
he has sung the most moving lament. For over jurisdiction, right-saying,

stands orthography, right-spelling, and woe to the former if the latter should be wanting. Here, too, therefore, he confronts the press; indeed, in this charmed circle he holds his fondest rendezvous with the *lemures*. He has seen through law as have few others. If he nevertheless invokes it, he does so precisely because his own demon is drawn so powerfully by the abyss it represents. By the abyss that, not without reason, he finds most gaping where mind and sexuality meet—in the trial for sexual offenses—and has sounded in these famous words: "A trial for sexual offenses is the deliberate development from an individual immorality to a general immorality, against which dark background the proven guilt of the accused stands out luminously."

Mind and sexuality move in this sphere with a solidarity whose law is ambiguity. The obsession of demonic sexuality is the ego that, surrounded by sweet feminine mirages "such as the bitter earth does not harbor," enjoys itself. And no different is the loveless and self-gratifying trope of the obsessed mind: the joke. Neither reaches its object: the ego does not attain women any more than the joke attains words. Decomposition has taken the place of procreation; stridency, that of secrecy. Now, however, they shimmer in the most winsome nuances: in repartee, lust comes into its own; and in onanism, the joke. Kraus portrayed himself as hopelessly subjugated to the demon; in the pandemonium of the age, he reserved for himself the most melancholy place in the icy wilderness lit by reflected flames. There he stands on the Last Day of Humankind[9]—the "grumbler" who has described the preceding days. "I have taken the tragedy, which disintegrates into scenes of disintegrating humanity, on myself, so that it might be heard by the spirit who takes pity on the victims, even though he may have renounced for all time his connection with a human ear. May he receive the keynote of this age, the echo of my bloodstained madness, through which I share the guilt for these noises. May he accept it as redemption!"

"I share the guilt . . ." Because this has the ring of the manifestos—even if they are finally self-accusations—of an intelligentsia seeking to call to mind the memory of an epoch that seemed to be turning away from it, there is something to be said about this guilt feeling in which private and historical consciousness so vividly meet. This guilt will always lead to Expressionism, from which his mature work was nourished by roots that cracked open their soil. The slogans are well known—with what scorn did not Kraus himself register them: *geballt, gestuft, gesteilt* [clenched, stepped, steeped]; stage sets, sentences, paintings were composed.—Unmistakable—and the Expressionists themselves proclaim it—

is the influence of early medieval miniatures on the world of their imagination. But anyone who examines their figures—for example, in the Vienna Genesis[10]—is struck by something very mysterious, not only in their wide-open eyes, not only in the unfathomable folds of their garments, but also in their whole expression. As if falling sickness had overtaken them thus, in their running which is always headlong, they lean toward one another. "Inclination" may be seen, before all else, as the deep human affect tremulously pervading the world of these miniatures, as it does the manifestos of that generation of poets. But only one, as it were inwardly curved, aspect of this relation is revealed by the front of these figures. The same phenomenon appears quite different to someone who looks at their backs. These backs are piled—in the saints of the adorations, in the servants of the Gethsemane scene, in the witnesses of the entrance into Jerusalem—into terraces of human necks and human shoulders that, really clenched in steep steps, lead less toward heaven than downward to and even under the earth. It is impossible to find, for their pathos, an expression that ignores the fact that they could be climbed like heaped rocks or rough-hewn steps. Whatever powers may have fought out their spiritual battles on these shoulders, one of them, from our experience of the condition of the defeated masses immediately after the end of the war, we are able to call by its name. What finally remained of Expressionism, in which an originally human impulse was converted almost without residue into a fashion, was the experience and the name of that nameless power toward which the backs of people bent: guilt. "That obedient masses are led into danger not by an unknown will but by an unknown guilt makes them pitiable," Kraus wrote as early as 1912. As a "grumbler" he participates in their lot in order to denounce them, and denounces them in order to participate. To meet them through sacrifice, he one day threw himself into the arms of the Catholic church.

In those biting minuets that Kraus whistled to the *chassé-croisé* of Justitia and Venus, the leitmotif—that the philistine knows nothing of love—is articulated with a sharpness and persistence that have a counterpart only in the corresponding attitude of *décadence*, in the proclamation of art for art's sake. For it was precisely art for art's sake, which for the decadent movement applies to love as well, that linked expertise as closely as possible to craftsmanship, to technique, and allowed poetry to shine at its brightest only against the foil of hack writing, as it made love stand out against perversion. "Penury can turn every man into a journalist, but not every woman into a prostitute." In this formulation Kraus betrayed the false bottom of his polemic against journalism. It is much less

the philanthropist, the enlightened friend of man and nature, who un-
leashed this implacable struggle than the literary expert, artiste, indeed
the dandy, whose ancestor is Baudelaire. Only Baudelaire hated, as Kraus
did, the satiety of healthy common sense, and the compromise that intel-
lectuals made with it in order to find shelter in journalism. Journalism is
betrayal of the literary life, of mind, of the demon. Idle chatter is its true
substance, and every feuilleton poses anew the insoluble question of the
relationship between the forces of stupidity and malice, whose expression
is gossip. It is, fundamentally, on the complete agreement of two forms of
existence—life under the aegis of mere mind, and life under the aegis of
mere sexuality—that the solidarity of the man of letters with the whore
is founded, a solidarity to which Baudelaire's existence is once again
the most inviolable testimony. So Kraus can call by their name the laws
of his own craft, intertwined with those of sexuality, as he did in *Die
Chinesische Mauer* [The Great Wall of China]. Man "has wrestled a
thousand times with the other, who perhaps does not live but whose vic-
tory over him is certain. Not because he has superior qualities but be-
cause he is the other, the latecomer, who brings woman the joy of variety
and who will triumph as the last in the sequence. But they wipe it from
her brow like a bad dream, and want to be the first." Now, if language—
this we read between the lines—is a woman, how far the author is re-
moved, by an unerring instinct, from those who hasten to be the first
with her; how multifariously he forms his thought, thus inciting her with
intuition rather than slaking her with knowledge; how he lets hatred,
contempt, malice ensnare one another; how he slows his step and seeks
the detour of followership, in order finally to end her joy in variety with
the last thrust that Jack holds in readiness for Lulu![11]

The life of letters is existence under the aegis of mere mind, as prosti-
tution is existence under the aegis of mere sexuality. The demon, how-
ever, who leads the whore to the street exiles the man of letters to the
courtroom. This is therefore, for Kraus, the forum that it has always been
for the great journalist—for a Carrel, a Paul-Louis Courier, a Lassalle.
Evasion of the genuine and demonic function of mere mind, to be a dis-
turber of the peace; abstention from attacking the whore from behind—
Kraus sees this double omission as defining the journalist.—Robert Scheu
rightly perceived that for Kraus prostitution was a natural form, not a so-
cial deformation, of female sexuality. Yet it is only the interlacing of sex-
ual with commercial intercourse that constitutes the character of prosti-
tution. It is a natural phenomenon as much in terms of its natural
economic aspect (since it is a manifestation of commodity exchange) as in

terms of its natural sexuality. "Contempt for prostitution? / Harlots worse than thieves? / Learn this: not only is love paid, / but payment, too, wins love!" This ambiguity—this double nature as twofold natural-ness—makes prostitution demonic. But Kraus "enlists with the power of nature." That the sociological realm never becomes transparent to him—no more in his attack on the press than in his defense of prostitution—is connected with this attachment to nature. That for him the fit state of man appears not as the destiny and fulfillment of nature liberated through revolutionary change, but as an element of nature per se, of an archaic nature without history, in its pristine, primeval state, throws un-certain, disquieting reflections even on his ideas of freedom and human-ity. They are not removed from the realm of guilt that Kraus has tra-versed from pole to pole: from mind to sexuality.

But in the face of this reality, to which Kraus exposed himself more harrowingly than any other, the "pure mind" that his followers worship in the master's activity is revealed as a worthless chimera. For this reason, none of the motives for his development is more important than the con-stant curbing and checking of mind. *Nachts* [By Night] is the title he gives to the logbook of this control. For night is the mechanism by which mere mind is converted into mere sexuality, mere sexuality into mere mind, and where these two abstractions hostile to life find rest in recog-nizing each other. "I work day and night. So I have a lot of free time. In order to ask a picture in the room how it likes work; in order to ask the clock whether it is tired and the night how it has slept." These questions are sacrificial gifts that he throws to the demon while working. His night, however, is not a maternal night, or a moonlit, romantic night: it is the hour between sleeping and waking, the night watch, the centerpiece of his threefold solitude: that of the coffeehouse, where he is alone with his enemy; of the nocturnal room, where he is alone with his demon; of the lecture hall, where he is alone with his work.

3. Monster [*Unmensch*]

Already the snow falls.
—KRAUS, *Words in Verse,* III

Satire is the only legitimate form of regional art. This, however, was not what people meant by calling Kraus a Viennese satirist. Rather, they were

attempting to shunt him for as long as possible onto this siding, where his work could be assimilated into the great store of literary consumer goods. The presentation of Kraus as a satirist can thus yield the deepest insight both into what he is and into his most melancholy caricatures. For this reason, he was at pains from the first to distinguish the genuine satirist from the scribblers who make a trade of mockery and who, in their invectives, have little more in mind than giving the public something to laugh about. In contrast, the great type of the satirist never had firmer ground under his feet than amid a generation about to mount tanks and put on gas masks, a mankind that has run out of tears but not of laughter. In him civilization prepares to survive, if it must, and communicates with him in the true mystery of satire, which consists in the devouring of the adversary. The satirist is the figure in whom the cannibal was received into civilization. His recollection of his origin is not without filial piety, so that the proposal to eat people has become an essential constituent of his inspiration, from Jonathan Swift's pertinent project concerning the use of the children of the less wealthy classes, to Léon Bloy's suggestion that landlords of insolvent lodgers be conceded a right to the sale of the lodgers' flesh. In such directives, great satirists have taken the measure of the humanity of their fellow men. "Humanity, culture, and freedom are precious things that cannot be bought dearly enough with blood, understanding, and human dignity"—thus Kraus concludes the dispute between the cannibal and human rights. One should compare his formulation with Marx's treatment of the "Jewish question," in order to judge how totally this playful reaction of 1909—the reaction against the classical ideal of humanity—was likely to become a confession of materialist humanism at the first opportunity. Admittedly, one would need to understand *Die Fackel* from the first number on, literally word for word, to predict that this aesthetically oriented journalism, without sacrificing or gaining a single motif, was destined to become the political prose of 1930. For this it had to thank its partner, the press, which disposed of humanity in the way to which Kraus alludes in these words: "Human rights are the fragile toy that grownups like to trample on and so will not give up." Thus, drawing a boundary between the private and public spheres, which in 1789 was supposed to inaugurate freedom, became a mockery. Through the newspaper, says Kierkegaard, "the distinction between public and private affairs is abolished in private-public prattle . . ."

To open a dialectical debate between the public and private zones that commingle demonically in prattle, to lead concrete humanity to victory— this is operetta's purpose, which Kraus discovered and which in

Offenbach he raised to its most expressive level.[12] Just as prattle seals the enslavement of language through stupidity, so operetta transfigures stupidity through music. To fail to recognize the beauty of feminine stupidity was for Kraus always the blackest philistinism. Before its radiance the chimeras of progress evaporate. And in Offenbach's operettas the bourgeois trinity of the true, the beautiful, and the good is brought together, freshly rehearsed and with musical accompaniment, in its star turn on the trapeze of idiocy. Nonsense is true, stupidity beautiful, weakness good. This is Offenbach's secret: how in the deep nonsense of public discipline—whether it be that of the upper ten thousand, a dance floor, or a military state—the deep sense of private licentiousness opens a dreamy eye. And what, in the form of language, might have been judicial strictness, renunciation, discrimination, becomes cunning and evasion, obstruction and postponement, in the form of music.—Music as the preserver of the moral order? Music as the police of a world of pleasure? Yes, this is the splendor that falls on the old Paris ballrooms, on the Grande Chaumière, on the Clôserie des Lilas in Kraus's rendering of *La Vie parisienne*. "And the inimitable duplicity of this music, which simultaneously puts a plus and a minus sign before everything it says, betraying idyll to parody, mockery to lyricism; the abundance of musical devices ready to perform all duties, uniting pain and pleasure—this gift is here developed to its purest pitch."[13] Anarchy as the only international constitution that is moral and worthy of man becomes the true music of these operettas. The voice of Kraus speaks, rather than sings, this inner music. It whistles bitingly about the peaks of dizzying stupidity, reverberates shatteringly from the abyss of the absurd; and in Frescata's lines it hums, like the wind in the chimney, a requiem to the generation of our grandfathers.—Offenbach's work is touched by the pangs of death. It contracts, rids itself of everything superfluous, passes through the dangerous span of this existence and reemerges saved, more real than before. For wherever this fickle voice is heard, the lightning flashes of advertisements and the thunder of the Métro cleave the Paris of omnibuses and gas jets. And the work gives him all this in return. For at moments it is transformed into a curtain, and with the wild gestures of a fairground showman with which he accompanies the whole performance, Kraus tears aside this curtain and suddenly reveals the interior of his cabinet of horrors. There they stand: Schober, Békessy, Kerr, and the other skits, no longer enemies but curiosities, heirlooms from the world of Offenbach or Nestroy—no, older, rarer still, *lares* of the troglodytes, household gods of stupidity from prehistoric times.[14] Kraus, when he reads in public, does

not speak the words of Offenbach or Nestroy: they speak from him. And now and then a breathtaking, half-blank, half-glittering whoremonger's glance falls on the crowd before him, inviting them to the unholy marriage with the masks in which they do not recognize themselves, and for the last time invokes the evil privilege of ambiguity.

It is only now that the satirist's true face, or rather true mask, is revealed. It is the mask of Timon the misanthrope. "Shakespeare had foreknowledge of everything"—yes. But above all of Kraus. Shakespeare portrays inhuman figures—Timon the most inhuman of them—and says: Nature would produce such a creature if she wished to create something befitting the world as your kind have fashioned it, something worthy of it. Such a creature is Timon; such is Kraus. Neither has, or wants, anything in common with men. "An animal feud is on, and so we renounce humanity"; from a remote village in the Swiss mountains Kraus throws down this challenge to mankind, and Timon wants only the sea to weep at his grave. Like Timon's verse, Kraus's poetry stands opposite the colon of the *dramatis persona,* of the role. A Fool, a Caliban, a Timon—no more thoughtful, no more dignified or better—but, nevertheless, his own Shakespeare. All the figures thronging about him should be seen as originating in Shakespeare. Always he is the model, whether Kraus is speaking with Otto Weininger about man or with Peter Altenberg about women, with Frank Wedekind about the stage or with Adolf Loos about food, with Else Lasker-Schüler about the Jews or with Theodor Haecker about the Christians. The power of the demon ends at this realm. His semihuman or subhuman traits are conquered by a truly inhuman being, a monster. Kraus hinted at this when he said, "In me a capacity for psychology is united with the greater capacity to ignore the psychological." It is the inhuman quality of the actor that he claims for himself in these words: the cannibal quality. For in each of his roles the actor assimilates bodily a human being, and in Shakespeare's baroque tirades—when the cannibal is unmasked as the better man, the hero as an actor, when Timon plays the rich man, Hamlet the madman—it is as if the actor's lips were dripping blood. So Kraus, following Shakespeare's example, wrote himself parts that let him taste blood. The endurance of his convictions is persistence in a role, in its stereotypes, its cues. His experiences are, in their entirety, nothing but this: cues. This is why he insists on them, demanding them from existence like an actor who never forgives a partner for denying him his cue.

Kraus's public readings of Offenbach, his recital of couplets from Nestroy, are bereft of all musical means. The word never gives way to the

instrument; but by extending its boundaries further and further, it finally depotentiates itself, dissolving into a merely creaturely voice. A humming that is to the word what his smile is to the joke is the holy of holies of this performer's art. In this smile, this humming—in which, as in a crater lake amid the most monstrous crags and cinders, the world is peacefully and contentedly mirrored—irrupts the deep complicity with his listeners and models that Kraus has never allowed to enter his words. His service to the word permits no compromise. But as soon as the word turns its back, he is ready for anything. Then the tormenting, inexhaustible charm of these recitals makes itself felt: the charm of seeing the distinction between like and unlike minds annulled and the homogeneous mass of false friends created—the charm that sets the tone of these performances. Kraus confronts a world of enemies, seeks to coerce them to love, yet coerces them to nothing but hypocrisy. His defenselessness before the latter has a precise connection to the subversive dilettantism that is particularly prominent in his Offenbach renderings. Here Kraus confines music to limits narrower than were ever dreamed of in the manifestos of the George school.[15] This cannot, of course, obscure the antithesis between the linguistic gestures of the two men. Rather, an exact correlation exists between the factors which give Kraus access to both poles of linguistic expression—the enfeebled pole of humming and the armed pole of pathos—and those which forbid his sanctification of the word to take on the forms of the Georgean cult of language. To the cosmic rising and falling that for George "deifies the body and embodies the divine," language is simply a Jacob's ladder with ten thousand word-rungs. Kraus's language, by contrast, has done away with all hieratic moments. It is the medium neither of prophecy nor of domination. It is the theater of a sanctification of the name—with this Jewish certainty, it sets itself against the theurgy of the "word-body." Very late, with a decisiveness that must have matured in years of silence, Kraus entered the lists against the great partner whose work had arisen at the same time as his own, beneath the threshold of the century. George's first published book and the first volume of *Die Fackel* are dated 1899. And only retrospectively, in "After Thirty Years" (1929), did Kraus issue the challenge. There, as the zealot, he confronts George, the object of worship,

> who dwells in the temple from which
> he never had to drive the traders and the lenders,
> nor yet the pharisees and scribes,
> who therefore—camped about the place—describe it.

> The *profanum vulgus* praises this renouncer,
> who never told it what it ought to hate.
> And he who found the goal before the way
> did not come from the origin [*Ursprung*].

"You came from the origin—the origin is the goal" is received by the "Dying Man" as God's comfort and promise. To this Kraus alludes here, as does Berthold Viertel when, in the same way as Kraus, he calls the world a "wrong, deviating, circuitous way back to paradise." "And so," he continues in this most important passage of his essay on Kraus, "I attempt to interpret the development of this odd talent: intellectuality as a deviation . . . leading back to immediacy; publicity—a false trail back to language; satire—a detour to the poem." This "origin"—the seal of authenticity on the phenomenon—is the subject of a discovery that has a curious element of recognition. The theater of this philosophical recognition scene in Kraus's work is poetry, and its language is rhyme: "A word that never tells an untruth at its origin" and that, just as blessedness has its origin at the end of time, has its at the end of the line. Rhyme—two putti bearing the demon to its grave. It died at its origin because it came into the world as a hybrid of mind and sexuality. Its sword and shield—concept and guilt—have fallen from its hands to become emblems beneath the feet of the angel that killed it. This is a poetic, martial angel with a foil in his hand, as only Baudelaire knew him: "practicing alone fantastic swordsmanship,"

> Flairant dans tous les coins les hasards de la rime,
> Trébuchant sur les mots comme sur les pavés,
> Heurtant parfois des vers depuis longtemps révés.
>
> [Scenting rhyme's hazards in every corner,
> Stumbling on words as on uneven pavements,
> Jostling now and then long-dreamed-of lines.]

Also, to be sure, a licentious angel, "here chasing a metaphor that has just turned the corner, there coupling words like a procurer, perverting phrases, infatuated with similarities, blissfully abusing chiastic embraces, always on the lookout for adventure, impatient and hesitant to consummate in joy and torment." So, finally, the hedonistic impulse of the work finds its purest expression in this melancholy and fantastic relationship to existence in which Kraus, in the Viennese tradition of Raimund and Girardi, arrives at a conception of happiness that is as resigned as it is sensual.[16] This must be borne in mind if one is to understand the urgency

with which he decried the dancing pose affected by Nietzsche—not to mention the wrath with which the monster [*Unmensch*] was bound to greet the Superman [*Übermensch*].

The child recognizes by rhyme that it has reached the ridge of language, from which it can hear the rushing of all springs at their origin. Up there, creaturely existence is at home; after so much dumbness in the animal and so much lying in the whore, it has found its tongue in the child. "A good brain must be capable of imagining each fiber of childhood with all its manifestations so intensely that the temperature is raised"—in statements such as this, Kraus aims further than it appears. He himself, at any rate, satisfied this requirement to the extent that he never envisaged the child as the object of education; rather, in an image from his own youth, he saw the child as the antagonist of education who is educated by this antagonism, not by the educator. "It was not the cane that should be abolished, but the teacher who uses it badly." Kraus wants to be nothing except the teacher who uses it better. The limit of his philanthropy, his pity, is marked by the cane, which he first felt in the same class at school to which he owes his best poems.

"I am only one of the epigones"—Kraus is an epigone of school anthologies. "The German Boy's Table Grace," "Siegfried's Sword," "The Grave in the Busento," "Kaiser Karl Inspects a School"—these were his models, poetically re-created by the attentive pupil who learned them. So "The Steeds of Gravelotte" became the poem "To Eternal Peace," and even the most incandescent of his hate poems were ignited by Hölty's "Forest Fire," whose glow pervaded the anthologies of our schooldays. And if on the last day not only the graves but the school anthologies open, to the tune of "How the Trumpets Blow, Hussars Away," the true Pegasus of the little folk will burst from them and, with a shriveled mummy, a puppet of cloth or yellowish ivory, hanging dead and withered from the shoulders of his horse, this unparalleled fashioner of verses will go careening off; but the two-edged saber in his hand, as polished as his rhymes and as incisive as on the First Day, will belabor the green woods, and blooms of style will bestrew the ground.

Language has never been more perfectly distinguished from mind, never more intimately bound to eros, than by Kraus in the observation, "The more closely you look at a word, the more distantly it looks back." This is a Platonic love of language. The only closeness from which the word cannot escape, however, is rhyme. So the primal erotic relationship between nearness and distance is, in his language, given voice as rhyme and name. As rhyme, language rises up from the creaturely world; as

name, it draws all creatures up to it. In "The Forsaken" the most ardent interpenetration of language and eros, as Kraus experienced them, expresses itself with an innocent grandeur that recalls the perfect Greek epigrams and vase pictures. "The Forsaken" are forsaken by each other. But—this is their great solace—also with each other. On the threshold between dying and rebirth, they pause. With head turned back, joy "in unheard-of fashion" takes her eternal leave; turned from her, the soul "in unwonted fashion" silently sets foot in an alien world. Thus forsaken with each other are joy and soul, but also language and eros, also rhyme and name.—To "The Forsaken" the fifth volume of *Words in Verse* is dedicated. Only the dedication now reaches them, and this is nothing other than an avowal of Platonic love, which does not satisfy its desire in what it loves, but possesses and holds it in the name. This self-obsessed man knows no other self-renunciation than giving thanks. His love is not possession, but gratitude. Thanking and dedicating—for to thank is to put feelings under a name. How the beloved grows distant and lustrous, how her minuteness and her glow withdraw into name: this is the only experience of love known to *Words in Verse*. And, therefore, "To live without women, how easy. / To have lived without women, how hard."

From within the linguistic compass of the name, and only from within it, can we discern Kraus's basic polemical procedure: citation. To quote a word is to call it by its name. So Kraus's achievement exhausts itself at its highest level by making even the newspaper quotable. He transports it to his own sphere, and the empty phrase is suddenly forced to recognize that even in the deepest dregs of the journals it is not safe from the voice that swoops on the wings of the word to drag it from its darkness. How wonderful if this voice approaches not to punish but to save, as it does on the Shakespearean wings of the lines in which, before the town of Arras, someone sends word home of how in the early morning, on the last blasted tree beside the fortifications, a lark began to sing. A single line, and not even one of his, is enough to enable Kraus to descend, as savior, into this inferno, and insert a single italicization: "It was a nightingale and not a lark which sat there on the pome*granate* tree and sang."[17] In the quotation that both saves and punishes, language proves the matrix of justice. It summons the word by its name, wrenches it destructively from its context, but precisely thereby calls it back to its origin. It appears, now with rhyme and reason, sonorously, congruously, in the structure of a new text. As rhyme, it gathers the similar into its aura; as name, it stands alone and expressionless. In citation the two realms—of origin and destruction—justify themselves before language. And conversely,

only where they interpenetrate—in citation—is language consummated. In it is mirrored the angelic tongue in which all words, startled from the idyllic context of meaning, have become mottoes in the book of Creation.

From its two poles—classical humanism and materialist humanism—the whole world of this man's culture is embraced by citation. Schiller, admittedly unnamed, stands beside Shakespeare: "There is also a moral nobility. Mean natures pay / With that which they do; noble, with that which they are"—this classical distich characterizes, in the convergence of manorial *noblesse* and cosmopolitan rectitude, the utopian vanishing point where Weimar humanism was at home, and which was finally fixed by Stifter. It is decisive for Kraus that he locates origin at exactly this vanishing point. It is his program to reverse the development of bourgeois-capitalist affairs to a condition that was never theirs. But he is nonetheless the last bourgeois to claim his justification from Being, and Expressionism was portentous for him because in it this attitude had for the first time to prove its worth in the face of a revolutionary situation. It was precisely the attempt to do justice to this situation not by actions but by Being that led Expressionism to its clenched, precipitous voice. So it became the last historical refuge of personality. The guilt that bowed it and the purity it proclaimed—both are part of the phantom of the unpolitical or "natural" man who emerges at the end of that regression and was unmasked by Marx. He writes:

> Man as member of bourgeois society, unpolitical man, necessarily appears as natural man. . . . Political revolution dissolves bourgeois life into its component parts without revolutionizing or criticizing these components themselves. It stands to bourgeois society, to the world of needs, work, private interests, private right, in the same relation as it does to the foundation of its existence . . . and therefore to its natural basis. . . . The real man is acknowledged only in the form of the egoistical individual; the true man, only in the form of the abstract *citoyen*. . . . Only when the really individual man takes back into himself the abstract citizen and, as an individual man, has become in his empirical life, in his individual work, in his individual circumstances a species-being . . . and therefore no longer separates social power from himself in the form of political power, only then is human emancipation complete.[18]

The materialist humanism which Marx here opposes to its classical counterpart manifests itself for Kraus in the child, and the developing human being raises his face against the idols of ideal man—the romantic child of nature as much as the dutiful citizen. For the sake of such development,

Kraus revised the school anthology, investigated German education, and found it tossing helplessly on the waves of journalistic caprice. Hence his "Lyrik der Deutschen" [Lyric of the Germans]:

> He who *can* is their man and not he who *must*;
> they strayed from being to seeming.
> Their lyrical case was not Claudius
> but Heine.

The fact, however, that the developing man actually takes form not within the natural sphere but in the sphere of mankind, in the struggle for liberation, and that he is recognized by the posture which the fight with exploitation and poverty stamps upon him, that there is no idealistic but only a materialistic deliverance from myth, and that at the origin of creation stands not purity but purification—all this did not leave its trace on Kraus's materialist humanism until very late. Only when despairing did he discover in citation the power not to preserve but to purify, to tear from context, to destroy; the only power in which hope still resides that something might survive this age—because it was wrenched from it.

Here we find confirmation that all the martial energies of this man are innate civic virtues; only in the melee did they take on their combative aspect. But already no one recognizes them any more; no one can grasp the necessity that compelled this great bourgeois character to become a comedian, this guardian of Goethean linguistic values a polemicist, or why this irreproachably honorable man went berserk. This, however, was bound to happen, since he thought fit to change the world by beginning with his own class, in his own home, in Vienna. And when, admitting to himself the futility of his enterprise, he abruptly broke it off, he placed the matter back in the hands of nature—this time destructive not creative nature:

> Let time stand still! Sun, be consummate!
> Make great the end! Announce eternity!
> Rise up with menace, let your light boom thunder,
> that our strident death be silenced.
>
> You golden bell, melt in your own heat,
> Make yourself a gun against the cosmic foe!
> Shoot firebrands in his face! Had I but Joshua's power,
> I tell you, Gideon would be again![19]

On this unfettered nature Kraus's later political credo is founded, though in antithesis to Stifter's patriarchal code; it is a confession that is in every

respect astonishing, but incomprehensible only in the fact that it has not been preserved in *Die Fackel*'s largest type, and that this most powerful of postwar bourgeois prose must be sought in the now-vanished issue of November 1920:

> What I mean is—and now for once I shall speak plainly to this dehumanized brood of owners of property and blood, and to all their followers, because they do not understand German and from my "contradictions" are incapable of deducing my true intention . . .—what I mean is, communism as a reality is only the obverse of their own life-violating ideology, admittedly by the grace of a purer ideal origin, a deranged remedy with a purer ideal purpose: the devil take its practice, but God preserve it as a constant threat over the heads of those who have property and would like to compel all others to preserve it, driving them, with the consolation that worldly goods are not the highest, to the fronts of hunger and patriotic honor. God preserve it, so that this rabble who are beside themselves with brazenness do not grow more brazen still, and so that the society of those exclusively entitled to enjoyment, who believe they are loving subordinate humanity enough if they give it syphilis, may at least go to bed with a nightmare! So that at least they may lose their appetite for preaching morality to their victims, take less delight in ridiculing them!

A human, natural, noble language—particularly in the light of a noteworthy declaration by Loos: "If human work consists only of destruction, it is truly human, natural, noble work." For far too long, the accent was placed on creativity. People are only creative to the extent that they avoid tasks and supervision. Work as a supervised task—its model being political and technical work—is attended by dirt and detritus, intrudes destructively into matter, is abrasive to what is already achieved and critical toward its conditions, and is in all this opposite to the work of the dilettante luxuriating in creation. His work is innocent and pure, consuming and purifying masterliness. And therefore the monster stands among us as the messenger of a more real humanism. He is the conqueror of the empty phrase. He feels solidarity not with the slender pine but with the plane that devours it, not with the precious ore but with the blast furnace that purifies it. The average European has not succeeded in uniting his life with technology, because he has clung to the fetish of creative existence. One must have followed Loos in his struggle with the dragon "ornament," heard the stellar Esperanto of Scheerbart's creations, or seen Klee's *New Angel* (who preferred to free men by taking from them, rather than make them happy by giving to them) to understand a humanity that proves itself by destruction.[20]

Justice, therefore, is destructive in opposing the constructive ambiguities of law, and Kraus destructively did justice to his own work: "All my errors stay behind to lead." This is a sober language that bases its dominance on permanence. The writings of Kraus have already begun to last, so that he might furnish them with an epigraph from Lichtenberg, who dedicated one of his most profound works to "Your Majesty Forgetfulness."[21] So his modesty now appears—bolder than his former self-assertion, which dissolved in demonic self-reflection. Neither purity nor sacrifice mastered the demon; but where origin and destruction come together, his reign is over. Like a creature sprung from the child and the cannibal, his conqueror stands before him: not a new man—a monster, a new angel. Perhaps one of those who, according to the Talmud, are at each moment created anew in countless throngs, and who, once they have raised their voices before God, cease and pass into nothingness. Lamenting, chastising, or rejoicing? No matter—on this evanescent voice the ephemeral work of Kraus is modeled. Angelus—that is the messenger in the old engravings.

Published in the *Frankfurter Zeitung und Handelsblatt*, March 1931. *Gesammelte Schriften*, II, 334–367. Translated by Edmund Jephcott.

Notes

1. Gustav Glück (1902–1973), perhaps Benjamin's closest friend during the 1930s, was director of the foreign section of the Reichskreditgesellschaft (Imperial Credit Bank) in Berlin until 1938. He was able to arrange the transfer to Paris of the fees Benjamin received from his occasional contributions to German newspapers until 1935. In 1938 Glück emigrated to Argentina; after World War II, he was a board member of the Dresdner Bank.
2. The Austrian satirist and critic Karl Kraus (1874–1936) founded the Viennese journal *Die Fackel* in 1899 and edited it until shortly before his death. In the journal's early years, its contributors included the architect Adolf Loos (see note 3 below) and the composer Arnold Schönberg, but, after December 1911, Kraus wrote the entire contents of the journal himself.
3. The Austrian architect Adolf Loos (1870–1933) was a trenchant critic of the attempts of the Wiener Werkstätte [Vienna Workshops] to unite the fine and the decorative arts by turning the house into a richly ornamented "total work of art." The Wiener Werkstätte produced furniture, jewelry, textiles, and household objects.
4. Johann Peter Hebel (1760–1826) was a German journalist and author who developed a number of innovative short prose forms during his work as editor and chief writer at the *Badischer Landkalendar*, an annual publication

not unlike the American *Old Farmer's Almanac*. See Benjamin's two 1926 essays on Hebel in Benjamin, *Selected Writings, Volume 1: 1913–1926* (Cambridge, Mass.: Harvard University Press, 1996), pp. 428–434.

5. Otto Stössl, *Lebensform und Dichtungsform* [Life Form and Poetic Form] (Munich, 1914).

6. This quotation by the Austrian writer Adalbert Stifter (1805–1868) comes from the introduction to his *Bunte Steine* (1853), a volume of short stories. Stifter's prose is characterized by an unusually graceful style and a reverence for natural processes. See Benjamin's essay "Stifter" (1918), in Benjamin, *Selected Writings*, vol. 1, pp. 111–113.

7. Matthias Claudius (1740–1815), German poet, was perhaps the most notable poetic voice between Klopstock and Goethe. He served as editor of the important journal *Der Wandsbecker Bote*.

8. Johann Nestroy (1801–1862), Austrian dramatist and character actor, used satire, irony, and parody as weapons against the newly rising bourgeoisie. His best-known work is *Einen Jux will er sich machen* (He Intends to Have a Fling; 1842), adapted by Thornton Wilder as *The Matchmaker* and later turned into the musical play and film *Hello, Dolly!* Jacques Offenbach (1819–1880), German-born musician and composer, produced many successful operettas and *opéras bouffes* in Paris, where he managed the Gaîté-Lyrique (1872–1876).

9. *Die letzten Tage der Menschheit* (The Last Days of Humankind) is the title of Kraus's mammoth apocalyptic drama, which sought to expose the bureaucratic mediocrity and political criminality that he believed had brought Europe to the Great War. The play was published in its final form in 1923. Due to its length (it has 220 scenes and approximately 500 characters), it was first performed in Vienna only in 1964—and even then in a shortened version.

10. "Vienna Genesis" refers to an illuminated manuscript—a copy of the book of Genesis—in the collection of the Austrian National Library. Its dating (early Byzantine, perhaps 500–600 A.D.) and place of origin (Constantinople or Syria) are disputed. The linkage of Expressionism and late antiquity had been a concern of Benjamin's from the time he read the Austrian art historian Alois Riegl's study *Die spätrömische Kunst-Industrie* (The Late Roman Art Industry; 1901) during the years of the First World War.

11. Benjamin refers here to the "Lulu" cycle, two dramas by the German playwright Frank Wedekind (1864–1918). In *Erdgeist* (Earth Spirit; 1895) and *Die Büchse der Pandora* (Pandora's Box; 1904), the conflict of a desiccated, hypocritical bourgeois morality with a personal and, above all, sexual freedom is played out in the fate of the amoral femme fatale Lulu. Alban Berg based his opera *Lulu* on Wedekind's plays.

12. Kraus translated and edited Offenbach's farcical operetta *La vie parisienne* (libretto by Henri Meilhac and Ludovic Halévy), which premiered at the

Palais Royal in 1886. See Benjamin's "Karl Kraus Reads Offenbach" (1928) in Benjamin, *Selected Writings, Volume 2: 1927–1934* (Cambridge, Mass.: Harvard University Press, 1999), pp. 110–112.

13. Karl Kraus, "Offenbach Renaissance," *Die Fackel*, 557–558 (April 1927): 47.

14. The Austrian politician Johann Schober (1874–1932) was twice prime minister of Austria (1921–1922 and 1929–1930). He served for many years as Vienna's chief of police, and was responsible for the bloody suppression of workers' demonstrations in 1927. Imre Békessy (1887–1951) founded the gossipy and sensationalist Vienna daily *Die Stunde* (The Hour) in 1923. Alfred Kerr (Alfred Klemperer; 1867–1948) was Berlin's most prominent and influential theater critic. All were targets of Kraus's polemics in the 1920s.

15. "George school" refers to the circle of conservative intellectuals around the poet Stefan George (1868–1933), whose high-modernist verse appeared in such volumes as *Das Jahr der Seele* (The Year of the Soul; 1897) and *Der siebente Ring* (The Seventh Ring; 1907). George's attempt to "purify" German language and culture exerted a powerful influence on younger poets.

16. The Austrian comic dramatist Ferdinand Raimund (1790–1836) was—along with Johann Nestroy—among the preeminent playwrights of Vienna in the mid-nineteenth century. The Austrian actor Alexander Girardi (1850–1918) was famous for his performances in Raimund's plays.

17. Kraus cites this line in *Die Fackel* and attributes it to an anonymous Belgian soldier. *Granat* means "pomegranate"; *Granate,* "grenade" or "shell."

18. This is the conclusion of Karl Marx's 1844 review of Bruno Bauer's "On the Jewish Question."

19. Karl Kraus, *Worte in Versen,* II (Words in Verse, II).

20. Benjamin discusses the German writer Paul Scheerbart (1863–1915) in his essays "Experience and Poverty" (1933), in Benjamin, *Selected Writings*, vol. 2, pp. 733–734, and "On Scheerbart" (late 1930s or 1940), in Benjamin, *Selected Writings, Volume 4: 1938–1940* (Cambridge, Mass.: Harvard University Press, 2003), pp. 386–388. The *New Angel* is Paul Klee's ink wash drawing *Angelus Novus* (1920), which Benjamin owned for a time.

21. Benjamin refers to the German scientist, satirist, and aphorist Georg Christoph Lichtenberg (1742–1799).

41

Reflections on Radio

The crucial failing of this institution has been to perpetuate the fundamental separation between practitioners and the public, a separation that is at odds with its technological basis. A child can see that it is in the spirit of radio to put as many people as possible in front of a microphone on every possible occasion; the public has to be turned into the witnesses of interviews and conversations in which now this person and now that one has the opportunity to make himself heard. Whereas in Russia they are in the process of drawing out the logical implications of the different apparatuses, with us the mindless notion of the "offering," under whose aegis the practitioner presents himself to the public, still has the field to itself. What this absurdity has led to after long years of practice is that the public has become quite helpless, quite inexpert in its critical reactions, and has seen itself more or less reduced to sabotage (switching off). There has never been another genuine cultural institution that has failed to authenticate itself by taking advantage of its own forms or technology—using them to create in the public a new expertise. This was as true of the Greek theater as of the Meistersingers, as true of the French stage as of orators from the pulpit. But it was left to the present age, with its unrestrained development of a consumer mentality in the operagoer, the novel reader, the tourist, and other similar types to convert them into dull, inarticulate masses—and create a "public" (in the narrower sense of the word) that has neither yardsticks for its judgments nor a language for its feelings. This barbarism has reached its zenith in the attitude of the masses toward radio programs, and now seems on the point of reversing itself. Only one thing is needed for this: listeners must direct their re-

flections at their own real reactions, in order to sharpen and justify them. This task would of course be insoluble if their behavior really were—as radio managers and especially presenters like to imagine—more or less impossible to calculate, or simply dependent upon the content of the programs. But the most superficial reflection proves the opposite. No reader has ever closed a just-opened book with the finality with which the listener switches off the radio after hearing perhaps a minute and a half of a talk. The problem is not the remoteness of the subject matter; in many cases, this might be a reason to keep listening for a while before making up one's mind. It is the voice, the diction, and the language—in a word, the formal and technical side of the broadcast—that so frequently make the most desirable programs unbearable for the listener. Conversely, for the same reason but very rarely, programs that might seem totally irrelevant can hold the listener spellbound. (There are speakers who can hold your attention while reading weather forecasts.) Accordingly, it is the technical and formal aspects of radio that will enable the listener to train himself and to outgrow this barbarism. The matter is really quite obvious. We need only reflect that the radio listener, unlike every other kind of audience, welcomes the human voice into his house like a visitor. Moreover, he will usually judge that voice just as quickly and sharply as he would a visitor. Yet no one tells it what is expected of it, what the listener will be grateful for or will find unforgivable, and so on. This can be explained only with reference to the indolence of the masses and the narrow-mindedness of broadcasters. Not that it would be an easy task to describe the way the voice relates to the language used—for this is what is involved. But if radio paid heed only to the arsenal of impossibilities that seems to grow by the day—if, for example, it merely provided from a set of negative assumptions a typology of comic errors made by speakers—it would not only improve the standard of its programs but would win listeners over to its side by appealing to them as experts. And this is the most important point of all.

Fragment written no later than November 1931; unpublished in Benjamin's lifetime. *Gesammelte Schriften*, II, 1506–1507. Translated by Rodney Livingstone.

42

Theater and Radio

Theater and radio: for the unprejudiced reader, the contemplation of these two institutions will not perhaps evoke an impression of harmony. It is true that the competition between them is not as acute as between radio and the concert hall. Nevertheless, we know too much about the ever-expanding activities of radio, on the one hand, and the ever-increasing problems of the theater, on the other, to find it easy to envisage a collaboration between the two. For all that, collaboration does exist. And has existed, moreover, for a considerable time. They could only work together in the realm of education—so much must be admitted from the outset. But this collaboration has just been initiated with particular energy by Südwestfunk [Southwest Radio]. Ernst Schoen, the artistic director, has been one of the first to take note of the works that Bert Brecht and his literary and musical colleagues have been introducing to public discussion over the last few years.[1] It is no accident that these works—*Der Lindberghflug, Das Badener Lehrstück, Der Jasager, Der Neinsager,* among others—were unambiguously geared toward education.[2] On the other hand, they also represent a highly original combination of theater and radio. These foundations would soon prove viable. Radio plays of a similar kind could be broadcast—*Ford,* by Elisabeth Hauptmann, is one such.[3] In addition, problems of everyday life—school and education, the techniques of success, marriage difficulties—could be debated in the form of example and counterexample. So-called radio-models [*Hörmodelle*]—written by Walter Benjamin and Wolf Zucker—

393

were also promulgated by the Frankfurt-based radio station (in collaboration with Berlin). Such extensive activity provides a welcome occasion for a closer look at work of this kind, and simultaneously helps prevent misunderstandings about it.

But taking a closer look of this sort means being unable to ignore the most obvious aspect of radio—namely, its technological dimension. Here we would be well advised to put all touchiness aside and simply to affirm that, in comparison to the theater, radio represents not only a more advanced technical stage, but also one in which technology is more evident. Unlike the theater, it does not have a classical age behind it. The masses it grips are much larger; above all, the material elements on which its apparatus is based and the intellectual foundations on which its programming is based are closely intertwined in the interests of its audience. Confronted with this, what can the theater offer? The use of live people—and apart from this, nothing. The theater's future development out of this crisis may very well take its lead above all from this fact. What is the significance of the use of live people? There are two very distinct possible answers to this: one reactionary and one progressive.

The first sees absolutely no reason to take note of the crisis at all. According to this view, universal harmony remains intact, and man is its representative. Man is conceived to be at the height of his powers, the Lord of Creation, a personality (even if he is the meanest wage laborer). His stage is modern culture, and he holds sway over it in the name of "humanity." This proud, self-confident, big-city theater is as indifferent to its own crisis as to that of the world outside it (even though its best-known magnate recently abandoned it). And whether it presents dramas of the poor in the modern style or libretti by Offenbach, it will always produce itself as "symbol," as "totality," as *Gesamtkunstwerk* [total artwork].

What we have described here is a theater of education and of entertainment [*Zerstreuung*].[4] Both functions, however opposed to each other they may seem, are merely complementary phenomena in the realm of a saturated stratum which turns everything it touches into stimuli. But it is in vain that this theater attempts to use complex machinery and a vast horde of extras in order to compete with the attractions of the mass-market film; in vain that its repertoire is expanded to include all times and places, when, with a much smaller apparatus, radio and the cinema can create space in their studios for anything ranging from ancient Chinese drama to the latest Surrealist experiments. It is hopeless to try to compete with the technological resources available to radio and cinema.

But not hopeless to debate with them. This is the only thing that can be expected from the progressive stage. Brecht, the first to have developed its theory, calls it "epic." This Epic Theater is utterly matter-of-fact, not least in its attitude toward technology. This is not the place to expound on the theory of Epic Theater, let alone to show how its discovery and construction of *gestus* is nothing but a retranslation of the methods of montage—so crucial in radio and film—from a technological process to a human one. It is enough to point out that the principle of Epic Theater, like that of montage, is based on interruption. The only difference is that here interruption has a pedagogic function and not just the character of a stimulus. It brings the action to a halt, and hence compels the listener to take up an attitude toward the events on the stage and forces the actor to adopt a critical view of his role.

The Epic Theater brings the dramatic *Gesamtkunstwerk* into confrontation with the dramatic laboratory. It returns with a fresh approach to the grand old opportunity of theater—namely, to the focus on the people who are present. In the center of its experiments stands the human being in our crisis. It is the human being who has been eliminated from radio and film—the human being (to put it a little extremely) as the fifth wheel on the carriage of its technology. And this reduced, debarred human being is subjected to various trials and judged. What emerges from this approach is that events are alterable not at their climactic points, not through virtue and decision-making, but solely in their normal, routine processes, through reason and practice. What Epic Theater means is the attempt to take the smallest possible units of human behavior and use them to construct what was known as "action" in the Aristotelian theory of drama.

Thus, Epic Theater challenges the theater of convention. It replaces culture with training, distraction with group formation. As to this last, everyone who has followed the development of radio will be aware of the efforts made recently to bring together into coherent groups listeners who are similar to one another in terms of their social stratification, interests, and environment generally. In like fashion, Epic Theater attempts to attract a body of interested people who, independently of criticism and advertising, wish to see realized on the stage their most pressing concerns, including their political concerns, in a series of "actions" (in the above-mentioned sense). Remarkably enough, what this has meant in practice is that older plays—such as *Eduard II* [Edward II] and *Dreigroschenoper* [Threepenny Opera]—have been radically transformed, while more recent ones—such as *Der Jasager* and *Der*

Neinsager—have been treated as if they were parts of ongoing controversies.[5] This may shed light on what it means to say that culture (the culture of knowledge) has been replaced by training (the training of critical judgment). Radio, which has a particular duty to take up older cultural products, will best do this by means of adaptations that not only do justice to modern technology, but also satisfy the expectations of an audience that is contemporary with this technology. Only in this way will the apparatus be freed from the nimbus of a "gigantic machine for mass education" (as Schoen has described it) and reduced to a format that is worthy of human beings.

Published in *Blätter des hessischen Landestheaters,* May 1932. *Gesammelte Schriften,* II, 773–776. Translated by Rodney Livingstone.

Notes

1. Ernst Schoen (1894–1960), German musician, poet, and translator, was the artistic director of a major radio station in Frankfurt. Schoen provided Benjamin with opportunities to present his work on the radio during the 1920s and early 1930s.

2. *Der Lindberghflug* is a cantata (with text by Brecht and music by Kurt Weill) based on Brecht's radio play *Der Flug der Lindberghs* (The Flight of the Lindberghs; 1930), which was later renamed *Der Ozeanflug* (The Flight over the Ocean). Brecht wrote the didactic plays *Das Badener Lehrstück vom Einverständnis* (The Baden-Baden Didactic Play of Acquiescence; 1929), *Der Jasager* (He Who Said Yes; 1930), and *Der Neinsager* (He Who Said No; 1930) for performance by amateur, politically engaged troupes.

3. The dramatist Elisabeth Hauptmann (1897–1973) began collaborating with Brecht in 1924. She emigrated in 1933, first to France and then to the United States.

4. *Zerstreuung* means not only "entertainment" but also "distraction," a sense to which Benjamin turns later in this essay.

5. Benjamin is referring to Brecht's plays *Leben Eduards des Zweiten von England* (Life of Edward the Second of England; 1924) and *Die Dreigroschenoper* (The Threepenny Opera; 1928).

43

Conversation with Ernst Schoen

"Just as an upright piano might appear in a poem by Laforgue, in a scene from Proust, or in an image by Rousseau, the scraggly figure of the loud-speaker, or of headphones bulging on ears like tumors with the hanging entrails of the cord, is suited to the poetry of Aragon or Cocteau, to a painting by Beckmann or, better, de Chirico."[1] This is an incisive and compelling observation. It is taken from an essay in the journal *Anbruch* entitled "Musical Entertainment by Means of Radio."[2] The author is Ernst Schoen.[3] Which makes the compelling also surprising: it is the director of a radio station who is here speaking about his instrument in such an apposite, cultivated, yet unpretentious way. To listen to the plans and goals of such a man struck me as all the more interesting because the station in question is Radio Frankfurt, which had acquired a reputation throughout Europe even before its former program director, Hans Flesch,[4] focused attention on Frankfurt when he was hired away by Berlin and left his colleague behind as his successor.

"To understand something historically," Schoen begins, "means to grasp it as a reaction, as an engagement. Our Frankfurt enterprise thus must also be grasped as a response to an inadequacy, indeed as an opposition to that which originally determined the shape of the radio station's programming. This was, in short, Culture with a massive capital C. People thought that radio had put into their hands the instrument of a vast public-education enterprise; lecture series, instructional courses, large-scale didactic events of all sorts were introduced—and ended in fiasco. What did this reveal? That the listener wants entertainment. And radio had nothing of the sort to offer: the shabbiness and inferiority of its "col-

orful" offerings corresponded to the dryness and technical narrow-mindedness of the pedagogical programs. This is where someone had to intervene. What had previously been a decorative ornament supplementing the serious program—club fare like "Pillow Roll" or "Happy Weekend"—would now have to be elevated out of the stale atmosphere of amusement into a well-ventilated, loose, and witty topicality, fashioned into a structure in which the most varied elements could be related to one another in a positive way. Schoen provided the slogan: "Give every listener what he wants, and even a bit more (namely, of that which *we* want)." What Radio Frankfurt demonstrated, however, was that to do this was possible today only by means of a politicization which shapes the current historical moment—without the illusory ambition of civic education—the way Le Chat Noir and Die Elf Scharfrichter did in former times.[5]

The first step was already sketched out. What was needed now was to move from the status quo of the urban cabaret to a selection of those qualities which are available in such a vigorous manner only to radio. Simultaneously, radio had to take advantage of its superiority over cabaret in this specific regard—namely, its ability to gather, in front of the microphone, artists who would be unlikely to come together in the space of a cabaret. In this context Schoen remarks:

> What is much more important to me than the currently somewhat forced search for the literary radio play, with its dubious sonic scenery, is to find the best methods for translating every word-based work—from the lyric drama to the experimental play—into currently emergent forms. The situation is of course completely different with respect to nonliterary radio plays, which are determined by their materials and topical content and which in fact were pioneered by Radio Frankfurt. Here, we will first have to develop a series of models and counter-models of techniques of negotiation—"How do I deal with my boss?"[6] and the like—based on experience gained from the programs on crime and divorce, which were produced with such success.

This part of Schoen's agenda has already won the support of Bert Brecht, who will be a partner in these ventures.[7]

Schoen does not, by the way, think complacently of anointing the technical achievements—the sort one hears every month in the radio—as "cultural treasures." No, he keeps a cool head about such matters and is, for example, completely aware of the fact that television—which repre-

sents an expansion of his field of activity—brings with it new difficulties, problems, and dangers. For the moment, radio does not have to deal with a fully developed television. But when we consider the next relevant chapter—optical radio [*Bildfunk*],[8] whose establishment depends on the Reich's Radio Corporation—it is clear that its capacities for artistic employment will (as Ernst Schoen says) expand to the extent that we are able to liberate it from mere reportage in order to play with it.

My mainly literary interests may be the cause—but isn't it more likely the modesty of my partner (Ernst Schoen actually trained as a musician, and was a student of the Frenchman Varèse) which has so far kept our conversation from touching on musical issues? He won't be able to completely sidestep a question about the Baden-Baden Music Festival, which, as everyone knows, devoted two days to music composed for radio.[9] But I am a bit surprised to see that here, too, Schoen avoids being seduced into the domain of the aesthetic. He remains focused on the technological, and makes more or less the following argument: Technicians think there is no need for radio-specific music, since radio is sufficiently developed to transmit any sort of music perfectly. Schoen comments:

> Yes, in theory. But this presupposes perfect transmitters [*Sender*] and perfect receivers, which do not exist in practice. And this determines the task of radio music: it must take into account specific losses of quality that are still an unavoidable aspect of all broadcasting today. Moreover (and here Schoen aligns himself with Scherchen),[10] the grounds—call them aesthetic—for a newly established radio music do not yet exist. The Baden-Baden festival confirmed this. The hierarchy of the value of the works which were played there corresponded perfectly to their relative suitability for radio. In both respects, the Brecht-Weill-Hindemith *Lindberghflug* and Eisler's *Tempo der Zeit* cantata clearly came out on top.[11]

"At a specific and relatively arbitrary point in its development," Ernst Schoen remarks in conclusion, "radio was torn from the silence of the laboratory and made into a matter of public concern. Prior to that moment, its development was slow; these days, it is scarcely developing any faster. If even a portion of the energies currently being expended on the often all-too-intense enterprise of broadcasting were instead directed toward experimental work, the result would promote the advancement of radio."

Published in *Die literarische Welt*, 5, no. 35 (August 30, 1929). *Gesammelte Schriften*, IV, 548–551. Translated by Thomas Y. Levin.

Notes

1. Benjamin is referring here to Jules Laforgue (1860–1887), French Symbolist poet; Marcel Proust (1871–1922), French novelist, essayist, and critic; Henri Rousseau (1844–1910), French post-Impressionist painter, known as "Le Douanier"; Louis Aragon (1897–1982), French poet and novelist; Jean Cocteau (1889–1963), French Surrealist poet, novelist, dramatist, designer, and filmmaker; Max Beckmann (1884–1950), German painter, draftsman, printmaker, sculptor, writer, and champion of "New Objectivity"; and Giorgio de Chirico (1888–1978), pre-Surrealist Greek-Italian painter and founder of the *scuola metafisica* art movement.

2. Ernst Schoen, "Musikalische Unterhaltung durch Rundfunk," *Anbruch: Monatsschrift für moderne Musik*, 11, no. 3 (1929): 128–129. This Austrian journal, published in Vienna from 1919 to 1937, was the first devoted exclusively to contemporary music. Schoen's essay appeared in a special issue on "light music" which also contained texts by Theodor Adorno, Ernst Bloch, and Kurt Weill.

3. Ernst Schoen (1894–1960), the program director for Radio Frankfurt, was a trained musician and composer, having studied with both Ferruccio Busoni and Edgard Varèse. He was one of the very few friends Benjamin had retained from his schooldays—and this despite Schoen's affair with Benjamin's wife, Dora, in the early 1920s. Schoen is credited with getting Benjamin involved in radio, to such an extent that Benjamin earned a living from his radio broadcasts for three years (1929–1932).

 Besides a series of letters Benjamin wrote to Schoen prior to 1921—which are collected in *The Correspondence of Walter Benjamin*, ed. Gershom Scholem and Theodor W. Adorno (Chicago: University of Chicago Press, 1994)—there is an important (and unfortunately still untranslated) epistolary exchange about radio politics in April 1930 which is reprinted, along with a textual fragment entitled "Situation im Rundfunk," in Benjamin, *Gesammelte Schriften*, II, 1497–1505. See also Ernst Schoen, "Musik im Rundfunk: Der Frankfurter Sender," *Anbruch*, 12 (1930): 255–256.

4. Hans Flesch (1896–1945), the pioneering first program director of Radio Frankfurt starting in 1924, explored from the outset the possibilities of radio-specific works, including the remarkable *Zauberei auf dem Sender* (Magic in Airwaves), the very first German *Hörspiel* (radio play), in which Flesch anticipated the possibility of acoustic montage years before it became a technological reality. He quickly made a name for himself as a tireless innovator, which enabled him to get not only Walter Benjamin but also the young Theodor W. Adorno, Bertolt Brecht, and Flesch's friend and brother-

in-law Paul Hindemith interested in collaborating on projects for Radio Frankfurt. On July 1, 1929, Flesch took over as the director of the Funk-Stunde AG (Radio Hour Ltd.) in Berlin, where he continued to pursue his avant-garde programming.

5. Le Chat Noir ("The Black Cat"), a well-known Parisian cabaret founded in 1881 in the bohemian district of Montmartre, was the model for Die Elf Scharfrichter ("The Eleven Executioners"), the first literary-artistic cabaret in Munich (1901–1903). As a private club, the latter was able to elude censorship of its often highly satirical program of chansons, recitations, puppet plays, dramatic pieces, and literary parodies. Its most well-known regular was the author, performer, and *enfant terrible* of Munich's avant-garde, Frank Wedekind, whose famous *Moritaten*—satirical ballads marked by horrific detail and moralizing judgments—would later be taken up by Brecht and become a stylistic model for German cabaret singing.

6. "Wie nehme ich meinen Chef?" (How Do I Deal with My Boss?) is in fact the title of the very first of the *Hörmodelle* ("listening models") that Benjamin wrote, together with Wolf Zucker, in the late 1920s and that were designed to explore various negotiating strategies. It was broadcast by the Berlin Funk-Stunde on February 8, 1931, and was subsequently taken up by Radio Frankfurt, which broadcast it on March 26, 1931, under the title "Gehaltserhöhung?! Wo denken Sie hin?" (A Raise?! Where Did You Get That Idea?); Benjamin, *Gesammelte Schriften*, IV, 630ff. An English version of "Gehaltserhöhung?!" translated by Seetha Alagapan as "Pay Rise? You Must Be Joking!" and edited and introduced by Kenneth G. Hay, was published in *The Tempest* (Leeds), 1, no. 1 (December 1992–January 1993).

7. For Brecht's position on radio, see his 1932 text "The Radio as an Apparatus of Communication," in Anton Kaes et al., eds., *The Weimar Republic Sourcebook* (Berkeley: University of California Press, 1994), pp. 615–616.

8. Optical radio, or *Bildfunk*—the use of radio waves to send pictures, in a manner that today would seem reminiscent of the telefax—was first introduced with much fanfare in Germany on November 20, 1928, but was abruptly suspended just over a year later due to lack of commercial interest. Though today it is largely forgotten, this fascinating moment in the genealogy of the televisual was still a subject of great media-theoretical discussion at the time of Benjamin's essay.

9. In 1927 the Donaueschingen Music Festival, an annual event begun in the early 1920s and devoted to the promotion of contemporary (chamber) music of all sorts, changed its venue (and name) to Baden-Baden, where it continued to explore avant-garde composition and the relationship to new media such as film and radio as well as new musical technologies such as Jörg Mager's Sphärophon (an electronic microtone generator which was the forerunner of the modern synthesizer). The 1929 festival, which featured works for radio, music for amateurs, and film scores, was given financial support

by the German Reich's Radio Corporation. For a contemporary review, see Frank Warschauer, "Musik und Technik in Baden-Baden," *Anbruch*, 11, no. 7–8 (1929).

10. The German conductor, violist, and composer Hermann Scherchen (1891–1966), was an engaged advocate of contemporary music, conducting the world premieres of numerous works by composers such as Arnold Schönberg, Alban Berg, Anton Webern, Paul Hindemith, and Ernst Krenek.

11. The "epic" libretto of Bertolt Brecht's *Der Lindberghflug* (The Lindbergh Flight)—a cantata for voices, chorus, and orchestra which took the first successful transatlantic airplane voyage by Charles Lindbergh in 1927 as a figure for the power of the individual in society—had its world premiere, with music by Paul Hindemith and Kurt Weill, on July 27, 1929, at the Baden-Baden Chamber Music Festival as a purely radiophonic work. Broadcast into numerous nearby spaces from a room that had been outfitted as a makeshift studio, it was only one of numerous pieces performed at the festival that were written especially for radio, including Eisler's "radio cantata" *Tempo der Zeit* (Tempo of the Time).

44

Two Types of Popularity

The radio play "What the Germans Read While Their Classical Authors Wrote," which this journal has excerpted for its readers,[1] attempts to do justice to a few basic thoughts about the sort of popularity [*Volkstümlichkeit*][2] which radio should be striving for in its literary profiles. Given how transformative the advent of radio was in so many respects, it is—or should be—nowhere more transformative than with respect to what is understood as "popular" [*Volkstümlichkeit*]. According to an older conception of the term, a popular presentation—however valuable it may be—is a derivative one. This can be explained easily enough, since prior to radio there were hardly any modes of publication that really served the purposes of popular culture or popular education. The forms of dissemination that did exist—the book, the lecture, the newspaper—were in no way different from those in which scientists conveyed news of their research to their professional circles. As a result, representation appropriate to the masses [*volksmäßige Darstellung*] had to take place via forms employed by science and was thus deprived of its own original methods. Such representation found itself limited to clothing the contents of specific domains of knowledge in more or less appropriate forms, perhaps also seeking points of contact in experience or in common sense; but whatever it offered was always second-hand. Popularization was a subordinate technique, and its public stature confirmed this.

Radio—and this is one of its most notable consequences—has pro-

foundly changed this state of affairs. Thanks to the technological possibility it opened up—that of addressing countless numbers of people simultaneously—the practice of popularizing developed beyond a well-intentioned philanthropic effort and became a task with its own types of formal and generic laws, a task as different from the older practices as modern advertising is from the attempts of the nineteenth century. This has the following consequences for experience: the older type of popularization simply took for granted the time-tested and well-established inventory of science, which it propounded in the same way the sciences themselves had developed it, but stripped of the more difficult conceptual lines of thought. What was essential to this form of popularization was omission: its layout always to some extent remained that of the textbook, with its main sections in large type and elaborations in small print. The much broader but also much more intensive popularity [*Volkstümlichkeit*], which radio has set as its task, cannot remain satisfied with this procedure. It requires a thorough refashioning and reconstellation of the material from the perspective of popularity [*Popularität*]. It is thus not enough to use some contemporary occasion to effectively stimulate interest, in order to offer to the now expectantly attentive listener nothing more than what he can hear in the first year of school. Rather, everything depends on conveying to him the certainty that his own interest has a substantive value for the material itself—that his inquiries, even if not spoken into the microphone, require new scientific findings. In the process, the prevailing superficial relationship between science and the popular [*Volkstümlichkeit*] is replaced by a procedure which science itself can hardly avoid. For what is at stake here is a popularity that not only orients knowledge toward the public sphere, but also simultaneously orients the public sphere toward knowledge. In a word: the truly popular interest is always active. It transforms the material of science and penetrates that science.

The more liveliness demanded by the form in which such pedagogical work takes place, the more indispensable is the demand that it develop really lively *knowledge* and not only an abstract, unverifiable, general liveliness. This is why what has been said here is especially true of the radio play, to the extent that it has a didactic character. Now, as regards the literary radio play in particular, it is no better served by so-called conversations culled in an arts-and-crafts manner from the fruits of reading and from quotations of books and letters than it is by the dubious arrogance of having Goethe or Kleist adopting the language of whoever wrote the manuscript and speaking it into the microphone. And because the former

is just as dubious as the latter, there is only one way out: to take on the scientific questions directly. This is exactly what I am trying to do in my experiment.[3] The heroes of the German spirit do not appear there as themselves, nor did it seem appropriate to present as many acoustic samples of works as possible. In order to explore the question deeply, the point of departure was intentionally kept on the surface. It was an attempt to show listeners what was in fact present so randomly and abundantly that it permitted typification: not the literature but the literary *conversation* of those days.[4] Yet it is this conversation—which, as it occurred in cafés and at trade shows, at auctions and on walks, commented in an infinite variety of ways upon schools of poetry and newspapers, censorship and bookstores, youth education and lending libraries, enlightenment and obscurantism—that is also most intimately related to issues of the most advanced literary scholarship, a scholarship that increasingly tries to research the demands made on poetic activity by the conditions of its time. To bring together once again the talk about book prizes, newspaper articles, lampoons, and new publications—in itself the most superficial talk imaginable—is one of the least superficial concerns of scholarship, since such retrospective recreations make substantial demands on any factual research that is adequate to its sources. In short, the radio play in question seeks the most intimate contact with the latest research on the so-called sociology of the audience. It would find its strongest confirmation in its ability to capture the attention of both the expert *and* the layman, even if for different reasons. And thereby would also give voice to what may be the simplest definition of the concept of a new popularity [*Volkstümlichkeit*].

Published in *Rufer und Hörer: Monatshefte für den Rundfunk* (September 1932). *Gesammelte Schriften*, IV, 671–673. Translated by Thomas Y. Levin.

Notes

1. Benjamin's radio profile of a historical literary taste, "Was die Deutschen lasen, während ihre Klassiker schrieben" (*Gesammelte Schriften*, IV, 641–670), was broadcast by Radio Berlin on February 7, 1932, in its Funk-Stunde (Radio Hour) program. The sections published that same year in the radio journal *Rufer und Hörer*, 2, no. 6 (September 1932)—which differ from the full-length version in that they contain numerous simplifications of expression as well as Germanizations of foreign words—are reprinted in *Gesammelte Schriften*, IV, 1056–1071.

2. *Volkstümlichkeit* refers to a broad range of cultural objects and practices that

are folksy and folkloric on the one hand and popular (i.e., mass-oriented, or intended for the general public) on the other.

3. The *Versuch* ("experiment") Benjamin refers to here, using an explicitly Brechtian genre-designation, is his own radio play "What the Germans Read While Their Classical Authors Wrote."

4. The "conversation about literature" was a common Romantic form. See, for example, Friedrich Schlegel's "Gespräch über die Poesie" (Conversation about Poesy; 1800), one of his most important formulations of literary theory.

45

On the Minute

After trying for months, I had received a commission from the head of broadcasting in D. to entertain listeners for twenty minutes with a report from my field of specialization: the study of books. I was told that if my banter fell on sympathetic ears, I could look forward to doing such reports on a more regular basis. The program director was nice enough to point out to me that what was decisive, besides the structure of my observations, was the manner and style of the lecture. "Beginners," he said, "make the mistake of thinking they're giving a lecture in front of a larger or smaller audience which just happens to be invisible. Nothing could be further from the truth. The radio listener is almost always a solitary individual; and even if you were to reach a few thousand of them, you are always only reaching thousands of solitary individuals. So you need to behave as if you were speaking to a solitary individual—or to many solitary individuals, if you like, but in no case to a large gathering of people. That's one thing. Then there is another: you must hold yourself strictly to the time limit. If you don't, we will have to do it for you, and we'll do so by just brutally cutting you off. Experience has taught us that going over the allotted time, even slightly, tends to multiply the delays over the course of the program. If we don't intervene at that very moment, our entire program unravels.—So don't forget: adopt a relaxed style of speaking and conclude on the minute!"

I followed these suggestions very precisely; after all, a lot was at stake for me in the recording of my first lecture. I arrived at the agreed-upon hour at the radio station, with a manuscript that I had read aloud and timed at home. The announcer received me cordially, and I took it as a

particular sign of confidence that he did not insist on monitoring my debut from the adjacent booth. Between his opening announcement and the concluding sign-off, I was my own master. For the first time I was standing in a modern radio studio, where everything was designed for the complete comfort of the speaker and the unencumbered realization of his capacities. He can stand at a podium or settle into one of the roomy seats, has a choice of the widest variety of light sources, and can even walk to and fro carrying the microphone with him. There is also an elapsed-time clock—whose face marks not hours but only minutes—which keeps him informed of the value of every moment in this soundproof chamber. When the clock hit forty, I had to be done.

I had read more than half of my manuscript when I glanced over at the clock, whose second hand was tracing the same path prescribed for the minute hand, only sixty times faster. Had I made a production error at home? Had I now set the wrong pace? One thing was clear: two-thirds of my speaking time had already elapsed. As I continued reading word after word, in a confident tone, I silently and feverishly sought a solution. Only a brazen decision could help—entire sections would have to be sacrificed and the observations leading to the conclusion would thus have to be improvised. To wrench myself out of my text was not without its dangers. But I had no other choice. I gathered all my strength, skipped a number of manuscript pages while drawing out a longer sentence, and finally landed happily, like a pilot at his airport, in the conceptual nimbus of the final paragraph. With a sigh of relief I immediately gathered up my papers and, in the heady rush of the command performance that I had just completed, stepped away from the podium in order to put on my coat in a leisurely fashion.

At this point the announcer really ought to have come in. But he was nowhere to be seen, and so I turned to the door. In the process my gaze fell once again upon the clock. Its minute-hand indicated thirty-six! A full four minutes remained until forty! What I had noted in midflight, a moment before, must have been the position of the *second hand!* The announcer's absence suddenly made sense. However, in the same instant the silence, which had just been so comforting, suddenly enveloped me like a net. In this chamber made for technology and the people who rule by means of it, I was suddenly overcome by a new shudder, which was related to the oldest shudder known to man. I lent myself my own ears, which suddenly perceived nothing except the sound of silence. But I recognized that silence as the silence of death, which at that very moment was snatching me away in thousands of ears and thousands of homes.

I was overcome by an indescribable fear and immediately thereafter by a wild determination. "Save whatever can still be saved!" I said to myself, as I tore the manuscript out of my coat pocket, grabbed the first page I could find among the ones I had skipped, and began to read again with a voice that seemed to be drowned out by the thumping of my heart. I couldn't expect myself to come up with any ideas on the spot. And since the passage that I'd happened upon was short, I stretched out the syllables, let the vowels resonate, rolled the R's, and inserted pregnant pauses between the sentences. In this way I once again reached the end—this time the right one. The announcer came and released me in a cordial manner, just as he had received me earlier. But my anxiety did not abate. So when I ran into a friend the next day who I knew had heard my talk, I asked in passing what he'd thought of it. "It was very nice," he said. "But these receivers are always unreliable. Mine completely stopped working again, for an entire minute."

Published under the pseudonym Detlef Holz as "Auf die Minute," *Frankfurter Zeitung,* 79, nos. 620–621 (December 6, 1934). *Gesammelte Schriften,* IV, 761–763. Translated by Thomas Y. Levin.

INDEX

CREDITS

The translations of "Bekränzter Eingang" (Garlanded Entrance), "Antinomien der Allegorese" (Antinomies of Allegorical Exegesis), "Die Ruine" (The Ruin), "Sprachzerstückelung" (Dismemberment of Language), "Antoine Wiertz: Gedanken und Gesichte eines Geköpften" (Antoine Wiertz: Thoughts and Visions of a Severed Head), "Peintures chinoises à la Bibliothèque Nationale" (Chinese Paintings at the Bibliothèque Nationale), "Gespräch mit Ernst Schoen" (Conversation with Ernst Schoen), "Zweierlei Volkstümlichkeit" (Two Types of Popularity), and "Auf die Minute" (On the Minute) are published for the first time in this volume.